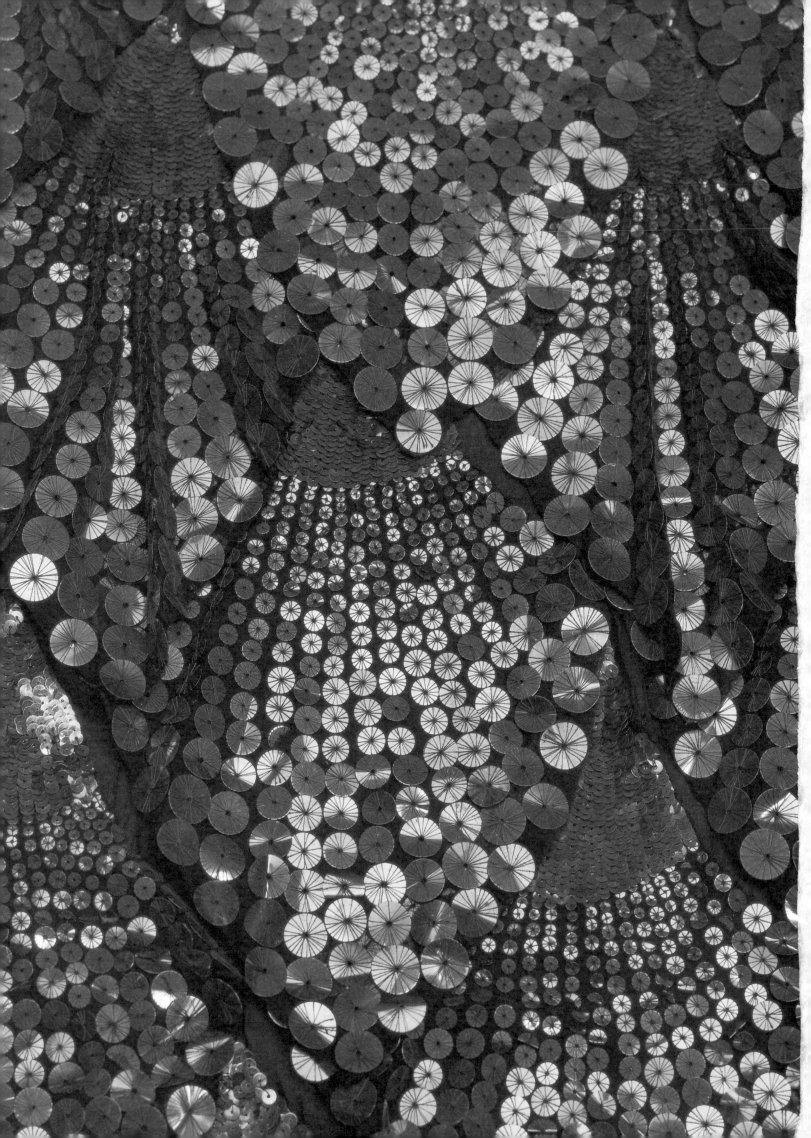

LANVIN

DEAN L. MERCERON

FOREWORD BY ALBER ELBAZ

INTRODUCTION BY HAROLD KODA

ART DIRECTION BY IAN LUNA

IMAGE COORDINATION BY MANDY DeLUCIA

DESIGN BY MARK MELNICK & EUGENE LEE

RIZZOLI
NEW YORK

LANVIN

DEDICATION

This book is dedicated to the most influential women in my life. Laura Moreau Merceron and Marie-Louise Begué Drury—my highly skilled and talented grand-mothers whom I miss daily. I am proud and grateful to have inherited their hand skills and various artistic abilities. My mother, Mary Drury Merceron, is the force behind the knowledge I possess within the realm of fashion, textiles, color, and, most important, style. She continues to be my strength and guiding force to all things creative, inspired, and beautiful. Thank you.

To my father, Dale A. Merceron, my soul support. Thank you for your understanding and encouragement.

First published in the United States of America by Rizzoli International Publications, Inc.
300 Park Avenue South, New York, NY 10010
www.rizzoliusa.com

Editor: Ian Luna
Image Coordination: Mandy DeLucia
Editorial Assistants: Tricia Levy, Claire L. Gierczak, April Huot, Henry Casey, Moraiah Luna, Micah Hayes, and Joshua D. Jones

Art Direction: Ian Luna
Designed by Mark Melnick & Eugene Lee
Production: Maria Pia Gramaglia, Kaija Markoe and Colin Hough Trapp

Printed in China

2008 2009 / 10 9 8 7 6 5 4 3

Library of Congress Control Number: 2007932584
ISBN-10: 0-8478-2953-8
ISBN-13: 978-0-8478-2953-8

TABLE OF CONTENTS

For me, there is nothing scarier than being "the designer of the moment," because the moment ends. When I was hired at Lanvin, it dawned on me that the one thing I had to do there was go back to basics. The challenge now is to make everything about *design* rather than style.

France gave me style, elegance and individualism. America offered me comfort. Morocco transmitted sensuality and a keen color sense. Israel gave me strength. I believe my life is an incessant, virtual voyage. I'm more true to myself now and more honest with my work. I feel more mature. Originality, personality, the freedom to do what you like, when you like. The freedom to "make mistakes." When you work with joy, it's reflected in the colors, the fabrics and the feeling of the clothes.

What I know how to do is fashion, because without fashion I'm nothing. When I start a collection, I always have a story as an inspiration. I need a story because if I don't, I can't do anything. You are only as good as your next collection. Not as your last one but as your next one and this is so good because it means you can never be happy with nothing. The moment you finish a collection it is already the past. The next is coming; the future is on the door. So here we go—paranoia with depression. You are always being criticized and you are always being watched. I am a voyeur myself and a voyeur cannot be watched.

Fashion is not a sketch with a front and back view. It's about what exists between the drawing and the outfit: the woman. It's difficult for women today, as they are not allowed to age. As a designer, I have to know what a woman experiences in the course of a day as she is obligated to be perfect at home and in the office: the perfect lover, the perfect mother, perfect daughter. I think about the women I know and women I like—and how I would love them to be dressed. And they have no age! I find that when I have a connection with all of these women around me, there is such a dialogue with all of them. I think everything is so easy when I communicate with a dress; I create a relationship with a coat, look how easy it is!

How would I like them to dress? How would I like to see them? What would I love to offer them to wear? Or what would they want to wear? I always work on a wardrobe with no consideration to the fashion show, but of the woman who is going to wear it.

We are looking for emotional clothes, but no one can define that exactly. For me, comfort is the most modern thing in clothes, but most dangerous for a designer. In fashion and in life, you need fear and insecurity in order to move forward.

Art is only about feelings, but designers have to think. For what I do there is no formula: developing a new direction, a modern version of the antiquated idea of couture. I respect the past even though I do not believe I belong there. I feel like an acrobat balancing between two worlds: the past and the present. I love tradition, but I also love the idea of representing it in a different way. Art is a monologue: design is a dialogue. A dress represents memories--each of my dresses is a short story.

Nothing is perfect. Imperfection within perfection. Perfection is never interesting to me, but the search for perfection, which all women feel, is interesting. I don't relate to perfection and we have to bring beauty back to fashion, creating dresses that stroke the body and yet, never grip it...airy, light-handed, creating restrained allure--dresses that skim as opposed to cling.

I believe in covered allure. If sensuality is too much in your face, it is hard to digest. Someone said to me they love Lanvin because they're the kind of clothes that make a man fall in love. What I want is clothes to make the woman who wears them fall in love, clothes that follow, rather than sex up the natural curves of the female form. My clothes are about comfort, simplicity, and not stealing attention away from the face. If you change a woman's look, you change her persona.

I think it is a good time to reintroduce the word "smart" to fashion. The highest compliment a woman can receive is "My God, she looks smart!" not that "she's sexy," "she's so beautiful." Smart is a word used in computers, cars, and architecture. I want to do clothes that are smart like that. Clothes should be timeless, that the elegant simplicity of a skirt or sweater should endure for many seasons.

1

JEANNE LANVIN
INTRODUCTION
BY HAROLD KODA

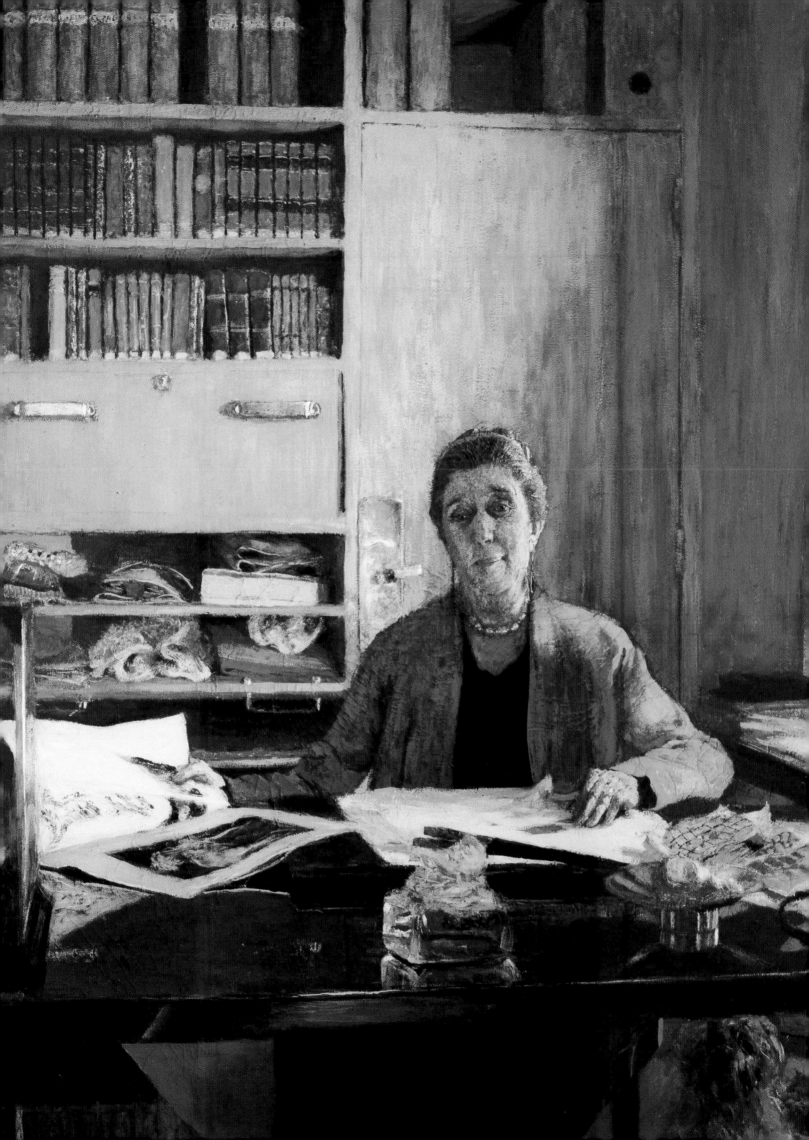

Là, tout n'est qu'ordre et beauté,
Luxe, calme, et volupté

Charles Baudelaire
From *Les fleurs du mal*, L'Invitation au voyage (1857)

IN JEAN RENOIR'S masterful film, *Rules of the Game*, the sympathetic and central role of Christine, the Marquise de la Cheyniest, would have benefited by being gowned in a Jeanne Lanvin. The Marquise's combined qualities of an endearing and carefully managed flirtatiousness masking her essential rectitude are essential components of the Lanvin style: a compelling prettiness paired with sophisticated discretion, and luxurious, even aristocratic, effects mediated by a clarifying innocence and freshness. For Lanvin, more than any other designer, epitomized the aesthetic of feminine beauty and elegant charm as represented in such *raffiné* French publications as *La Gazette du Bon Ton*, 1912-25 and *Art, Goût et Beauté*, 1921-33. Although her creations appeared with no greater frequency than those of other important houses of the day—many which did not survive World War II and are for the most part forgotten—hers was a style of picturesque lushness balanced by a quiet propriety. She captured precisely the haute Parisienne sensibilities represented in the romantic pochoirs of such illustrators as Marty, Iribe, Lepape, de Monvel and Barbier. In the film, however, Renoir's darkly satiric intentions, despite the director's protestations to the contrary, are apparent in his selection, of Gabrielle "Coco" Chanel, the modernist couturiere of ironic design strategies, to costume the female roles, rather than Lanvin, whose fashions invariably reified the authority of French elegance.

Although the significance of the life and work of Jeanne Lanvin, the eponymous founder of the house which is active to this day, has been well acknowledged in surveys of 20th century fashion, she has not been accorded the stature of some of her contemporaries like Paul Poiret, Elsa Schiaparelli, and Chanel, to cite the most obvious examples. This absence of clearly distinguished reputation may be ascribed to Lanvin's own careful management and control of her image during the period of her active creative life. But it is also due in part to the traditional definitions of design movements, based on art historical models, that have only recently been expanded.

The primary artistic tendencies ascribed to modernism in the first decades of the 20th century have generally served to elide the decorative and narrative-imbued approach endorsed by Lanvin. While the reductive styles *à la garçonne* advocated by such designers as Jean Patou, Gabrielle Chanel and Lucien Lelong are seen in comfortable conjunction with nascent abstraction in painting and sculpture of the period and International Style in architecture, Lanvin's romantic historicism aligned her with the artistic and decorative arts movements seen until recently as outside avant gardist tendencies because of their allusive, and hence—according to this line of thinking—*retardataire* impulses. By this limited reading of the stylistic components of modernity, even Paul Poiret, the proponent at the beginning of the 20th century for a corsetless figure who utilized the imagery of Orientalism and Classicism in his advocacy of a liberated form of dressing, is posited not as a fully fledged modernist, but rather as a transitional figure to the "true" modernism of fashions post-WW I and in the 1920s. Like Poiret and the Callot Sœurs, Lanvin, with her evocative motives and historicizing silhouettes, was not viewed as an exemplar of the modernist movement, a movement that was thought to repudiate the past. Instead, she was an anomaly, retaining a criteria of beauty and elegance that appeared to be, however evolved, a nonetheless persistent, pre-modernist sensibility.

Interestingly, Madeleine Vionnet who had worked with the Callots, with her fracturing of the planes of the body in conceptually complex, but apparently simple, designs, though hardly a proponent of the self-abnegating stringency of "reverse chic," has been seen to conform to the purist principles of the International Style. Vionnet's creations appear to adhere to a "form follows function" strategy of an integrated structural and decorative interplay, no matter that her motifs of birds, bow knots, or roses are no more abstract than those of Lanvin. Therefore, unlike the Callots and other romanticists, Vionnet's work was placed comfortably within the parameters of the modernist movement.

But Lanvin was closer to the design philosophy of the Callots, Vionnet's mentors, and her contemporaneity was submerged as was theirs beneath the highly embellished and aestheticized surfaces that they preferred. Recently, working with more encompassing definitions of modernity, scholars have begun to assess the conceptual breadth of couturiers beyond the simple evidence of their primary work. Poiret's re-evaluation by Nancy Troy expands on the applicable elements of his innovative approach to the creation of a design house, examining not only Poiret's fashions and his contributions toward a new ideal of feminine beauty, but his range of products including fragrance, decorative arts and furnishings, inventive promotion, licensing, and artistic collaborations, all as integral components of his modernity.

In this climate of re-assessment, some of the most compelling creators of the early 20th century whose work did not fall neatly into prior criteria of artistic advance and avant gardism emerge with the significance of their own time. In revisiting Lanvin's work and career, an impressive paradigm for the 20th century woman emerges. The fact that Lanvin was born in 1867 only enhances the magnitude of her innovations and accomplishments. Chanel, a decade younger, has come to epitomize the New Woman of the 20th century, but Lanvin, represents an equally compelling, if less lurid, example of the self-made professional, a woman creative and entrepreneurial in equal measure. And, while Chanel's personal mythology was based on an abandoned child, kept woman, and internationally successful businesswoman trajectory and narrative, Lanvin's was that of a doting and working mother.

The high fashion system with its seasonal advocacy of the new and an associated obsolescence of preceding styles, perhaps inevitably dismisses, if not obliterates, its own history. The pertinence or vivacity of a contemporary fashion house will often obscure the reputation of other more enduring design establishments, as a fashion house is only as relevant as its current collection. In the case of Lanvin, the legacy of her house has benefited from the recent surge of interest generated by its critically lauded designer, Alber Elbaz, the latest in the series of many talents who have sustained the viability of Lanvin's creative vision. By a quirk of fate, the reinstallation of Lanvin's apartments in the Musee des Arts Decoratifs at the same time as this revivification of the house has underscored the importance of Lanvin herself, and the designer's place in the artistic life of her time.

The newly refurbished period rooms done by Lanvin in collaboration with Armand Rateau introduce a time of aesthetic delights, a high point of the French decorative arts surrounding the influential 1925 Art Deco exposition. As much as her fashions that survive in all the major costume collections of the world, Lanvin's private quarters suggest the richly decorative sophistication of her world. The notion that a designer would create not only fashions for men, women and children

and establish a series of classic fragrances, but also venture into the world of interior design and the decorative arts, confirms her advanced belief in the role of the designer beyond that of a fashion maker, but as a purveyor of "lifestyle."

Unlike the couturiere, Vionnet, who described herself as a "dressmaker" and whose house was known for its technical innovation, Lanvin situated herself in the world of artists and creators. Without the bombastic affectations of Charles Frederick Worth who dressed the part of the artist rather than the entrepreneur or Paul Poiret who dressed the part of the dandy while pursuing a side career as a painter, Lanvin conveyed in her comments about her work an emphasis of feeling above technique, and of intuition as the motivator to her skill. Like any artist, she claimed to not only identify and materialize the momentary zeitgeist in her collections, but anticipate its direction, as well.

Though her collections offered a quite varied menu of styles from which her clients could select, and though she avoided categorical definitions of a house style, her design sensibility was in fact readily identifiable. Her preference, seen in much of her work, of incorporating some form of applied detail in leitmotifs that recur throughout her career. While her collections are generally responsive to the shifts in fashion, her adherence to the full-skirted silhouette of the *robe de style* through the '20s suggests her independence and confidence in her aesthetic authority. But even her most sumptuously decorated fashions invariably conform to an approach which prioritizes a clean and graphic silhouette. Ornamentation, either applied or integrated into the structure of the ensemble, was defined by clearly articulated forms.

In this, Lanvin shares with the great American couturier, Charles James, an approach to dressmaking inflected by a background in millinery. However, unlike James, whose milliner's approach was manifested in an obsessive interest in seaming as a device for shaping, and in the creation of complex, self-sustaining understructures, not unlike the blocked body of a hat over which the decorative skin of luxurious fabrics might be applied, Lanvin's methodology adhered more closely to the milliner modistes of the 18th century, most famously Rose Bertin, who customized the headdresses and voluminous gowns of their clients as much by the application of decorative ornaments and trims as by a manipulation of their forms. Lanvin's love of clarified silhouettes, whether the signature volume of the *robe de style*, or the sensual but sharp linearity of her body-skimming sheathes of the 1930s, suggests that her underlying strategy of elegance was to create strong but apparently simple effects.

Even her decorations conformed to this aesthetic. And when and where they are applied, her ornamental techniques and trims, no matter how finely wrought and conceived, have a decisively graphic or sculptural resolution, and however bold the patterning of bows, flowers, or arcing abstractions on her dresses, the employment of the finest handwork yields the pleasure of close examination. There is in the technique of her embellishments a celebration of the métiers of *les petites mains*, the artisanal trades that support the luxurious details of the haute couture. In a world of an emerging café society where social women could be seen in venues once more appropriate for the demimondaine, the public view, somewhat distant, was addressed by Lanvin's boldly scaled motifs. Still, by retaining an uncompromising concern for the details of her designs, Lanvin continued to provide for a closer view, the scrutiny of intimates and the client. All but

invisible stitching on complex appliqués, massings of varied beading combined to unified effect, threadwork glimpsed through finely ridged shirring, and the fragile interstices of drawnwork brides or silk tulle webbing imbue Lanvin's work with an acknowledgment of the societal transformation of increasing opportunities for public self-presentation without relinquishing the private pleasures of the couture.

Throughout her career, Lanvin's reference points were, like many of the great decorative artists and furniture makers of the day, the highpoints of aristocratic refinement of the French royal courts of the 18th century and the period of the Second Empire. Her persistent advocacy of the *robe de style* may be seen as a harking back to forms from these grand epochs of French elegance—the *panniered* gowns of the court at Versailles, and the inflated crinoline dresses promoted by the Empress Eugenie and her ladies at a time when the very business of the haute couture was being advanced by Charles Frederick Worth. Fashion plates from the late 1850s and '60s were hung in a series that lined the walls of her salon, suggesting the powerful influence of the decades just preceding Lanvin's birth on her ideas of fashionability and elegance.

While it has often been observed that female designers have themselves to consider as they create a collection, Lanvin had the further advantage of having her daughter, the beautiful and social Marguerite, later the Comtesse de Polignac, as a muse. Not only did her pool of clients whose lives and social requirements she had observed so closely as a milliner inform her approach to dressing the *beau monde*, Lanvin had in the coming of age of her daughter the opportunity to understand the changed world of the 20th century and thus channel the desires of the new generation. Although Jean Patou and Gabrielle Chanel introduced a new sportswear

sensibility to high fashion that came to characterize the century, Lanvin, unlike the designers who preceded her or were her true contemporaries (both Patou and Chanel were over a decade younger than Lanvin), was able to present not only a convincing alternative to the industrial modernism of her younger colleagues with her emphatic but rarely cloying romanticism. Even her dresses for her young daughter, capture the femininity of a little girl, but with a paradoxical mix of sophistication and charm. It was a potent combination that a woman might desire for herself. Even at her sleekest, the Lanvin woman never conveyed the hard chic of Chanel. The air of prettiness created in the Lanvin ateliers of *tailleur* and *flou*, reflected a gentler ideal of elegance.

It is this ideal that has been recalled by Lanvin's current designer, Alber Elbaz. With his love of astonishing juxtapositions of fragile and unusual textiles, his play of color and texture, his ability to make masterful old techniques come to life with contemporary relevance, and his supple working of fabric over the female form, the original spirit of Lanvin has been transposed to the present. If Jeanne Lanvin adorned the new woman of the 20th century with the aristocratic narratives of the French courts of the 18th and mid-19th centuries, or imagined her in the spiraling geometries of a medieval angel, Elbaz dresses the woman of the 21st century with the exquisite refinements of Paris between the wars, but with a new conceptual complexity. While Elbaz rarely cites the house's rich history with any literalness, his understanding of the lightness of hand that was the measure of the house's founder has yielded collections of a poetry that recall the same Beaudelarian aestheticism that might have defined Lanvin, herself.

CAREER AND FAMILY

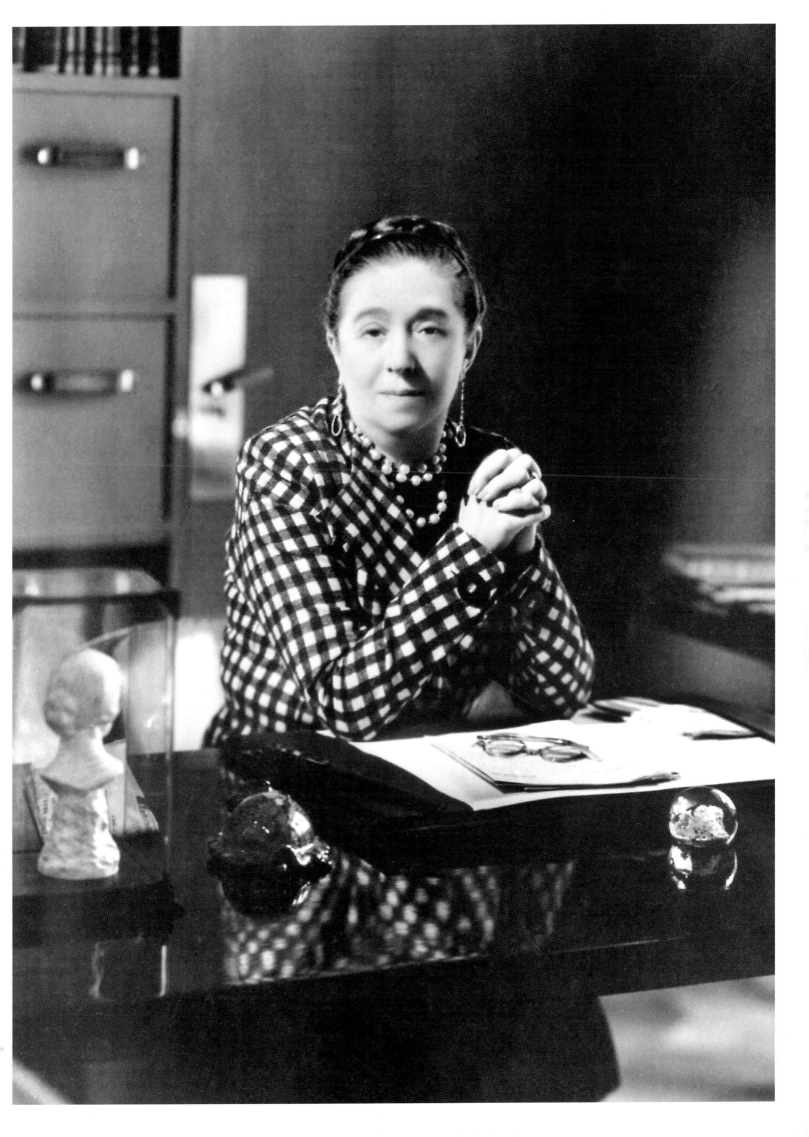

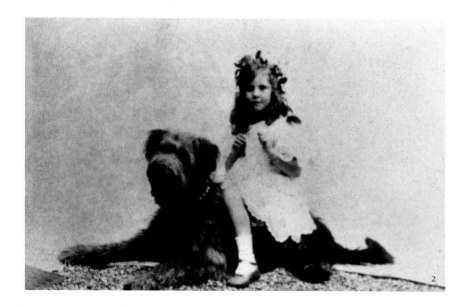

"THE HOUSE OF LANVIN evolved from the creative force and remarkable energy of an extraordinary woman, Jeanne Lanvin."[1] (Fig. 1 & 3) The design career of Jeanne Lanvin survived fifty-six successful and productive years—Lanvin was the oldest surviving couture house in continuous existence, from 1909 to 1993, a period of 84 years. Lanvin still exists in its original location as a luxury goods and ready-to-wear business for men and women, and the house continues to open boutiques around the world. But to this day, compared with more famous names such as Gabrielle "Coco" Chanel or Paul Poiret, many remain unaware of the identity and achievements of Jeanne Lanvin—and her contributions to the fashion industry, and the world of design in general.

The longevity of this couture house may be attributed to the untiring force and determination of a woman driven by the relentless need to create, succeed, and excel in a field dominated by many worthy, predominantly male contemporaries. Fueled by the single-minded devotion to her daughter, Marguerite Marie-Blanche, her love for the child manifested itself in the most inspired, creative, and feminine fashions. (Fig. 2)

Also contributing to the survival of the couture house was Madame Lanvin's versatility. She successfully melded the Lanvin image with the changing desires and needs of fickle fashion clientele. (Fig. 4) The house of Lanvin's image was clearly defined and redefined from season to season, and always maintained its image of youth, femininity, and beauty. Madame Lanvin was a fashion leader and innovator in the 1920s, using original colors and innovative surface decorations that ensured the distinctiveness of her creations. Although the garments are masterfully constructed, the true appeal and originality of these designs is in the surface detail and embellishment. The origin and influences of these beading and embroidery designs are of great importance and interest.

The stylings at Lanvin were distinct from those being offered by other leading fashion houses, consistently lauded and generating impressive sales. Madame Lanvin offered a vast array of styles and options catering to women of all ages and their unique needs. She managed to maintain her style and adjusted her perspective with the vicissitudes of fashion. Marguerite was her muse; her youthful and contemporary perspective served to sustain the fresh and up-to-date image of the fashion house.

When one actually examines a Lanvin product, it is quite obvious why the couture house remained in favor with a loyal international clientele for such a long time. Madame Lanvin's artistic sensibility and creative spirit is evident in even the simplest of forms. She collected books, textiles, and assorted artifacts on her world travels. (Fig. 6-7) She is one of the few designers of her time who successfully drew inspiration from colors, motifs, and symbols inspired by visits to cathedrals, museums, and art galleries. There is a small but important difference between "being inspired by" and "using" something as an inspiration. "Being inspired by" allows one to draw upon the essence of an object, a color, or an image to produce something original. "Using" something as an inspiration implies a literal translation in the design process. There is no original thought or creativity required, only appropriation.

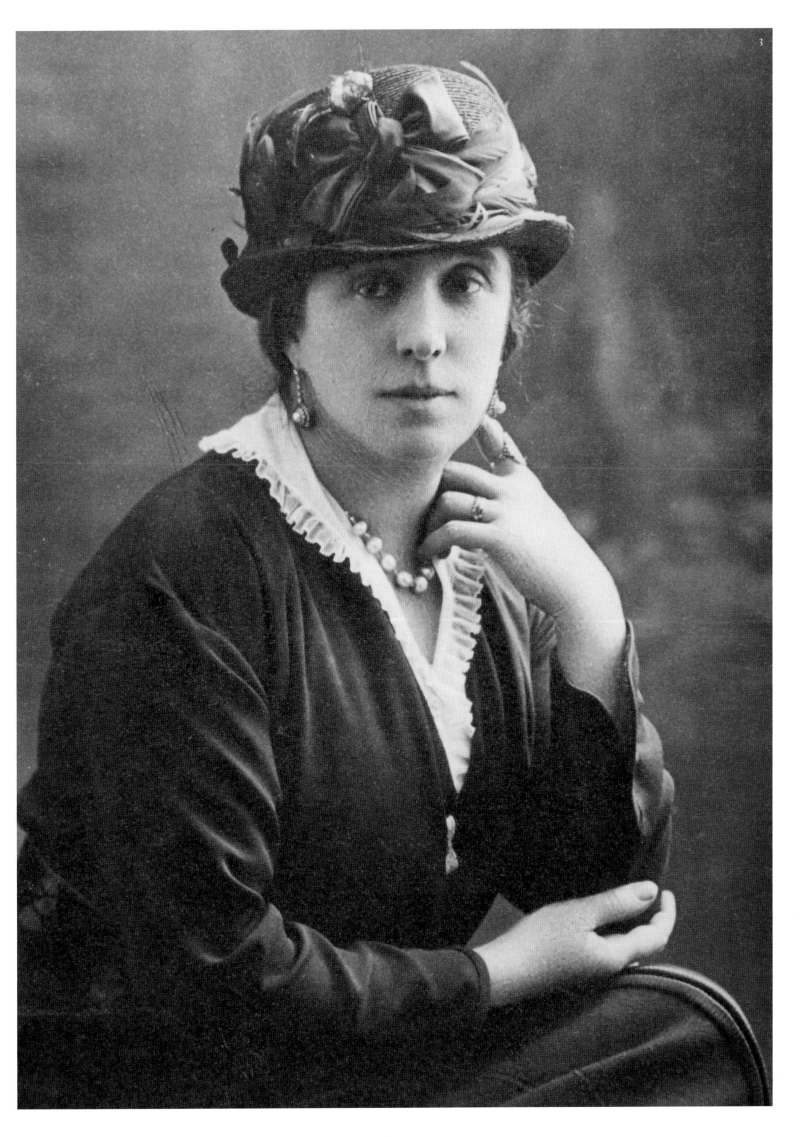

Figure 4: The quintessential Lanvin client at a horserace, 1923-24.

Opposite page: Figure 5. Woman's tunic with mirror-work and embroidery.

Figure 6: From the Lanvin archive, antique ethnographic objects that were used as inspiration.

Figure 7: Madame Lanvin on holiday in Egypt.

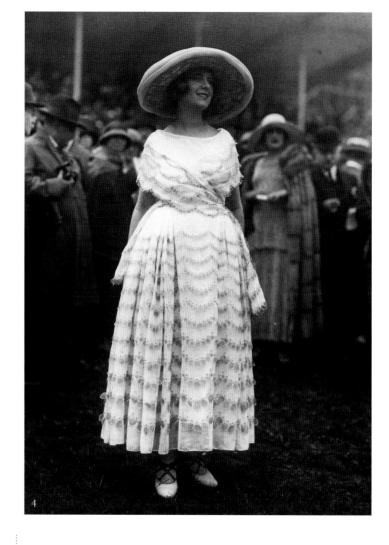

Madame Lanvin was a designer who could successfully extract elements and incorporate them into viable, modern, and functional designs. An excellent example of this is the development of her signature color, "Lanvin blue." Evidence in the Patrimoine Lanvin suggests that it was inspired by a color present in frescoes painted by Fra Angelico; however, other texts state that the blue color was derived from the cobalt of medieval stained glass. There is no definitive proof to resolve these contradictory accounts of its origin, but over the years many Lanvin creations extract from—or reference the works of—Fra Angelico and the same blue color consistently found in the palette he and his followers utilized. (Fig. 8)

The desire to create the perfect colors for her designs, which included "rose Polignac," for her daughter, who would later marry to become the comtesse Marie-Blanche de Polignac, and "Velasquez green," prompted Madame Lanvin to establish her own dye factories in 1923, located in Nanterre, France. This establishment would ensure the originality and exclusivity of her colors in that they could never be duplicated.

Her obsession with creating the perfect colors and combinations was further developed by her relationship with the Les

Nabis painter Edouard Vuillard. (Fig. 11) Lanvin collected works of art by other French painters such as Henri Fantin-Latour, Odilon Redon (Fig. 10), Jean-Honoré Fragonard, Pierre-Auguste Renoir (Fig. 9), and Edgar Degas. She was greatly influenced by the Impressionist painters and their evocative use of color and light. Lanvin wished to embody this feeling in her creations, saying, "Modern clothes need a certain romantic feel."[2] (Fig. 12)

The work of the Symbolist painter Redon had a particular influence on Madame Lanvin, further influencing her interest in the mystery of color, the use of color, and the desire for the non-color black. "I have made an art for myself," wrote Redon in explanation of the mystical quality of his painting. "My art determines nothing. I wish it to carry people, as music does, out into a mysterious, indefinable world. I wish to inspire, but never to define."[3] In 1945 Madame Lanvin expressed the same sentiment of designing for oneself and creating what one deems beautiful. She stated, "For many years now, those who have seen my collections have always been eager to define a Lanvin style. I know it is often discussed; nevertheless I have never limited myself to a particular kind of clothing, and have never sought to emphasize a specific style. On the contrary, I make great efforts every

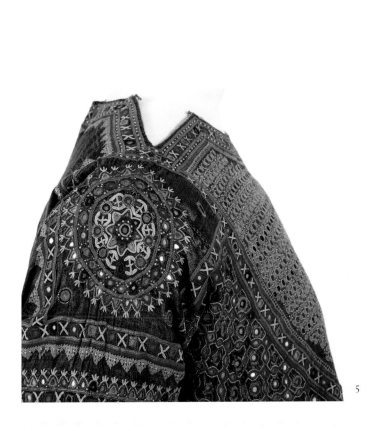

5

6

7

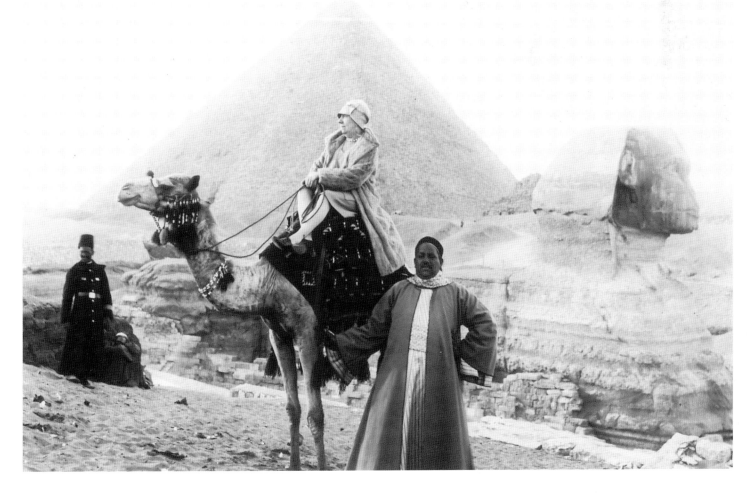

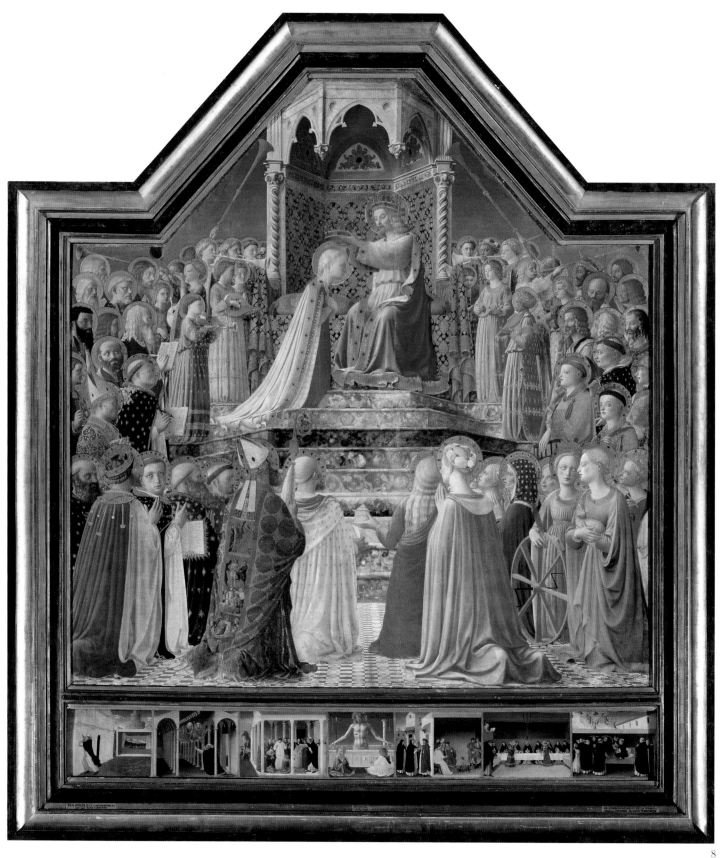

8

Opposite page: **Figure 8.** Fra Angelico, *Coronation of the Virgin* (before 1435). Tempera and gold on panel. Musée du Louvre, Paris.

Figure 9: Pierre-Auguste Renoir, *The Washerwomen* (1913). Oil on canvas. Collection Melet-Lanvin.

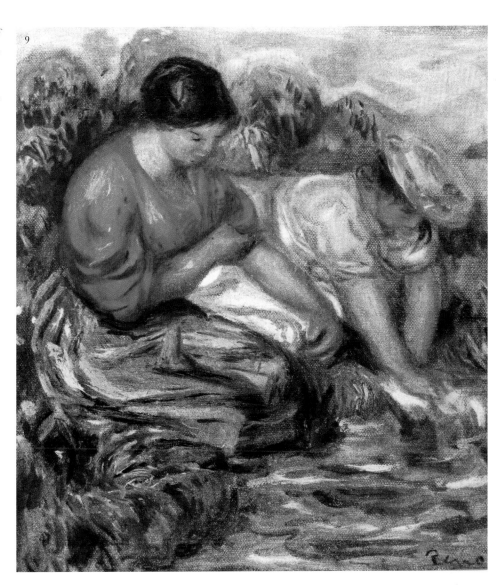

season to capture a certain mood, and use my own interpretation of events around me to put my fleeting concept into tangible form."[4]

Spontaneity of design is also a shared theory between the two artists as confirmed by this observation in *Vogue*, June 1, 1922: "And you feel in his [Redon's] painting that always he is striving to reach the invisible and so to saturate his work with the quality of that mysterious region... A quite unconscious quality of decoration pervades Redon's paintings. (Fig. 10) They are done with a sense of sheer beauty of colour that one can imagine furnishing the key-note for sumptuous colour schemes in a variety of ways."[5] Madame Lanvin advocated spontaneous design: "I act on impulse and believe in instinct. My dresses aren't premeditated. I am carried away by feeling, and technical knowledge helps me make my clothes become a reality."[6]

Madame Lanvin ventured to create her own exclusive colors inspired by various external artistic resources. Redon also employed interesting techniques and applications. "That something of it radiates through the painting to the sensitive beholder, sometimes by a gossamer quality of paint, sometimes—strangely enough—through a flaming madness of colour, and again because of a somber note, for Redon regarded 'black as the agent of the spirit.'"[7] It later became apparent that Madame Lanvin herself thought that black was the epitome of chic and it virtually became her uniform for life.

Madame Lanvin created her own place within the ranks of the hierarchical and male-dominated structure of the French fashion industry by working hard and saving money. The business she created was built on sweat equity, without financial loans to support the business; no partners were ever involved. In addition to the challenges of working to support and employ her ten siblings, Jeanne Lanvin was attempting to gain entry into an arena that had been dominated by men for many years. Although the male couturiers ruling the fashion industry, such as Charles Frederick Worth (Fig. 15), Jacques Doucet, Emile Pingat, Maison Redfern, and Poiret (Fig. 20), resisted the admittance of new people—most especially women—into their fashion domain, the substantial talent, ability, and headstrong determination of Jeanne Lanvin overpowered their resistance.

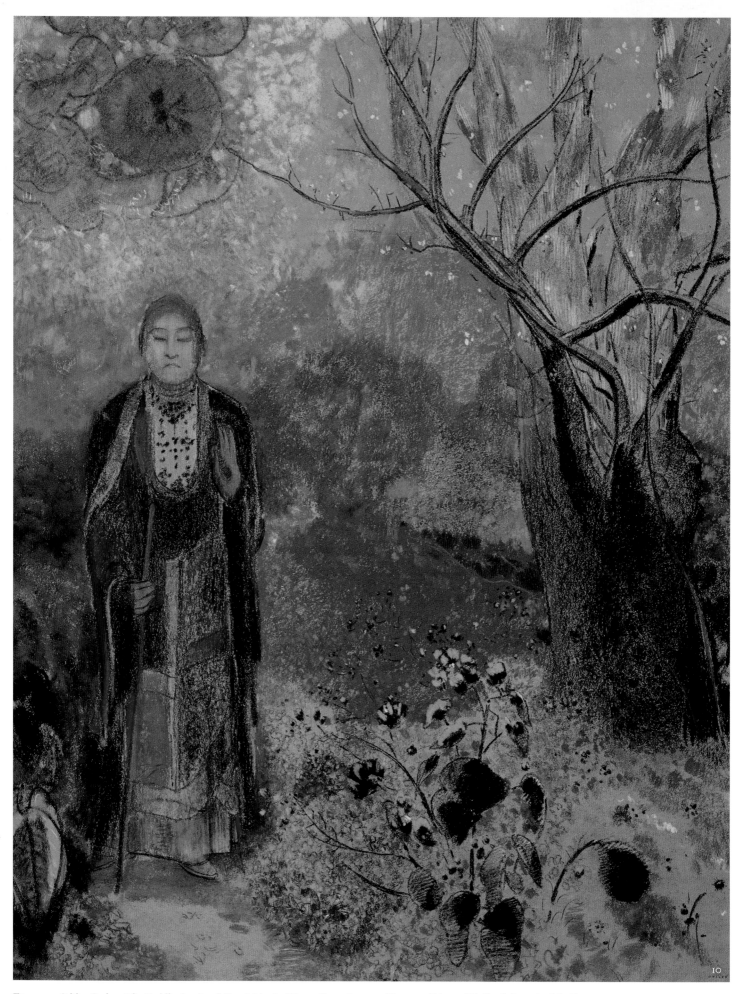

Figure 10: Odilon Redon, The Buddha (1906-07). Pastel. Musée d'Orsay. **Opposite page: Figure 11.** Edouard Vuillard, *Portrait of the Countess Jean de Polignac* (1932), born Marguerite Marie-Blanche di Pietro, the only daughter of Jeanne Lanvin.

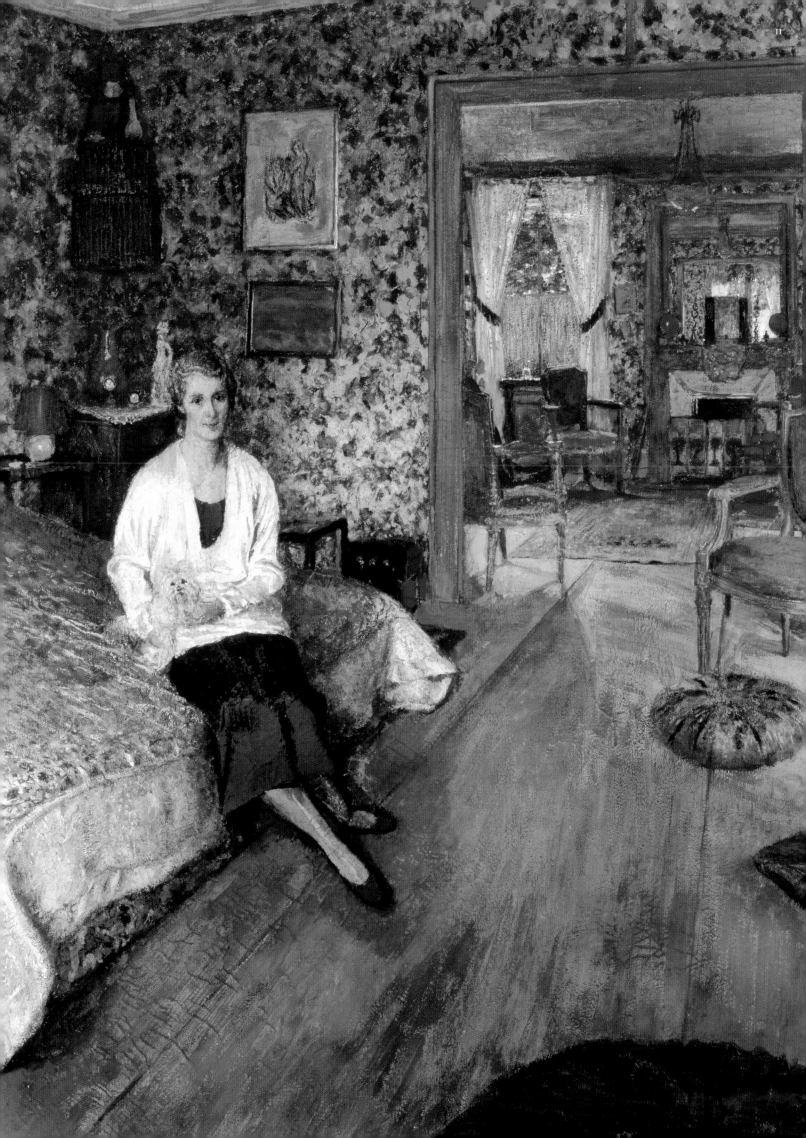

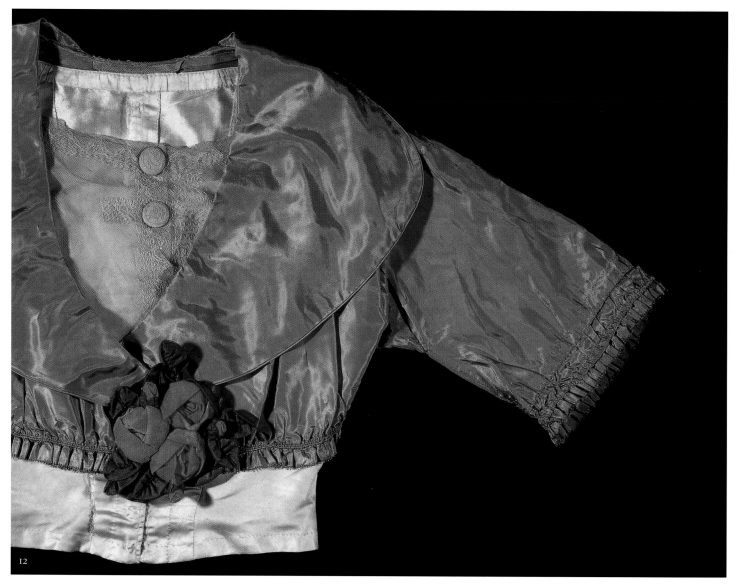

Figure 12: Bodice of irridescent silk taffeta–*taffetas changeant*–in peach and light blue with chiffon rose detail, Jeanne Lanvin, 1910-12.
Opposite Page: **Figure 13.** Elsa Schiaparelli. **Figure 14:** Madeleine Vionnet. **Figure 15:** Charles Frederick Worth in artists' costume with his dog, Scrubbs. **Figure 16:** Gabrielle "Coco" Chanel.

While the success of the Lanvin empire was a significant accomplishment in itself, Madame Lanvin applied her skills and talents to other creative fields, particularly the decorative arts. Collaborating with the architect Armand Albert Rateau, she accomplished several interior design projects, including her own homes in Paris and Vesinet, multiple boutiques, and the Théâtre Daunou. Another artistic and successful collaboration was with Jean Dunand and his experimentation with sprayed lacquer on textiles in Cubist-inspired patterns. Dunand's other creations in the forms of vases, multi-paneled screens, and other decorative furnishings graced her home and complemented the designs of Rateau. In addition, once her business was stable and self-sustaining, she undertook the enormous administrative responsibility of organizing and executing the couture exhibits at many of the great world expositions. These and other ventures kept

the Lanvin name and image in wide circulation, serving as productive, albeit unintentional, sources of publicity. Self-promotion was hardly the driving force behind her efforts. While working to satisfy her strong and determined work ethic, she served to improve and benefit the fashion industry as a whole.

Unlike her successful contemporaries, such as Paul Poiret, Madeleine Vionnet (Fig. 14), Gabrielle "Coco" Chanel (Fig. 16), and Elsa Schiaparelli (Fig. 13), Madame Lanvin shunned the spotlight; she maintained minimal, necessary relations with clients. Jeanne Lanvin preferred to socialize within smaller circles of artists, musicians, designers, and writers. Only on occasion could Madame Lanvin be seen at the races, such as Longchamps, Prix de Diane, and Prix de Drags, and often solely for the purpose of observing fashionable women

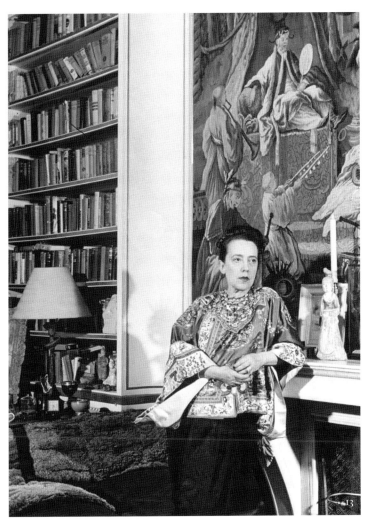

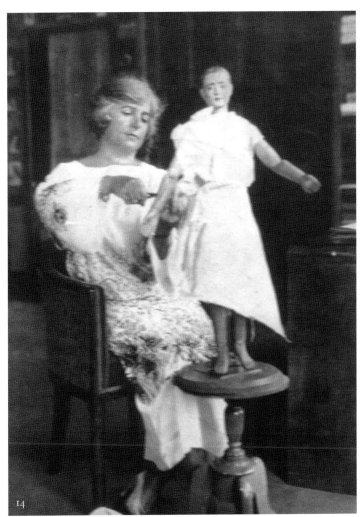

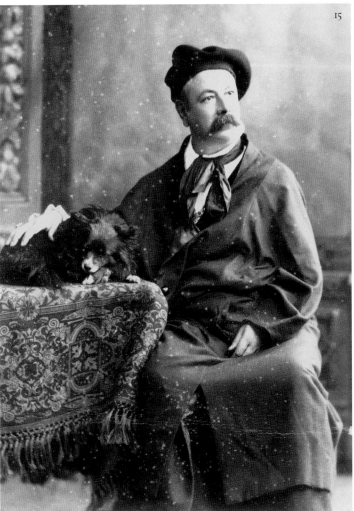

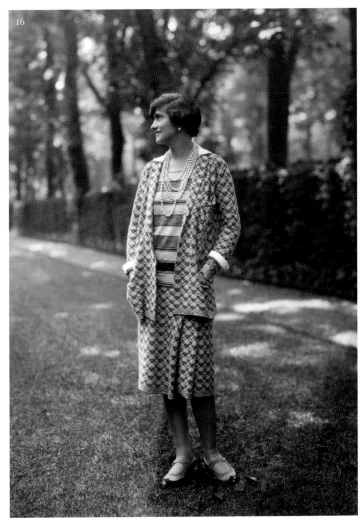

and potential clients. (Fig. 18) She considered these outings a form of research, and from them predicted what the ladies would soon wish to add to their wardrobes. Madame Lanvin had a special gift for knowing what the clients would need or desire before they knew themselves.

A fertile social environment provided opportunities for a designer to make contact with potential clientele, generating work and revenue for the couture house: Coco Chanel dominated the scene. In 1920, Chanel was a 37-year-old single woman with no children, free to do as she pleased. Jeanne Lanvin was 53 years old, by nature rather unsociable, with a 23-year-old daughter and a thriving business to maintain. (Fig. 11) The café society and demimonde was not the milieu for this dedicated and responsible mother and business-woman. The demimondaines willingly fulfilled their roles as promoters for the leading couture houses, as the latest fashions were offered to them at production cost. Consequently the best-dressed women in town, they showcased the latest creations and their lead was one to follow. Women of higher social rank—who were more than willing to wear the same makes as those of the "professional beauties"—were in fact the more dependable clientele, sustaining the great houses as they paid retail price for the latest fashions.

Other major designers receiving recognition during this époque were Martial et Armand, Callot Soeurs, Jenny, Worth, Doucet, Drecoll, Premet, Poiret, and Doeillet. Although few of these names are widely known today, they have hardly become household names like Chanel. Even though the creations of Lanvin received more press and recognition than the creations of Chanel prior to the 1920s, Coco Chanel received more publicity and recognition for her very public private life. Her *à la garçonne* look was a great success in the 1920s, dominating the fashion industry. It was through Parisian society that Chanel created and lived her reputation. This was also the arena in which she could meet potential clientele.

Some of the earliest photographs of Lanvin creations appeared in the women's periodical *Les Modes* in 1908. (Fig. 17) The talent and output of Madame Lanvin was promoted simultaneously with the millinery styling of Coco Chanel, under the name Chanel et Cie. Although there were several instances when Chanel and Lanvin appeared in the same issue of *Les Modes*, the quantity and quality of Lanvin promotion far outweighed that of Chanel.

In many instances, designs by Lanvin, Chanel, and Schiaparelli were featured on the same page within a fashion periodical. The designs of Madame Lanvin were certainly fashionable, timely, and tasteful in comparison to her peers. Karl Lagerfeld explained one substantial reason for lack of recognition received by the accomplished artist and designer today, stating, "Her image was not as strong as that of Chanel, because she was a nice old lady and not a fashion plate."[8] Chanel was her own best promoter. Because she fit her own client profile, she flogged her own style and new designs by first wearing them herself. In contrast, Madame Lanvin had a matronly identity and appearance that did not help to further the youthful image of the clothing she designed. Madame Lanvin would not wear a sleeveless *robe de style* with low décolletage. She wore conservative, discreet black and white ensembles with minimal detail, and her favorite pearl necklace.

Chanel once stated, "It is a shame to rely on one's youth. Youth should be replaced by mystery."[9] Madame Lanvin was nothing if not mysterious in her work and social life, limiting it to a strictly professional environment by keeping interaction with the public and her clients to a minimum. Madame Lanvin steered clear of the social scene, preferring to focus on her work and her family, namely Marguerite Marie-Blanche. Her unwillingness to socialize and chat with clients rendered her a somewhat unidentifiable personality to the general public; as a result, her low-key image and private life have contributed to the fact that she is hardly known today. Madame Lanvin spoke very little about her work confident that her creations would speak for themselves. In contrast, Chanel claimed that "image survives better than style and, more so, than the clothes themselves."[10]

Although Jeanne Lanvin and Coco Chanel both began their design careers as milliners, Lanvin used her own resources to create and develop her business, whereas Chanel relied on the assistance of Etienne Balsan, one of her many male "friends." At this time, the designs of Lanvin—original, sophisticated, and polished—were considered significant and featured in the periodical *Les Modes*. The designs of Chanel et Cie, on the other hand, had not yet been fully developed and lacked direction.

Paul Poiret and Jeanne Lanvin had much in common throughout their careers. They both rose through the ranks of designers who blazed the couture trail for them. Unlike Lanvin, who saved her money and worked hard to begin her business, Poiret received financing from his mother, who

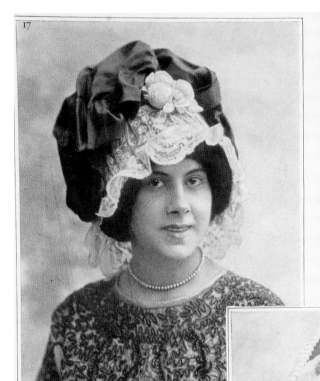

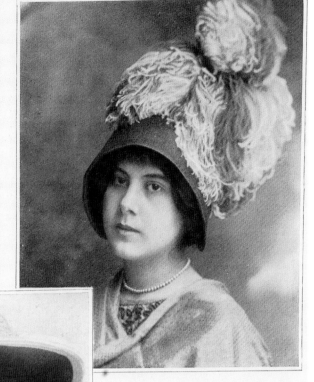

jupe fendue ; jusqu'à présent elle est encore timide et découvre à peine la fine attache de la cheville — et un peu au-dessus ; mais sans doute voudra-t-elle monter plus haut, et vous voyez que comme principe, comparée à la jupe-pantalon, le diable n'y perd rien, mais elle est si séduisante ?... et les visions néo-grecques et «Directoriennes»

de Madame Tallien et de Madame Récamier exerçant leur grisante attirance, je m'imagine que bien des jolies femmes se laisseront captiver par leur exemple — en le tempérant de quelques dessous vaporeux. En attendant, l'eut-on cru ? c'est surtout pour les costumes tailleur et les robes relativement simples que se pratique cette jupe fendue ou plutôt, non fermée du bas. Cela

tient à ce que l'étroitesse des jupes restant réduite à un minimum d'exiguïté, et la marche étant une difficulté lorsqu'on est enserrée dans un fourreau qui, pour les formes très minces, ne dépasse guère un mètre trente-cinq, on a imaginé de ne point terminer une ou deux des coutures de jupe sur une hauteur de quinze centimètres environ, cela suffit à dégager le pied, lais-

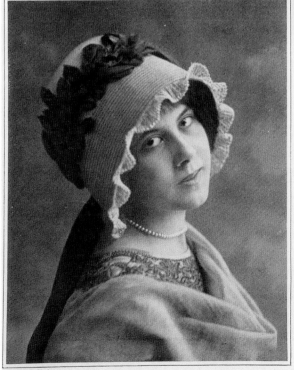

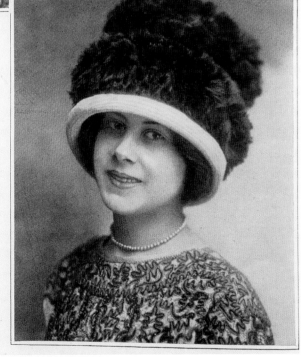

sant voir le soulier à grande boucle, la cheville, et — mais je l'ai déjà dit — un peu plus encore ; malgré cela l'ensemble est très net, très correct et point fait pour effaroucher ; de plus, la marche y gagne en aisance et en naturel. Un grand couturier est si enthousiaste de cette nouveauté — renouvelée — que presque tous les costumes et les robes sortant de ses ateliers sont composés en ce

Photos P. Nadar.

Figure 17: *Les Modes* pictorial from 1908, photographed by Paul Nadar, of Lanvin milinery.

gave him 50,000 francs. Both designers began with the promotion of the Directoire line and the chemise frock, and both designers were inspired by various global influences, especially the exotic, including kimonos, and Egyptian, peasant, Arab, and Greek costumes. The primary difference between Poiret and Lanvin is that she siphoned from various influences, reinterpreting them into designs that were wearable and saleable; Poiret executed literal and exaggerated translations, changing fabrics and colors only. Many of his ensembles retained too much authenticity, looking like stylish national costumes not readily accepted by consumers. Both designers made multiple contributions to the design industry in general as both achieved great success and recognition for these efforts.

Poiret, the promoter, did so by creating niches for himself in all areas of the applied arts and design, including decorative arts, interior design, printing, embroidery, haberdashery, furniture, lighting, clothing, and accessories.[11] Ten years before Chanel, Poiret broke into the market of fragrance and toiletries with his perfumes. Eventually, the creative work executed by Poiret and his collaborators would be recognized and valued, leading to his first licensing agreements in the cosmetics and fragrance industry.

Poiret also promoted himself through social venues, such as his famous parties held at various Paris residences. Rather than spending money on advertising, Poiret hosted extravagant, memorably-themed parties, attended by his clients and celebrity friends. These spectacular events were regarded as powerful promotional tools, the most infamous of which was the "Thousand and Second Night," an Oriental extravaganza held on June 24, 1911, and attended by everyone who was anyone in Paris. The exotic décor was designed by Raoul Dufy and Poiret himself designed the costumes, which were handed out as the guests arrived.

In 1925, Poiret made sure that his contribution to the Exposition des Arts Décoratifs would not be overshadowed by the contributions of seventy-two other dress designers. (Fig. 19) Poiret hired three barges—*Amours*, *Délices*, and *Orgues*—which traveled up and down the Seine; they became the highlight of the event. (Fig. 19) Although the barges were a great success in self-promotion, the debt created by the extravagance far outweighed the financial gain, sending Poiret into a destructive downward spiral. Poiret's successful professional life ended in the early 1930s, due to his inability or unwillingness to bend and change with the times—a valuable skill perfected by Madame Lanvin very early on in her career.

Like Chanel, Elsa Schiaparelli was an astute self-promoter. Born into Italian aristocracy, Schiaparelli relocated to Paris to pursue and satisfy her creative desires. Her shop was established using outside financing, and she received an allowance from her father. Influenced by modernism and the surrealists, most notably Salvador Dalí, she went on to create fashion with an artistic and "shocking" perspective. "Through her clothes Elsa Schiaparelli used wit and shock tactics to arm modern women in their thrust towards equality and independence."[12]

With encouragement and coaxing, Poiret would prove to be an inspiration and creative influence on Schiaparelli and her future endeavors. Schiaparelli's first collection debuted in 1927, eight years after Chanel's—their rivalry was antagonistic—and eighteen years after Jeanne Lanvin established her first shop. While Chanel approached dressmaking as a profession, Schiaparelli approached it as an art form. This was demonstrated in her use of textiles, colors, patterns, and embroideries executed by the house of Lesage, and additional collaborations with groundbreaking artists such as Jean Cocteau and Christian Bérard. "Whereas Chanel stood for calculated ease and luxurious simplicity, Schiaparelli was tough and brash, offering sensational effects in bright and bold colours."[13] Schiaparelli's association with the upper echelon of society, in conjunction with her outrageous fashion perspective and artistic sensibility, gained her much free publicity. "Curiously enough, in spite of Schiaparelli's apparent craziness and love of fun and gags, her greatest fans were the ultra-smart... wives of diplomats and bankers."[14] She would later dress the Duchess of Windsor in the famous Dalí-inspired lobster dress.

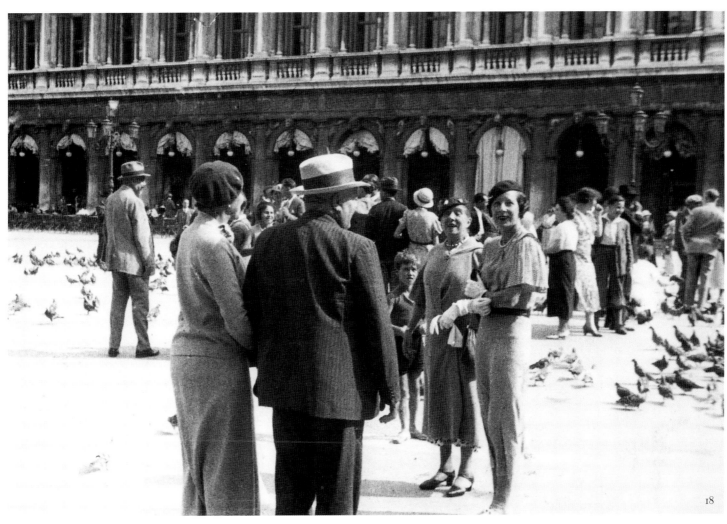

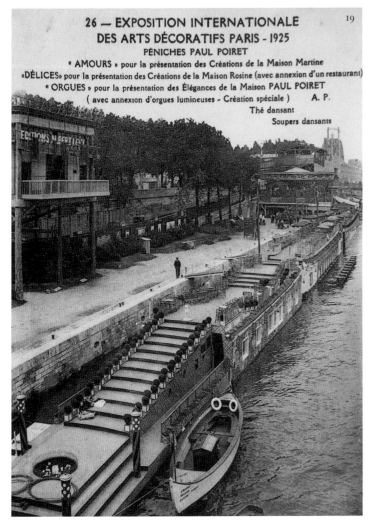

26 — EXPOSITION INTERNATIONALE
DES ARTS DÉCORATIFS PARIS - 1925
PÉNICHES PAUL POIRET
« AMOURS » pour la présentation des Créations de la Maison Martine
« DÉLICES » pour la présentation des Créations de la Maison Rosine (avec annexion d'un restaurant)
« ORGUES » pour la présentation des Élégances de la Maison PAUL POIRET
(avec annexion d'orgues lumineuses - Création spéciale) A. P.
Thé dansant
Soupers dansants

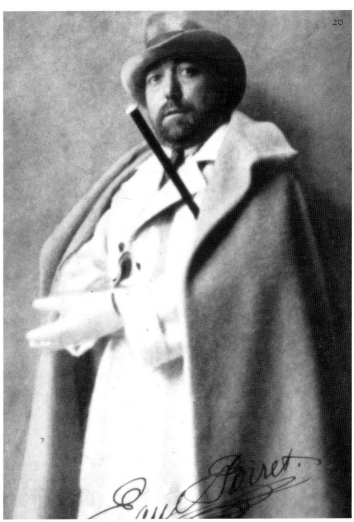

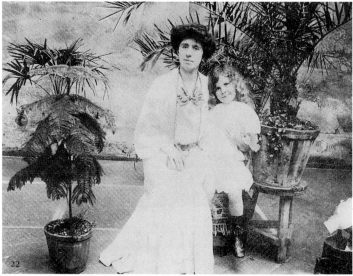

JEANNE LANVIN SPENT much of her youth as a seamstress and millinery apprentice in Paris. She started working at the impressionable age of thirteen for the firm of Madame Bonni. In 1883, Jeanne Lanvin began working for the famous milliner and couturier Maison Félix, at the corner of rue du Faubourg Saint-Honoré and the rue Boissy d'Anglais. Her own business would later occupy this building, and not only would maison Lanvin come to occupy every floor, but it would expand into the neighboring buildings as well. (Figs. 21 & 30)

After working at Maison Félix, Madame Lanvin was employed by the successful millinery and accessories house of Cordeau et Lagaudin at 32 rue Mathurins, where she worked her way up to the position of *premiére garnisseuse*. In order to supplement her income, during the off-season she found temporary employment with a regular customer of Cordeau et Lagaudin. In 1885, at eighteen years of age, Jeanne Lanvin—the daughter of Breton parents and the eldest of eleven children—was employed by contract to Madame Maria-Berta Valenti of Barcelona, a well-respected dressmaker. According to the contract, (Fig. 24) Jeanne Lanvin was to arrive in Barcelona and work for three months for the sum of two hundred francs per month. Madame Valenti became Lanvin's mentor and friend. She specialized in clothing for adults as well as children, and nurtured and developed in a young and eager Lanvin all of the necessary skills needed to create couture-quality garments. When Lanvin returned from Spain in 1890, she had forty francs in her pocket and three hundred francs in credit. With this money, Lanvin opened her millinery shop in a modest apartment at 16, rue Boissy d'Anglais. She stayed in touch with the

Valentis, who were more like family than employers, and often visited them during holidays and vacations.

An afternoon encounter at Longchamps with an Italian "gentleman rider" named Henri-Émile-Georges di Pietro would soon prove to have an enduring and profound effect on the life and career of Jeanne Lanvin. The couple married on February 20, 1896; their daughter, Marguerite Marie-Blanche, was born on August 31, 1897. In 1903, when the marriage ended in divorce, Madame Lanvin became a single mother and the sole support of her daughter. It was Marguerite Marie-Blanche who became the muse and source of inspiration for one of the greatest and most successful designers of the twentieth century. (Fig. 22)

Jeanne Lanvin married a journalist, Xavier Melét, in 1907. Melét later became the French consul in Manchester, England. (Fig. 23) The details of the marriage are obscure, but it is clear that this marriage was financially advantageous to Melét and socially advantageous to Lanvin. It enabled her to shed the role of "single mother," which was not regarded as favorable and could potentially have a negative effect on the business to which she had dedicated herself. While they posed as a happily married couple in public, the marriage was actually an arrangement of convenience; it was devoid of romance. After Melét retired with a negligible income, he played the supporting role of dutiful husband to Lanvin's starring role as successful couturier and mother, and maintained his place in the family until his death in 1953.

Madame Lanvin's daughter, Marguerite Marie-Blanche, was her pride and joy. She dedicated every moment and every

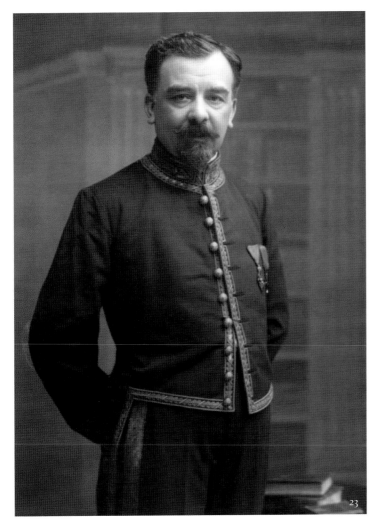

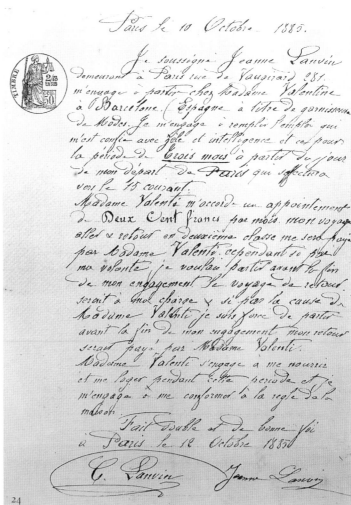

Figure 23: Journalist Xavier Mélet (1862-1953), later to become the French consul in Manchester, England. Figure 24: Summer employment contract of 1885 between Jeanne Lanvin and Madame Maria-Berta Valenti of Barcelona, Spain.

ounce of energy not consumed by the business to her daughter, hoping to ensure her success and happiness. The two most important parts of Lanvin's life—her daughter and her business—thrived off of each other. The millinery business and the child were both Lanvin's creations, and both required endless amounts of nurturing, dedication, and love.

Marguerite Marie-Blanche was Lanvin's "work in progress." It was imperative that her daughter's appearance was impeccable and her deportment and demeanor beyond reproach. Marguerite Marie-Blanche's musical talents were perfected as she entertained guests at her mother's Sunday salons. Although she excelled at the piano, it was her vocal talent that was most celebrated. The great composer Francis Jean Marcel Poulenc said, *"la cantatrice dont la voix m'a dicté mes mélodies"* [the singer whose voice dictates my melodies]. She closely followed the great musical talents of the day, such as Poulenc, Igor Stravinsky, Arthur Rubinstein, and after World War II, Leonard Bernstein. Undeniably talented musically, Marguerite possessed a thorough and knowing sophistication, undoubtedly cultivated and perfected by her mother.

It was only after Jeanne Lanvin created an inspired wardrobe for her daughter that her millinery clients realized and appreciated her creativity. As they clamored to place orders for their children, a new aspect of the design business was realized. Until then, children's clothing tended to be constrictive and impractical scaled-down versions of adult clothing. Lanvin creations were sophisticated, handmade, and therefore, expensive; her original designs were exquisitely detailed allowing for a new perspective on children's clothing. Her impeccable selection of colors and textiles, consistent trademarks of Lanvin design, lent an air of whimsy and childhood naïveté to otherwise sophisticated clothing. But it was not silly or juvenile. Affluent parents purchased luxurious clothing for their children, and their well-dressed offspring were a reflection of their good taste, sophistication, and status.

The success of the children's department was in direct proportion to Lanvin's love for her daughter. Marguerite was the catalyst for the designs, as Lanvin created and fabricated nothing more or less than the type of clothes that she wanted

Figure 25: Marguerite-Marie Blanche and René Jacquemaire-Clémenceau on their wedding day, 1917. **Figure 26:** Marie-Blanche and her husband in St. Moritz, Count and Countess Jean de Polignac, 1936-37. **Figure 27:** Mademoiselle Georges and Marianne Gaumont pose in Lanvin costume and millinery for the photographer, Paul Nadar. 1911. **Figure 28-29:** *Robe de petite fille.* Circa 1923.

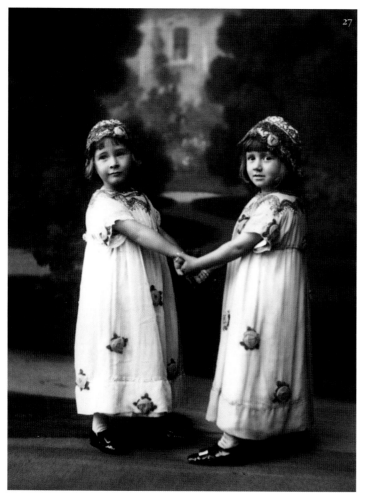

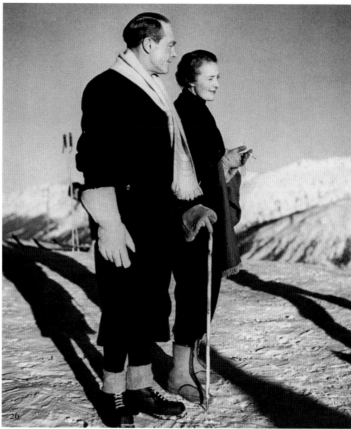

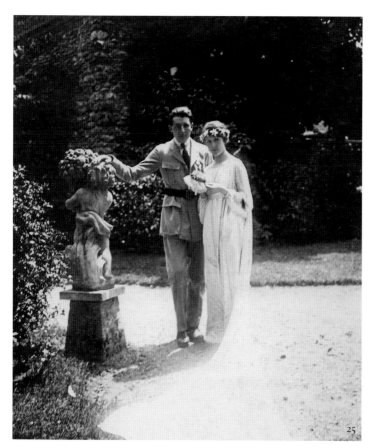

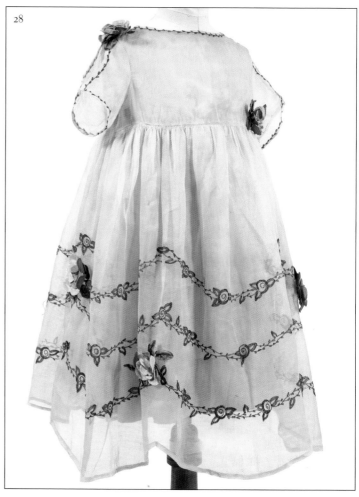

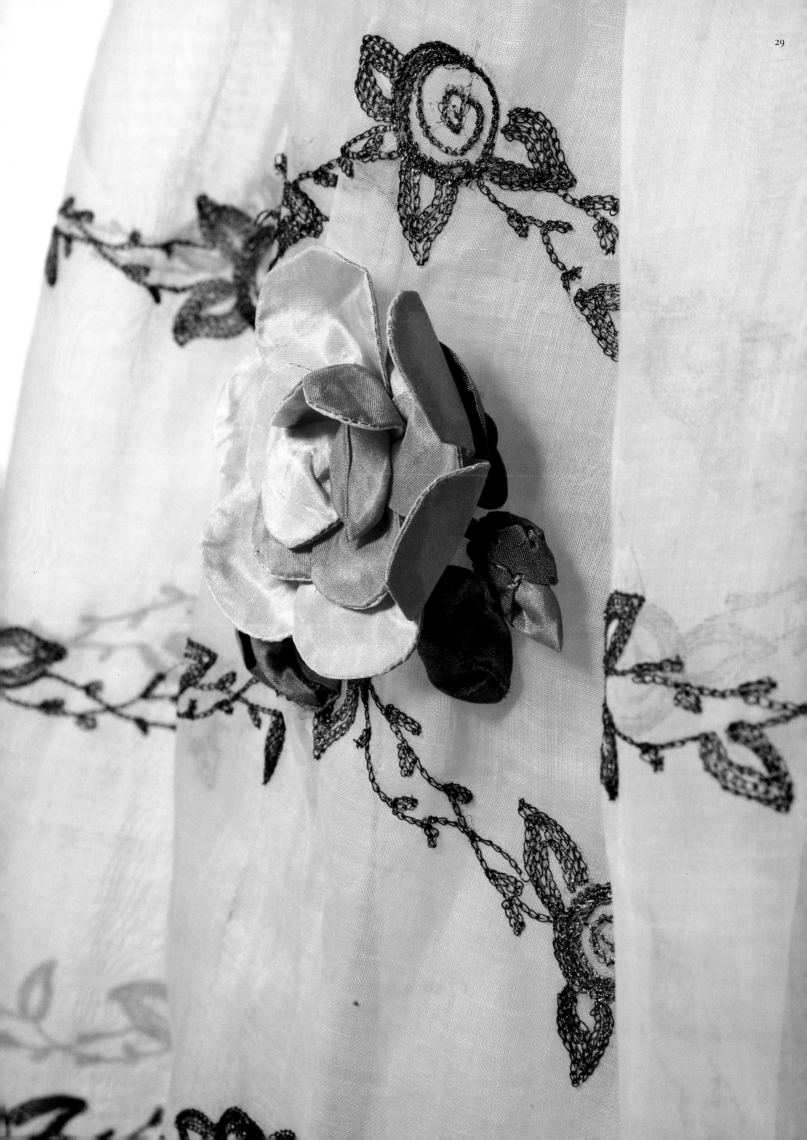

for her own child. It was a matter of good taste and fortune that many other mothers realized the quality and originality of these clothes. Marguerite became an unofficial model, dressing in multiple ensembles during the day in order to entice parents to follow her mother's lead. Jeanne Lanvin's designs were inspired and propelled by youth, beauty, and femininity, and these themes would remain at the foundation of the house for the remainder of her career. (Figs. 27-29)

Marguerite Marie-Blanche married for the first time in 1917. (Fig. 25) Her marriage to René Jacquemaire-Clémenceau was short-lived; they divorced in 1922. On April 28, 1924, she married Jean Marie Henri Melchior de Polignac, who was nine years her senior. At the request of her husband, she stopped using her first name, becoming Marie-Blanche de Polignac—or Marie-Blanche, comtesse Jean de Polignac. (Fig. 26) For Count de Polignac, this change of name signified a rebirth for the young woman, who was beginning a new life at the height of society. Both Christian names, Marie and Blanche signify the purity of the Virgin Mary.

This marriage proved to be a financial boon to maison Lanvin. The aristocratic Polignac family, as well as their friends and associates, began to frequent maison Lanvin for their couture and millinery needs; they lent their image, name, and cachet to a couture house struggling to hold its own against stiff competition from other houses. Maison Lanvin's modern, youthful, and feminine designs began to entice loyal clients from the older and more traditional couture houses such as Worth and Doucet.

30

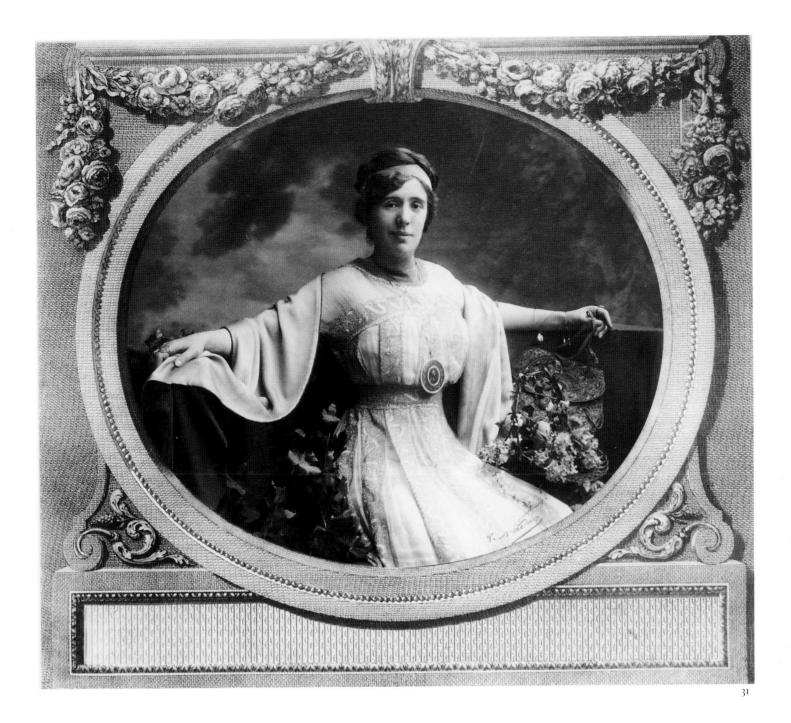

31

1 Quoted from a Lanvin press release, 1985, np.

2 Quoted in Barillé, Elisabeth. *Fashion Memoir, Lanvin* (London: Thames and Hudson, 1997), p. 13.

3 *Vogue*, (June 1, 1922), 66.

4 Quoted in Barillé, Elisabeth. *Fashion Memoir, Lanvin* (London: Thames and Hudson, 1997), p. 12.

5 *Vogue*, (June 1, 1922), 66.

6 *Vogue*, (March 1, 1934), np.

7 *Vogue*, (June 1, 1922), 66.

8 Quoted in the documentary film, *Chanel Chanel*, 1986.

9 Ibid.

10 Ibid.

11 Baudot, François. *Fashion Memoir, Poiret* (London: Thames and Hudson, 1997),10.

12 White, Palmer. *Elsa Schiaparelli: Empress of Fashion*, (London: Aurum Press, 1995), 18.

13 Ibid. 94.

14 Schiaparelli, Elsa. *Shocking Life* (Paris: Denoël, 1954). np.

2

THE BEGINNING OF
LANVIN HAUTE COUTURE:
MILLINERY AND
CHILDRENSWEAR

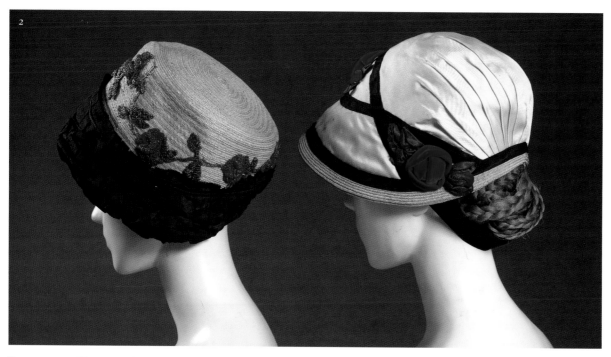

Previous page: **Figure 1.** *Pochoir* illustration for a Lanvin invitation to the private fashion show held within the boutique. 1910-1912.

Left: Figure 2. Natural straw bonnet (left), with embroidered rose garland rendered in glass seed beads in three color gradations of red and two shades of green. The bonnet edge bordered with black pleated silk taffeta. Around 1912. Straw bonnet (right) covered with ivory silk satin. Decorated with blue silk crisscross banding and punctuated with red velvet roses and green silk leaves. An attached band is used to tuck under a chignon. Around 1910.

Opposite page: Figure 3. Madame Lanvin dressed her clients from head to foot as demonstrated on the cover of *Les Modes*, September 1912. Mademoiselle Eve Lavalliere, an actress, was dressed in a white silk chiffon dress embroidered with cherry red roses and bright green leaves rendered in glass bugle and seed beads. The turban of green silk satin was also embroidered with the same rose motif.

THE MILLINERY INDUSTRY was the foundation on which the Lanvin empire was built. Madame Lanvin established a fledgling millinery workshop on rue du marché Saint-Honoré in 1885, with financial support of a loyal client; later, in 1889, she opened her own successful millinery boutique at 16 rue Boissy-d'Anglais. *Vogue* of April 1919 declared, "Madame Lanvin, in designing a toilette, never forgets the head, which she insists shall be in harmony with the costume."[1] (Fig. 3) Characteristic of Lanvin design, original and interesting headwear was created using a mélange of materials, influences, and inspiration.

Hat-wearing is a trend that waxes and wanes like many others. Images of Lanvin hats from the turn of the century reveal her strong affinity and refined tastes for the art of millinery design. The modes and manners of the era dictated that proper women did not leave the house without a dressed head. Even in the home, some women wore caps, unstructured bonnets, or at the very least, hair ornaments. Headdresses created by Jeanne Lanvin included simple beaded, embroidered, or unadorned headbands, bonnets, large-brimmed picture hats, cloches, toques, turbans, tricornes, and bicornes.

In 1909, the photographer Paul Nadar created some of the earliest images of Lanvin millinery fashions for use in the women's periodical *Les Modes*. Having recognized the potential effects and benefits of light reflecting off of fabric, he became the first photographer to experiment with artificial light. However, in the ateliers, with glass ceilings, walls of windows, and white curtains, most of his portraits were executed with natural light.

The work of Nadar clearly demonstrates his acute attention to detail. "What cannot be taught is the honesty in one's work, the zealousness, the research, and the constant tireless, perseverant search for the best." The haute couture industry greatly benefited from Nadar's work, as economic growth allowed for the widespread use of photography and the medium was accepted by the public in general. Photographic reproduction grew with the success of popular periodicals such as *La Théâtre*, founded in 1898, and *Les Modes*, founded in 1901, for which Paul Nadar was the original photographer.

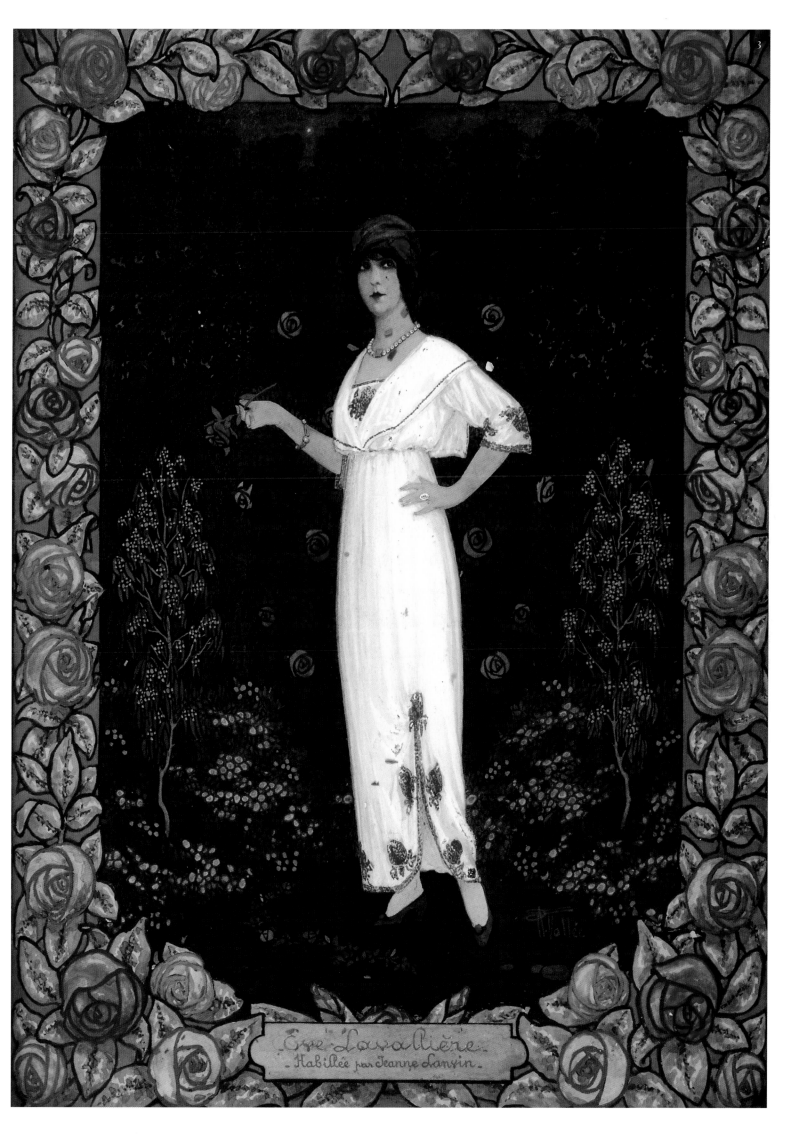

Ève Lavallière
Habillée par Jeanne Lanvin

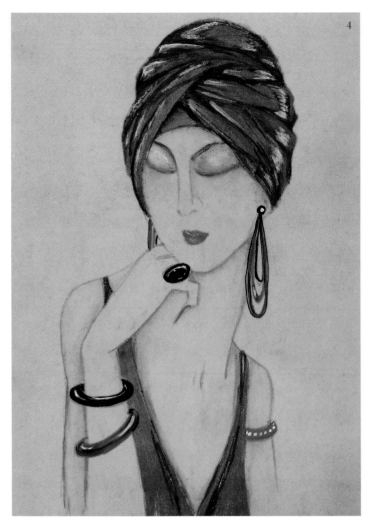
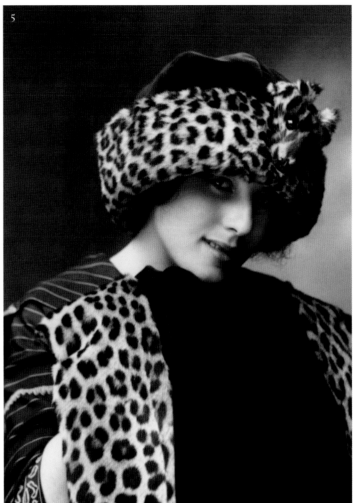

Figure 4: Gold lamé exotic turban, Winter 1923. Figure 5: Brown velvet hat and muff trimmed with leopard fur. September, 1911. Photo by Paul Nadar.

Opposite page: Figure 6. "Cigale" ensemble of velvet and satin with white fur muff and exotic satin turban complete with a cluster of egret feathers. November 1911. Photo by Paul Nadar. Figure 7: Voluminous millinery shapes were used to counter-balance the long-slim silhouette of the epoque. As seen in *Les Modes*, June 1909, a blue dinner dress is completed by the large-scale hat.

Complex ensembles with subtle and refined details demanded precision and required that the models look less spontaneous than the typical style preferred by Nadar. Aside from these considerations, his work best represented contemporary haute couture. Paul Nadar was retained by Lanvin from 1909 to 1913, as she felt a strong affinity for his original vision; his photographic style was in perfect synchronicity with her creations. After 1913, public interest in fashion photography waned. Poiret commissioned Paul Iribe and Georges Lepape, two leading illustrators of the time, to create a portfolio of fashion illustrations for his latest collections; these drew the wandering eye of the public in a different direction.

A 1911 Nadar photograph of Renée, a Lanvin house model, was taken for *Les Modes*. (Fig. 5) It reveals a dress of classic and conservative striped silk with minimal wool yarn embroidery. The hat and muff of brown velvet and leopard fur trim are in stark contrast and highlight the subtle ensemble. The velvet hat with the animal's head at center front is worn pulled down close to the face, while the generously sized velvet muff is finished with wide borders of leopard.

Jeanne Lanvin created many combinations of hat and muff, as it was considered the ultimate in chic to have matching accessories to coordinate with the ensemble. "Cigale," an afternoon costume of 1911, is created with horizontal seaming of two fabrics that contrast in both color and texture. (Fig. 6) The neck scarf and muff were created from a light-colored fur and the shirred satin hat features a large spray of ostrich plumes at center front. Trimmings for hats included feathers, ribbons, or wired shapes of silk or velvet. Hats were weighted down under great quantities of plumes. "So devastating to bird life was this fad for fine plumage that, through efforts of the Audubon Society of America, protective measures were passed, bringing about the passing of the craze."[2]

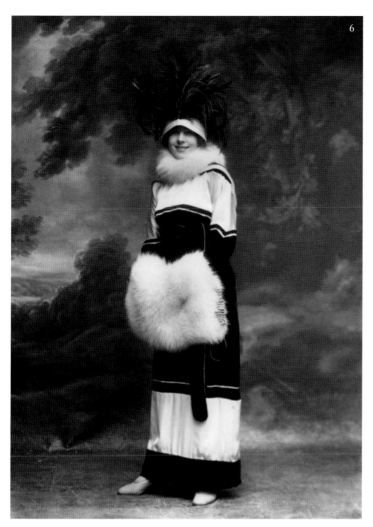

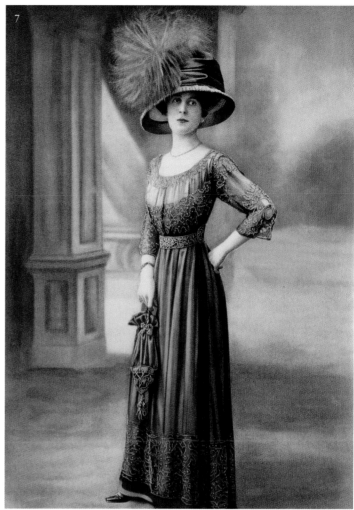

Lanvin house model Aimee, in 1913, wore a dark velvet hat in the style of Rembrandt van Rijn. (Fig. 8) This floppy velvet hat is unadorned but features a crenellated edge along the top for added interest; it is inspired by the 16th-century French renaissance. The high neckline of re-embroidered, pleated tulle harkens back to 17th-century Holland.

An Orientalist turban of sequins adorned with a cluster of long egret plumes reveals a taste for the exotic. (Fig. 9) Particular events and happenings around Paris tended to influence the direction of fashion, at least among the avant-garde. In 1903 the dances and costumes of Isadora Duncan contributed to the idea of a supple and simple line. Diaghilev's Ballets Russes of 1909, and the set design of Léon Bakst of the same time, had profound effects on the selection and use of color and décor. This curious ensemble is a chiffon tunic with beading and embroidery at the exposed shoulders, waist, and center back trailing over the rear end. The chiffon tunic is worn over a satin dress with restricted movement at the

knees, which is created by an external, decorative but functional hobble garter. This contrasts with how the hobble garter was typically used—not as decoration but with the sole purpose of preventing long strides of the wearer and found under an ensemble attached to the legs.

The long, lean line of the chemise frock, whether softly belted or free-flowing, was balanced by the horizontal line of wide-brimmed hats extending from shoulder to shoulder and topped with a very shallow crown. It is on this wide frame that a modiste was able to pile on the garnishments of ribbons, plumes, flowers, and fruit. Madame Lanvin worked in a restrained fashion and embellished this large frame with the simplistic use of silk tulle, adding minimal weight and visual volume to the structure.

Materials remained interesting and practical, as this Nadar image from 1913 suggests, featuring sixteen-year-old Marguerite and Marianne Gaumont, the niece of Jeanne

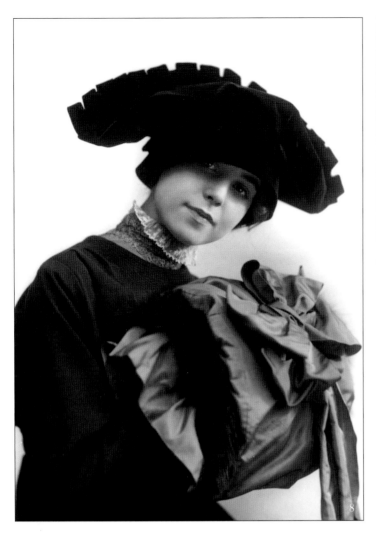

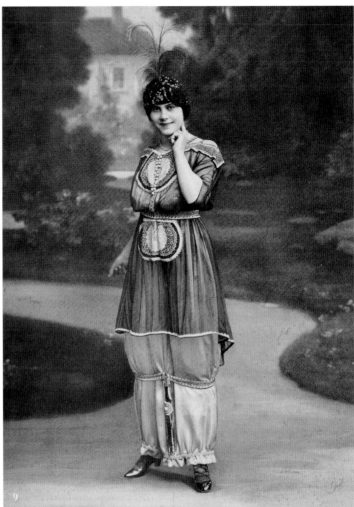

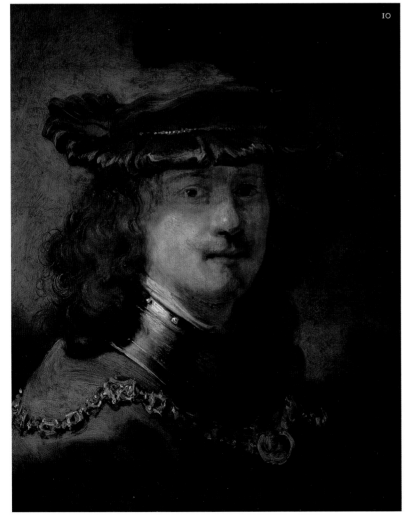

Figure 8: Velvet beret with crenellated edge. 1913 by Paul Nadar.

Figure 9: Orientalist fashion exhibited in a sheer tunic over a dress with external hobble garter. The sequined turban with egret feathers is a nod to the influence of Leon Bakst and the Ballet Russes of 1909.

Figure 10: Govaert Flinck, *Portrait of Rembrandt with a Velvet Beret and Iron Collar.* (1634) Oil on oak panel. Gemäldegalerie, Staatliche Museen, Berlin.

Opposite page: Figure 11. Marguerite Marie-Blanche and her cousin Marianne Gaumont pose for *Les Modes.* 1913.

Figure 12: Dark blue velvet hat trimmed with a magenta plume and jeweled ornaments, 1914. Inspired by 17th century "Cavalier Fashion" with sweeping brim and "weeping ostrich plumes."

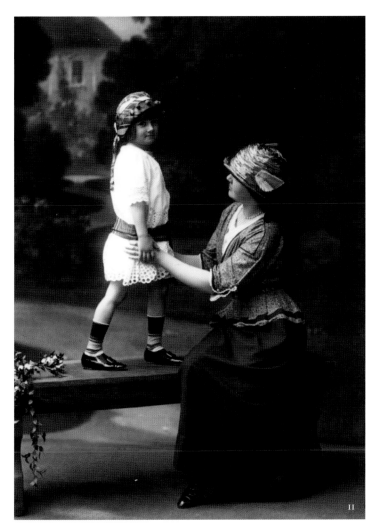

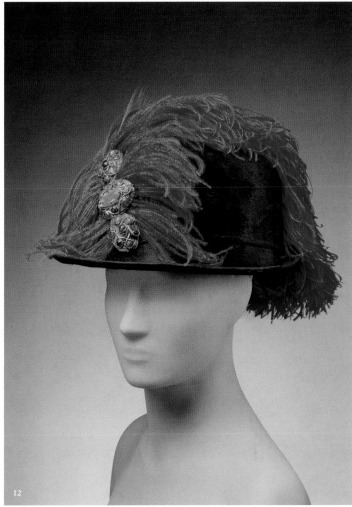

Lanvin. Hats for young girls were smaller in scale and balanced out the proportions of the ensembles. (Fig. 11) This petite hat made of loosely woven straw features two small bird's wings on either side of the crown, similar to the one worn by Mercury, the messenger of the Olympian gods. He wears a *petasos*, or winged hat, round and low-crowned, sometimes with a pointy front. Marianne's hat, made from the same plaid madras-satin fabric as her sash, is in a cloche shape with turned-up brim. Ribbon streamers at center back and little balls covered in self-fabric dangle from the brim for an air of whimsy and youth, a childlike yet sophisticated detail.

These eminently feminine millinery confections continue until just before the dawn of the 1920s, when bobbed hair became popular. Although sometimes concealed under cloche hats women's short hair became a symbol of their newfound place in society. Women were increasingly independent thanks to joining the workforce and earning their own money; they enjoyed a liberated social life and acquired the right to vote. In July 1922, the novel *La Garçonne*, written by Victor Margueritte, depicted a scandalous female character, Monique Lherbier. She epitomized and reveled in androgyny, liberated womanhood, and a sportif lifestyle like that of a young boy or *garçon*. The look was perpetuated by

the fashions of Chanel with her tubular silhouettes and her newly bobbed hair. This boyish look for women was characterized by the extra short hairstyles associated with the razor cuts of military recruits and contemporary lesbians. (Fig. 13-14) In addition, the women were adopting garments and fashions associated with their male counterparts. "Many women in bathing suits have a masculine and somewhat singular appearance. They look like little boys who have just taken their baccalaureat."[3] The *garçonne* fashion reflected a woman's "freedom," both personal and political, and a melding of the classes—and the simplicity of the look translated easily to the masses.

Several illustrations from the Lanvin archive, dated 1918 and 1919, reveal the new desire for minimal millinery accoutrement. Focus was drawn to the face and the neatly coiffed head with beaded skullcaps dangling ornaments and bejeweled headbands with cascading crystals; this headwear served as replacements for jewelry at the neck and ears. (Fig. 15) Headbands of embroidered, light-colored ribbons and ribbons with silk-flower embellishments were offered as an elegant daytime option absent of the sparkle and ostentation reserved for the evening.

At the end of the 1920s, the use of the traditional brimmed hats had all but vanished as the sleek look of shingled and shellacked coiffures became the chic complement to the modern minimal lines of fashion. As styles morphed into new proportions over the decades, so too did the millinery stylings of maison Lanvin. *Vogue* of 1924 describes the preference for the cloche hat, "Lanvin continues with the cloche, making it of soft *crêpe* to match afternoon summer frocks..." The cloche or bell-shaped hats were a successful direction in millinery fashion lasting for more than ten years and appearing in many different versions.

Vogue of 1921 extols "The Charm of the Brilliant Tea Gown," chastising the leading couturiers for making too many dresses in black and dull or neutral-toned crepes. The elements featured were an attempt to get the Parisian woman to liven up her wardrobe, at least by teatime. Two Lanvin hats are featured in this article, both in soft, ladylike colors. The veil of an Arabian sheik was the inspiration for this headdress. "The Arab wears it in wool to counteract the sun of the desert, but the Parisienne wears it in pink chiffon and pearls... to enhance loveliness and satisfy love of colour."[4] With this piece Lanvin removed the functional elements of an Arabian veil, reworked the design lines, added soft color in a feminine fabric, and secured the veil with a headband of pearls. "That of course is the secret of the whole matter. Originally designed by man for the protection of man and the strict limitation of the scope of feminine charm—Mohammed, so they say, first imposed it on feminine modes—the veil has always been at its inmost heart, the accomplice of woman, double-dealing in its ways, pretending to fulfill the original purpose, yet by a thousand secret tricks understood only by woman rendering beauty doubly alluring, concealing only that it might suggest far more than was concealed."[5]

"The veil of to-day is decoratively and decisively behind the woman, behind her charm. Behind the individuality of which we hear so much, behind the smartest of hats and the most piquant of faces. On its support she has come to count as she once counted on its protection, for the changing ways of woman have altered the duties and privileges of the veil so greatly that only an accomplice as versatile and completely devoted as that misty bit of loveliness could have mastered the intricate adaptations that the change involved."[6]

This Madonna-inspired illustration, by Helen Dryden, elevates motherhood to the status of sainthood. (Fig. 17) On the cloche hat of silver lamé with a three-dimensional crescent top a silver veil is suspended. The veil has triangular edging that finishes the hem inspired by the images of the Italian Renaissance. Many hats featured veils, especially those by Lanvin; they were usually of black Chantilly lace, chiffon, or silk tulle. This hat with its veil suspended in the rear was a new take on an old idea, using the image of the Madonna as an appropriate reference while reinforcing the maternal feelings of Madame Lanvin. Treasuring the role and responsibilities of motherhood, the Madonna and child, the ultimate image of motherhood in the Western tradition, communicates the privileged and highly respected position of being a mother. A version of this hat, found within the Patrimoine Lanvin, is of beige silk crepe and covered with gold sequins in a *pavé* technique as well as gold seed beads.

In 1922 Howard Carter and Lord Carnarvon discovered the tomb of King Tutankhamun in Egypt. Many were inspired and fascinated by the dazzling sight of these ancient relics,

Opposite page: Figure 13. "La Garçonne" as offered by Lanvin. Tailored satin evening jacket with sequin-embroidered pockets and pleated skirt.

Right: Figure 14. "La Garçonne" image of the 1920s.

Figure 15: Jeweled headband, 1918 for the Biarritz clientele.

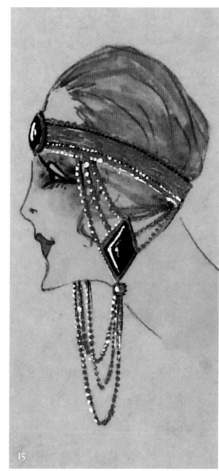

symbols, and radiant gold paired with the brilliant colors of multiple semiprecious stones such as turquoise, carnelian, coral, and lapis lazuli. Two important hats found in the Patrimoine Lanvin, dating from the 1920s, are framed structures both covered with gold lamé and decorated with crystals, pearls, gold bugle beads, and silver threadwork. Designers in all segments of the industry capitalized on this new influence, inspiration, and design direction: Madame Lanvin was no exception. These two millinery creations are important as the design inspiration demonstrates Madame Lanvin's sensitivity to the past.

One headpiece is clearly inspired by the headdress of the Egyptian queen. A featherlike pattern is rendered in crystal revealing the form of a massive wingspan of a thunderbird. The wingspan and shape of this hat was scaled down to be faithful to the sleek proportions and silhouette of the 1920s aesthetic. The caul, a woman's headdress of ancient Greece, is the obvious influence for the second headpiece from the same collection. The shape of the headpiece is identical to the caul, including the positioning on the forehead and the elongated, blunt point at the rear of the head. The beaded pattern on the hat is the two-dimensional representation of the fastening bands typically found securing the caul to the head of the wearer.[7] (Fig. 23)

The tricorne, a three-cornered hat or cocked hat, and bicorne, a two-cornered hat, appeared frequently in the millinery collections of Madame Lanvin. (Figs. 20) These masculine hats, worn by gentlemen and nobles, were high fashion during the first half of the eighteenth century; they were usually edged with various gold braids and trimmings. In the 1780s, the tricorne continued to be worn, although in a scaled-down size, but the most popular hat of the period was the bicorne, a variation of the Swiss military hat, called the "Androsmane." During the French Revolution and the subsequent Directoire , a desire for simpler dress, minimizing class distinction, was favored. The tricorne hat was replaced by the bicorne, which was encircled by a silk cord and had a red, white, and blue cockade to one side; the red color was always flanked by the blue and white. The attached black Chantilly lace veil follows the vogue of the period, inspired by Venetian women and the Carnival of Venice.

"No hat which values its reputation as the top of the mode goes unveiled nowadays, and this hat is no exception. Through the fine mesh, the eyes of the wearer may look with inscrutable air at the havoc wrought by beauty, which is not only in the eye of the beholder, but in the eye of the beheld as well."[8]

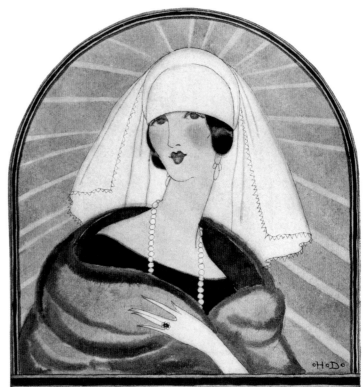

Three superb millinery examples from the early 1920s, in the collection of Musée Galliera in Paris, reflect inspiration from the Middle and Far East. The first example from 1920 is clearly inspired by Chinese culture and its aesthetic. (Fig. 16) A six-sided black silk taffeta hat with a turned-up scalloped edge features a substantial basket-weave border executed in tightly twisted straw. This juxtaposition of elegant black taffeta with utilitarian straw is a superb distillation of the essence of Chinese influence refined to suit Parisian taste.

A second example, from 1923, is of black silk satin outlined with gold *soutache*. (Fig. 24) *Soutache* is a three-dimensional flat braid with a groove in the center, allowing for easy surface application by machine, and may be as narrow as an eighth of an inch. The piece represents a reinterpretation of *Japonisme* in a most refined sense. At first glance one sees a shiny satin, helmet-shaped headpiece with minimal detail—nothing much and unimpressive. After further visual digestion of this object and pondering of its origin, it becomes quite clear that this shiny black helmet shape, padded out for additional soft volume, potentially represents the silhouette of the elaborate and heavily ornamented coiffure of the traditional Japanese woman of the Late Edo period.

The three-dimensional petal structure at the crown might possibly represent different widely used symbols from Japanese life—it could be a simple chrysanthemum motif. Viewed from the side, however, a second option reveals itself: perhaps rice-paper parasols with shiny lacquer finish traditionally used by Japanese women to shade the sun off their porcelain-finished complexions. Gold soutache implies thin bamboo spokes that support the structure. The final detail at the center of the crown is an ivory sphere that is carved, using scrimshaw technique, into a Japanese character known as a *netsuke*. *Netsukes* were the multiple carved ivory trinkets found at the end of Japanese sashes as a means to weigh them down; they were carved in various shapes such as animals or characters from everyday life.

A millinery structure from 1923 is covered in black silk crepe georgette embroidered in gold metal threads in a geometric pattern attributed to the aesthetic of *Turquerie*. In a similar helmet-like shape of the previous example, three-dimensional fin-like structures were added to either side of the hat and down the center. These "fins" were embroidered in gold metal thread of graduated geometric patterns, which contributed to the three-dimensional aspect of the design; this hat was designed for viewing in the round. Along with *Chinoiserie* and *Japonisme*, *Turquerie*, with a more sophisticated aesthetic, is one facet of Orientalism that is consistently drawn upon for fashion and the decorative arts.

While Madame Lanvin subscribed to the tubular silhouette of the 1920s, she knew that her clients were not prime candidates for these short slips requiring the slimmest of figures. She continued to offer her flattering full-skirted versions of the *robe de style* as well as the appropriate millinery options to the women who chose to wear the fuller silhouette. The options included scaled-down bonnets inspired by the 18th-century *merveilleuse*, variations on the cloche, wide-

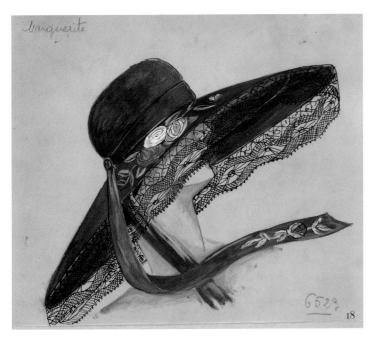

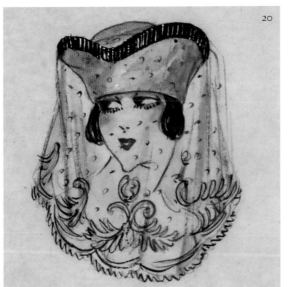

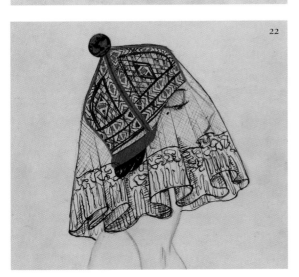

Previous page: **Figure 16.** Black silk taffeta and basket-woven natural straw evokes an Asian aesthetic, circa 1920. **Figure 17:** Hat with chiffon fall is illustrated in a classic Madonna pose; the shape of the hat implies a halo. Inspired by the 16th century French Renaissance. November 15, 1922. *Vogue.* Sketch by Helen Dryden. This page: **Figure 18.** A garden hat with lace scallop edging and embroidered brim and ribbon streamers, 1923. **Figure 19:** Named like the *robe de style* in pages 86-87, is a garden hat in the same quasi two-dimensional silhouette of the dress. Although the side brim reaches from shoulder to shoulder, the back and front brim are shallow, 1923. **Figure 20.** Soft sculpted tri-corne hat with soft Chantilly lace veil for Deauville, 1919. **Figure 21:** Plaster cast hands of Madame Lanvin. **Figure 22:** Japonisme style hat, embroidered in red and black with black lace veil and red scrimshaw-carved *netsuke* on top, 1923. Similar to the image in fig. 24.

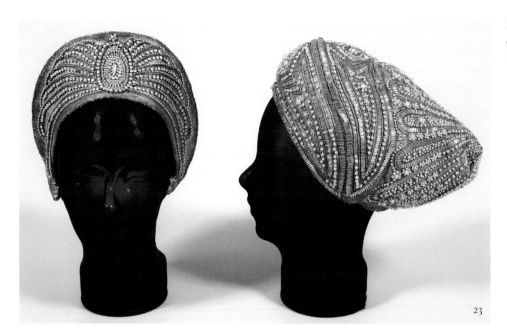

brimmed traditional garden hats, and heavily adorned hats with brims reaching from shoulder to shoulder. (Figs. 18-19)

Created in 1920, a light pink silk garden hat is pure in design as the same fabric is used to cover and line the millinery structure and create the decorative large-scale Lanvin rose. The only contrast is the green silk of the leaves. Lightweight in structure, fabrication, and ornamentation, this is the perfect hat for warm summer days. (Fig. 25) In the same vein, and from the same year, is a black Chantilly lace capeline. With no structural support for the crown, the scalloped edge trim extends over the black silk brim just enough to create an obscure veiled effect over the eyes.

One of the most identifiable hats from Lanvin is this example of ruched black silk taffeta covering the millinery frame. A single large flower was formed from looped black silk ribbon; the center of the flower was created from pink-silk-covered beads topped off with a milk-glass bead. Like the silhouette of the robe de style—flat at center front and center back, and reaching its greatest width across the hips—the brim of the hat mimics the silhouette reaching its widest point from shoulder to shoulder. (Fig. 26 & 28)

Miniature or "doll hats" were used as a novelty and were typically worn low on the brow and tilted to one side. A Lanvin model, featured in *Harper's Bazaar* in 1939, is a white straw sailor hat detailed with a white grosgrain ribbon and the finest of black veils. The magazine's advice was to "Set your sailor squarely on your head, just grazing the bridge of the nose." These two Lanvin ensembles, captured by the Seeberger Fréres, are classic examples of the scaled-down hats of the late-1930s. The model on the left side of the image wears a hat with

a diminutive crown so narrow that the hat just rests on top of the head. It is the voluminous veil that cages the face and secures the petite millinery creation. The model on the right wears a hat of the same minimal proportions, but with subtle embellishment and devoid of a face veil. (Fig. 29)

Plumage made a strong comeback for day and evening in the second half of the 1930s, after reaching its pinnacle in the first decade of the twentieth century. The trend and desire for plumage was stronger than ever as whole birds were used as ornamentation. In 1938, a Lanvin client wore the entire bird—literally a chicken nests on her head. Of course, the proper face veil makes it a stylish millinery choice. (Figs. 30)

There were many millinery options at the end of the 1930s. Those with small, low crowns and wide brims, known as cartwheels, gained popularity as women sought to balance out line and proportion with the perfect millinery accessories. Clients who chose the sleek and lean line of bias-cut creations required minimal headwear, if any at all; clients who chose ensembles with fuller skirts, and more volume, needed millinery that complemented that aesthetic. A whimsical millinery confection of 1939 takes on similar proportions as the classic straw boater. (Fig. 31) This hat is covered in stripes; the chevron pattern over the crown is complementary to the narrow minimal classic black suit and white blouse. The shallow brim and the tall crown contribute to the whimsical feeling as do the black pom-pom and the striped looping detail. This image of a model posed in the original Lanvin boutique shows the Rateau accessories vitrine, which is still used in the boutique today.

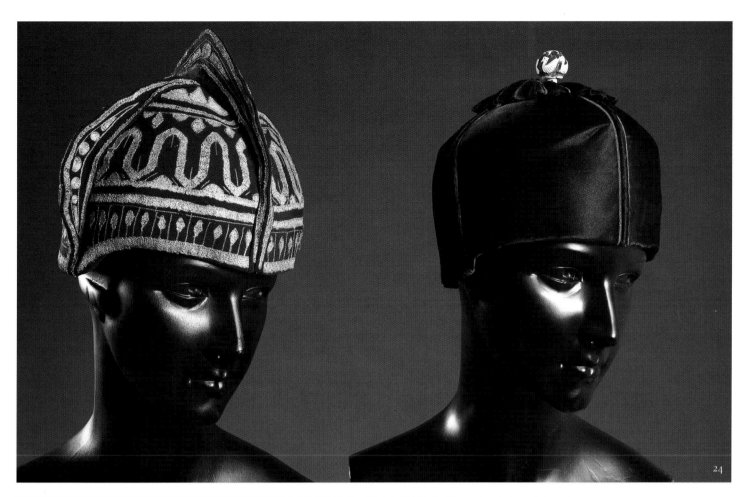

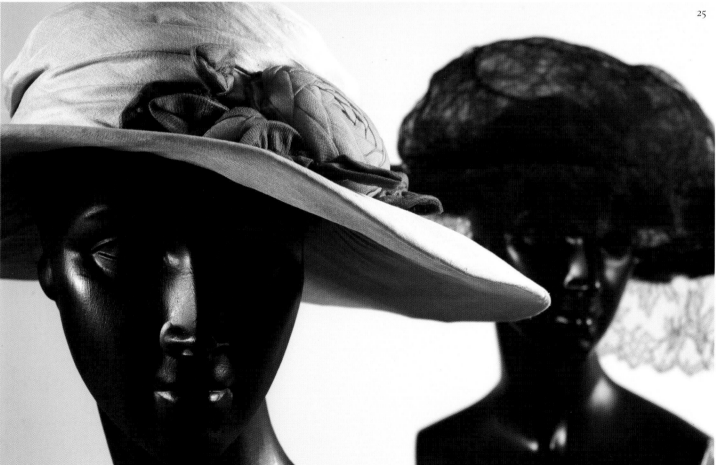

Figure 24: From 1923 (left), black crepe georgette embroidered in gold metallic threads under the influence of Turquerie. From 1923 (right), black silk satin padded form with three dimensional petal structure at the crown topped off my a scrimshaw-carved *netsuke*. **Figure 25:** From 1920 (left), light pink silk garden hat of asymmetric drape adorned with pink silk chiffon Lanvin rose and green leaves. From 1920 (right), black Chantilly lace capeline, with asymmetric drape of scalloped edge gently veiling the face.

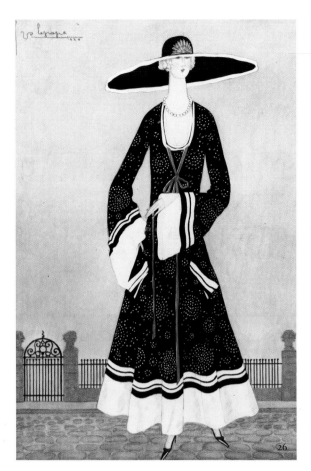 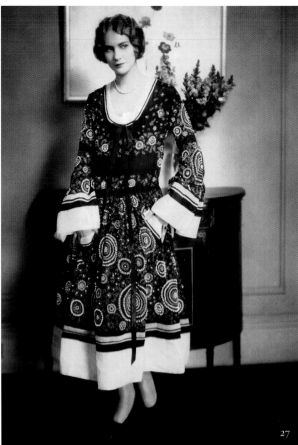

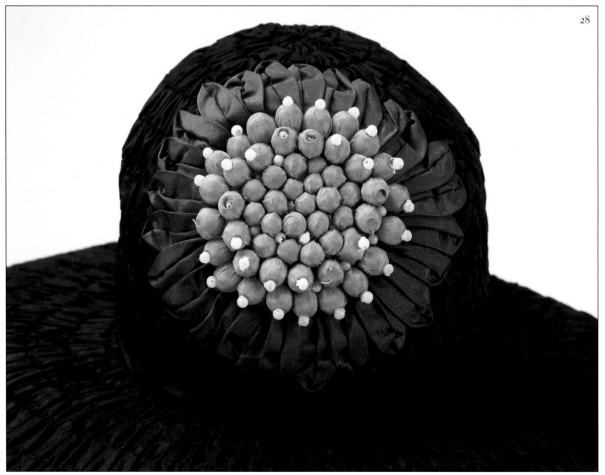

Figure 26: Georges Lepape illustration for Lanvin, 1924. Figure 27: "**Ma Mie**," black dress bordered in white, embroidered in white and silver, only ornamented with flaming red streamers from the center front neckline. May 1, 1924 **Figure** 28: Detail of hat from fig. 26. Ruched black silk taffeta with single flower detail, at center front, of pink silk and white milk-glass beads. 1922.

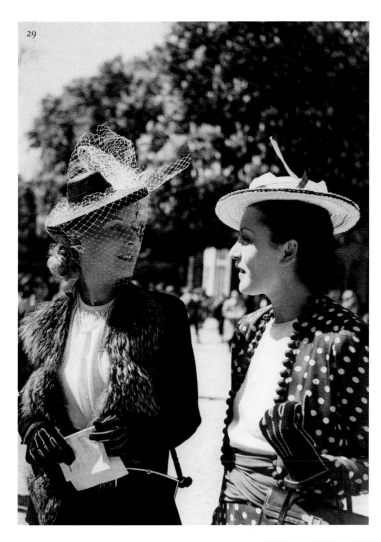

Figure 29: Lanvin models were outfitted and sent out to be seen in the most trafficked social areas of the city as an informal source of publicity. 1938

Figure 30: Madame Yvonne Denay, 1938, photographed with a Lanvin millinery creation in the form of a nesting chicken including a face veil.

Figure 31: A model poses at the accessories case, within the Lanvin boutique, fully suited with whimsical hat and tailored suit. April 1939.

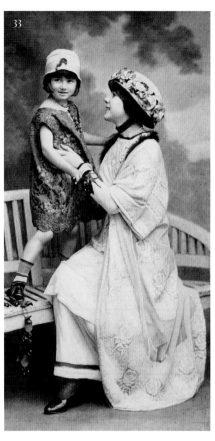

Figure 32: Marguerite Marie-Blanche, at eleven years of age, modeled a Lanvin ensemble for the *fillette* or young girl. *Les Modes*, December 1908.

Figure 33: Lanvin model Anaïs and Marianne Gaumont—Jeanne Lanvin's niece—are photographed by Paul Nadar for *Les Modes*, September 1913. Child's red dress of antique brocaded floral textile, re-embroidered with gold soutache and cording, completing the ensemble with a crepe cloche.

Opposite page: Figure 34. Opposite page, Red brocade dress with gold embroidery as seen in Figure 33.

MILLINERY CUSTOMERS of Madame Lanvin saw the original and sophisticated clothing she made for Marguerite Marie-Blanche and quickly realized the abundance of talent contained within the diminutive yet highly creative woman. (Fig. 32) They desired these smart ensembles for their children. A well-maintained and adorned woman reflected the husband's professional success and status—hence, a well-groomed and well-mannered child was a direct reflection of the parents, particularly the mother. A child served as a social calling card for the mother; great effort and cost was exerted to create a polished, well-dressed child that could be presented to elders and peers without hesitation and embarrassment to parents.

Madame Lanvin focused much attention on Marguerite Marie-Blanche in order to ensure she was a well-rounded, happy, and successful child. She was well-versed and musically talented, and performed for friends of the family on many occasions. Marguerite was a positive and bright reflection on Jeanne Lanvin, serving as a powerful image for the children's clothing that she would come to informally promote as the muse of the designer. Perhaps other mothers who wanted to create an image of the ideal child, like Marguerite, purchased the clothing hoping their children would be viewed in the same positive light.

Because of the demand, a collection of childrenswear was offered for the first time in 1908; the attention to extensive detail and exquisite fabrication were novelties of these confections. Although the silhouette and structure of the garments had been updated from previously worn, scaled-down adult clothing to more functional and practical forms, the selection of textiles and use of color remained quite sophisticated. Photographs taken by Paul Nadar for *Les Modes* show children's clothing photographed alongside clothing for young ladies and women. Perhaps originally unintentional, it is photographs like these—revealing the important and irreplaceable bond between mother and daughter—that helped support and promote the mother-daughter image of the house. Once again, the images photographed by Nadar for *Les Modes* document the earliest of the children's and women's wear. An image of frequent Lanvin models Aimée, an infant Marianne Gaumont, and Camille was photographed as a *tableau vivant*. The impressionist movement influenced this style as the photographs attempted to capture fluid lines and contour. These so-called avant-garde artists were called *pictorialistes*.

There was a break with tradition as photographers attempted to reinvent composition. Cropping harmonized with the fluid lines of the images, providing more realistic reproductions than idealized fashion gravures. "In this way, these figures have an elegant beauty and a living soul: For the simplicity is the very same as life."[9]

An image photographed by Paul Nadar in 1911 features Madame Lanvin's sister, Madame Gaumont, who was respon-

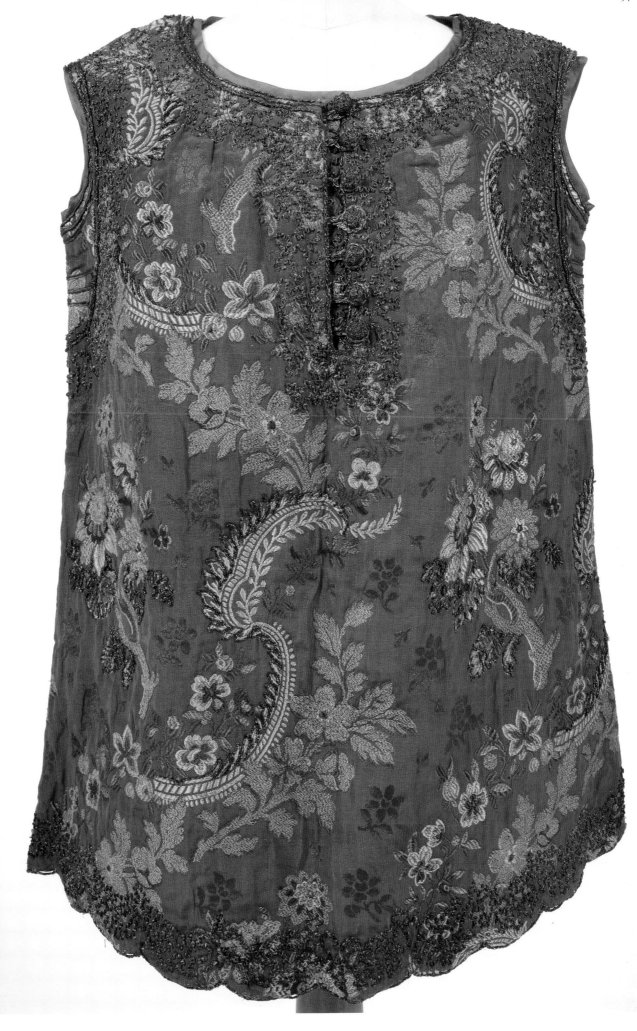

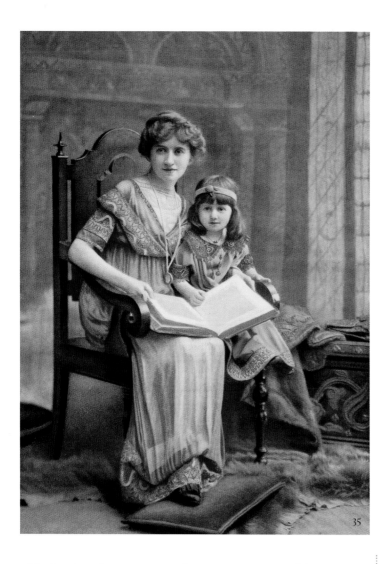

35

Figure 35: Madame Gaumont, the only sister of Jeanne Lanvin, was photographed by Paul Nadar in this romantic setting with her daughter Marianne, who served as a model up until the first World War. *Les Modes,* May 1911.

Opposite page: Figure 36. White chiffon child's dress with heavy silver *soutache* embroidered shoulders. A Greek key border and silver boullion fringe finish the hemline, 1911.

Figure 37: Two examples of the same soft red silk taffeta dress with gold *soutache* embroidered shoulder yoke and buttons with cartridge pleating, 1919. The child's version, on the mannequin, is "Chatoyante" and the girls' model, draped over a Rateau chair is "Colette".

sible for the administration of maison Lanvin, and her young daughter Marianne. (Fig. 35) Marianne remained a frequent childrenswear model up until World War I. This image shows two dresses, featuring the quality, interesting design, and embroidery that has become synonymous with the house. This image, in a Renaissance Revival style, is romantic and exotic as it depicts mother and daughter dressed in elaborate costume with even more elaborate gold embellishment. The *mise-en-scène,* with heavy architectural background and leaded glass windows, is made complete with wild animal skins on the floor that serve as rugs, heavily embroidered throws with tassels, and an elaborately carved chest.

The mother's dress is a classic chemise frock with *soutache* embroidery around the neckline and hem of the sleeves, as well as a deep border of embroidery at the hemline of the skirt. The child's short-sleeved tunic is full length with a jewel neckline and a center front buttoned opening embellished with *soutache;* the same treatment appears on the scalloped hem of the short sleeves and tunic. A simplistic headband completes the child's ensemble. This lush, luxurious environment, rich in color, texture, and mood, is the perfect setting in which to photograph apparel equally as rich and embellished. Although the primary focus of this image is to promote the clothing designs of Madame Lanvin, a pervasive underlying theme of mother-daughter permeates.

"Chatoyante," French for shimmer or sparkle, is the name of this red silk taffeta dress from the 1917 summer collection. (Fig. 37) The shoulders and back are covered by a capelet of gold lace, which has been heavily re-embroidered with gold *soutache* as well as the three buttons at center front. The combination of rich, regal red and sparkling gold creates an ecclesiastical feeling like the robes of Catholic cardinals. The bodice is fitted and the voluminous skirt emerges from a tight row of cartridge pleats just below the chest. The sleeves and bottom of the dress are finished with multiple rows of frills and the hemline is scalloped. Two versions of this dress—one for a child and one for a young girl—exist in the Lanvin archives. The detail of metallic-gold thread has tarnished over time and no longer sparkles.

Lanvin shapes net, silk, and organdy into dresses that may confidently venture to a party.[10]

Madame Lanvin also made fancy dresses for the young set, as seen in *Vogue.* This same dress later appears in *Vogue* of August 1919; it follows the lines of a Mother Hubbard style.

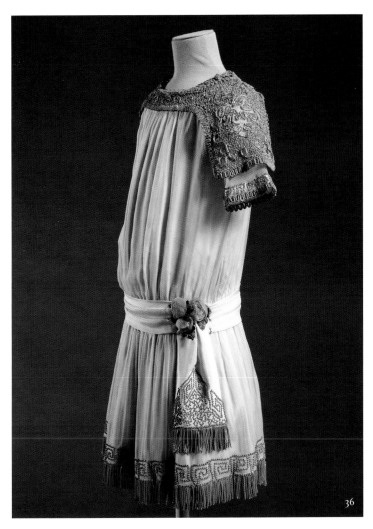

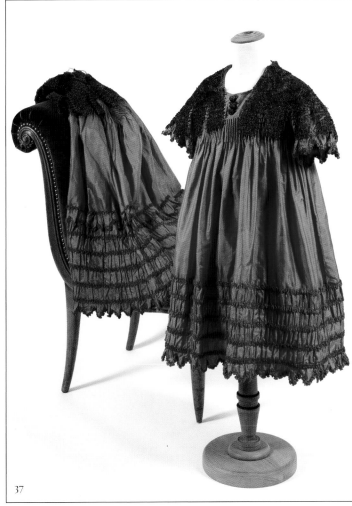

Made from rose-colored silk trimmed with a deep collar of gold lace, it is this sophisticated combination of fabrics and color that marks this dress as a signature Lanvin creation. Whether for women or children, dedication to good design was her foremost concern and passion. No dress details were too sophisticated or costly to execute on childrenswear. Only those children of the most fashionable and refined mothers would be given a fancy dress like this. "Lanvin continues to increase the charm of youth and to prove that simplicity is the better part of smartness."[11]

As mentioned previously, children used to wear scaled-down versions of clothing for adults; the clothing was cumbersome and difficult to put on and take off. In 1921, *Vogue* announced that the simplified child was now the mode in Paris. "Among the most characteristic sights in Paris, in the old days, were the children who, accompanied by nurses and governesses, used to play under the trees of the Champs Elysées, the Avenue du Bois, and the aristocratic Parc Monceau... There is a striking change in the appearance of the youth of the French capital. In the old days, little girls looked like animated dolls, with large hats, lacy frocks bisected at the knees by a large floppy sash, tiny gloves, the neatest of white or pale coloured shoes and socks, or, often, boots and stockings even

in the middle of the warm weather. Around their little necks were chains and pendants, upon their baby arms and fingers were bracelets and rings, and they all walked sedately with full consciousness that their clothes were made to be looked at, not played in." (Fig. 38)

"But a change has come over the spirit of the Parisian child's dream. His elders have learned the wisdom of loose and simple clothes, and the childish haunts of the city are gayer in consequence... Very little white lace and a great deal of strong colour are to be noted in the costuming of the modern Paris child." "For important occasions, little girl's frocks may be more elaborate with embroidery and fine stitchery, but they retain their simple form, and are easy to put on and take off again." (Fig. 39)

Black and white Seeberger Frères images are important documents, capturing children in their element—outside playing in the park with their siblings or escorted by an elder. They are outfitted from head to toe in maison Lanvin cold-weather clothing. Although the garments are small, they are complete ensembles brimming with details of exotic embroideries, fancy fastenings, and practical pockets.

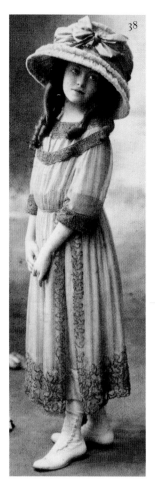
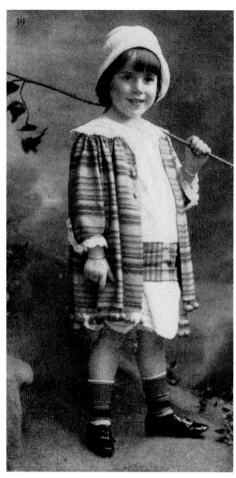

Figure 38: Ensemble for a young girl of blue *crepe de chine* with an overlay of blue silk chiffon embroidered with gold *soutache* including a large Byzantium-styled collar. With a hat of embroidered tulle embellished with a large bow of dusty blue. *Les Modes*, July 1909. Figure 39: Mlle. B. Devoto costumed by Jeanne Lanvin. Dress of white *broderie anglaise* with a pleated plaid satin belt. Jacket of plaid satin with a border of self-fabric pom-poms and a collar and cuffs of *broderie anglais* and *soutache* re-embroidery. The *crepe de chine* cloche hat is finished with a plaid satin bow. *Les Modes*, July 1913. Figure 40: Chantal and Alix Polignac wearing white wool coats, with dimensional wool felt appliqués of potted apple and orange trees on either coat pocket and center back. Coordinating hats and matching dresses completed the ensembles of 1926.

In 1926, sisters Chantal and Alix de Polignac, relatives of then-married Marguerite Marie-Blanche de Polignac, were photographed by the Seeberger Fréres in the park wearing matching ensembles: white wool coats with three-dimensional decorations of apple and orange trees. Under the coats, a coordinating stylish dress with applied stripe detail completes the sophisticated outfit. (Fig. 40)

"Nipon" is a coat and dress ensemble of wool flannel lined in silk *crepe de chine* (Fig. 43). In the original 1924 illustration, black is the color used for the coat and hat and green is used for the lining, tassel, and fastenings. A version of this ensemble is maintained in the collection of the Costume Institute and is fabricated in green wool with detail executed in black. The coat is simply styled with a double button closure just below the built-up neckline. On the right hip is a pocket flap with center slit detailed with ethnic threadwork embroidery. A large, embroidered self-fabric tassel is suspended holding the flap in an upright position. The hemline of the dress is detailed with self-fabric cording sewn into small triangular shapes. The coat is detailed with a wide border of waxed

black braid zigzagging back and forth down either side of center front, around each wrist, and around the full width of the coat several inches above the hemline.

Another example of sophisticated childrenswear from 1924 is "Carpillon" a black dress with an orange threadwork embroidery of a large stylized carp on one side. In the original fashion sketch, it is shown with an open neckline and cap sleeves, perhaps being offered for a spring/summer collection. A variation on the same model for fall/winter exists as a black velvet dress with long sleeves and a closed-in neckline secured with an orange silk scarf. Either way, this is an extremely sophisticated, non-traditional design in children's clothing both in the severe coloration and the use of an exotic carp motif.

In 1925, Jeanne Lanvin served as vice president of the Pavillon de l'Elegance at the Exposition Internationale des Arts Décoratifs in Paris. Along with her many responsibilities, she exhibited several pieces for maison Lanvin including childrenswear. Two of the most recognized are those pictured

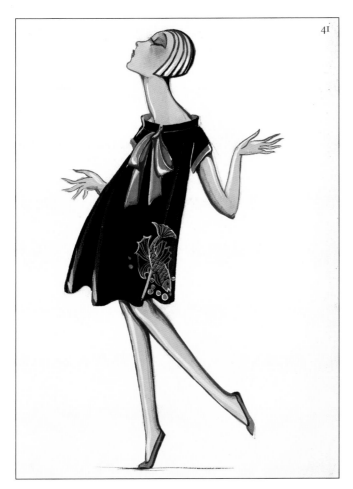

Figure 41: "Carpillon" black dress with an intense red/orange Cornelly embroidered highly-stylized Japanesque carp motif. Spring/Summer 1924. Figure 42: "Carpillon" Fall/Winter, 1924, offered as a long sleeve black velvet dress with a silk neck scarf and embroidered carp motif in red/orange.

here in documentation photographs; front view, side view, and profile shots were taken of every object produced by the house as a record and form of protection against style piracy.

The beige georgette dress is enhanced with an all-over floral pattern rendered in pastel-colored threadwork highlighted with metallic-gold thread. (Fig. 51 & 55) The full skirt has been gathered with multiple rows of hand-executed running stitches in order to attach the full skirt to the fitted bodice. A two-tier, scalloped hemline has been enhanced with multiple rows of metallic-gold embroidery for a slight touch of whimsy and sophistication. A center back closure is secured with a streaming gold lamé ribbon. The perfect coordinating hat completes the ensemble in signature Lanvin fashion.

The organdy confection of white, light blue, and dark blue is the perfect party dress with flouncing short sleeves and a multitiered skirt. (Fig. 52-54) Each tier of crisp white organdy is edged with a row of pinwheels created from a pleated circle of light blue organdy, with a coiled, self-fabric button center trimmed with a delicate ruffle of dark blue lace. The

sleeve hem features the same treatment. A wide sash of light blue organdy is concealed under the first tier of the skirt; it appears at center back as a grand bow embellished with a single light pink silk rose at the bottom of a streamer. A perfect cloche hat with ribbon chinstrap and streamers completes this ensemble.

Although children's clothing was produced well into the 1930s, this niche was not the mainstay of the Lanvin empire and received little attention—there is no documentation that substantial collections of childrenswear were designed for each season like that in the earliest years. One might assume that childrenswear was made at the request of important clients, since dresses for toddlers appear as late as 1937, in addition to special-occasion dresses for baptisms, first communions, and wedding attendants. However, Lanvin did remain in favor with the young ladies despite stiff competition from other design houses with a more avant-garde image.

Given her desire to dress clients from head to foot, Madame Lanvin offered high-fashion millinery designs for children

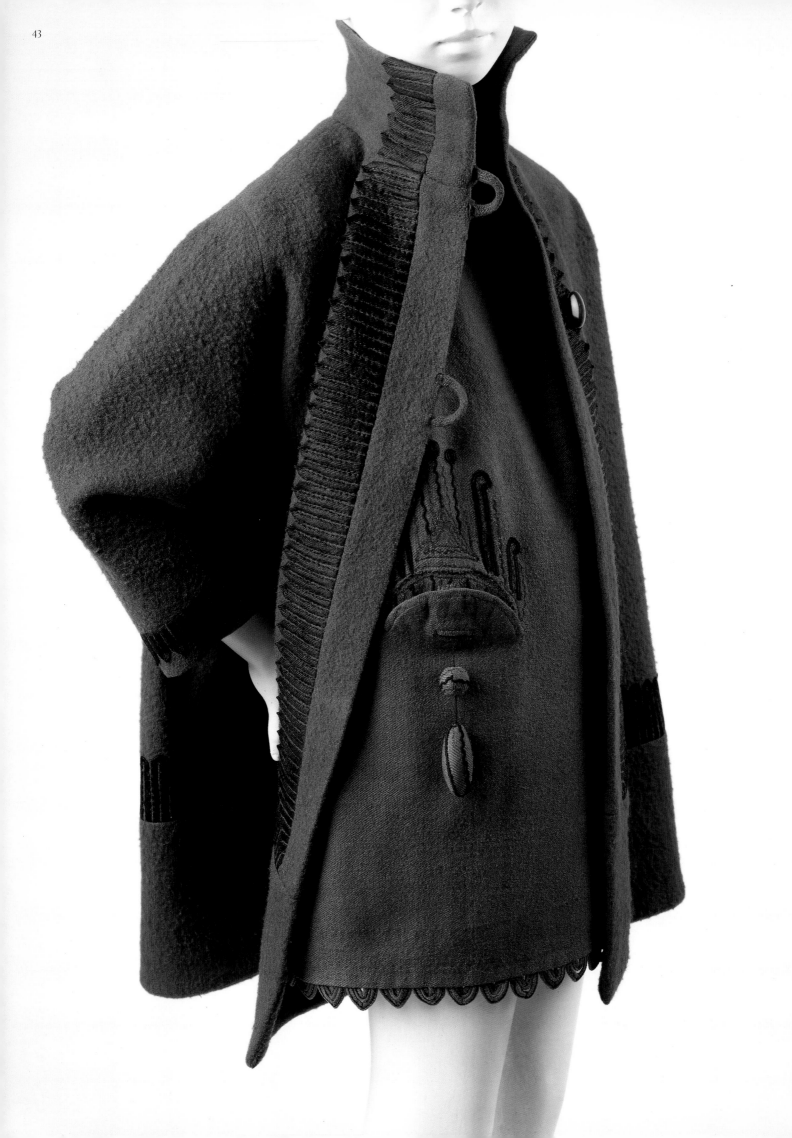

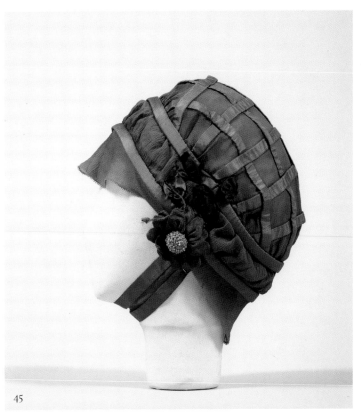

44

45

46

47

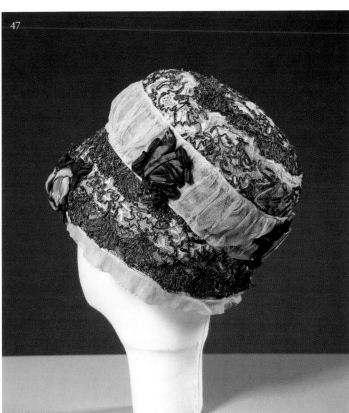

Opposite page: **Figure** 43. "Nipon", 1924. Green wool dress and jacket ensemble with black applied trim on the coat and an embroidered pocket with tassel detail.

Figure 44: Child's bonnet of ivory cotton *broderie anglaise*, with *soutache* embroidery, features a pink silk bow, 1910. **Figure** 45: Blue silk chiffon and charmeuse hat with self-fabric details and a lattice-patterned crown, 1918-1919. **Figure** 46: Fashion show invitation executed in the *pochoir* technique, 1910. **Figure** 47: Young girl's ivory silk tulle bonnet with metallic gold gimp embroidery, as seen on the children in Fig. 46. Silk *taffetas changeant* roses in burgundy, pink, and light blue spot the brim and central shirred decorative band of the bonnet grounded by dark green silk leaves. 1910.

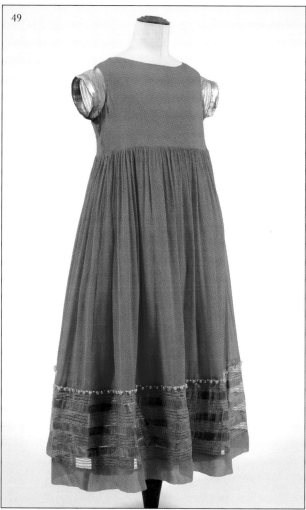

Figure 48: The composition of this illustration by Georges Lepape recalls the imagery and compostion of Velázquez portraits of Spanish infantas and infantes, including the presence of a small dog, the symbol of fidelity. *Vogue* 1 October 1924. Figure 49: Child's dress of red silk, *Le petit chaperon rouge* of 1924, highlighted with alternating bands of transparent and gold lamé ribbons including the cap sleeves. Various sized pearls punctuate the joint between the red crepe de chine and the gold border. Figure 50: Diego Velázquez, *Infante Philip Prosper* (1659). Oil on canvas. Kunsthistorisches Museum, Vienna.

and young ladies, too. A bonnet from 1910 is a fine example: it is made of ivory-colored cotton eyelet embroidery enhanced with *broderie anglaise* and supplemental *soutache* with an ivory-colored lace-ruffle trim around the face. A light pink silk bow on the left side is embellished with two streamers embroidered with metallic-silver soutache. (Fig. 44)

In the 1920s, various cloche hats were offered in a myriad of fabrications and trimmings. The first example, of blue silk chiffon, features a basket-weave pattern of blue silk charmeuse on top, while two additional bands of blue charmeuse sandwich a band of ruched silk chiffon just above the eyes. (Fig. 45) Marrying form and function, the most delicate visor of chiffon, with a picot edge, shields the wearer's eyes and face from the sun. A second visor of chiffon shields the delicate skin on the back of the neck. The left ear is decorated with a handmade blue chiffon flower and leaves of green silk taffeta; a self-fabric chinstrap secures the hat there. A second version of a similar style features ivory-colored silk

chiffon with a basket-weave detail of light blue silk ribbons over the head. The bias-cut frill with picot edge, which protects the eyes and neck of the wearer, is highlighted with clear glass beads; these beads also form the center of the looped ribbon flower.

Minimal documentation, sketches, or photos exist of apparel designed for *le petit garçon*—and there are even fewer existing examples. The clothing made was for very young boys who had not quite formed an opinion about clothing and could not object. An original sketch from the Lanvin archive, as well as two ensembles of similar styling found in the collection of the Musée Galliera, provide documentation of the earliest examples of boys' apparel. The sketch shows a classic design for young boys during this era—a belted tunic paired with shorts. In this case, the ensemble is rendered in a combination of white and light blue. The actual ensembles, which were donated to the Musée Galliera by the gentleman who wore them as a young boy, are identical with the exception of the

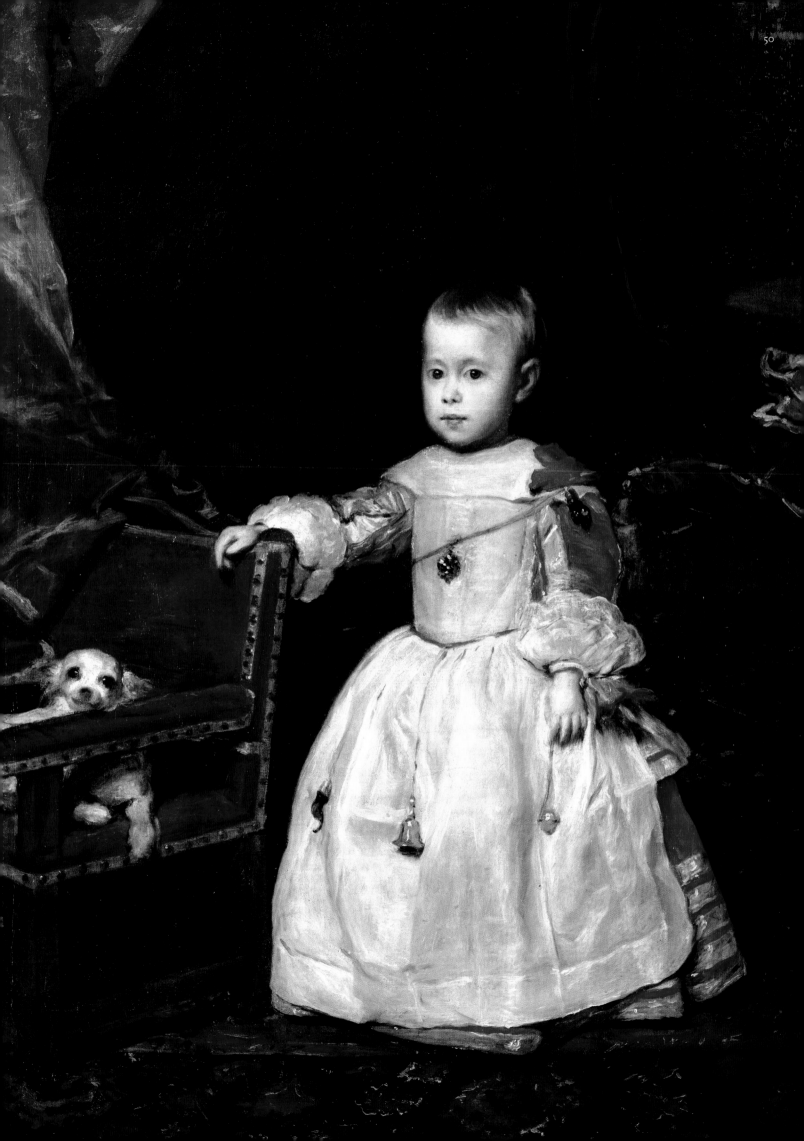

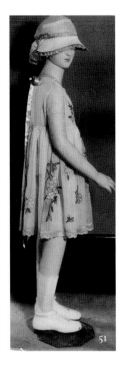
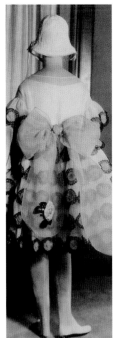
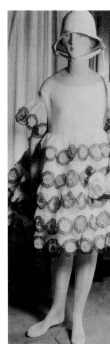
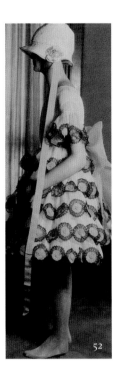

51

52

colors of the embroidery. A tunic of ivory-colored silk *shantung* features an embroidered shoulder yoke with an off-center button-up placket of self-fabric loops and round brass buttons. (Fig. 59) The tunic is detailed with a gathered self-fabric hip sash finished with hand-strung silk fringe. While one ensemble is entirely cream-colored, including the tone-on-tone embroidery and silk fringe, the other ensemble features a festive coloration of folkloric embroidery in vibrant red, blue, and green, which is also used for the fringe on the sash. Both ensembles have matching ivory-colored silk *shantung* shorts.

A little boy's red dressing gown with contrasting details was featured in the collection of Winter 1910–11. While young boys wore tunics and shorts, even younger boys wore little dresses and this one is topped off with a matching skullcap. The same little boy's ensemble is used again in 1913 as part of the cover illustration for the Jeanne Lanvin carton d'invitation, or fashion show invitation. (Fig. 56) The subject matter and composition are a direct, albeit not exact, copy of an illustration for mourning dress found in Rudolph Ackermann's Repository of Arts, dated 1809. (Fig. 57)

"Often one of the first things to come between a boy and his mother is the question of clothes, for there is a period when a boy considers comfort the first and only requisite, and his mother puts practically all the emphasis on appearances."[12]

The most important children's clothing created at maison Lanvin were pieces made for the British princesses, Elizabeth and Margaret. October 1938 *Harper's Bazaar* confirms it, "As the Princesses required clothing from the cou-

ture house, their dolls received new additions to their wardrobe as well... When her Majesty Queen Elizabeth first ordered Lanvin party dresses for her little girls, Madame Lanvin sent each child a doll dressed in duplicate. (Fig. 65-66) Now it has become a sort of tradition. Whenever the little girls get new party dresses, their dolls have new dresses, too. The frocks that have just gone over the Channel are: A long pink chiffon outlined in little round silver lamé buttons. A long white organdy appliquéd in ribbon flowers. A short blue crepe with Pierrot ruffles piped with silver kid."[13]

1 *Vogue*, (April 1, 1919), 45.
2 Wilcox, R. Turner. *The Mode in Costume* (New York: Charles Scribner & Sons, 1958), 357.
3 Carter, Ernestine. T*he Changing World of Fashion 1900 to the Present* (New York: G.P. Putnam & Sons, 1977), np.
4 *Vogue*, (1921), np.
5 Ibid.
6 *Vogue, (1922)*, np.
7 Wilcox, R. Turner. *The Mode in Costume* (New York: Charles Scribner & Sons, 1958), 17.
8 Ibid.
9 Deslandres, Y., et al. *L'Atelier Nadar et la Mode 1865-1913* (Paris: Direction des Musées de France, 1977), 66.
10 *Vogue*, (August 15, 1919), np.
11 *Vogue*, (1921), np.
12 Ibid.
13 *Harper's Bazaar*, (October 1938), np.

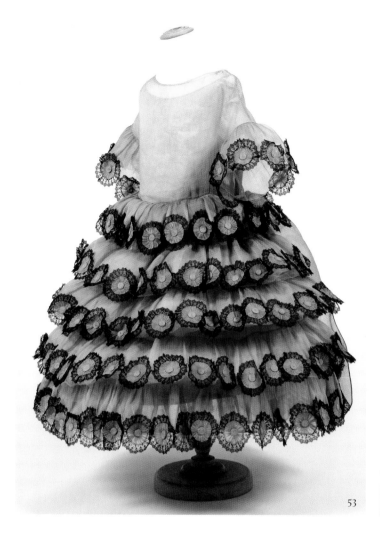
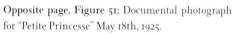

53

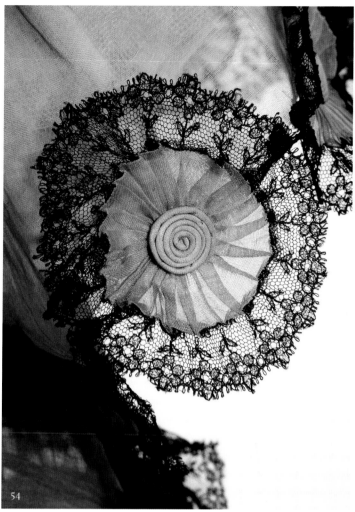

54

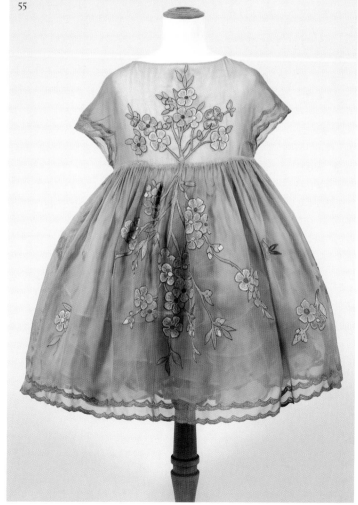

55

Opposite page, **Figure 51**: Documental photograph for "Petite Princesse" May 18th, 1925.

Figure 52: Documental photograph for "Les petites filles modeles" created for the Exposition International des Arts Decoratifs, 1925.

This page, **Figure 53**: "Les Petites Filles modeles," 1925.

Figure 54: Roundel detail of hemline from Figure 53.

Figure 55: "Petite Princesse" created for the Exposition Internationale des Arts Decoratifs, 1925.

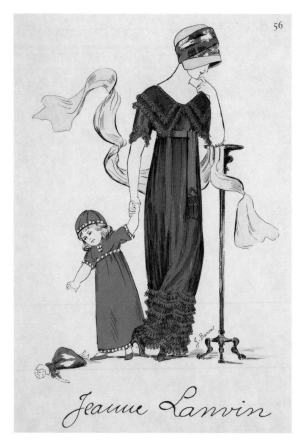

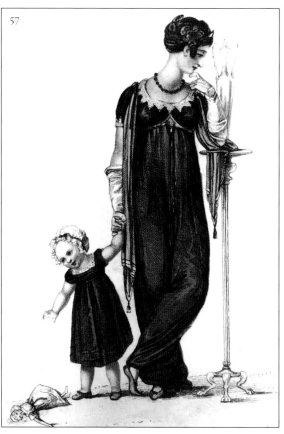

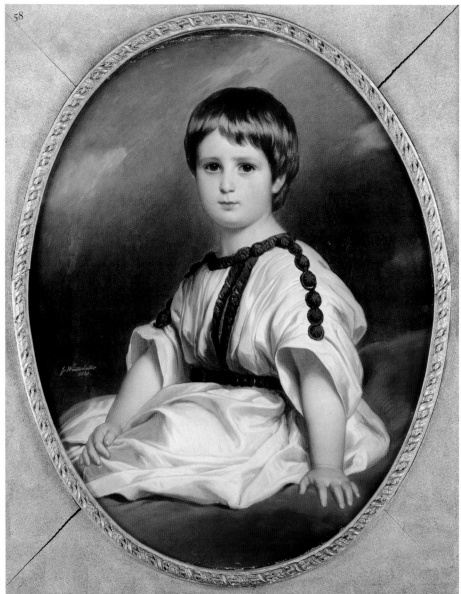

Figure 56: Jeanne Lanvin *pochoir* invitation for fashion presentation based on the Empire style, around 1913. The mother's dress of brown and green silk *taffeta changeant* is named "Feuille Morte" and originally from the summer season of 1911. The young boy wears a red dressing gown and skullcap detailed with blue and white accents.

Figure 57: An original illustration for mourning dress found in Ackerman's Repository of Arts, 1809. Although not an exact copy, it is clear that this design inspired the composition and styling for the *pochoir* invitation as seen in Figure 56.

Figure 58: Franz Xaver Winterhalter, Portrait of Philippe-Alexandre-Marie, Duke of Württemberg (portrayed at three years old, 1841). Oil on canvas. Chateaux de Versailles et de Trianon, Versailles.

Opposite page: Figure 59. Ivory silk shantung tunic with monochromatic embroidery and silk fringed sash, 1909.

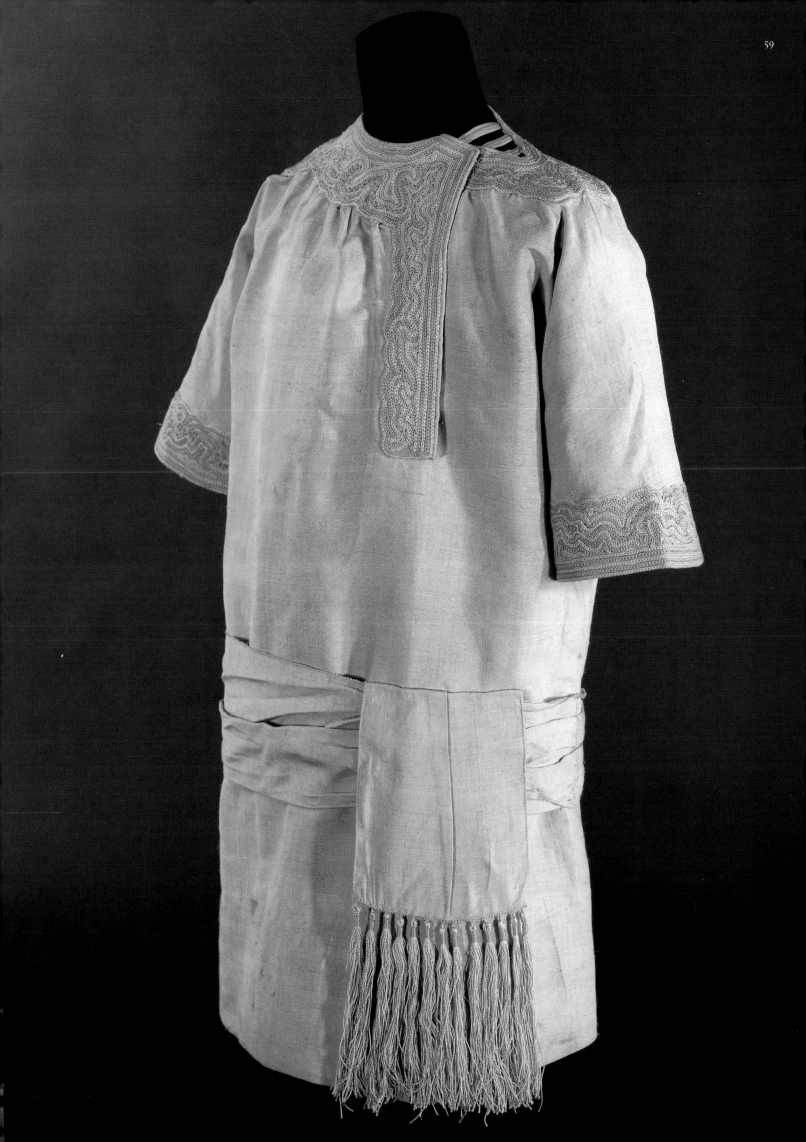

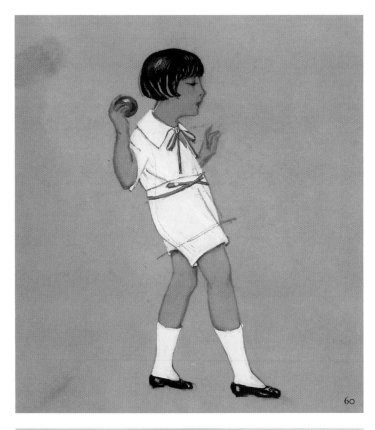

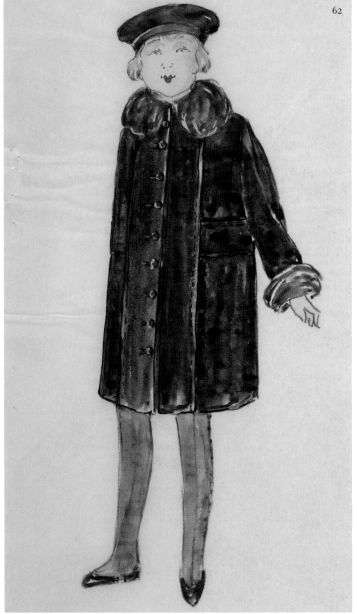

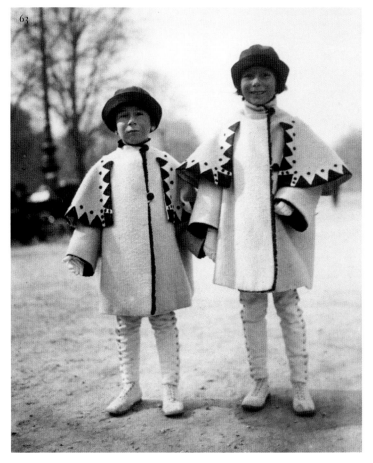

60

61

62

63

Opposite page: **Figure 60.** This daytime ensemble, with interesting belt detail, was meant for playtime. The mid-action pose of the figure throwing a ball reinforces the idea of play clothes versus "fancy dress" clothes. No spats on this young boy, only cotton knee socks. 1919-20.

Figure 61: "Michel," a young boy's light blue linen jumpsuit with short sleeves and collar of white bias-cut organdy. Easy and comfortable for play, the fabrication and generous cut is similar to beach pajamas. Circa 1919.

Figure 62: Boy's winter ensemble of coat with fur collar and cuffs, chamois-skin leggings and coordinating hat. Around 1921.

Figure 63: Young boys dressed in matching winter ensembles called "Patinetto." Wool coats with attached capelets are embellished with bold geometric appliqués and completed with coordinating hats. The chamois-skin leggings were practical keeping legs warm while buttoning up the side for easy accessibility. 1922.

This page: **Figure 64.** Illustration from *Harper's Bazaar*, 1938. "Madame Lanvin's dresses the little Princesses and their dolls." **Figure 65:** Princess Margaret Rose and her French felt play doll with painted face. 1935. **Figure 66:** Portrait of Princess Elisabeth and her French felt play doll with painted face. 1935.

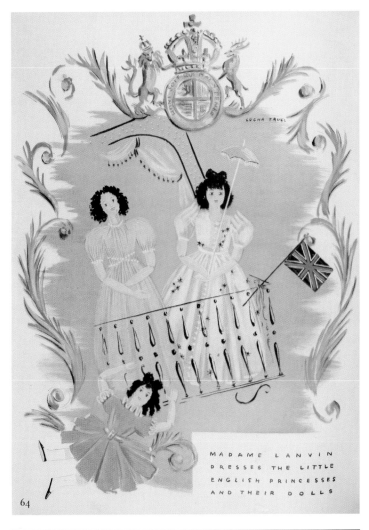

64

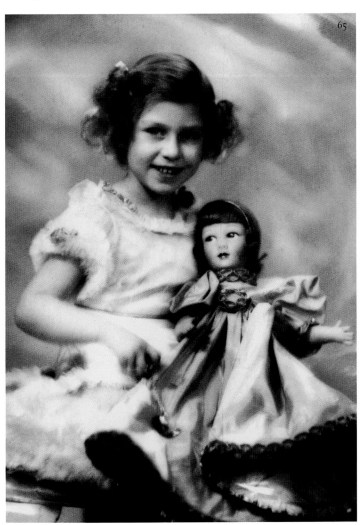

65

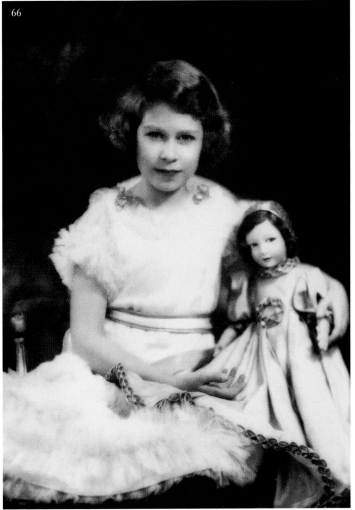

66

3

CLIENTELE

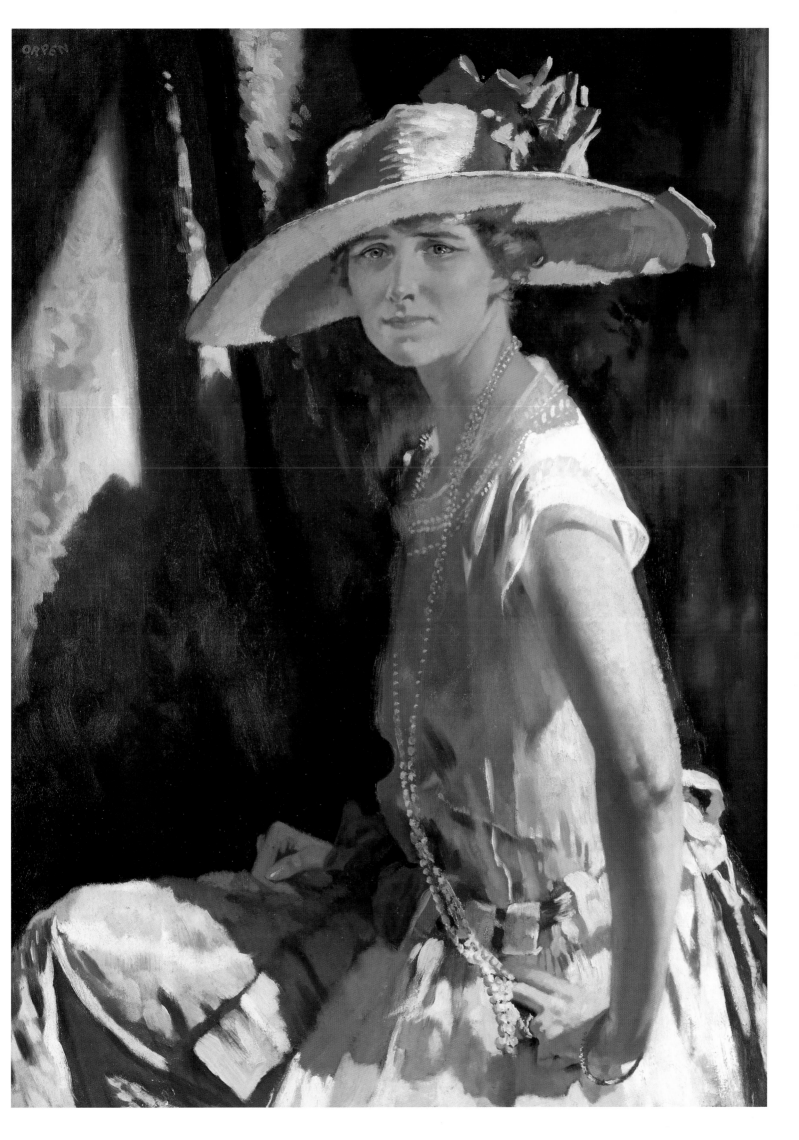

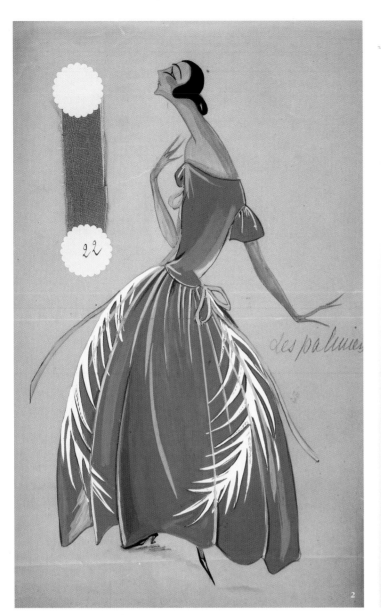

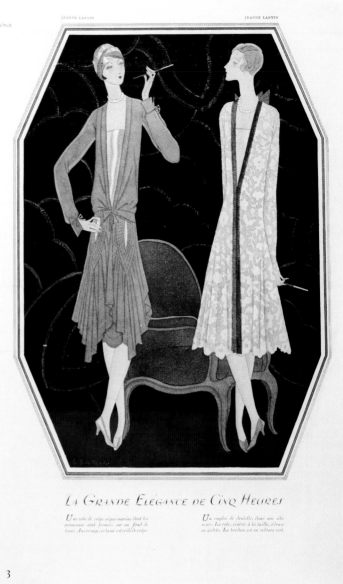

Previous page: Figure 1. William Orpen, *Mrs. Stephen C. Clark/Susan Vanderpoel Clark* (1921). Oil on canvas. The New York State Historical Association, Jane Forbes Clark Collection. **Above left: Figure 2.** "Palmiers." Blue silk taffeta *robe de style* with white chenille embroidery, winter 1922. **Figure 3:** "Le Grande Elegance de Cinq Heure." Jeanne Lanvin offered slender, feminine designs for the "modern" woman along with her full-skirted and very romantic *robes de style.* **Opposite page: Figure 4.** *Robe de style* of Mrs. Stephen C. Clark as it appeared in the Orpen portrait. Pink organdy bodice and overskirt with white organdy border. Embroidery and beading of white threadwork and milk-glass beads disguise the seam joining the organdy colors. The split center front skirt reveals the underskirt of silk taffeta in saturated teal blue, which is used again as the belt tied in front and back, 1921.

THE TYPICAL LIFE CYCLE of a Lanvin client was débutante, bride, and mother—yet all of these women were able to wear the *robe de style* silhouette. The silhouette was offered in every Lanvin collection, as it flattered every figure at every age and was appropriate for all occasions. The skirt widths varied from decade to decade, but the silhouette remained timeless.

Not all women could or would wear the revealing fashion-forward styles offered throughout the decades, but the *robe de style* offered a stylish alternative season after season. "The dress of the Winterhalter portraits charms us once more, and the crowning success of Lanvin is to have succeeded in creating a dress of this sort for the middle-aged women," *Vogue* from 1923 extolled. The successful formula consisted of a drop waist, scooped-neck or bateau neckline, cap sleeves or no sleeves, and full skirt that achieved maximum volume at the hips. The front and back of the skirt remained flat while the lightweight, "modern" version of an 18th-century *pannier* expanded the volume of the figure from side to side creating a quasi two-dimensional silhouette. The soft silhouette, romantic colors, and appropriate embellishment helped to blur the lines between generations.

1 *Vogue,* (1923), np.

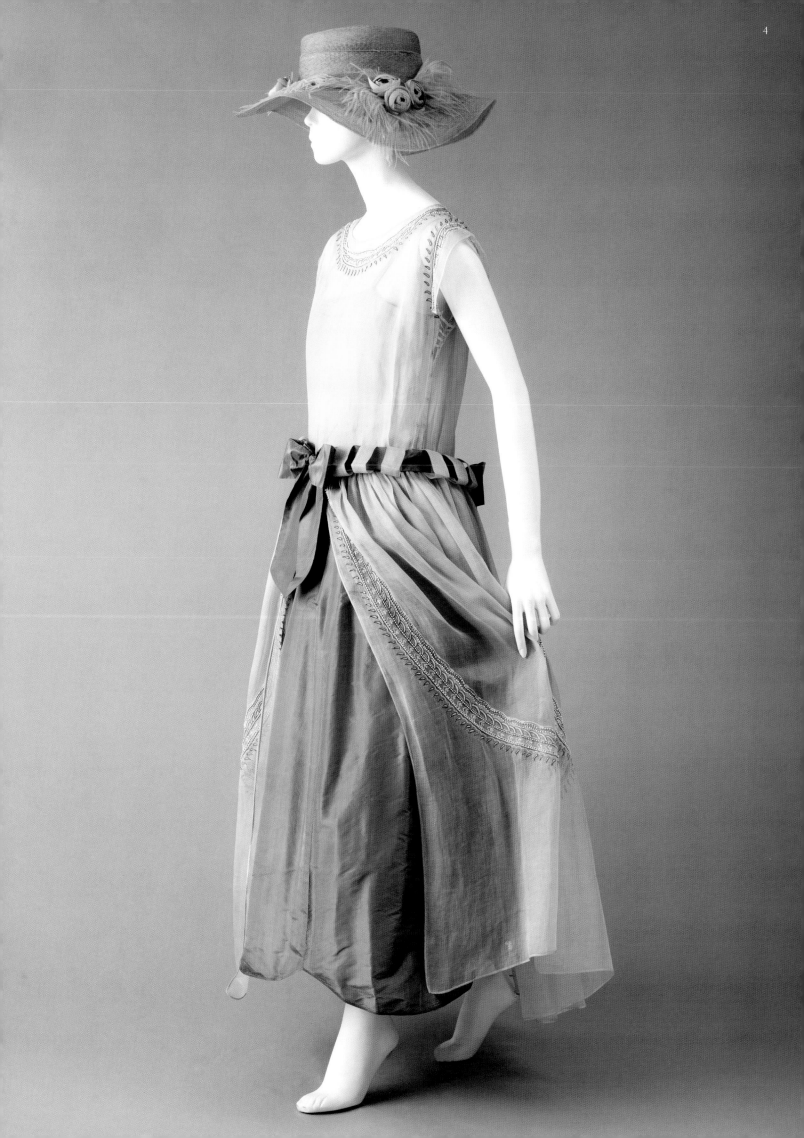

Figure 5: Mary Pickford was featured in a multi-page layout as a dedicated client of Lanvin in *The Ladies' Home Journal,* June 1921.

Figure 6: Client invoice for a Madame Marchand, dated "le 21 Octobre, 1919," but in fact the invoice commences from late November, 1918. Not only does the invoice list the model name, color, and fabric, it also contains the charges for alterations, cleaning, and reparation to beading and embroidery on previously purchased models.

Figure 7: Quintessential Lanvin clientele, mother and daughter, at the horse races in stylish Lanvin ensembles, 1930.

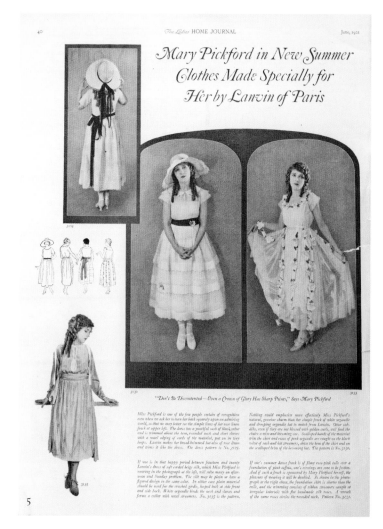

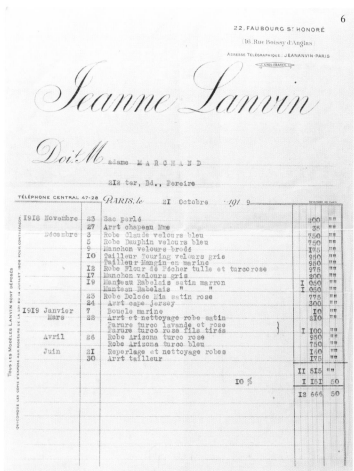

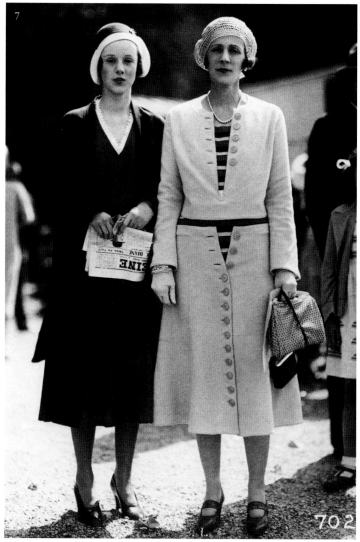

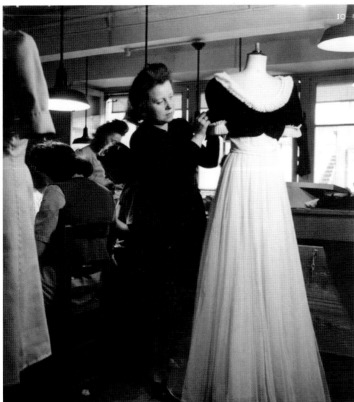

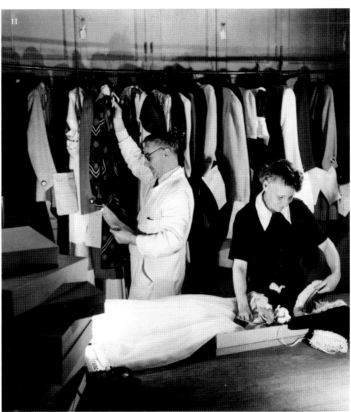

Figure 8: A Young lady enters the Lanvin boutique to attend a fashion show, 1937. Figure 9: While the models circulate the room, clients are free to handle the fabrics and inspect the designs. Figure 10: After the young client selects a dress, the seamstresses work to reproduce the model to the measurements of the client. Figure 11: After steaming and pressing, the dress is boxed and prepared for delivery.

COUTURE AND
THE EVOLUTION OF
THE ROBE DE STYLE

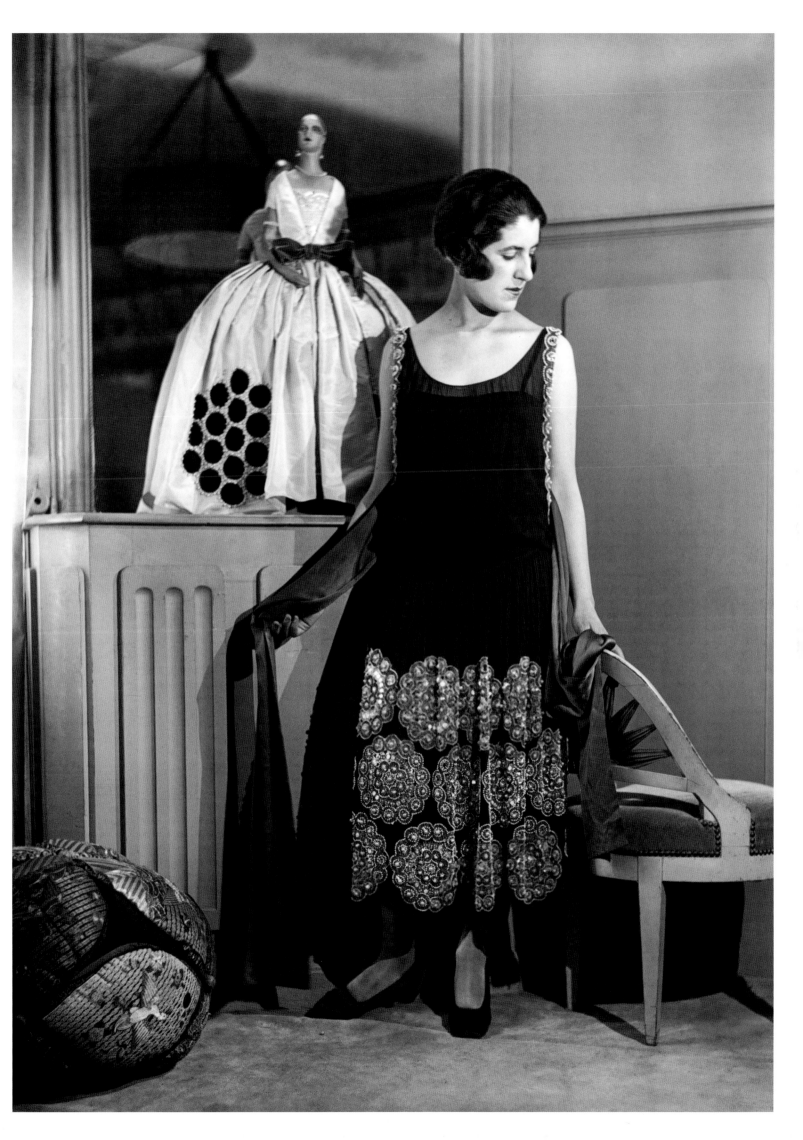

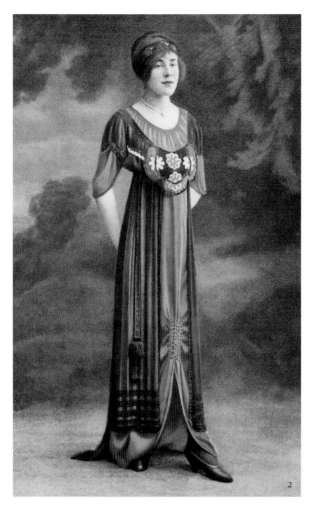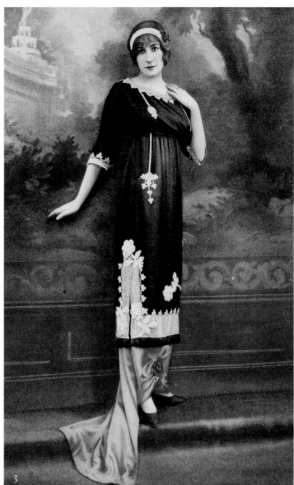

Previous page: **Figure 1.** Man Ray photo of a Lanvin model wearing an evening dress with beaded and embroidered roundels in a less-inflated silhouette like that of "Columbine" as seen on the plaster doll behind, 1924. Above: **Figure 2.** Evening dress, along the line of the chemise frock, "Libellule" or Dragonfly, of violette silk chiffon, cherry red beading with gold and white embroidery over a dress of emerald green silk. *Les Modes*, June 1912. **Figure 3:** Evening dress tunic-style of black silk charmeuse embroidered in white and beaded with clear bugle beads over a trailing skirt of chartreuse green satin. *Les Modes*, May 1912.

AT A TIME WHEN WOMEN were able to purchase creative and original millinery stylings for themselves and exquisite clothing for their children at maison Lanvin, some clients remained unsatisfied—they wanted feminine and original ensembles for themselves. Jeanne Lanvin first showed her chemise frock—a long, slender, empire-waist design—in 1909. Even though it was the debut collection of this venture, Madame Lanvin confidently presented dresses with a clean, feminine line accentuated with exquisite detail, such as beautifully wrought pleating outlining necklines and sleeves. Beading and embroidery, the trademark of Lanvin design, was ever-present and used to create belts anchored by tassels as well as fringe for the hemline of ankle-length skirts. (Fig. 4-5)

The decidedly feminine and striking Fauvist color combinations of the first collection included acidic chartreuse paired with rust as well as an orange and ochre combination. The very chic use of black and white, which would continue as a standard of Lanvin design, was also present in the first collection. The design, detail, and color of this initial collection

were not that of a shy and inexperienced mother hoping to make pretty little frocks for her friends. These were the designs of an artistic, confident, and fashionable business-woman whose passions were fueled by all things beautiful, not least of which was her own daughter.

By 1909, Lanvin had opened departments for millinery, children's wear, and women's wear. Meeting all of the requirements, Jeanne Lanvin became a full-fledged couturier joining the Syndicat de la Couture. Although there are several requirements to be met in order to join the Chambre Syndicale de la Haute Couture Parisienne today, the requirements to join the organization then were minimal. A potential member required sponsorship of two of their colleagues and to be voted in by the other members of the body.

The designs of Madame Lanvin had various readily identifiable characteristics including beading and embroidery, ethnographic inspiration, sublime combinations of texture and textiles, and, most of all, original use of color. Madame

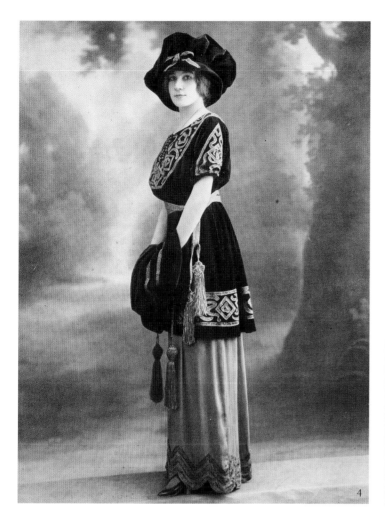

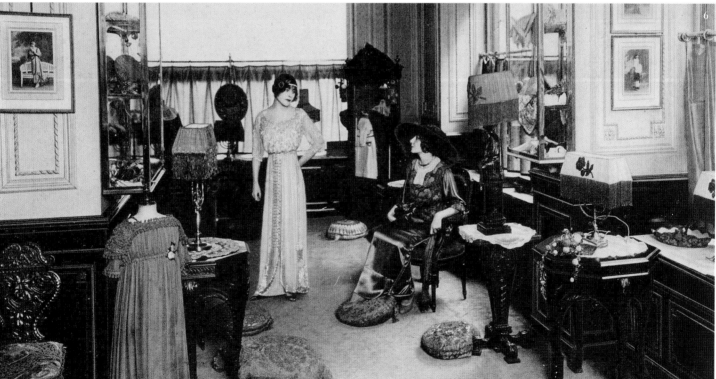

Figure 4: Afternoon dress of velvet *tunique* with old gold and green embroidery over a skirt of green *crepe de chine*, with matching belt and tassels. Black velvet beret with an embroidered bow of green and old gold as well as a black velvet muff lined in green silk once again embroidered in green and old gold. *Les Modes*, 1912. **Figure 5:** Blue beaded belt with double twisted cord. The head of the tassel is formed of beaded latticework revealing a rose-colored chiffon support. The center of the tassel head is cinched with green leaves and a small beaded bi-color rose. The tassel is complete with dense and lengthy fringe, circa 1912. **Figure 6:** Lanvin salon of 1912. Two years into a new business venture, the separate boutiques for dresses and millinery are well-appointed with photographs of the current and past collections on the wall, accessories in vitrines, children's dresses on mannequins, and ornately embellished footrest pillows on the floor. All aspects of the boutique have the Lanvin touch including the custom-made lampshades which have been beaded, embroidered, and fringed reflecting the aesthetic of the couturiere. Millinery offerings are perched on ornate hat stands like objet d'art.

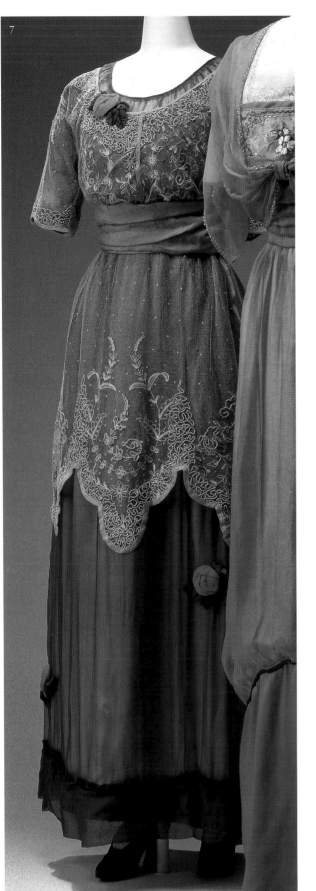

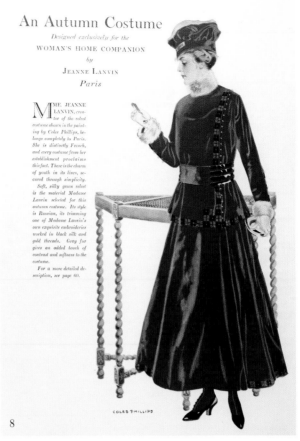

An Autumn Costume

Designed exclusively for the
WOMAN'S HOME COMPANION
by
JEANNE LANVIN
Paris

MME. JEANNE
LANVIN, crea-
tor of the velvet
costume shown in the paint-
ing by Coles Phillips, be-
longs completely to Paris.
She is distinctly French,
and every costume from her
establishment proclaims
this fact. There is the charm
of youth in its lines, se-
cured through simplicity.
Soft, silky green velvet
is the material Madame
Lanvin selected for this
autumn costume. Its style
is Russian, its trimming
one of Madame Lanvin's
own exquisite embroideries
worked in black silk and
gold threads. Gray fur
gives an added touch of
contrast and softness to the
costume.
For a more detailed de-
scription, see page 60.

COLES PHILLIPS

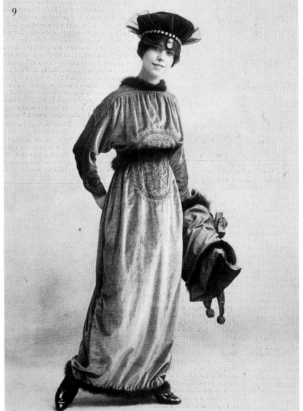

Figure 7: Evening dress of green silk chiffon with a re-embroidered tulle and lace tunic (left). Classic Lanvin roses and leaves are spotted on the skirt and again at the neckline. The waist is gently defined with a band of rose-colored silk. 1911. **Figure 8:** Fall costume of green velvet, embroidery of black silk and gold threads trimmed in gray fur collar and cuffs. Illustration by Coles Phillips from *Woman's Home Companion*, October 1915. **Figure 9:** Afternoon ensemble from 1913. Deep rich blue velvet dress with dolman sleeve embroidered in a cachemire-inspired pattern rendered in French knots of blue, magenta, and gold. Neckline, waistline, and hemline are trimmed with skunk fur. Blue velvet and black tulle hat embellished with small faux sapphire gemstones with coordinating muff complete the ensemble. **Opposite page: Figure 10.** Detail of Figure 7, original dress of Marguerite Marie-Blanche, devoid of skunk fur trimming.

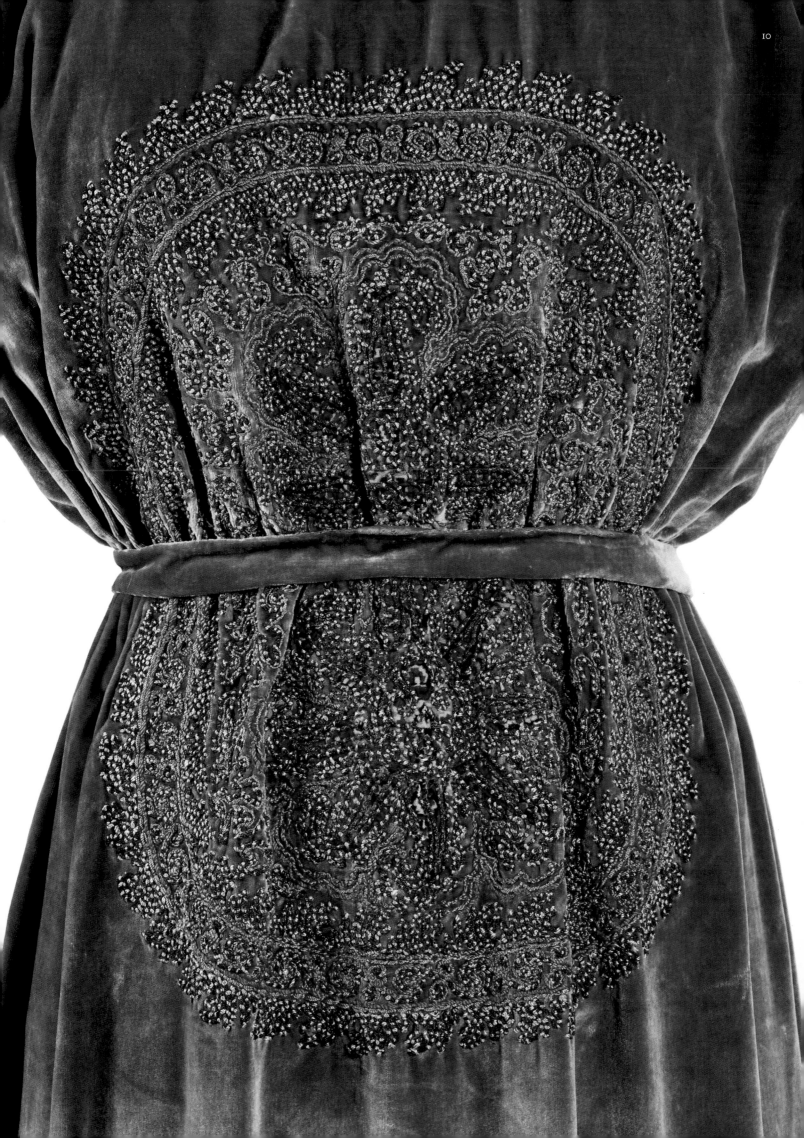

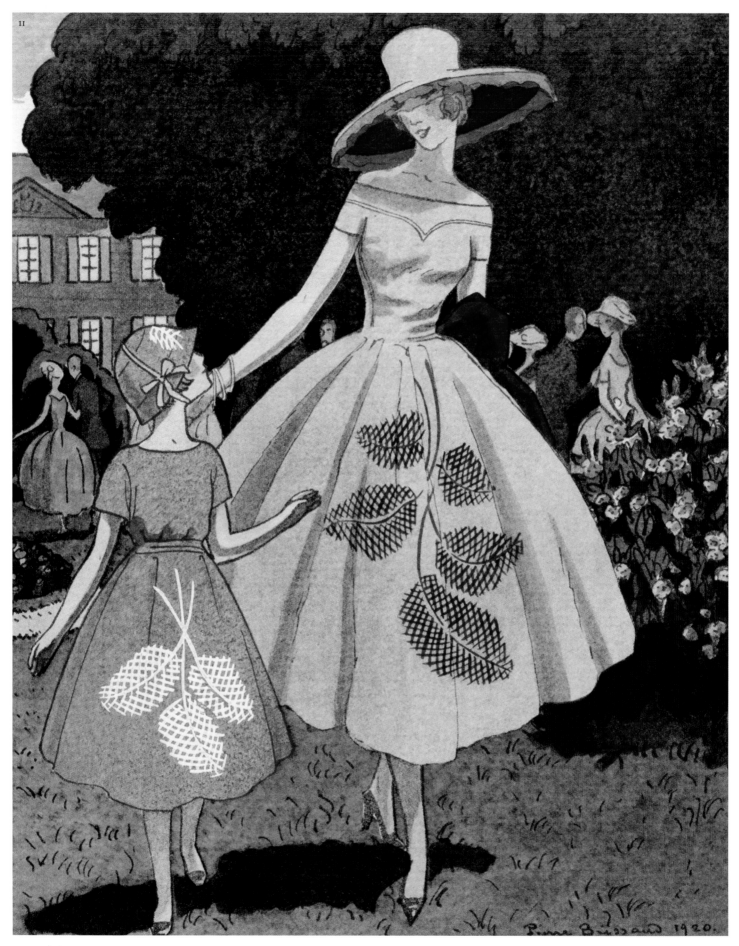

Figure 11: "La Fête est Finie" *pochoir* illustrating a pair of organdy *robes de style* for mother and daughter. From *Gazette du Bon Ton*, May 1920.
Opposite page: Figure 12. "Ils Ne M'ont Pas Reconnu" *pochoir* from *Gazette du Bon Ton*, 1921. **Figure 13:** Exotic bird motif in polychrome embroidery on Chantilly lace bouffant *robe de style*. Invitation to view the latest collection of Lanvin, executed in *pochoir* technique, circa 1910.
Following spread: Figure 14 & 15. *Robe de style* with silver lamé *fichu* collar secured at the waist with handmade rose detail. The silk tulle skirt with silver bugle-bead appliqué and detail is supported by a whalebone *pannier* visible only because the silver lamé underskirt has detached over time, Winter 1918.

Jeanne Lanvin

Lanvin was a strong proponent of color, though many times it was anchored with the use of black and/or white. Her signature *robe de style* silhouette—based on the full-skirted, wide-hipped silhouette of the 18th century—was developed and perfected season after season. "The *robe de style* is of the evening mode today, yesterday, and tomorrow—always picturesque and delightful."[1]

The *robe de style* was a charming, youthful, forgiving, and flattering silhouette offered continuously, from decade to decade, with variations of skirt width, length, proportion, fabrication, and detail. No matter what silhouette was dominant for the season, Lanvin featured variations of the *robe de style* for those loyal clients who were most comfortable in this classic look, be they débutantes, brides, or mothers.

Madame Lanvin took advantage of the full sweeping skirts, using them as blank canvases on which to render elaborate patterns and motifs in beading, embroidery, and appliqué techniques. Never would such a vast surface have gone unadorned as it would have contradicted the design sensibilities and aesthetic attributed to maison Lanvin. Successfully combining romanticism and historicism in the most modern way, she was able to achieve the full romantic silhouette of the 18th century without the cumbersome and restrictive weight, and complicated support structures.

Infanta silhouettes, Camargo frocks, Spanish hoop skirts, styles of the Second Empire, and of Louis Philippe, Louis XV, and Louis XVI, picture frocks, portrait dresses, garden dresses, and bouffant styles—whatever the name—these dresses were designed with a single purpose. Similar in silhouette and aesthetic, the intention of these calculated creations was to assist in blurring the line between generations as waistlines, hemlines, and necklines rose and fell from season to season. The *robe de style* was a saving grace for many fashionable women who were unable to wear trendy, figure-revealing silhouettes.

So called because it follows the exaggerated proportions of costumes worn by 17th-century Spanish princesses, the infanta silhouette is immortalized on the canvases of Diego Velázquez. Young infantas take on a two-dimensional appearance as their fitted bodices are overwhelmed by the widths of their skirts, which are dilated beyond that of their height. With vertical flat plains front and back, it is the exaggerated horizontal line that creates an overwhelming visual and physical volume. (Fig. 12)

The Camargo frock is named after the French/Belgian dancer Marie Anne de Cupis de Camargo (1710–1770), popularly known as La Camargo. At the age of ten she began dance training for the stage, later to be appointed as *première danseuse* in Brussels. Making her Paris debut on May 5, 1726, at the Paris Opera ballet, she was an instant success, the first

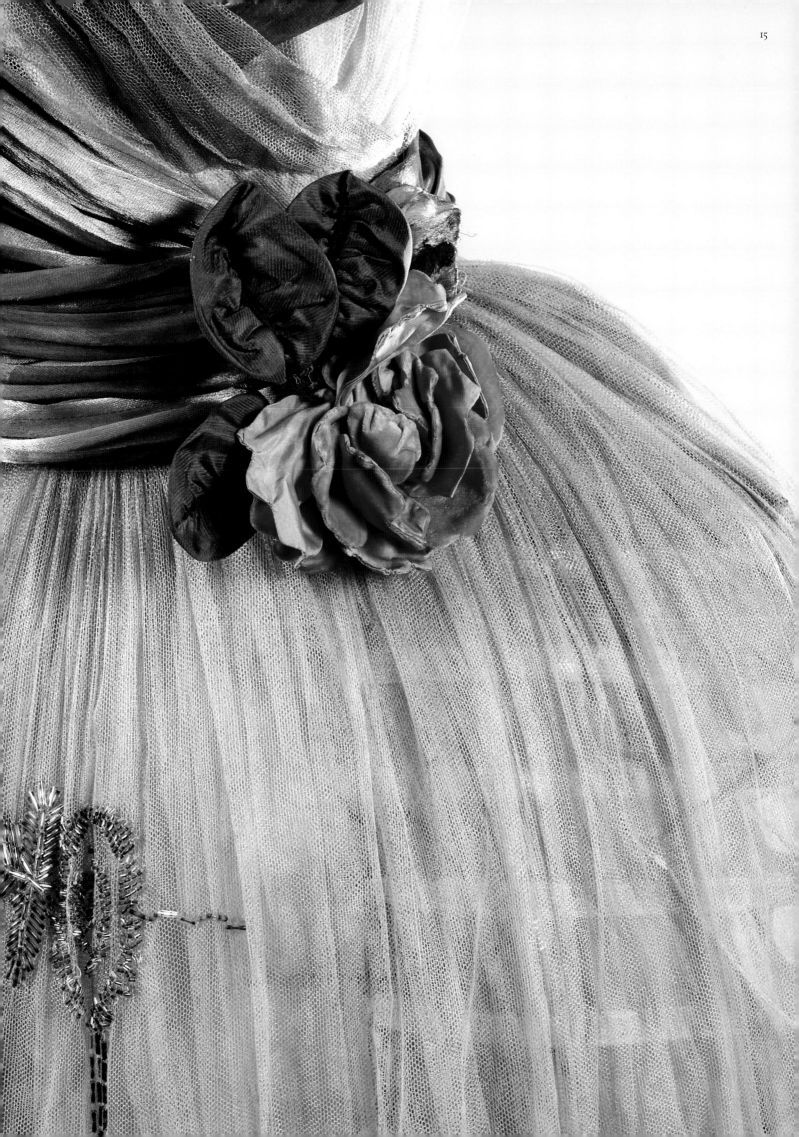

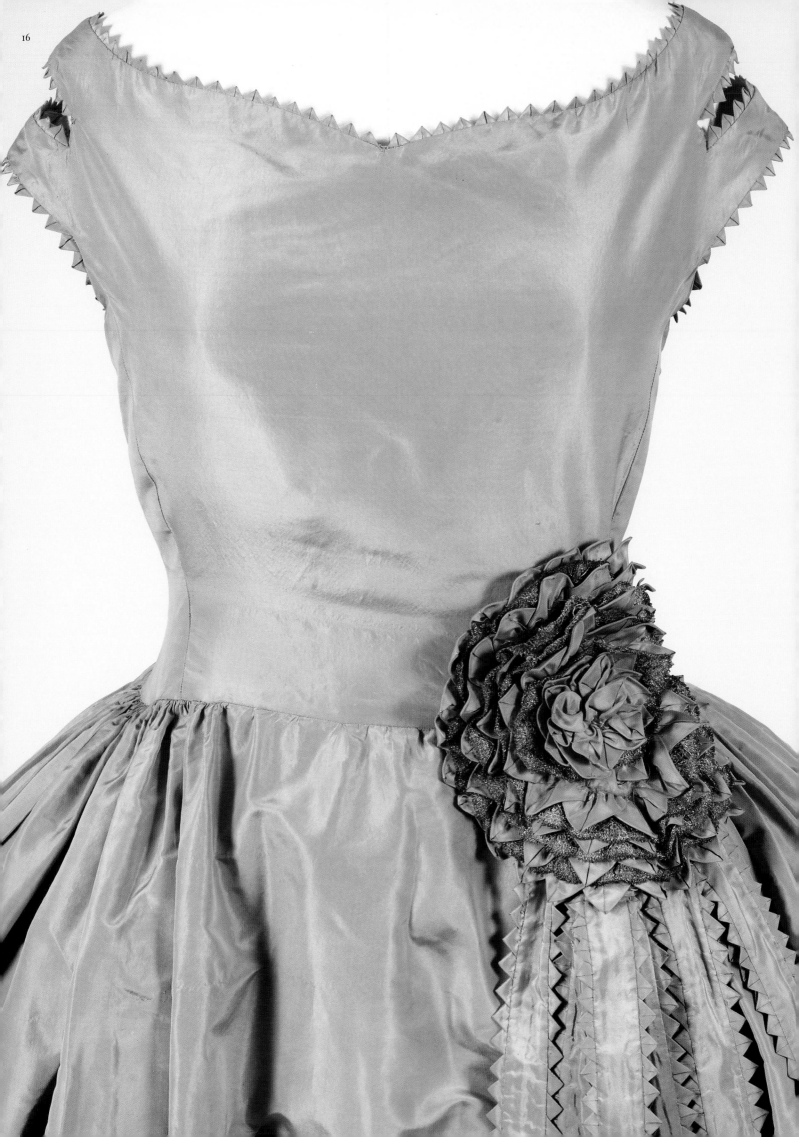

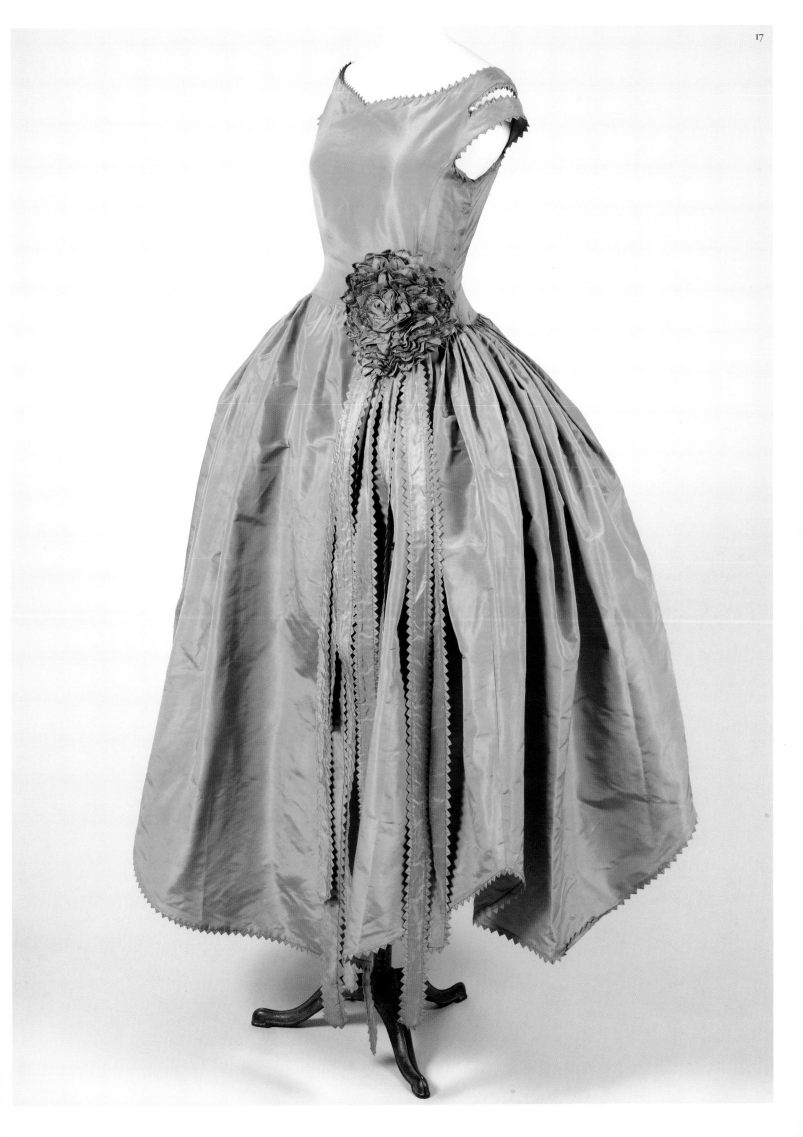

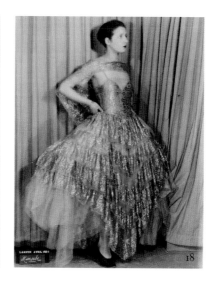

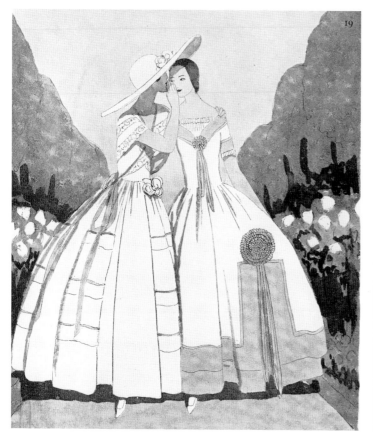

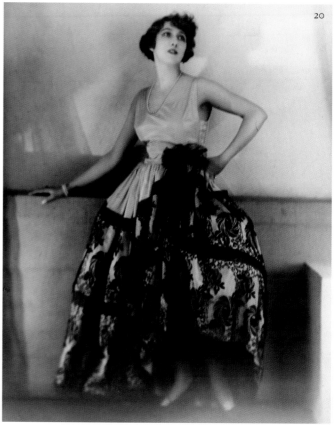

woman to execute the *entrechat quatre*. Labeled an innovator, she began to dance in slippers, not heeled shoes and, most important, she shortened her ballet skirt to what is now referred to as "regulation length." Her costumes heavily influenced the style of the times and every new fashion bore her name; hence, the Camargo frock. Female admirers also copied her hairstyles for court presentation. Nicolas Lancret painted a famous portrait of her that depicts a *pas de deux performance*; it exists in multiple versions, including one at the National Gallery of Art in Washington, DC. These paintings are in the popular 18th-century *fête-galante* style, in which subjects are painted in pastoral, romantic, fantastical settings that combine idyllic nature with the pretend world of the theatre. The admirers of Camargo herself were also patrons to Lancret. (Fig. 24)

The reference to Spanish hoop skirts is best illustrated by John Singer Sargent's *La Carmencita* (1890). Employing vibrant color, Sargent painted a very proud lady dressed in blazing golden color and gilded by surface embellishment–a deep scrolling border on the full skirt as well as the "Spanish" shawl and the beaded fringes that dangle. The waistline of the fitted bodice accommodates a massive quantity of gathered fabric that unfolds to reveal the full circular sweep of the ankle-length skirt. (Fig. 27)

The bouffant style was dominant just before the 1920s, when voluminous fashions were about to give way to the "modern" flapper silhouette and later the influence of the *garçonne* look. Frilly, feminine bouffant styles were physically voluminous but visually lightened with full skirts made of sheer

Preceding spread: Figure 16-17. Overall view and detail of "Marjolaine," the quintessential robe de style of Lanvin. Apple green silk *taffetas changeant* is used to create an off-the-shoulder drop-waist, full-skirted silhouette. The self-fabric *cocotte* detail outlines the neckline, shoulders, and armholes. This dress demonstrates form with a full panniered silhouette as well as youthful lines of the off-the-shoulder neckline, sleeveless, and dropped-waist working in harmony. The detail view shows the self-fabric corsage enhanced with the alternating use of silver lace scallops. Multiple full-length self-fabric streamers with double-sided *cocotte* trim are suspended from the corsage. The self-fabric detail is intricate in construction, yet visually subtle and simple. 1920.

Opposite page: Figure 18. "Minerve," an exaggerated infanta silhouette of metallic lace and sheer silk tulle creating an asymmetric pointed hemline, April 1928.

Figure 19: Garden dresses in the mode of 1850 with wide-brimmed picture hat. Rose organdy trimmed with white net and Lavender organdy trimmed with a band of navy blue organdy and cockade of navy blue ribbon. From *Vogue*, June 1, 1922.

Figure 20: Actress Marguerite Valmont in a beaded, embroidered, and appliquéed *robe de style* with asymmetric hemline, 1920-25.

Right: Figure 21. "Balsamine." *Robe de style* of ivory and black silk taffeta embroidered in black threadwork complete with black velvet appliqués and pink and black gathered velvet flowers applied in a swirling circular formation, 1924-25.

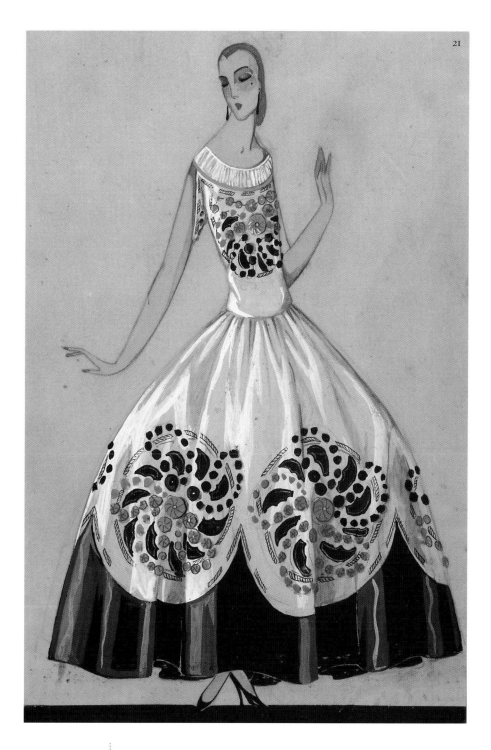

fabrics layered over slimmer, opaque underpinnings; this allowed for a sheer bodice and sleeve, if desired. Waistlines were raised, enhancing the youthful aspect of the style, and embellishments—ribbons, ruffles, cockades, beads, pearls, lace, bows, and streamers—were abundant. While the shortened tubular styles were popular during the 1920s, Madame Lanvin offered some of the most interesting versions, but only along with those designs following the *robe de style* lines.

To keep the *robe de style* interesting from season to season, changes were made in the overall silhouette as well as skirt length, proportions, necklines, and embellishments. "Lanvin's frocks are delightful, but then, who should fashion youthful clothes more charmingly, since she has drawn

many of her inspirations from her dainty children's clothes, with which she first established herself? Her skirts are longer than those shown by any other house. This means, then, that they will be worn by the debutante, and quite generally all of us."[2]

In the mid-1920s, options were abundant including double silhouettes of full three-quarter-length skirts shown layered over narrow full-length trailing skirts. Of course, necklines were shown plunging in the front and the back, "[...] and the bodice—Oh, it's going, going—gone." Skirts were lightened visually by the addition of sheer borders on the bottom. The opaque skirts were cut at a less than acceptable length, but to make up the difference, the length was added on in the form of a transparent fabric revealing more leg. (Fig. 22) These sheer

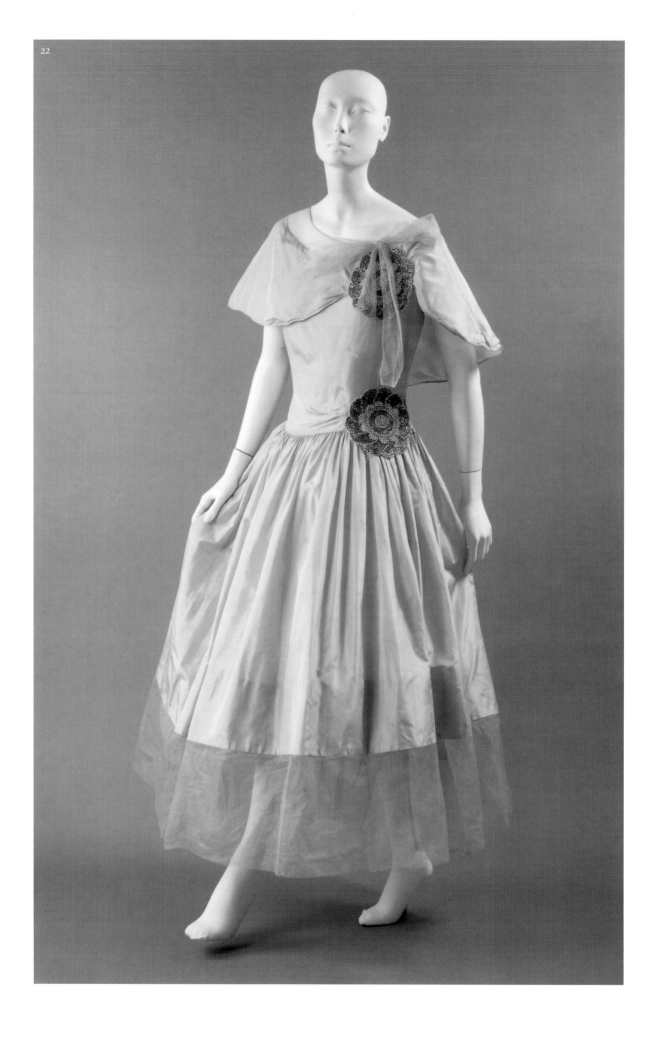

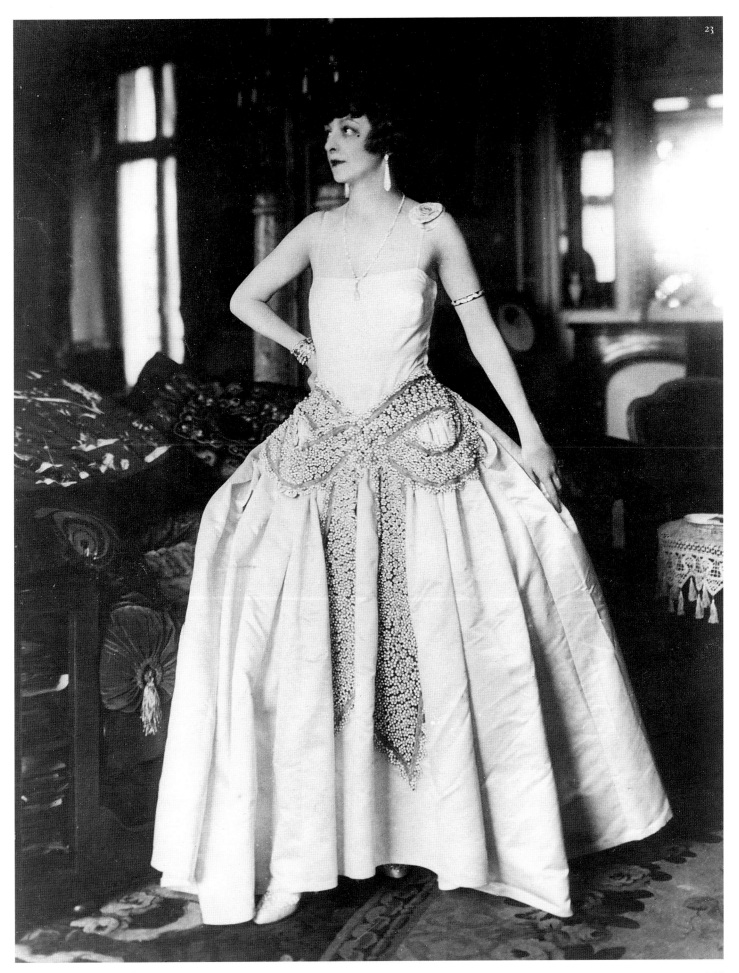

Opposite page: Figure 22. Ivory silk taffeta *robe de style* with deep bertha collar. Truncated skirt is lengthened by a seductive and youthful border of sheer silk tulle. Stylized flower appliqué of pearls, silver bugle beads, and rhinestones are located at left shoulder and hip, winter 1926-27. **Figure 23:** Actress Jane Renouardt in a *robe de style* prominently featuring a familial bow symbol encrusted in pearls and crystals. The grand theatrical quality of this dress readily translates to the stages on which she performed, which included the Théâtre Daunou. The dress hangs from two delicate shoulder straps with one featuring a singular Lanvin Art Deco rose of self-fabric, 1925.

Figure 24: Nicholas Lancret, *Mademoiselle Camargo Dancing* (after 1730). Oil on Canvas. The State Hermitage Museum, St. Petersburg.

Figure 25: Velvet flower appliqué detail of Figure 26, 1922.

Opposite page: Figure 26. Metallic lamé *robe de style* with built-in *pannier* structure. Silk tulle shoulder straps and hemline are bound in rose-colored velvet. Clusters of rose, lavender, and golden yellow velvet flowers are placed randomly on the skirt, and a larger corsage is placed on the bodice, 1922.

Following spread: Figure 27 John Singer Sargent, *La Carmencita* (1890). Oil on Canvas, Musée d'Orsay.

Figure 28. *Robe de style* of black silk *faille* embroidered with pearls and crystals. Hemline of skirt is embroidered with bands of gold metallic threads and mirrored circles. The exaggerated *panniers* of 17th-century Spanish infanta are attached to the underside of the skirt, circa 1920.

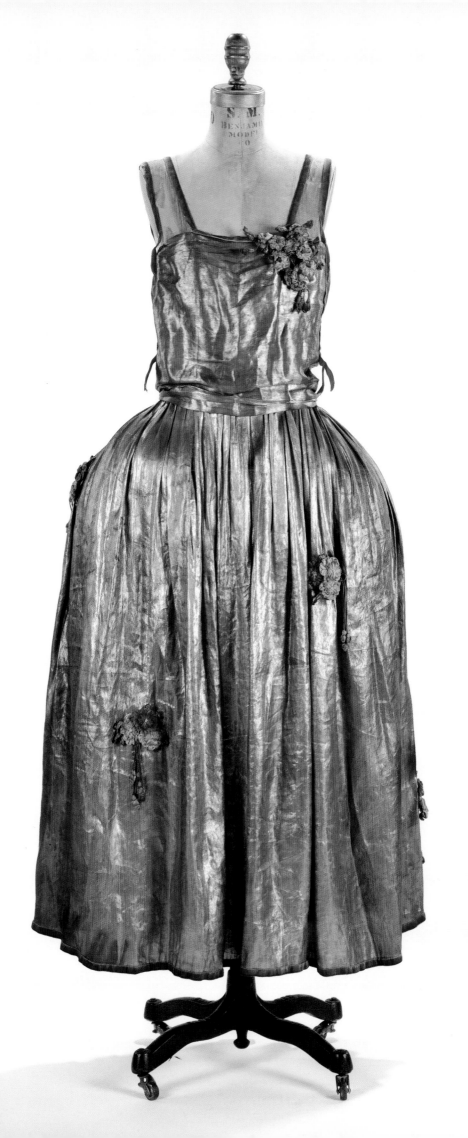

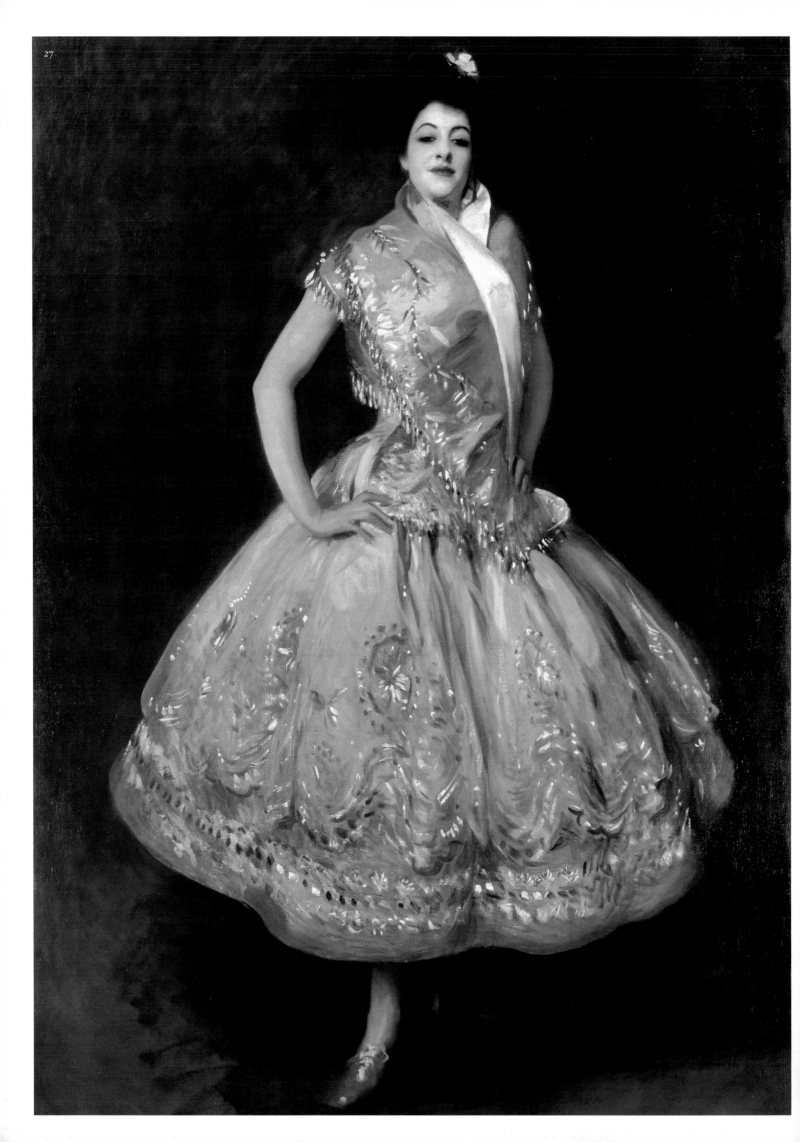

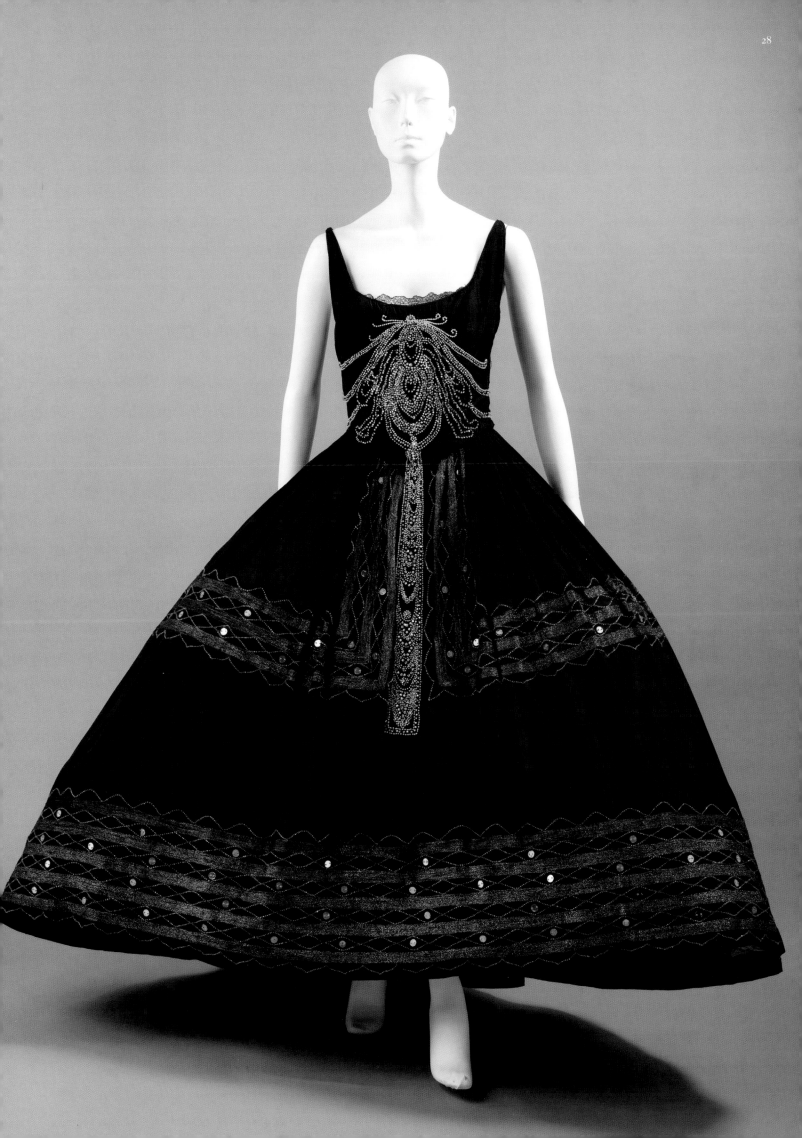

Opposite page: Figure 29. Youthful organdy *robe de style* of lavender with white scalloped border—the self-fabric flower detail and ribbon streamers are at center front. Around 1924.

Figure 30-31: Overall view of "Manon," a *robe de style* of the Camargo style featuring a black embroidered belt with lappets, 1915. The detail is of an antique Chinese embroidered tab that Mme. Lanvin used to inspire the embroidery and belt of "Manon."

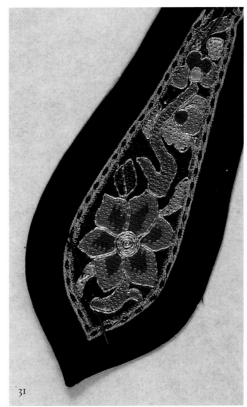

borders were created from tulle, lace, chiffon, organza, and organdy, one of Madame Lanvin's favorite offerings. For some styles, opaque skirts were split at center front to reveal a shorter opaque underskirt.

A 1925 edition of *Vogue* featured a *robe de style* with skirts much shorter than the standard length of three inches above the shoe. With this dress, its opaque underpinning ends just below the knee and the sheer embroidered organdy overskirt ends several inches below that at approximately midcalf. The deep, scalloped hemline and transparent fabrication enhances a feeling of movement while contributing to the seductive effect of the new shorter skirt.

The picture dress enjoyed great success. It was re-invented and updated, and remained highly fashionable and appropriate for a myriad of occasions. The most modern version of a picture dress appeared in 1926 as a two-piece ensemble. (Fig. 34) "This unusual afternoon dress with the feeling of a picture dress has a long and bouffant overblouse of black taffeta embroidered with silver disks, worn over a light green wool skirt. Such a dress is very charming for an occasion with a certain formality, a hint of grandeur, but would be a trifle ostentatious and 'arty' for the teas of every-day."[3]

These romantic dresses proved to be a tried-and-true staple of maison Lanvin, and variations were created from season to season. Many other couturieres began to offer this silhouette as well, including Worth, Poiret, Boué Soeurs, and Callot

Soeurs, but none experienced greater success with it than Jeanne Lanvin. "The picture dress can be the most perfect response that chic is able to make. Of course, a great many so-called picture dresses only babble. They say inane things. Some of them even talk baby talk. Properly, they are not sweetly picturesque, soulfully romantic, or intellectually arty. When casting about for a successful one, three things are to be remembered. A picture dress is distinctive rather than picturesque. It is only very slightly romantic. And in no sense a costume."[4]

In the late 1930s, the *robe de style* came full circle; it arrived at its place of origin reaching maximum width at the hip, using many yards of fabric, and with floor-length skirts. These were the last vestiges of the dresses, since fabric restrictions during and after World War II prohibited the use of excess textile yardage. By the time luxury textiles were available in vast quantities, women no longer subscribed to these voluminous and romantic styles. New clients were satisfied to wear the simple and elegant columnar evening dresses with embellished dinner jackets. And of course, Madame Lanvin excelled in the realm of embellishment as well.

1 *Vogue*, (November 1, 1924), 39.
2 *Vogue*, (October 15, 1922), np.
3 *Vogue*, (December 1, 1926), 72.
4 *Vogue*, (December 1, 1926), 72.

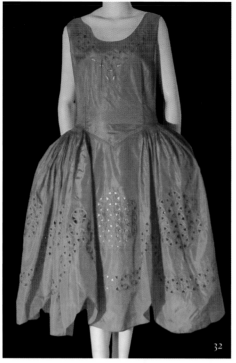

Figure 32: "Marquise" *robe de style* of cyclamen colored silk taffeta with built-in *pannier* structure. Medallions–formed by open-worked compositions derived from Japanese *mon*–encircle the skirt as well as forming a linear border just above the hemline. Because the mon structure is created with voids, the metallic gold lamé underdress shows through revealing a hint of glimmer where beading used to be employed for the same effect. from around 1925.

Figure 33: Detail of "Marquise" skirt detail.

Figure 34: The *robe de style* reaches the pinnacle of modernity created as a two-piece ensemble, 1926.

Figure 35 & 36: Fall/Winter 1926 black silk taffeta dress with embroidery of prong-set crystal, silver-lined bugle beads, silver, rocaille, and pearls forming a repetitive abstract pattern of a peacock feather as it overlaps in graduating size down the front of the skirt.

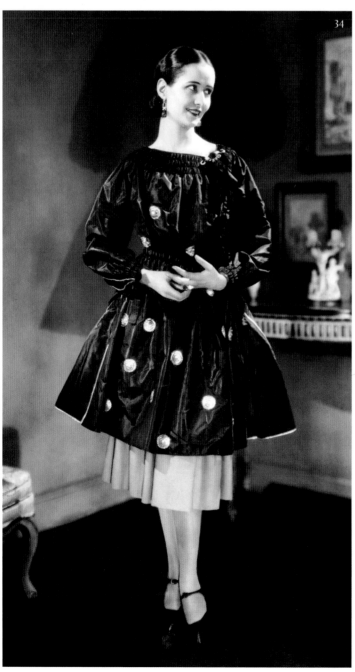

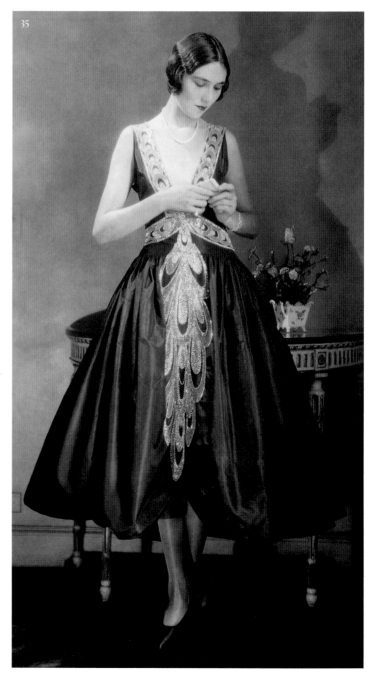

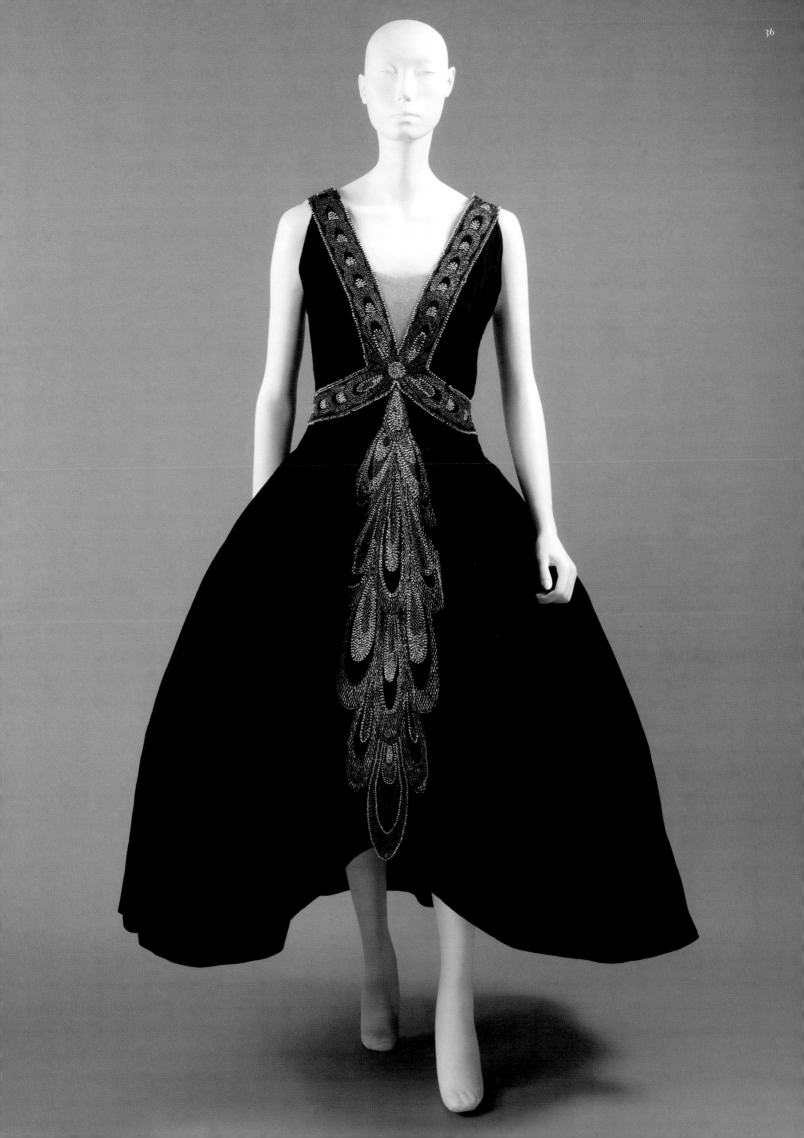

Jeanne Lanvin

37

38

CYCLONE

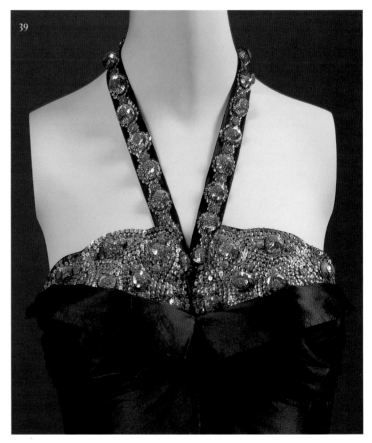

39

Figure 37: A Lanvin advertisement reinterprets the original mother/daughter trademark of maison Lanvin. Updated in Art Deco style, with the mother wearing a similar robe de style as seen in Figure 41, the young girl is in a pink, full-skirted dress with scalloped trim, 1926.

Figure 38 & 40: "Cyclone" from 1939, a two-tiered, full-skirted, smoke-gray silk taffeta evening gown with 18th century-inspired belted purse. Bust, neck strap, and purse are embroidered in silver sequins and seed beads as well as coral-colored daisy shapes. This dress was worn by Marie-Blanche, Countess Jean de Polignac, then donated in 1946, the year Madame Lanvin died.

Figure 39: Beading detail of "Cyclone," 1939.

Following spread: Figure 41. Black silk taffeta *robe de style* with black silk tulle yoke. Bertha collar with scalloped edge is embroidered in crystals and pearls, 1926.

Figure 42. During a visit to New York City in May 1926, Marie-Blanche sat for this Edward Steichen portrait in an off-the-shoulder robe de style with scalloped hem and self-fabric trim.

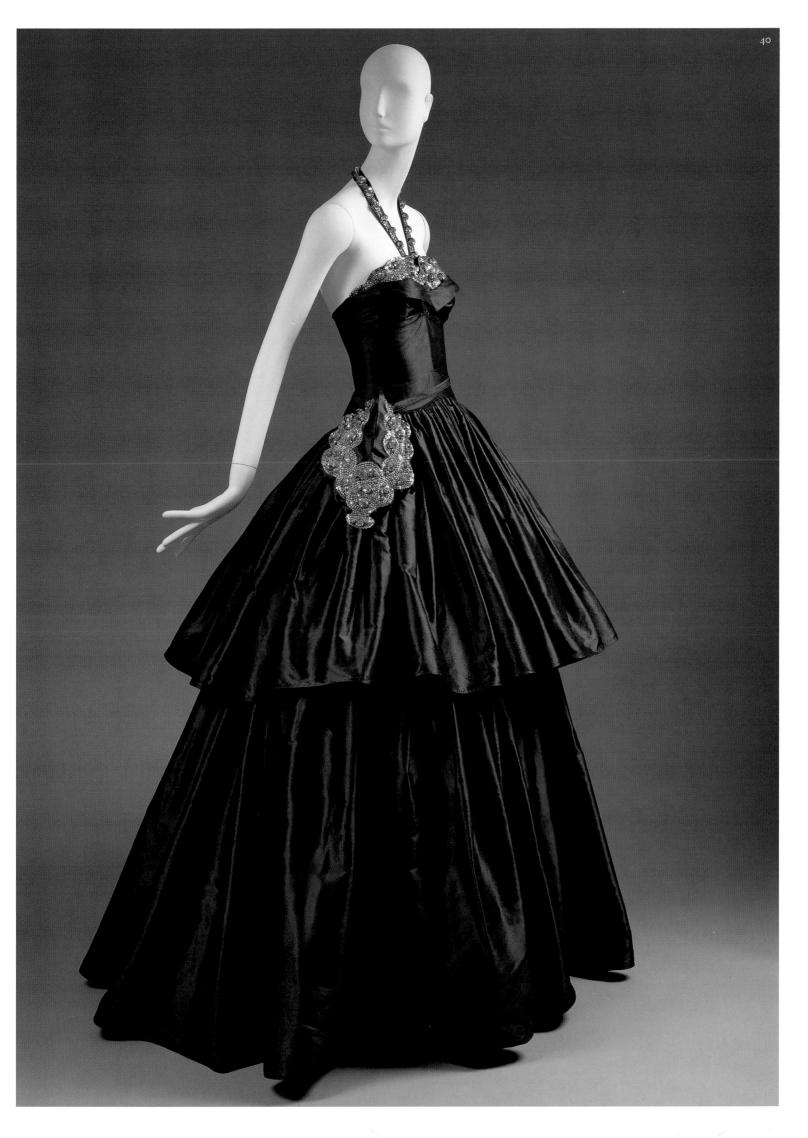

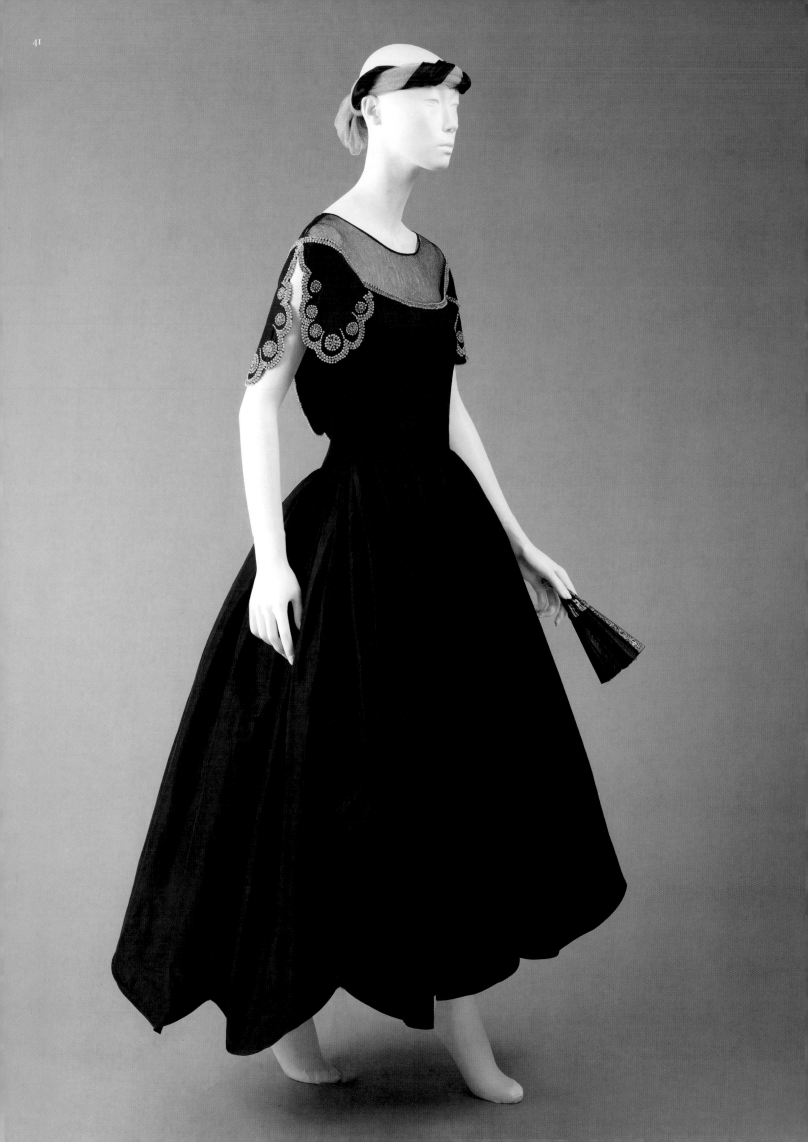

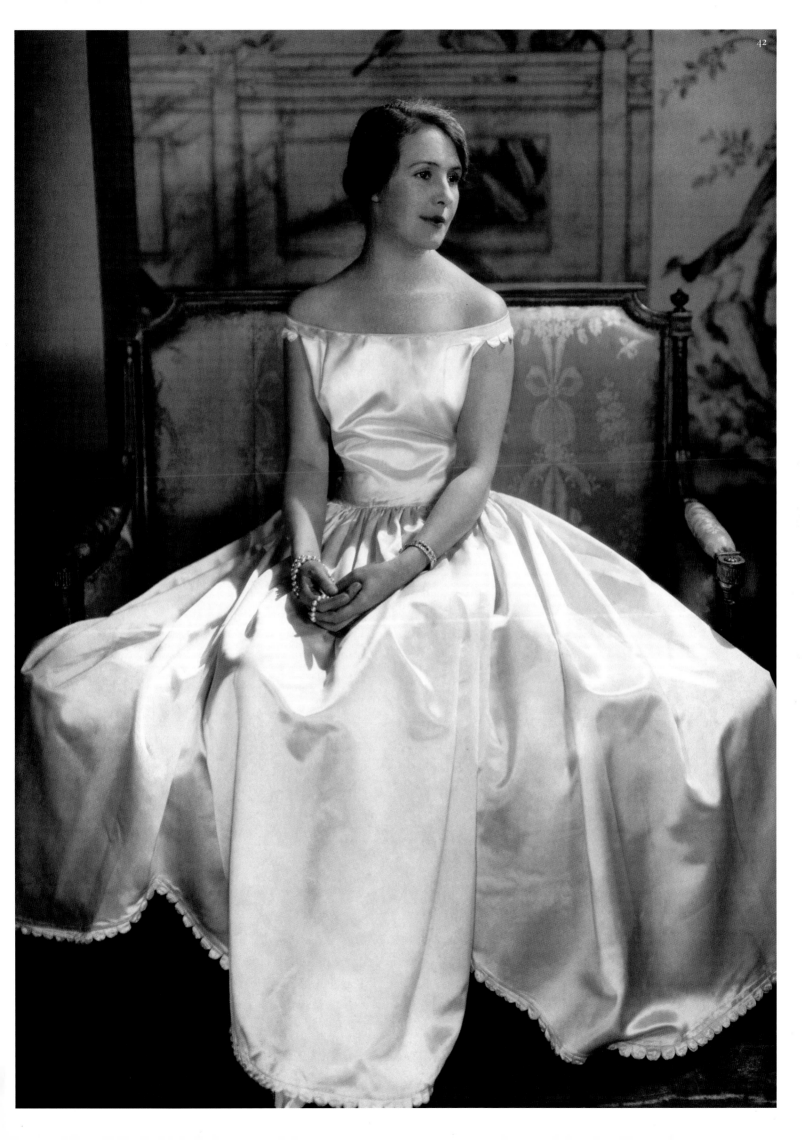

DÉBUTANTE

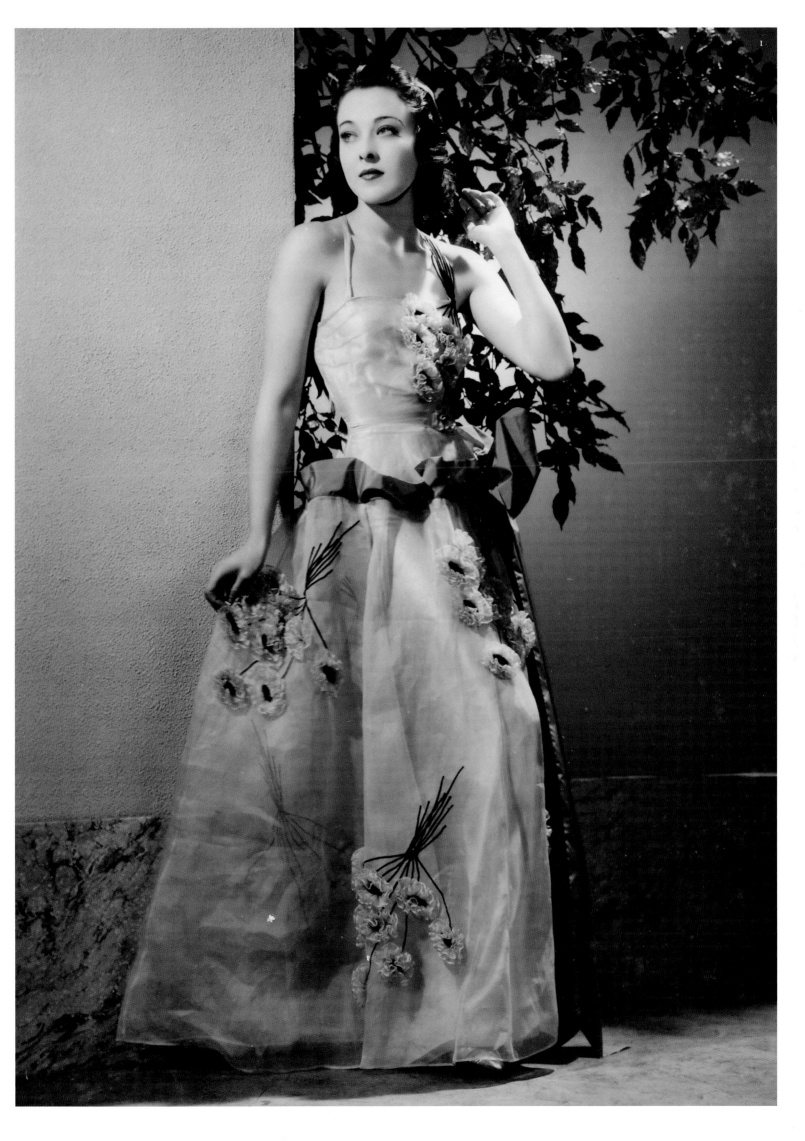

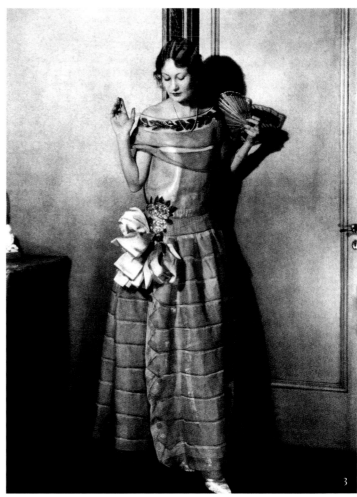

"WHO ARE THESE all-powerful beings? What is a débutante? Why is she?"[1]

Débutante is the French word for "female beginner," a young lady of age to be presented to society as a symbol of eligibility. The appropriate age varied depending on the period—in the 18th and 19th centuries, matches were arranged for young ladies as early as adolescence. As time progressed, so too did the appropriate age for making a debut and marriage. Jeanne Lanvin was a rare example of an independent spirit; in 1895, at the age of twenty-eight, she married for the first time.

Coming out signifies the official introduction of a young lady into society. This introduction may be through the preferred balls, luncheons, thé dansant, or formal dinners. It is most common to be presented on multiple occasions by various people, parents, grandparents, aunts, or married sisters. Because débutantes are young ladies, the costume in which they are presented should reflect their youth and femininity. Simple dress is recommended.[2]

Even within the first two decades of the twentieth century, young girls were getting married in their teenage years. And as higher education became more accessible, women sought their independence and equal rights. Marriage became less of a priority, but for many women it still meant security, stability, and respectability. Marguerite Marie-Blanche married for the first time in 1917 at the age of twenty.

In the early twentieth century, pre-début activities were limited to dancing school, summers in the country, and informal chaperoned parties, as girls stayed safe and secure living with their parents until marriage. Today young ladies are introduced to social life at a much earlier age and are formally presented to society without pretense. Whereas the most traditional débutante ensemble was the formal white gown, the youthful, independent spirit of the new débutantes, and their desire for individualism, permitted them to choose the style, fabric, and color that best suited them.

Surely, the young girl is dressed in the best of taste when, as the French woman described, she looks 'so inconspicuous that she does not force you to look at her, but so lovely that you can not look away.[3]

The May 1923 issue of Vogue presented a youthful light blue organdy and white tulle composition over a silver lamé slip. It was enhanced with an "1830" neckline embroidered with rose, blue, white, and green beads in a border of a laurel leaf

motif. A two-dimensional bouquet of flowers, embroidered with the same beads, is applied on the right hip and tied up with looping ribbons of light rose *faille*, "to the melody of eventide and youth." (Fig. 3)

As in many beading and embroidery designs employed by maison Lanvin, symbolism is contained in almost every composition. Like all plants that remain green during the winter months, laurel leaves are a symbol of immortality, perhaps the desire for perpetual youth.

The "robe de style" is ever the mode of the débutante—wide-skirted, picturesque, and infinitely youthful—and no débutante's wardrobe is complete without one from Lanvin, the leader of the cult of the picture gown.[4]

In November 1923, Vogue offered a Lanvin débutante design of brilliant rose satin. A youthful cape sleeve and open neck-line are edged with feminine pearl embroidery. The same embroidery was used to create the ornament on the center front of the skirt, which was edged in skunk fur and enhanced with streamers of silver lamé.

Women's periodicals of the day annually featured recommendations for the seasons' débutantes advising them on the selection of dress, shoes, and accessories. Year after year, the best advice was often reductive: "Simplicity, the débutante's most effective weapon... No evidence of bad taste is quite so glaring as a fresh-cheeked, golden-haired débutante dressed or rather over-dressed, in heavy metal laces or velvets, entirely unsuited to the youthful lines of her figure."[5]

A bouffant dress of pink silk taffeta, from the summer 1927 collection, rests on an oval boned petticoat, a firm nod to the historical influence of the style. It is demure and youthful, sleeveless and with an open neckline. The asymmetric, tiered skirt is embellished with a large self-fabric flower made up of individual wired petals. Two long, blue silk taffeta streamers originate from the center of the flower and hang asymmetrically. Overall, it is the perfect image of simplicity, youth, and innocence—the ideal combination for a débutante, the intended client for this dress. The dress was worn by Grace T. Layman for her 1927 debut; her sister, who was also making her debut, wore the same dress only with the two color positions reversed. (Fig. 6)

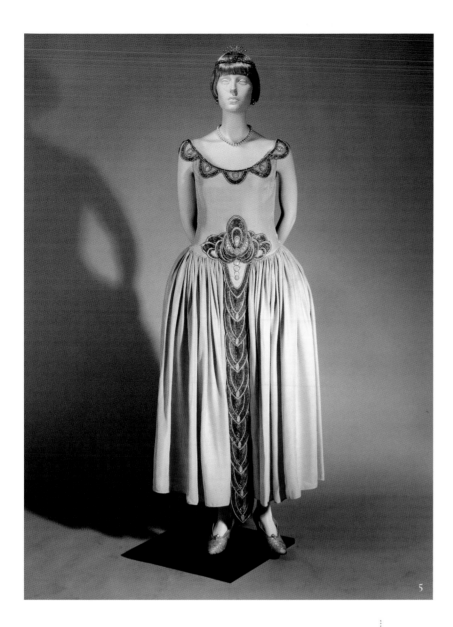

Some interesting and quintessential Lanvin details of this dress include a long-waisted bodice minimally enhanced by a crescent cutout above the bustline; it is filled in with the most delicate pink silk tulle. The same tulle-insert technique, one of many feminine details employed within the successful Lanvin lingerie atelier, is applied to create an illusion of a four-tiered skirt. In reality, the first and second tier are only one piece of fabric sliced by the finest insert of silk tulle, creating the trompe l'œil effect of two separate tiers. There is no formal explanation for this particular skirt detail. But because the assembly of the skirt is handled in this ingenious manner, it avoids additional bulk around the stomach and hips from the layering of the second—and necessary—tier that keeps all of the proportions in balance.

Simplicity is still the key-note of their costumes, but it is the simplicity of Lanvin, Vionnet, or Drecoll, which depends on its perfection of line and exquisite workmanship for effect and is far more costly than many elaborate models.[6]

As it was with most couture houses, client preferences held absolute sway. Necklines, sleeve treatments, color and fabric selection and other elements of design were always subject to the whim of individual clients. A similar version of this dress with some changes in detail appeared in the May 1927 issue of Vogue. The bodice featured a "sweetheart-style" neckline in taffeta maintained with a sheer upper-portion of the bodice, again sleeveless and with an open neckline. The absinthe-green taffeta model is asymmetric in style, like the pink version, but utilized a "soft veil of green tucked net," visually lightening the wide-tiered skirt while revealing a little more leg and stylish evening shoes. The large green taffeta flower revealed rose-colored petals in the center that gave way to streamers of the same rose color.

As débutante tradition changed and evolved, so too did the young ladies and their fashions. Vogue of August 1933 offered contemporary débutante a modern alternative to the *robe de style*. (Fig. 9)

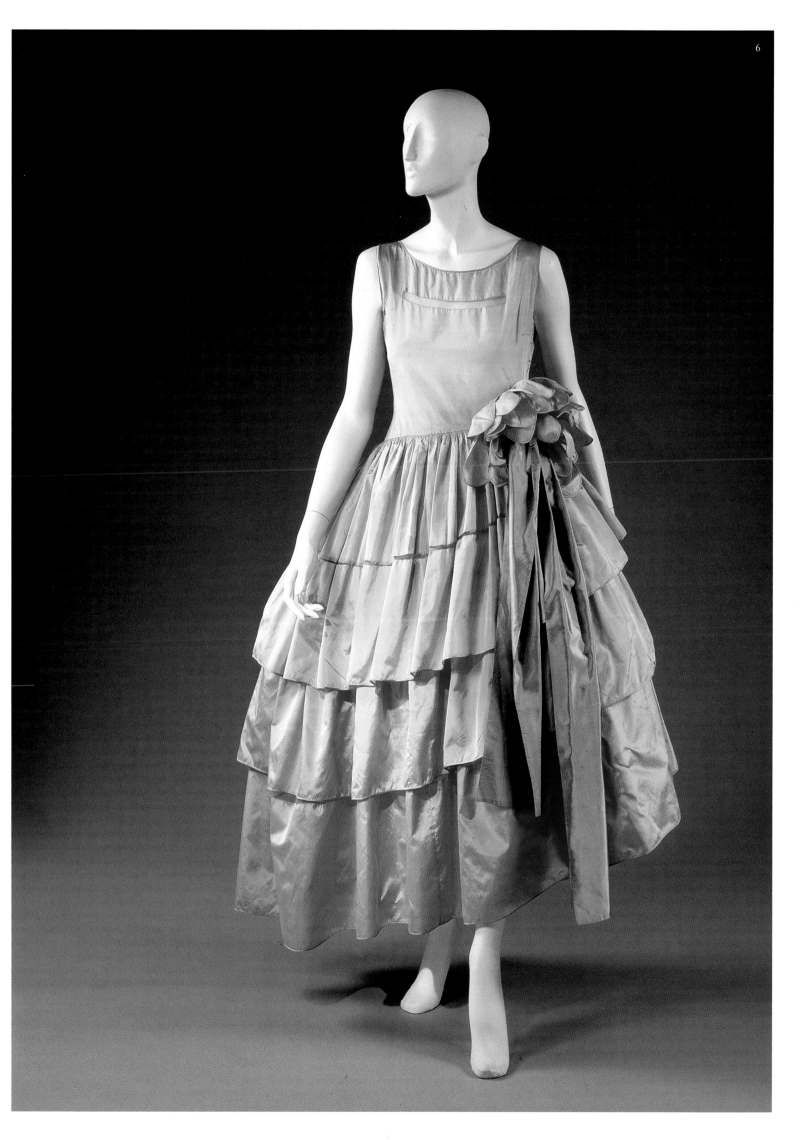

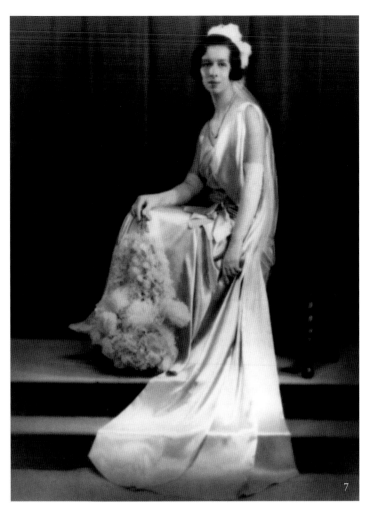

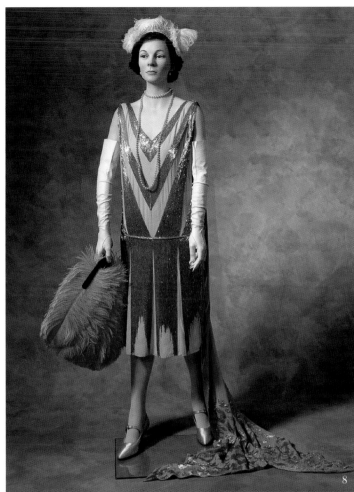

Do you remember those black taffeta robes de style that Lanvin made, not so many years ago, and all the smart world wore? Here is a 1933 version—so new and striking that it is certain to have as great success as its predecessors. Again, Madame Lanvin is the designer, and she calls it 'La Duse.' It is a dress a débutante could swish around in, and it is trimmed with a puffed ruffle set diagonally on the full skirt, at the top of an even fuller ruffle. Enormous wire loops bob out from the shoulders at each side like great artificial flowers.[7]

Presentation at Royal Court was another occasion in which young ladies were presented to society in the most formal manner. These events were a very important part of the social calendar and attendance was vital for the social and political elite. The regulations for presentation dress varied over the centuries, but typically the débutante wore white or ivory, a Prince of Wales ostrich-feather headdress of three white plumes, long, white kid gloves, and court train. These distinctive elements of court dress remained as late as 1939. (Fig. 5, 7 & 8)

While British Court tradition weathered the difficult years of World War I, the 1920s brought changes in ladies' Court dress. Elaborately embellished and lengthy trains were reduced in length and grandeur, and skirts were shortened succumbing to the style of the twenties. The last occasion for presentation in splendid attire was in 1939, the final Evening Court.

After World War II, Court occasion changed markedly and the distinctive Court dress was no longer required. Court presentation changed from a grand evening event to a daytime engagement with little prestige; it became increasingly insignificant until Elizabeth II abolished the court presentation ceremony of any women, including débutantes, in 1958.

1 *Vogue.* (July 1930), np.
2 *Vogue.* (October 15, 1922), np.
3 Ibid.
4 Ibid.
5 Ibid.
6 *Vogue.* (May 15, 1922), np.
7 *Vogue,* (August 1, 1933), np.

Opposite page: Figure 7. Susan Morse Hilles in court presentation gown, 1931. Two-piece (dress and detachable train) silk satin ensemble in classic 1930s silhouette, featuring the required three-plumed Prince of Wales headdress, long white kid gloves, as well as an ostrich plume fan.

Figure 8: Light pink court presentation gown worn by a sponsor of a débutante. Simple silver-lined bugle beaded chevron pattern echoes the V-neckline of the sleeveless drop-waist dress, which is shortened and tubular reflecting the latest mode. The ensemble is complete with a coordinating train (not Lanvin), tiara with Prince of Wales plumes, and pink ostrich plume fan, circa 1925.

Left: Figure 9. A modern alternative to the traditional robe de style—black silk taffeta "La Duse," *Vogue*, August 1933.

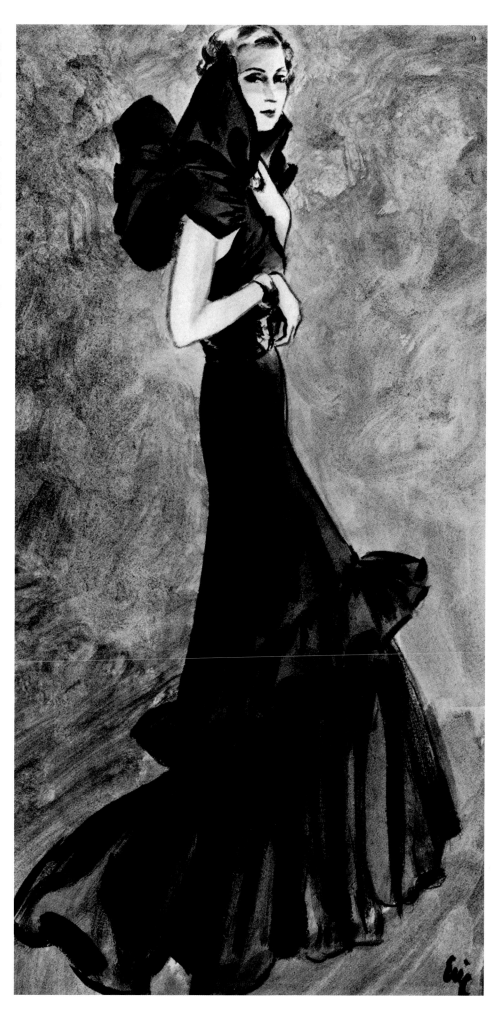

BRIDE

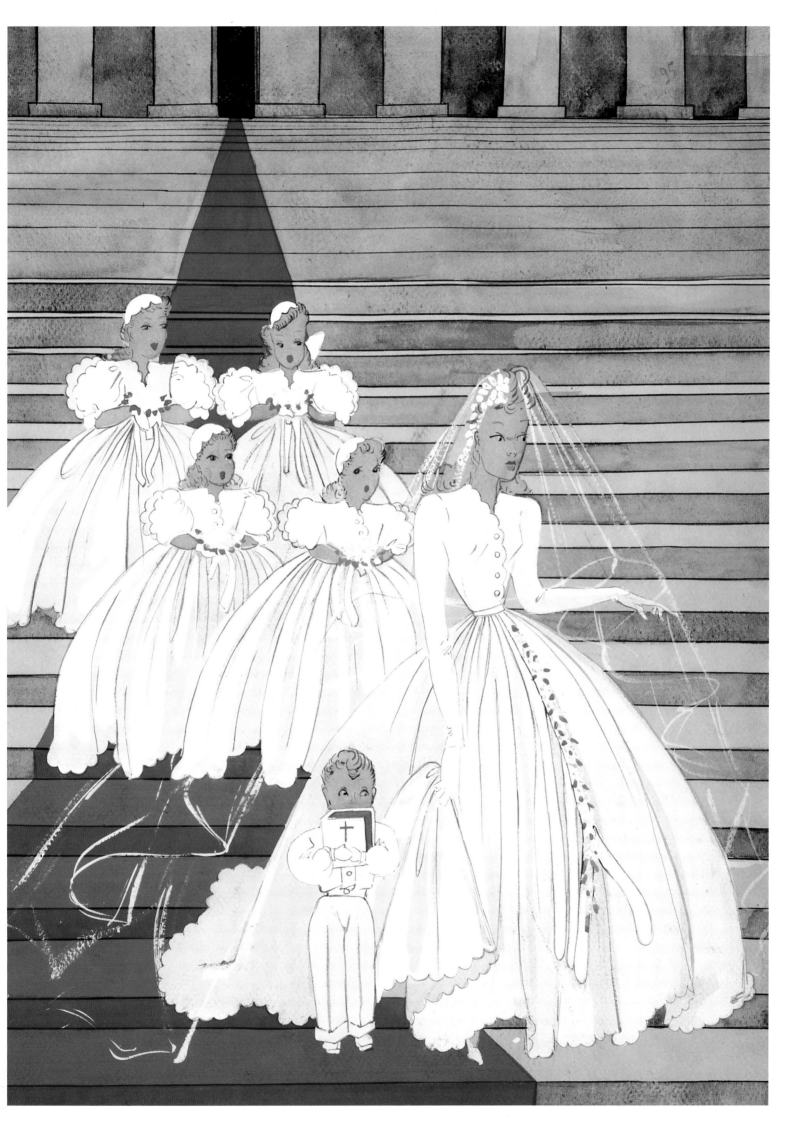

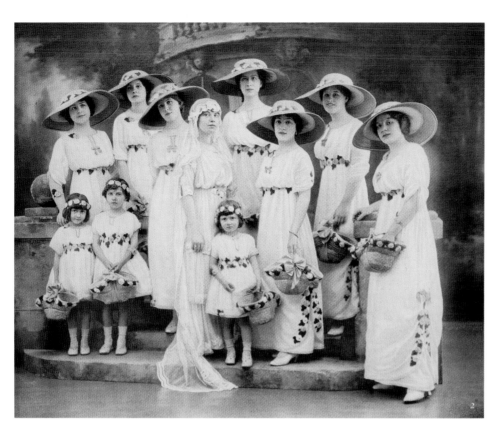

Previous page: Figure 1. Illustration of bride descending the staircase with her young attendants. 1944.

Figure 2: As seen in the July 1912 issue of *Les Modes*, a marriage for the house of Lanvin as the bride, married into the Lanvin family and two of the Lanvin nieces, Camille and Marianne, stand as attendants. This bridal party was the inspiration for the *pochoir* in Fig. 3. The dresses of the bridal party were described as white chiffon over a white skirt with garlands and leaves of green chiffon attached by roses of cherry red taffeta and pink chiffon.

Opposite page: Figure 3. Lanvin *carte d'invitation* for a 1912 fashion presentation executed in *pochoir* technique featuring a bride dressed in the lines of the chemise frock, and her young attendants dressed accordingly.

BRIDAL GOWNS WERE DESIGNED for those débutantes who were fortunate enough to have met their matrimonial match. Wedding gowns often followed the style lines of current fashions and it was typical for Madame Lanvin to use the same silhouettes offered in a current collection and re-fashioning and embellishing them for a bride. Wedding ensembles, usually white or ivory, were offered in a myriad of possible fabrications, from crisp and bouffant to soft and slinky, depending on the desired silhouette.

Many times, the fragile, painstaking, master-craftsmanship techniques utilized in the lingerie atelier of Lanvin found their way into the bridal and evening gown atelier, since the same soft fabrics of chiffon, tulle, and charmeuse were used in both. Beading and embroidery were executed in white, ivory, and sometimes pastels with the addition of metallic-silver or gold accents. Of course, these ensembles were topped off with the appropriate millinery pairing.

The earliest known Lanvin wedding dress was in the 1911 summer collection. Naturally, it followed the line of the chemise frock with a long, lean, easy silhouette that was lightly belted just under the bosom. With lace details on the bodice, sleeves, and bottom of the skirt, applied decoration was kept to a minimum—the crisscross back bodice and self-fabric train were detailed enough. A corsage of traditional orange blossom trickled from the waist.

In 1917, Jeanne Lanvin created the most important wedding dress of her career: the wedding ensemble for her daughter's first marriage to Dr. René Jacquemaire-Clémenceau. An ivory satin dress, along the style lines of the chemise frock, with silk tulle sleeves and self-fabric train extending from the shoulders is simple and elegant in silhouette; all ornate detail is rendered with beading, embroidery, and appliqué. Influenced by the style of the early transition period into the Arts and Crafts movement, the motif is of an open pomegranate spilling pearl seeds; light beams from behind the blossom. The pomegranate fruit has a smooth, hard shell filled with an abundance of delicate ruby red seeds, and this symbol of fertility is a highly sophisticated artistic choice for a matrimonial motif. Beaded details are rendered with crystal seed beads, satin-finish cut bugle beads, pearls, and metallic threadwork. The full tulle sleeves are beaded in a scallop pattern rendered in white and gold, while the self-fabric belt is encrusted with horizontal rows of pearls and cut bugle beads. Consistent with tradition, the bride wore a casual wreath of orange blossoms under a silk tulle veil. (Fig. 4-7)

In sharp contrast to the fashionable cylindrical silhouettes of the 1920s, Lanvin offers "La Mariée," (Fig. 11) a bouffant style in ivory silk taffeta and tulle. Many adjectives have been used to describe this particular style, such as "Watteau- or Fragonard-inspired;" this describes the volume of the silhouette and rich pastel shading of the embroidery "in the colors of Fragonard." The style consists of two pieces only, although

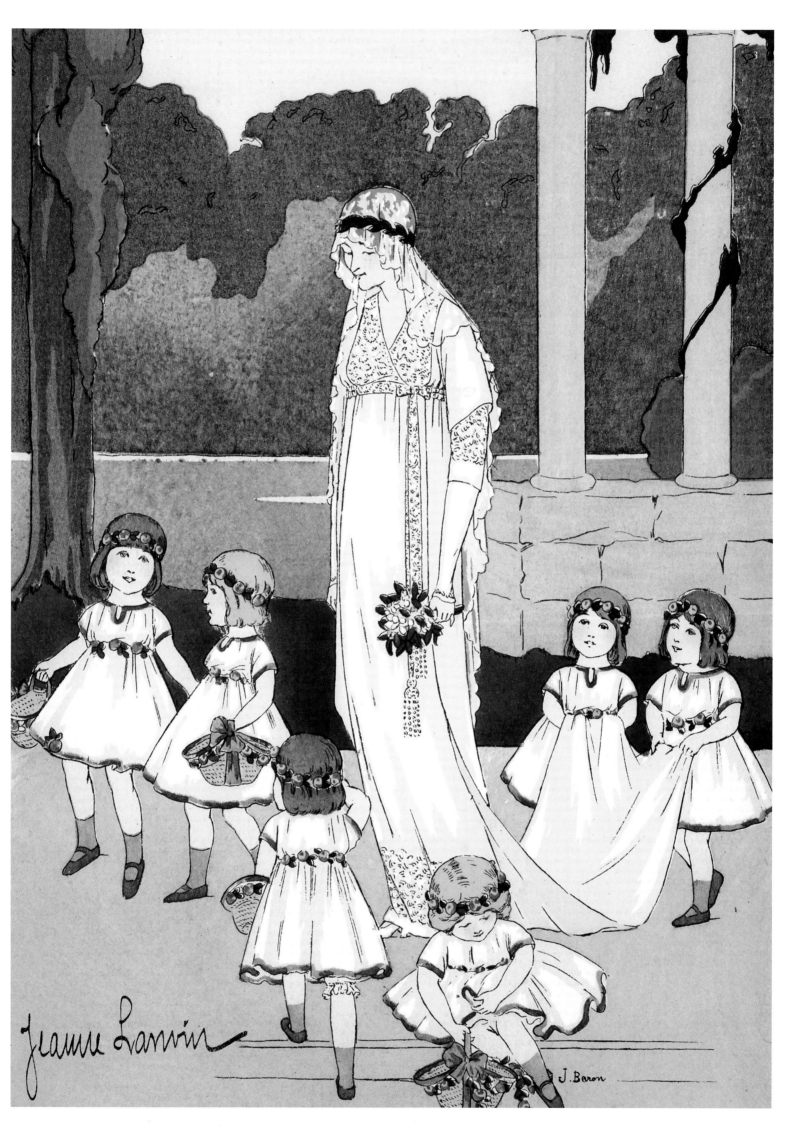

Jeanne Lanvin

J. Baron

Figure 4: Marguerite Marie-Blanche Jacquemaire-Clémenceau, née di Pietro, photographed by Nadar in her Lanvin designed wedding ensemble. From *Vogue*, September 1, 1917.

Figure 5: Detail of Figure 7, silk tulle sleeve with small acallop detail of white seed beads, pearls, and gold metallic threadwork, with coordinating beaded belt.

Figure 6: Detail of pomegranate pattern.

Opposite page: Figure 7. Ivory satin wedding dress of Marguerite Marie-Blanche in the style of the chemise frock.

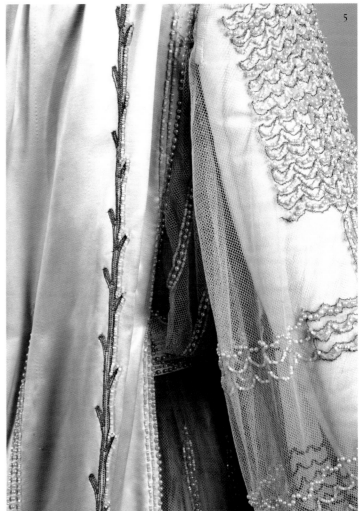

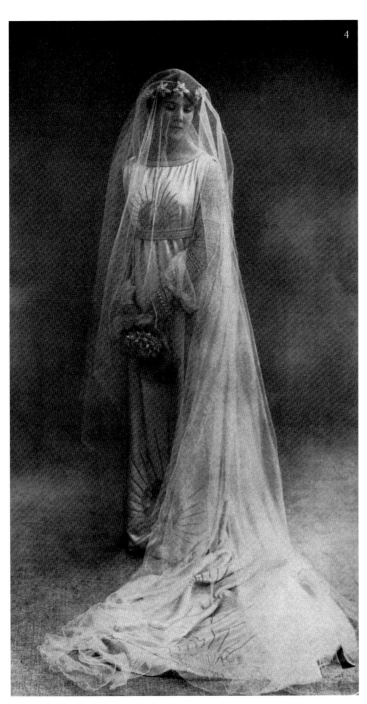

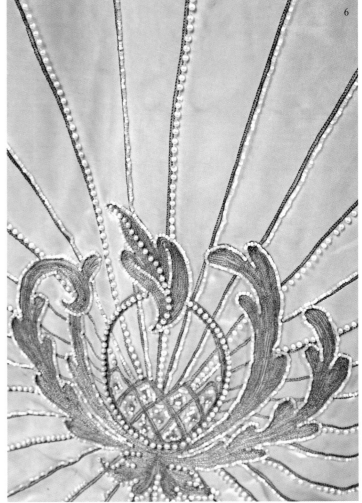

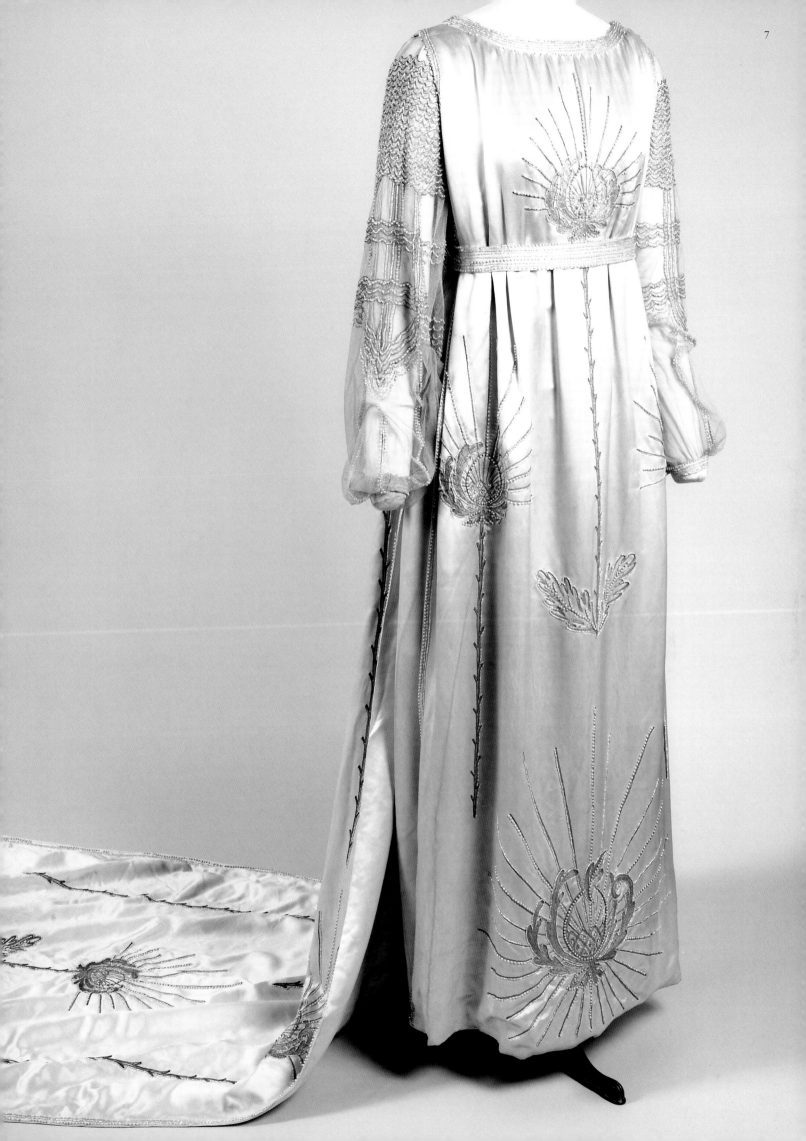

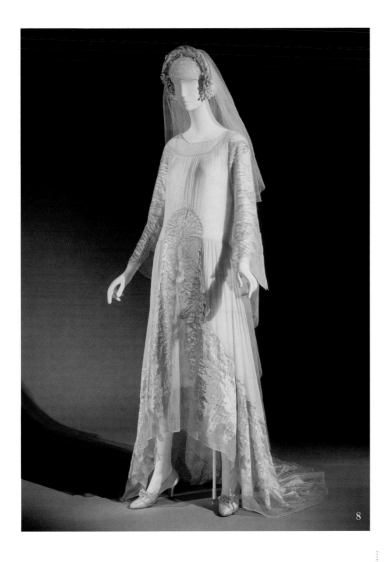

8

Figure 8: Bridal ensemble, 1925. Oyster white silk georgette dress with tubular drop-waist bodice and full circular skirt with a high-low hemline terminating in a long circular train. A border of silk tulle encircles the scooped neckline and serves as the foundation for the metallic feather-like embroidery on the bell-shaped sleeves and deep embroidered hemline of the skirt. The coronet roll headpiece of silver lamé embellished with orange blossoms is complete with a silk tulle veil.

Opposite page: Figure 9-10. Back and front view of "Fragonard," as seen in *Vogue*, May 1, 1923. Fabricated in black silk taffeta, it is the same model used for "La Mariee," fabricated in white and ivory, and when realized in bright blue, it takes on the name of "Watteau."

Figure 11: Rendering of "La Mariée" in its purest form as an unembellished wedding dress, around 1923.

Figure 12: Beading and embroidery detail from the neckline bib of "La Mariée."

Following spread: Figure 13. Appliqué detail of "Marche Nuptiale."

Figure 14: Rendering of "Marche Nuptiale," 1923.

it appears to be several. From the tulle yoke of the bodice to the hemline of the first tier skirt is one piece, including the bustle and bow; only the narrower full-length underskirt is separate.

Because a version of this model is in the collection of the Costume Institute at the Metropolitan Museum of Art in New York, details of the embroidery are available, and three variations of the same embroidery are used on the dress. The motif is a bouquet of Art Deco–style roses with branches and leaves rendered in silk chain stitch of rich pinks and reds. Stems and leaves are rendered in the complementary shades of green. The iridescent quality of mother-of-pearl shapes, used to fill in the spiraling roses and buds, makes a considerable and elegant contribution to the pastel coloring of the ensemble as the reflected colors of the fragments change according to the direction of the light source.

One version of this embroidery is found on the triangular-shaped bib that drapes over the bust. (Fig. 12) A bigger, bolder version of the embroidery is found in the center of the first tier skirt, scrolling across the skirt but not quite reaching from side to side. Where ethereal mother-of-pearl fragments were used to embellish the floral motif in other placements,

here metallic sequins in various deep pinks take their place. The third embroidery is found at the end of the train and rendered in the same silk chainstitch and motif, but in a color palette of the softest pink hues. The leaves, fronds, tendrils, and buds have been rendered in complementary light greens in the same less-intense hue. Additional options for this dress include a wedding dress rendered all in white devoid of beading and embroidery. Other photographs show that this dress was also offered in black silk taffeta with contrasting beading and bow; and for evening, it was offered as an organza dress layered over a narrow metallic lamé slip. (Fig. 9-10) Stylistic options were always offered to clients, as they greatly affected the overall cost, but the primary attraction to Lanvin—and the house's forté—was innovative beading and embroidery.

In the 1920s, wedding dresses followed the cylindrical shortened shapes closely associated with the decade. The somewhat cumbersome *robe de style* was reserved for other grand occasions, while the most modern and fashionable brides wore the current silhouette. Slender creations were adorned with feminine, delicate embroidery highlighted with fragile and painstaking pin tucks and pleats, smocking, and shirring executed by the skilled hands within maison Lanvin.

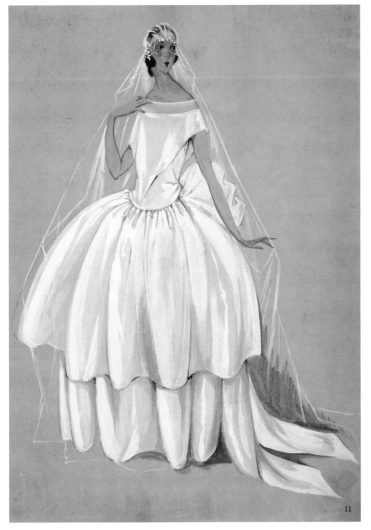

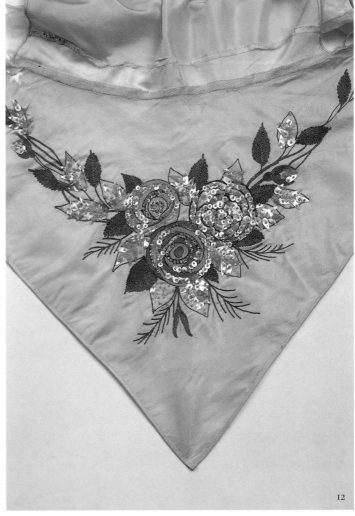

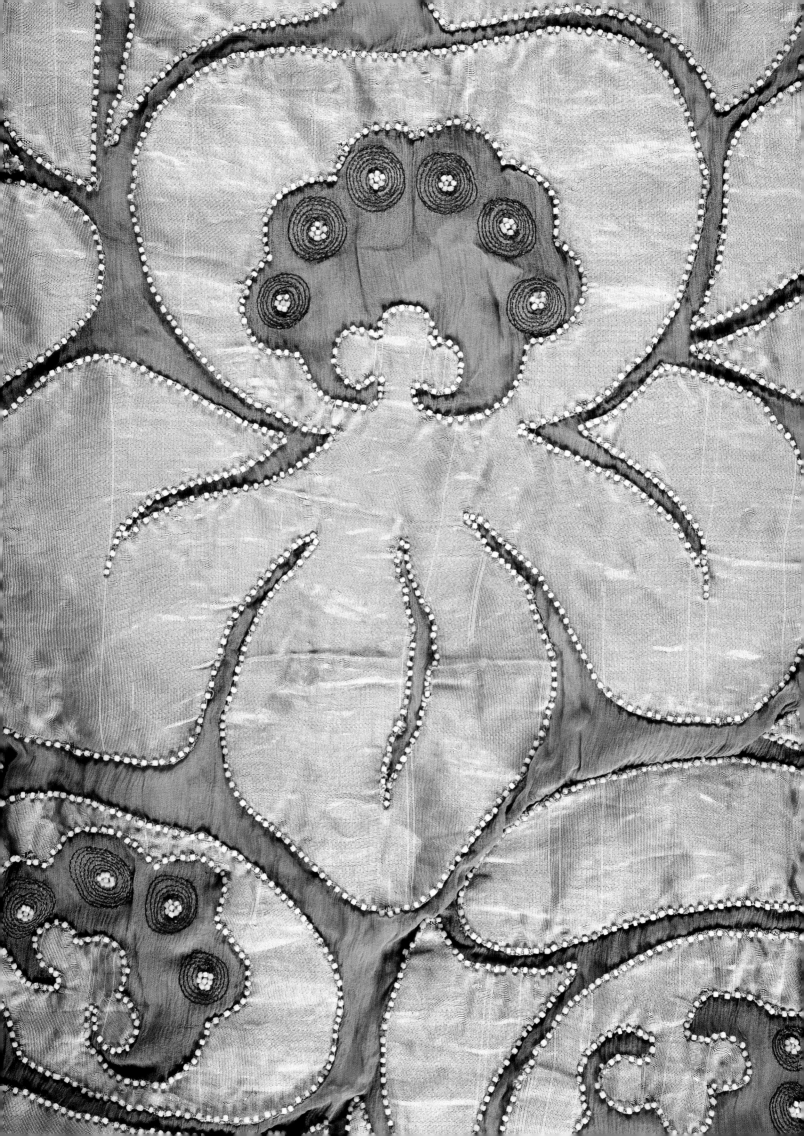

Figure 15. Wedding ensemble, 1924. Bands of silk crepe and tulle seamed together and secured by a fine row of pearls and crystals. The untraditional train of two bands, combining silk crepe and silver lamé, attaches to the wrists without distracting from the circular pattern seamed into the skirt. **Figure 16:** Detail of Raquel Meller, 1924. **Opposite page: Figure 17.** Raquel Meller in the film *La Terre Promise*, 1924.

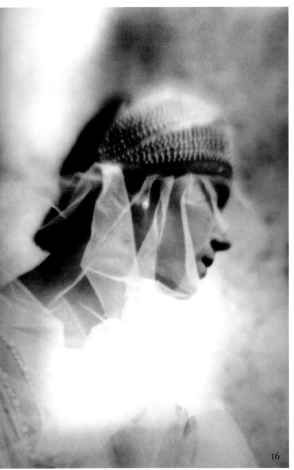

"Marche Nuptiale," a two-piece ensemble of sheer white chiffon from 1923, (Fig. 13-14) consists of a tunic suspended from a bateau neckline, which reveals the beaded lace portion of the white opaque underdress flowing from under the slip. The tunic of white chiffon is generously covered in silver lamé appliqué rendering huge exotic flowers outlined in pearls and crystal beads. The sides of the tunic are tied on each hip with white self-fabric bows. The sleeves are slim and secured at the wrist by a double row of silver lamé ribbons outlined in pearl and crystal.

The romantic bridal designs of Lanvin were recognized by all, including the film industry. A 1924 style with a dropped-waist, gathered skirt, and bishop sleeves, is detailed by seaming of alternating bands of detailed by seaming alternating bands of transparent and opaque fabrics. Within this featured detail, seams are erased and visual contrast is punctuated with pearls and crystal components. Replacing the traditional

train are additional lengths of fabric attached at the wrists and again at the back of the dress. These create a lightweight, voluminous look; as a result, with every gesture of hands and arms, a sweeping effect is achieved. In 1924, French actress Raquel Meller wore this Lanvin bridal ensemble in the film *La Terre Promise*—and the dramatic design translated into film successfully. (Fig. 16-17).

Consistently deriving inspiration from past centuries, two styles dating from 1927 demonstrate the affinity Madame Lanvin had for medieval costume. Various elements from the vast timeframe of the Middle Ages—the fifth to the sixteenth centuries—manifest in the form of fabric treatment, geometric motif, millinery styling, and the definitive acknowledgment of Christianity. The most literal translation of the Middle Ages is seen in the August 1927 wedding ensemble "Beatrice," (Fig. 18) with slashed sleeves, a repetitive, pointed geometric motif, and hip-band; the inspiration

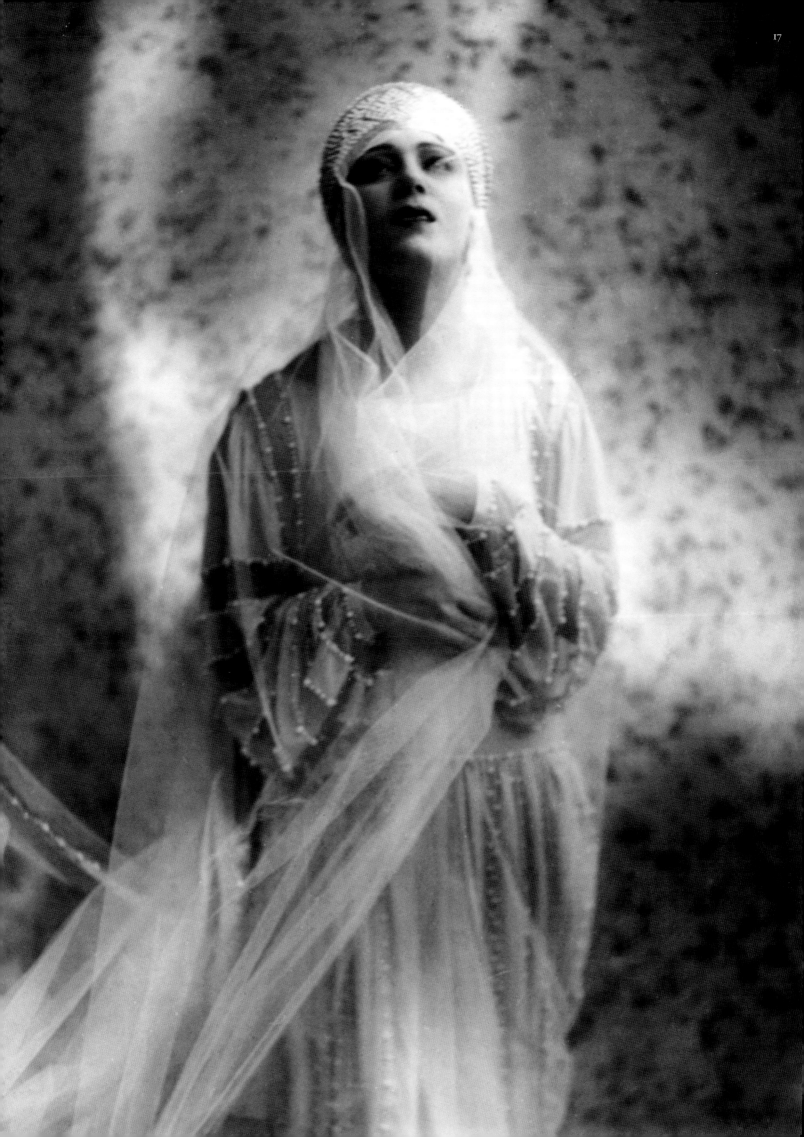

Below: Figure 18. "Beatrice," August 1927. Documental photograph shows the cylindrical silhouette of the 1920s with slashed sleeves, pectoral cross, and millinery accoutrement, all inspired by the Middle Ages, and embellished and with beads and crystals in the style of Lanvin. The cathedral length satin train is attached at the back waist. **Opposite page: Figure 19.** Madame Lanvin admires one of her most glorious bridal ensembles within the private environment of her office, end of the 1920s. **Figure 20:** Bridal design for Conchita Supervía's wedding to Ben Rubenstein in 1931.

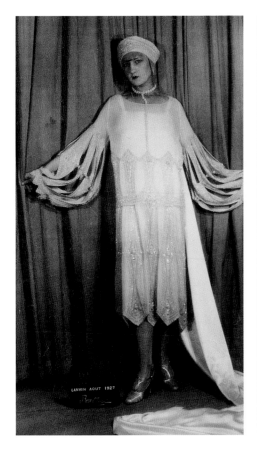
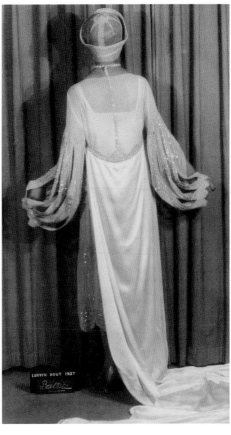
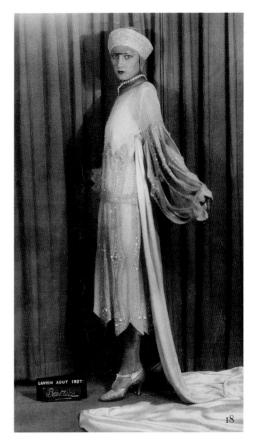

becomes even clearer with the consideration of the veiled head and the millinery design. Even the choker-style necklace terminates in what could be a pectoral cross or some other motif of the Middle Ages.

The quintessential image of a Lanvin wedding gown was photographed within Madame Lanvin's office. She is wearing her standard black and white ensemble, pearl necklace, and neatly coiffed hair, and sitting in a chair holding a fashion illustration in one hand with others scattered at her feet, as if she was reviewing the latest concepts for the next collection. With approving eyes, she admires the model in full wedding attire. (Fig. 19)

Created on the cusp of the thirties, this wedding ensemble is unlike any other Lanvin designs previously mentioned. Hardly similar to the classic Lanvin *robe de style*, this less than modest dress has a dropped-waist, sleeveless bodice with beaded shoulder straps, belt, and a full sweeping skirt. The modernity of the 1930s mingles with 18th-century romanticism. The skirt is cut in the high-low fashion: the front of the skirt is hemmed to mid-calf, and the back of the skirt is lengthened and widened creating a sweeping train.

The embroidery of the dress is large-scale; the voluminous skirt is used as a canvas for rendering a slick geometric image of shiny bugle beads influenced by Art Deco.

The headpiece, inspired by the Italian Renaissance, has been polished by the influence of Art Deco, with sweeping lines and graduated geometric shapes. The headpiece, devoid of tulle veiling, is extraordinary. A beaded cap supports a two-dimensional oval shape embellished with graduated beaded spheres across the center of the circle, across the base of the oval, and again on a crescent under the chin. This image represents the ever-successful Lanvin formula—the essence of historicism melded with modernity. Madame Lanvin permitted the aesthetics of the period to modernize her designs in the most subtle and sublime manner while maintaining the fresh and youthful image synonymous with the name.

A long, lean silhouette was introduced and became popular in the 1930s. This silhouette was made possible with minimal seaming, through the mastery of the bias technique developed and perfected by Madeleine Vionnet. With the long, narrow skirt and "fishtail" hems, the silhouette and

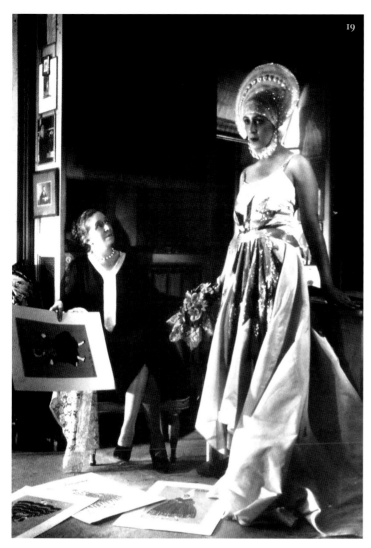

proportion morphed, shifting visual volume upward as seen in sleeve treatments and shoulder details.

Wedding ensembles were made by commission and, as mentioned previously, they typically followed the style lines of a season's offerings, which was then re-fashioned for a bridal ensemble. A gouache fashion illustration was made detailing the preferences of the client, and the client's name was painted near the bottom of the page. "Mlle. Superviel," inscribed at the bottom of a Lanvin illustration from 1931, (Fig. 20) is the French spelling of Conchita Supervía's name. She was born in Barcelona and was a successful mezzo-soprano who made her stage debut in 1910 in Buenos Aires, at the age of fifteen. Year after year, the popular singer traveled the world displaying her musicianship and charming audiences with her personality and humor. In 1930, she made her London debut at the Queen's Hall; in the following year, she married Ben Rubenstein, a London businessman. This wedding dress, with its clinging bias silhouette and simple knotted bodice detail with slight *gigot* sleeve, was not the only Lanvin design she had worn, as there are other illustrations associated with her name and existing garments with a Supervía provenance.

In the latter half of the 1930s, the silhouette gradually eased away from the body as some styles were cut on the straight grain of the textiles. In general, though, the silhouette remained lean but with some ease, as seen in "Mariée," a simple tunic shape gently drawn in at the neck and waist, and creating a blouson bodice and soft skirt. (Fig. 24) Bell sleeves are the focal point of this design. They are embroidered in silver, repeating the metallic element of the headpiece that is inspired by the Italian Renaissance but with an Art Deco influence. Consistently experimenting with volume, proportion, detail, and visual illusion, Madame Lanvin offered a variety of silhouettes and fabrications. These fulfilled the needs of the youthful bride as well as those who were older, perhaps World War II widows who were marrying for a second time.

Not a wedding dress by intention, a silk and linen "Lanvin blue" shirtwaist dress was selected by Mrs. Jefferson Patterson for her 1940 Berlin wedding at the American Chancery. (Fig. 24) Lantern-like sleeves extend the width of the shoulders, and the waist is cinched by the layering of three narrow belts of red, cream, and "Lanvin blue," sharing the same color palette of the abstract floral needlepoint

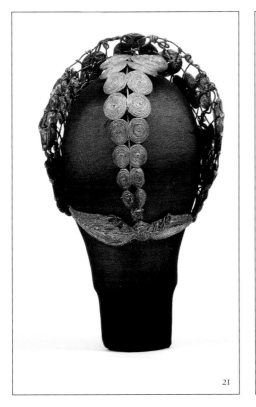

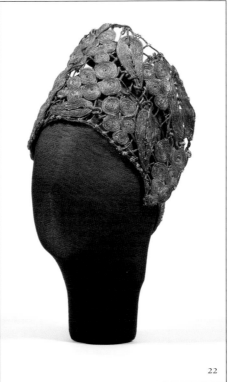

21

22

Figure 21-22: Back and three-quarter profile views of bridal headpiece to the ensemble "Hymnée," presented in February, 1927.

Figure 23: Gouache rendering of bride with "Les Palmiers" embroidery, with her maid of honor and young attendant, 1924.

Opposite page: Figure 24. "Mariée," 1935. Wedding dress in the style of a classical ancient Greek robe with gathered circular neckline, blouson bodice, gathered waist, and long skirt. Full bell sleeves are covered in a graduated lattice-work beading pattern, seemingly the only detail on this very simple dress. The weighty veil is suspended from a self-fabric cap which is secured by a structured headpiece decorated with metallic cording.

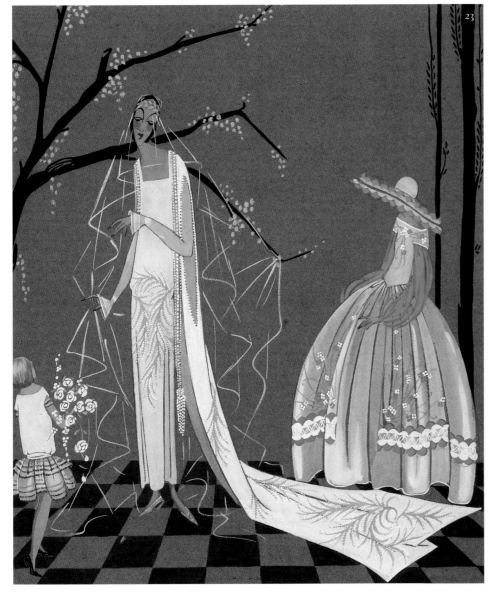

23

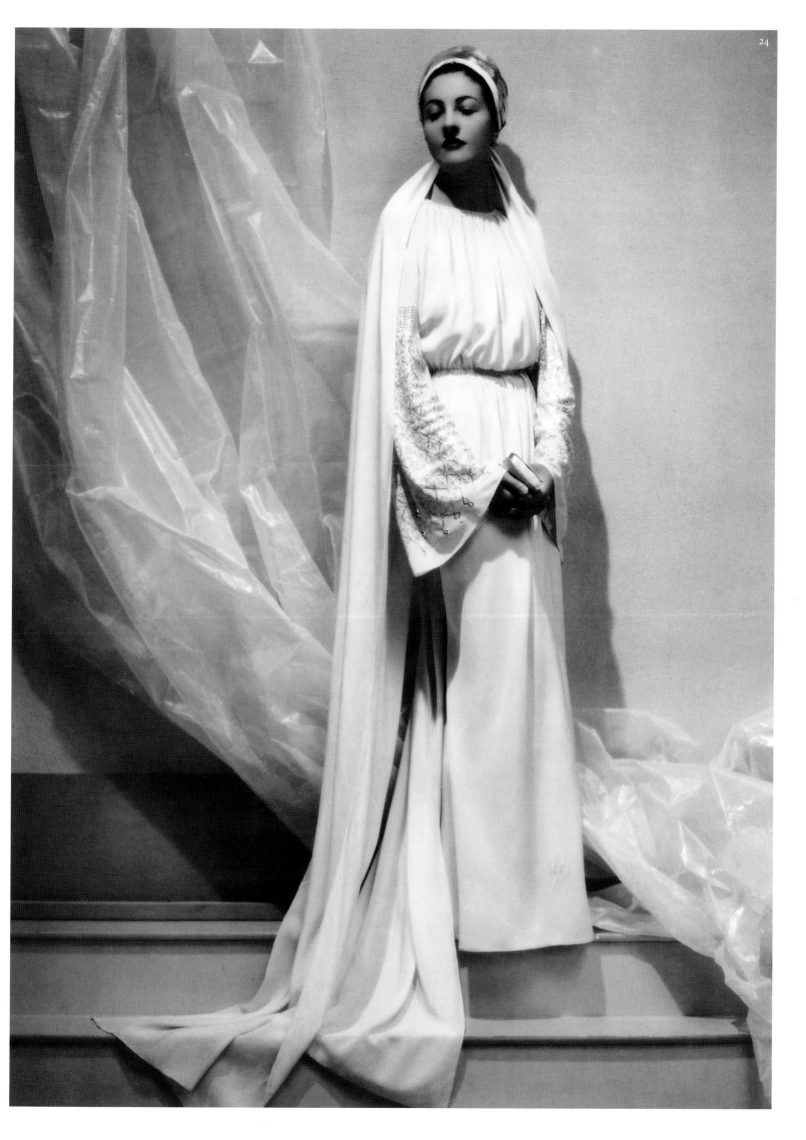

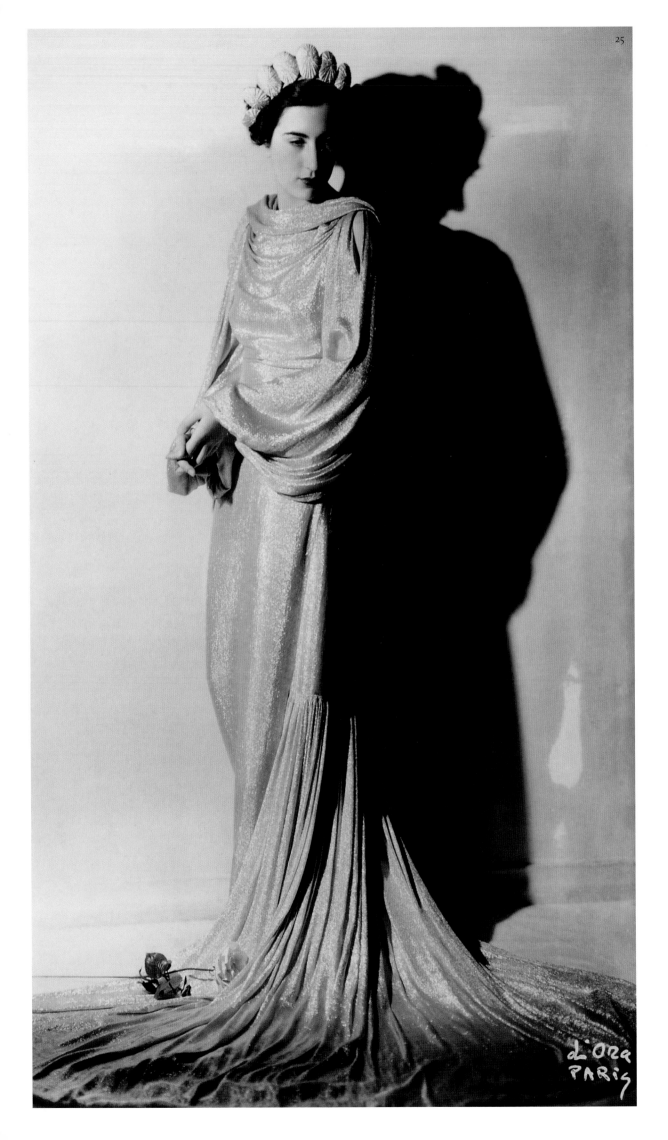

d'Ora
PARis

POMME DE PIN

Opposite page: Figure 25. In classic 1930s silhouette, this lamé dress of 1934 features a bias draped neckline and full bishop sleeves. The lower half of the dress is long and lean with graceful fullness added to the rear skirt forming the long sweeping train. The headpiece is the only embellishment found on this ensemble.

Figure 26: Rendering of headpiece "Pomme de Pin" [Pinecone] used with the dress in Figure 25, August 1934. **Figure 27:** Bridal headpiece with veil, 1939. Juliet cap formed of silk satin circles of various sizes and encrusted with silver sequins and pearls. The silk tulle veil is appliquéd with the same silk satin circular pattern tethered by scrolling tendrils rendered in silver cup and flat sequins of various sizes. The cleverest aspect of this veil is the facial opening, as the veil is a complete circle and is only attached to the cap in the rear.

embroidery on either breast pocket. A row of self-fabric-covered buttons vertically enhances the silhouette of a flared skirt. Although the headpiece is original to the ensemble it is not a Lanvin design.

In 1940, feeling some restraints resulting from World War II, Lanvin designed a modern and glamorous, yet somewhat reserved, satin shirtwaist wedding dress with matching belt. A star motif, executed in various sizes of cupped sequins, is embroidered on the upper-right chest bust and the upper-right sleeve. Overall, the design is not typical of Lanvin bridal clothing, but it is in keeping with the social climate and economic limitations felt by all during and after the war. The headpiece, created from three wide cords, pavéed with sequins, and interwoven to form a quasi-turban, provides a final chic touch for this ensemble. Without the veil, the ensemble was appropriate for other social events: with war restrictions in place, it was common for a special dress to serve multiple purposes harkening back to brides of the nineteenth century, who married in their best dresses or continued to wear their white wedding attire to social events for up to two years afterward.

28

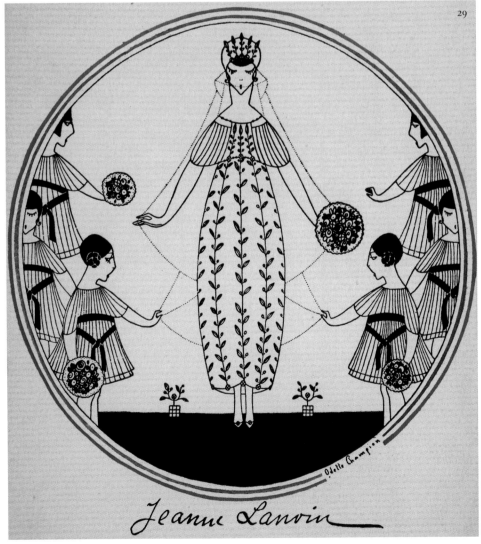

29

Jeanne Lanvin

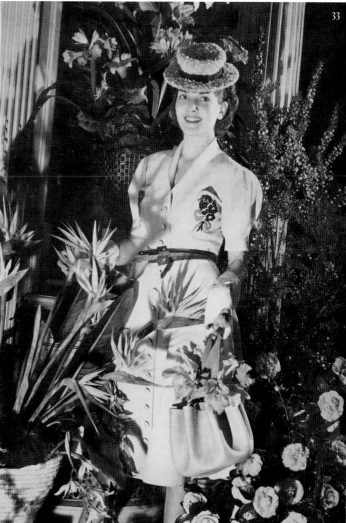

Opposite page: **Figure 28.** *Carte d'invitation* for a Spring/Summer Lanvin fashion presentation, rendered in *pochoir* technique, features a bridesmaid and young attendant in *cocotte* and ribbon-trimmed youthful *robe de style* designs. around 1925. **Figure 29:** Lanvin *carte d'invitation*, 1917. The central focus of the composition, rendered in black, is a youthful bride in a gown embroidered in evergreen leaves, a symbol of perpetual life, love, and vitality, while the red and blue circular frame represents the national colors.

Figure 30-31: Grid diagram of bouquet embroidery used in Figure 32, plotted out in grayscale to which an embroidery swatch is attached—also executed in grayscale. **Figure 32:** "Lanvin blue" silk and linen shirtwaist dress worn with three leather belts—blue, cream, and red. The colors are used in the abstracted floral embroidery found on either breast pocket. Worn by Mary Marvin Breckinridge with Jefferson Patterson at their wedding reception on the terrace of the American Chancery (Blücher Palace) in Berlin, Germany, June 20, 1940. **Figure 33:** Editorial image of Figure 30 as it appeared in Images de France, Plaisir de France, May 1940.

Following spread: **Figure 34,** "Le Lys" was offered in a season appropriate fabric of lamé, February 1941. **Figure 35.** Gouache rendering of "Le Lys" [White Lily] in white lace, summer 1941.

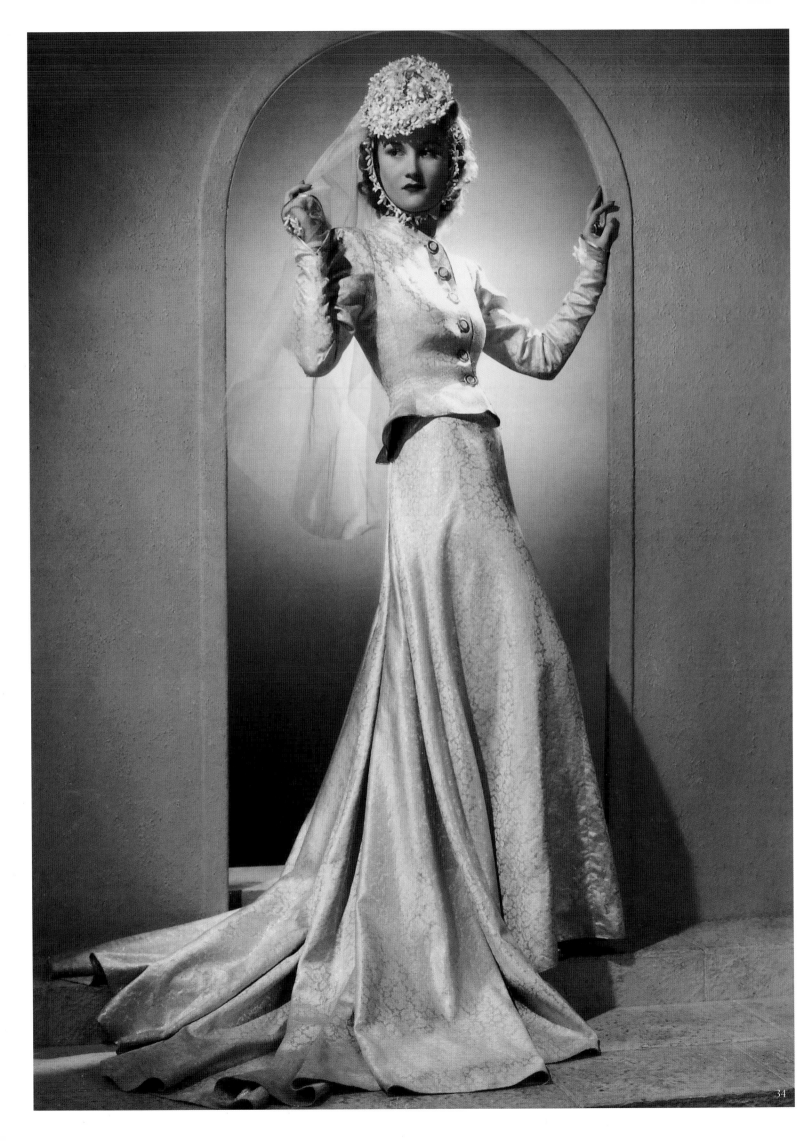

LE LYS

MOTHER

ONE OF THE MOST esteemed positions a woman can hold in her lifetime is that of mother: giver of life, nurturer, and caregiver. Mothers guide their children through their formative years, teaching the life skills necessary to survive in the world. The marriage of Jeanne Marie Lanvin to Henri-Émile-Georges di Pietro produced a daughter, Marguerite Marie-Blanche. It is she who fueled the creativity within Madame Lanvin, which manifested itself in the form of highly desirable children's wear. From this point, the mother-daughter bond pervaded every aspect of the Lanvin empire—in particular the symbol of the house, which was derived from a 1907 photograph, in profile, of mother and daughter holding hands while wearing formal dresses and hats in preparation to attend a ball. Although the original design was executed by Iribe, French architect Armand Albert Rateau may have refined the original idea resulting in the symbol as it is seen today. (Fig. 14). Other images of mother and child, in compositions other than the highly stylized Lanvin symbol, appear throughout the decades in various forms for different purposes.

As early as 1910, one year after opening the girls' and ladies' departments of Lanvin, *carte d'invitations*, elaborately rendered in *pochoir* technique, promoted a romanticized, idealized image of mother and daughter. In harmonious color and composition, the naïveté of a young mother is revealed as the iconic image of maison Lanvin is visually reinforced with every opportunity, season after season.

Pochoir is a French word describing a polychrome printing process requiring a stencil placement for the application of each color in the design. A costly process with superb results,

this illustration technique was used in place of black and white fashion photography in some periodicals. *Gazette du Bon Ton* was a French periodical for women that featured multiple plates of the latest fashion designs from the leading couture houses all rendered in this technique. Madame Lanvin was a huge proponent of the use of color in fashion; as a result, she preferred the *pochoir* technique over black and white photography. The *pochoir* printing process was more successful in projecting the original spirit and coloration of the design and with greater visual impact.

A little story in and of themselves, fashion plate images typically contained multiple primary characters—mother and child or mother and children—with secondary characters rendered with less clarity and detail. These characters are typically found in a setting—a home, park, or party—in mid-action, and a brief caption under each fashion plate alludes to the actions and setting of the characters, similar to a frame in a comic strip. Because couture houses commissioned or financially contributed to the production of fashion plates, the identity of the couture house featured was usually listed as well.

Illustrated advertisements for Lanvin throughout the decades seized every opportunity to reinforce the maternal image of the label with the "lead characters" dressed in the latest Lanvin styles. Within one illustration several retail categories could be targeted, from millinery and accessories to apparel for women and their children. Clever compositions combined imagery of the past and present, which, not incidentally, was the same successful design formula used by Madame Lanvin.

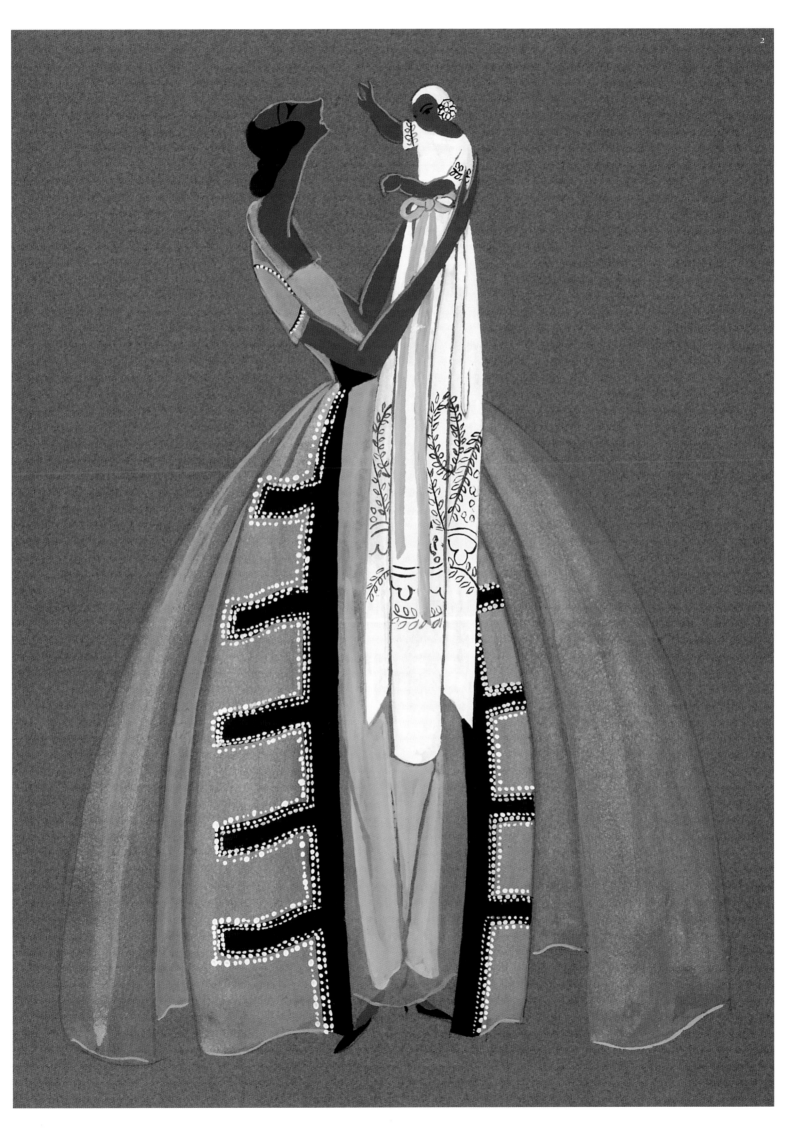

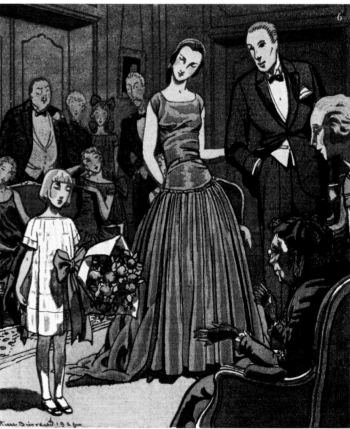

Above: Figure 3. "Ta maman va bien?" *pochoir* from *Gazette du Bon Ton*, April 1914. **Figure 4:** "La Visite," from *Gazette du Bon Ton*, March 1920. **Figure 5:** "Vous Étiez Haute Comme Ça ou Ça Ne Nous Rajeunit Pas," 1922. **Figure 6:** "La Sainte-Claire," from *Gazette du Bon Ton* 1922. **Opposite page: Figure 7.** Lanvin *carte d'invitation*, 1912.

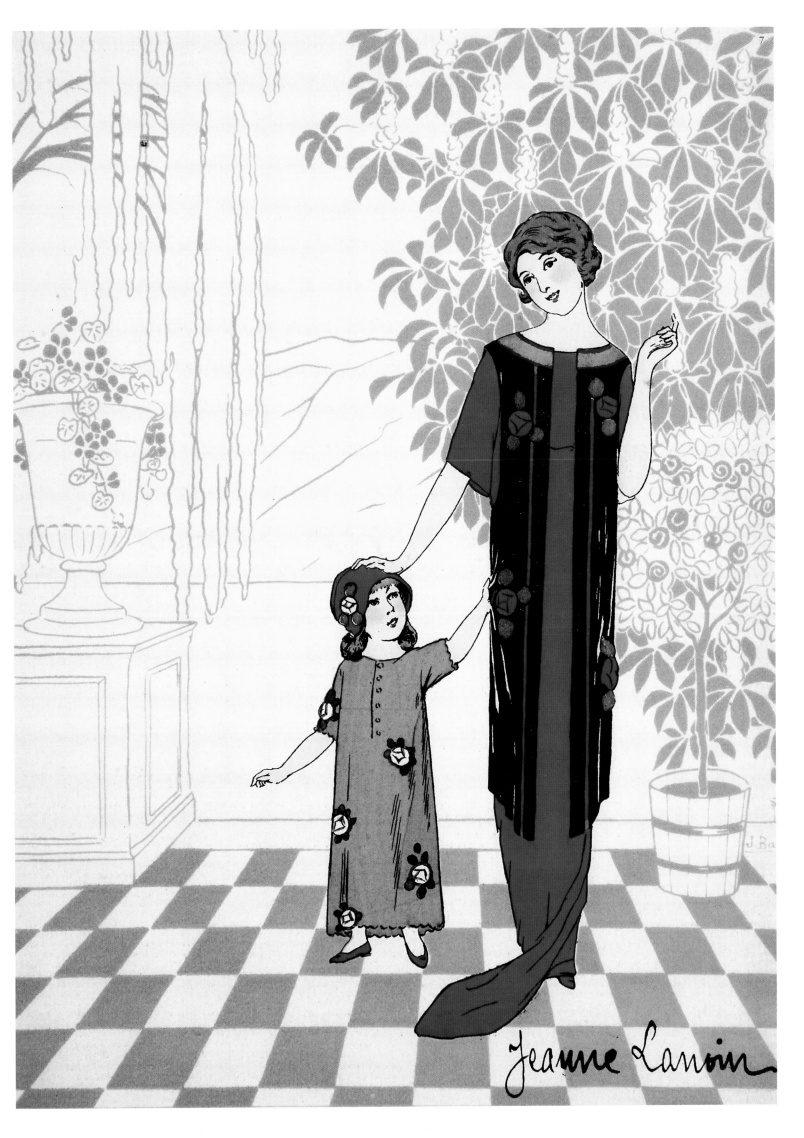

Jeanne Lanvin

Figure 8: Lanvin ensembles from *Les Modes*, 1913.

Figure 9: Lanvin *carte d'invitation*, April 1911.

Opposite page: Figure 10. "Il Na Pas Pleuré ou Notre Defénseur de Demain" *pochoir* from *Gazette du Bon Ton*, around 1923.

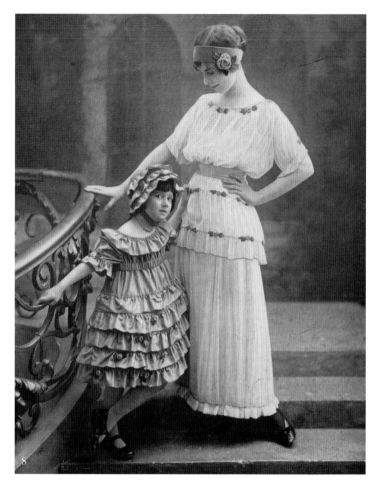

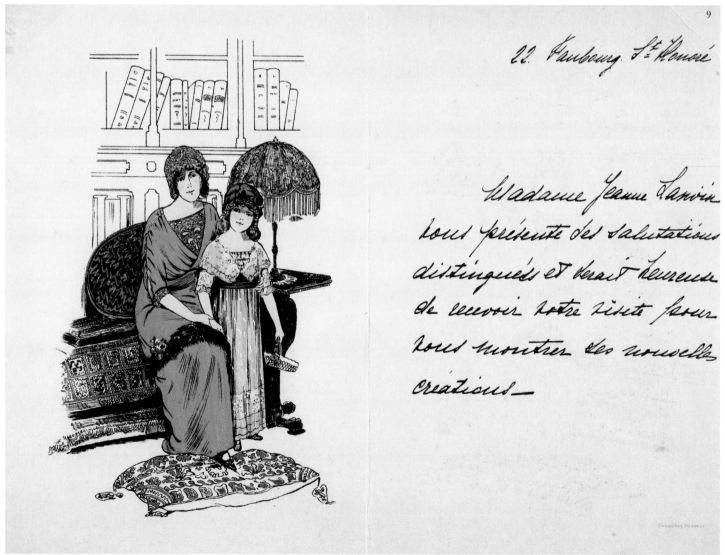

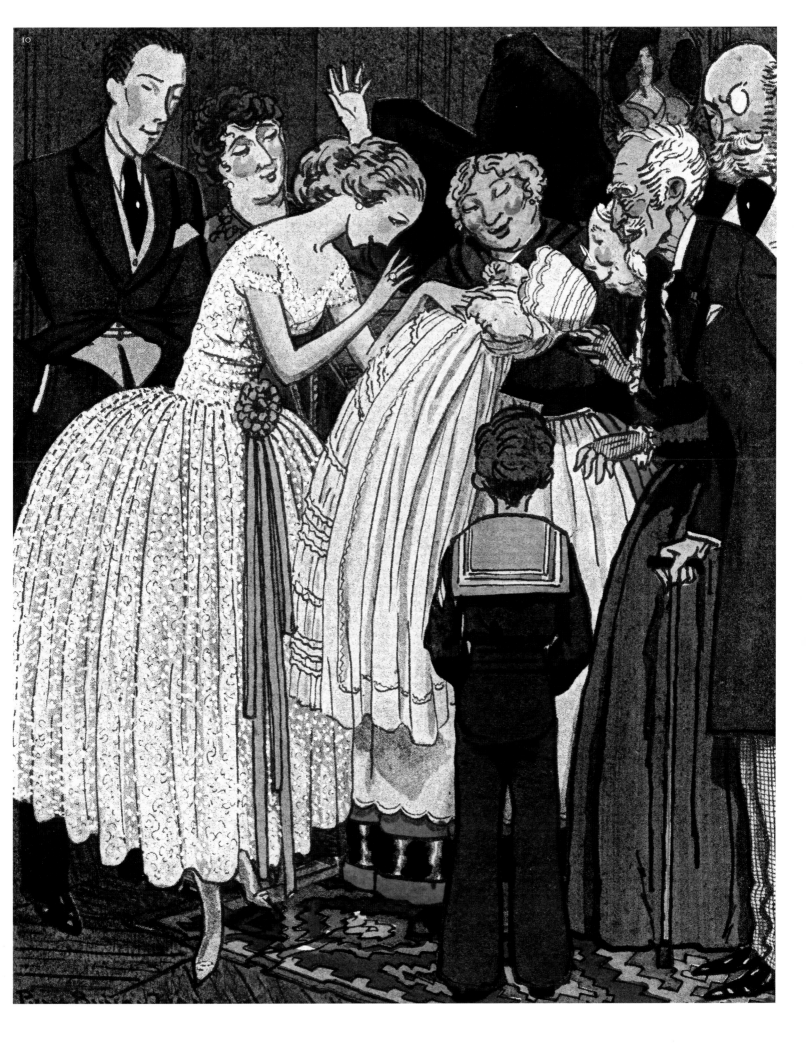

Figure 11: "Laisse-Le Moi Prendre…" 1922.

Figure 12: "Le Rose du Jardin," 1922.

Figure 13: "Portrait de Mme. V. R. et de sa Fille," 1922.

Opposite page: Figure 14. "Le boule noir," designed by Paul Iribe. Featuring the gold painted griffe designed by A. A. Rateau and a stopper referred to as "a melon slice."

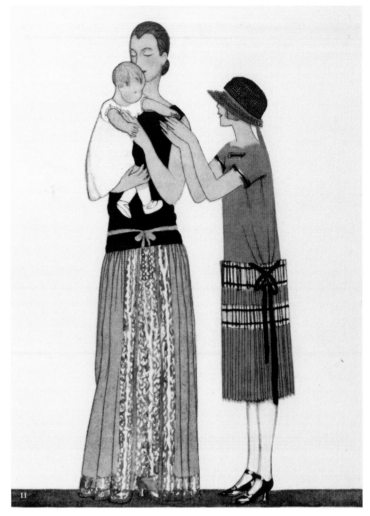

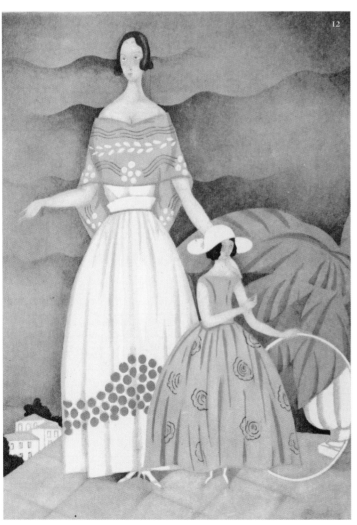

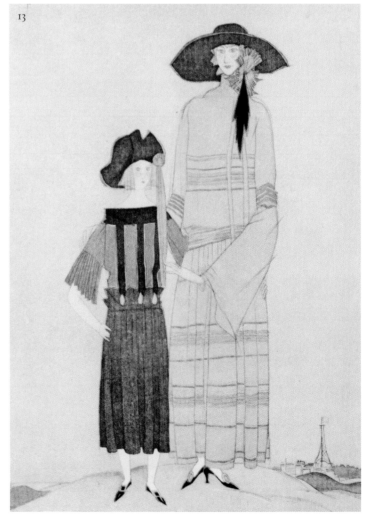

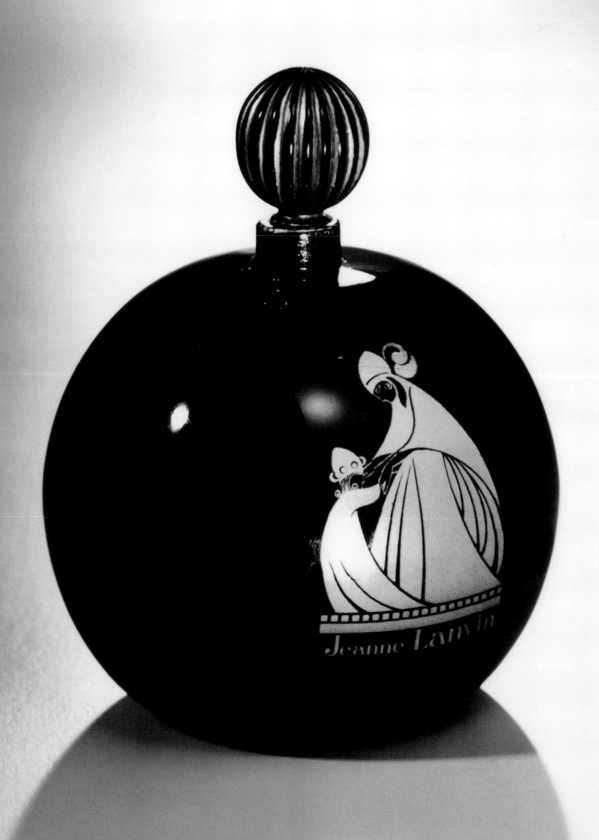

4

INSPIRATION
AND SYMBOLISM:
GLOBAL INSPIRATION

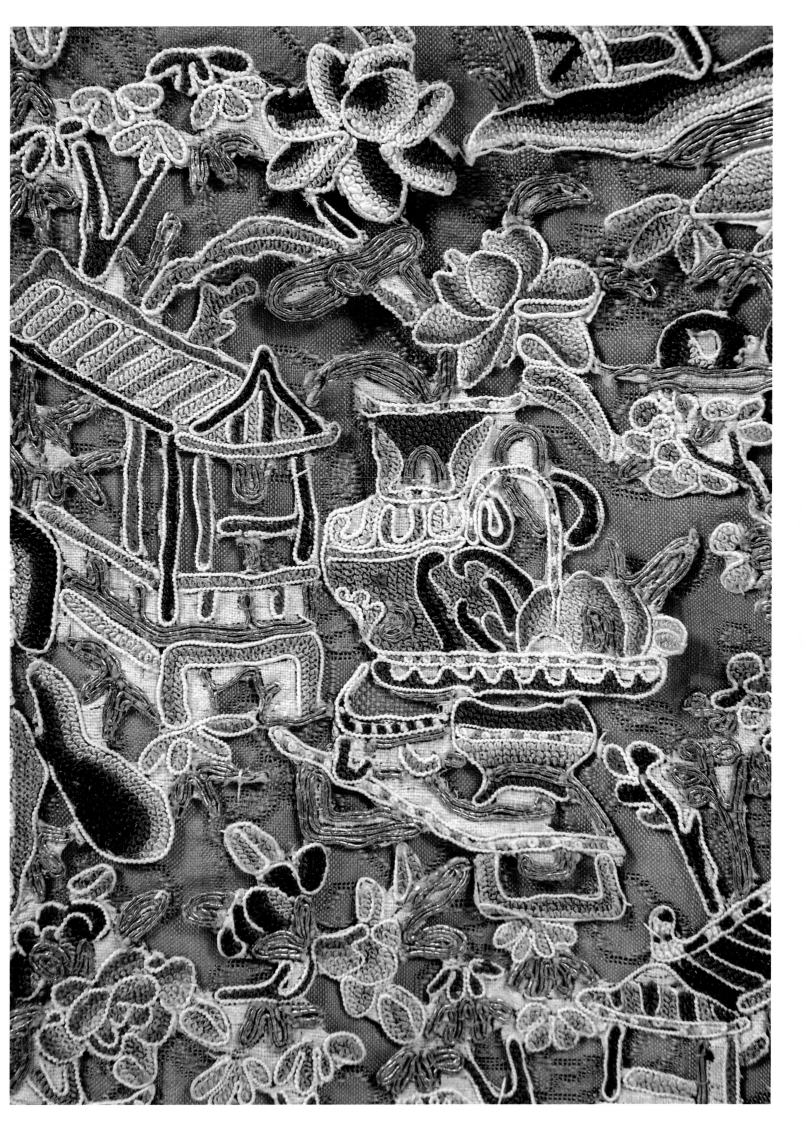

Previous page: Figure 1. Detail of antique Chinese textile fragment with polychrome silk embroidery of village life with floral and traditional Chinese symbols, date unknown.

Right: Figure 2. Overall view of antique Chinese skirt with embroidery .

Figure 3: Detail of skirt (Fig. 2) with polychrome silk embroidery of exotic plants and insects, date unknown.

Following spread: Figure 4. "In Salah," navy blue silk crepe jacket with pale celadon green grosgrain asymmetric collar closure. 1926.

Figure 5. "In Salah" detail of embroidery, suggesting Islamic scrollwork, executed in pale celadon green chainstitch with milk-glass tabular beads, 1926.

2

GLOBAL INSPIRATION is ever-present in the embroidery and beading designs of Jeanne Lanvin. She extracted the purest essence from a host of creative sources—many from around the world—to create original compositions in a range of materials. Within the private office of Madame Lanvin, the library is stacked with many unique volumes, and a selection of historical costumes, textiles, jewelry, and prints. Some objects are quite rare, and include antique maps, illustrations of flora and fauna, and illustrated periodicals from the 17th through the 19th centuries. Other objects in the collection include archaeological fragments, Venetian lace collars, embroidered African tunics, Coptic embroideries, and miscellaneous buttons and trims. Influences came from as far afield as the Middle and Far East as well as the French countryside of Brittany and Normandy. Among the various garments and fragments stored in this room, the most notable are the Chinese and Japanese ceremonial robes covered with intriguing and inspirational hand-embroidery executed in bright, multicolored silk floss.

Madame Lanvin had an intense interest in all things exotic and beautiful, and many of the objects in her archives feature motifs rendered in beading, embroidery, and appliqué. Madame Lanvin reinterpreted these into forms suited to the entirety of her output—from haute couture to childrenswear. Ethnographic material contributed more than just motifs to her work, as other cultures an their attendant histories served both as education and inspiration. In September, 2006, a Paris auction house sold assorted exotic objects accumulated by Jeanne Lanvin. The sold objects, all from a private collection, included 19th-century Kalamkari robes from Persia, embroidered Indian saris, 19th-century printed and embroidered Alsatian handkerchiefs, Qing dynasty Chinese velour robes, a black satin Indian wedding dress embroidered in polychrome silk and mirrors, liturgical ensembles from the 19th and 20th centuries, 18th-century *lambrequins*, assorted 19th-century embroidered suspenders, and an 18th-century *robe á la française* with Watteau-pleated back and pagoda sleeves.

Many additional objects of exotic origin were obtained from antiques dealers and vendors at the *marché aux puces*. Madame Lanvin also traveled for pleasure. She was forever in search of inspiration and new experiences, and no doubt acquired items abroad. It is typical to find fragments of textiles or costumes attached to a fashion illustration as a reminder of the original inspiration. Likewise, samples of exotic textiles of interest are contained within the endless

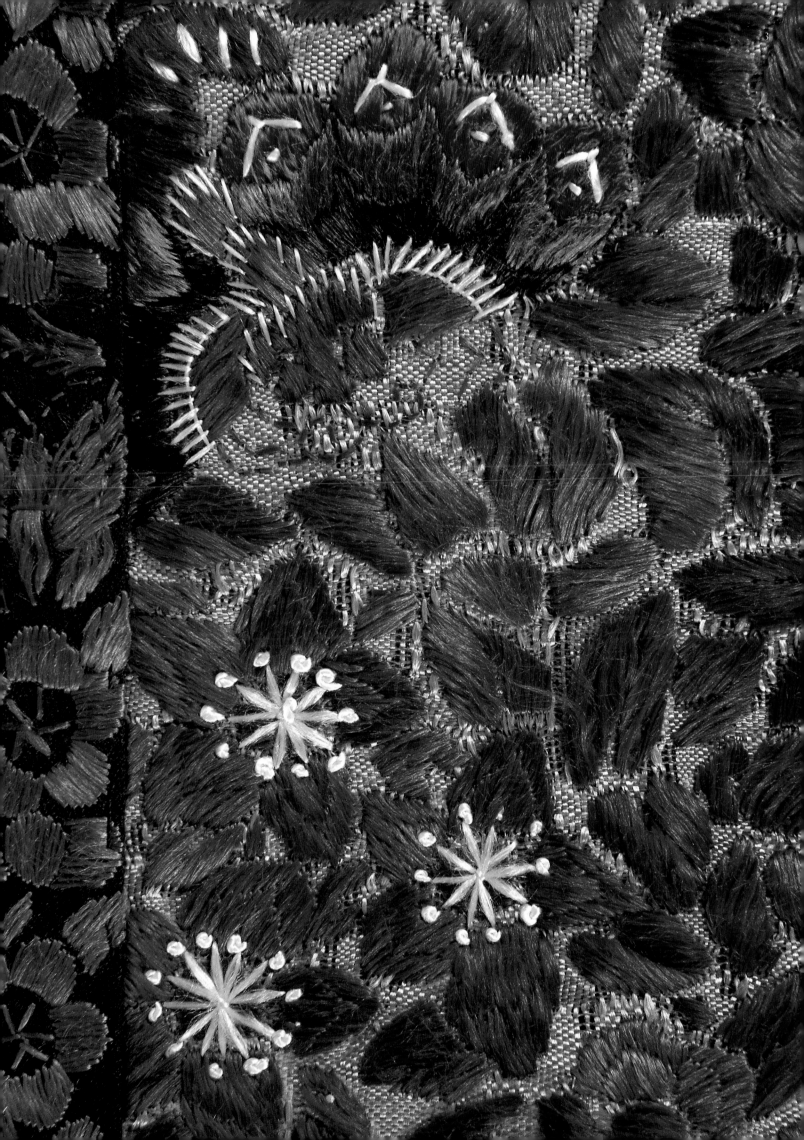

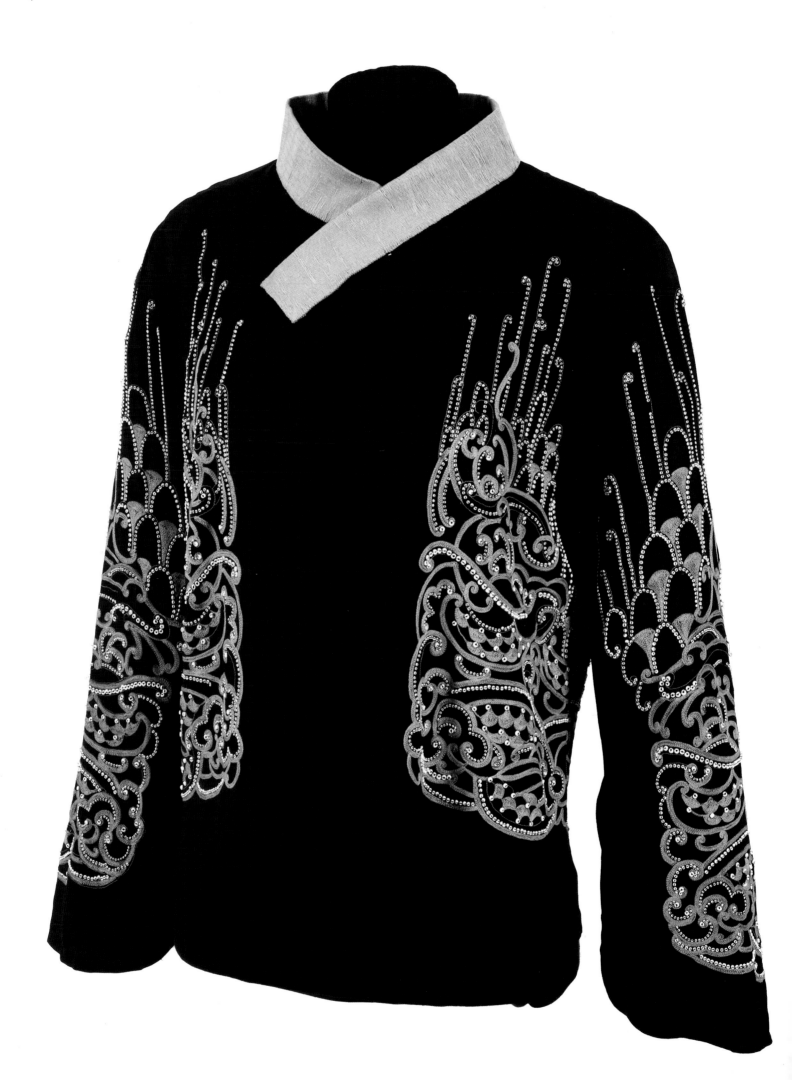

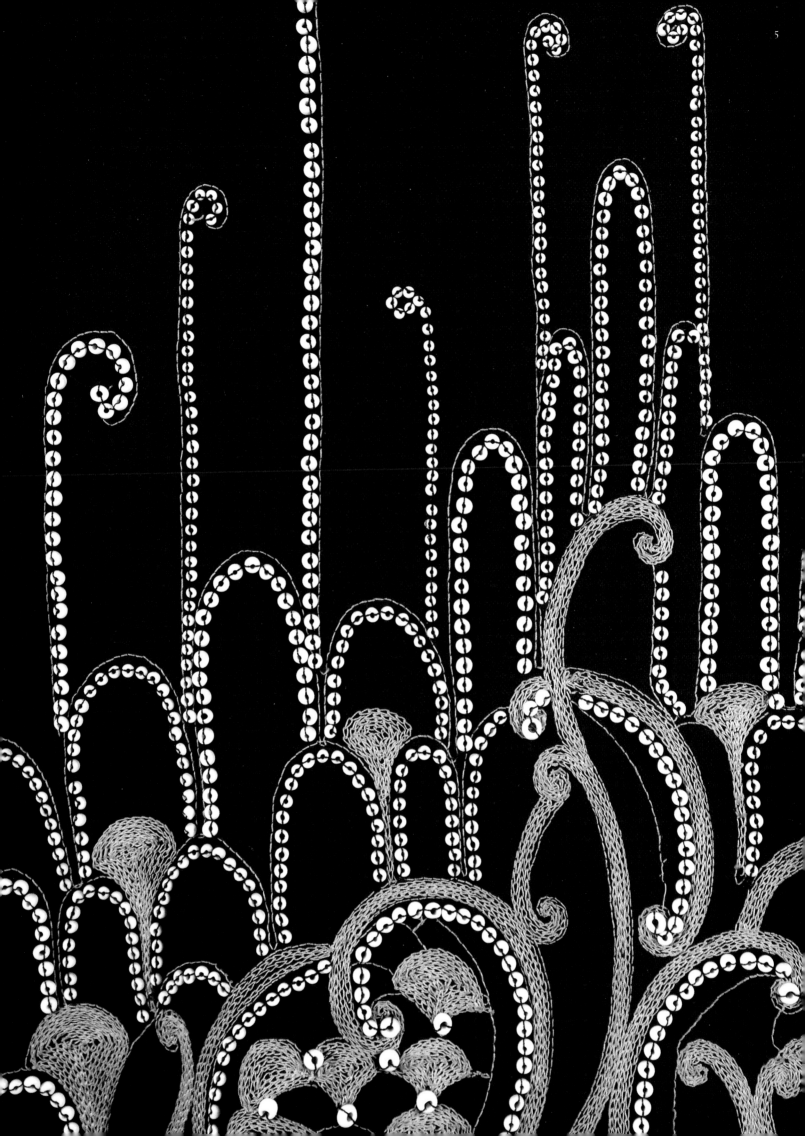

Figure 6: Lanvin client wearing a camel-colored wool coat with Islamic-influenced embroidery, 1921.

Figure 7: The same coat featured in Fig. 6. Navy blue and cream threadwork embroidery of Islamic influence, denoted by the cresent moon motifs.

Opposite page: Figure 8. Embroidered and appliquéd mask, evidence of the influence of "Egyptomania" following the discovery of the tomb of pharoah Tutankhamun in 1922. This embroidery Tutankhamun, was used for the model of the same name, February, 1925.

Figure 9: "Le Juivre," 1922. A long tunic of silver lace with an overdress of bronze green velvet; open on the side, revealing lace detail. Two sections of velvet at the extremities are beaded and embroidered as well as the velvet dress being asymmetrically draped and tied to one side. With distinguished simplicity and refined detail, this ensemble pays homage to the modesty required of the Jewish women upon entering temple. The long stole could possibly double as a headcover in relation to ritual and ceremony.

bound volumes of beading and embroidery swatches that were forwarded to the creative directors of the embroidery ateliers and served as inspiration for new patterns.

After viewing thousands of Lanvin garments, sketches, and photographs, it is evident that Japan was an inspirational source she drew upon most. There is clear influence in the form of motif, color usage, silhouette, and construction technique. One of Madame Lanvin's most profound and subtle uses of Japanese motifs was a 1938 evening dress of navy blue silk taffeta. It is embroidered with a *mitsuboshi* (three star) family crest formed by a cluster of three mother-of-pearl discs, each topped with single silver cup sequin and silver-lined seed bead. "The *mon*, or family crest, is usually an abstract image drawn from nature such as a bird or a flower; in this case it is celestial bodies forming *mitsuboshi*, an abstraction symbolizing the three stars of Orion's belt."[1]

Japonism is a consistent influence on the design sensibilities of Madame Lanvin, and it influenced all areas of design—children's wear included. For "Carpillon," designed in 1924, a black dress is embroidered with a large carp motif in rich vibrant orange; this motif is repeated as trim on the sleeves and on the collar. Orange and black is a strong and sophisticated color combination for a child, yet it clearly evokes Japanese red and black lacquerwork. In Japanese culture, the carp is a traditional symbol of long life. (Page 59, Fig. 41-42)

It is typical for formal Japanese kimonos to be marked with a family crest. The resulting insignia is an excellent example of effective organized design achieved within strict design limitations. In order to serve as an identifier, each crest is unique and easily legible; by tradition, a *mon* is confined within a circle as part of the design or simply implied. A *mon* consists of two colors, but more accurately uses only positive and negative space—occupied and unoccupied space. They are composed from a minimum of design elements.

Organization of each crest evolves from clever and imaginative manipulation of variables such as the number of circles (always from three to eleven) contained in the design, the size of the insignia, and the direction of movement within. A powerful and elegant statement evolves from simplicity of design and austerity of organization. "Véronique" is an example of how a 1925 *robe de style* yields to the influence of a traditional *mon*, as seen in bold appliqué above the skirt hemline. (Fig. 17) Although there are more than three roundel motifs appearing on this skirt, the tradition of the *mon* requiring a motif confined within a circle—whether literal or implied—is fulfilled. Using only the circle as a design motif and varying the sizes and colors to create visual interest, a new design is created. The color restrictions are adhered to using light blue and black as the primary design colors and white, the lack of color or negative space, as the ground color.

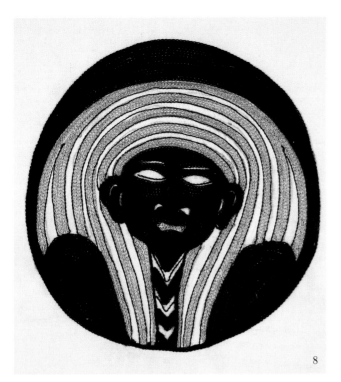

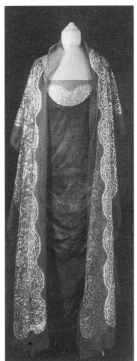

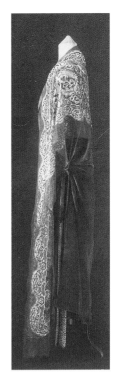

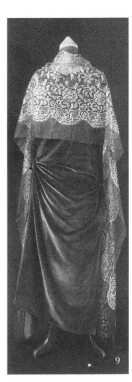

"Colombine," a creamy, crisp silk taffeta *robe de style* from the 1924 Paris collection of features a *mon*-like appliqué just above the dress hemline. Sliced down the center front bodice and peeled back lapels, a plunging V-neck reveals a silver-embroidered tulle *vestée* ending at the waist with a large crimson-velvet bow. Large circular compositions are formed from small circular black velvet appliqués outlined in large ivory pearls that reinforce the overall spherical motif. The use of white satin and black velvet adheres to mon tradition using only two colors and, more importantly, positive and negative space. (Fig. 18-19)

The simplistic form and pattern of the traditional Japanese kimono was deconstructed to suit the needs of the modern woman. Traditional Japanese technique dictates that a kimono is created from a single width of fabric that is cut down the center for half of the length allowing for a front opening and wrapping capability. Traditional floor length kimonos are longer, and Lanvin's versions are cropped to the waist or hip length and used as jackets. (Fig. 15 & 21) "The most important point was the rectangular cut that followed the warp and weft of the fabric and the unconfined garment that resulted from it."[2]

Applied square gold-tone metal plaques subtly imply the scaled armor of Samurai warriors on a Japanese-inspired silhouette of black and red silk taffeta. Guided by *mon* tradition, the diamond-shaped motif is found in groups of three, as the metallic embroidery intersects with a deep V-neckline at the

back of a Samurai-inspired bias-cut dress. (Fig. 20) The diamond motif, in triplicate, is repeated on the truncated sleeves of the kimono jacket. Contributing to the Japanese aesthetic of the garment are the flowing bias skirt panels of crisp silk taffeta, wide shoulder straps of a sleeveless dress, obi-style belt, and metal plaques implying oversize proportions of armor. The bias-cut technique applied to this dress is indicative of the late 1920s and the 1930s, in particular. It represents the taste for minimal construction as well as a long, sleek silhouette. The look and feel of bias-cut ensembles is intended to be "easy"—unconfined and unrestricted. Pierre Loti describes the kimono from a Western point of view: "It gives me great pleasure to look at them... especially the nearly excessive ease and looseness of the clothes [kimono] they wear. The sleeves are extremely large, and it could almost be said that the girls have neither backs nor shoulders. Their clothing seems to float around them, and like tiny, fleshless marionettes, their delicate bodies disappear within their voluminous robes."[3]

The Japanese kimono influence is more apparent in the short black jacket. The forty-two-inch sleeve opening reveals a lining of an intense red hue. The kimono jacket is cropped and "modernized." A bias-cut dress characteristically clings to reveal the figure while the square-cut jacket intentionally wraps to conceal. Madame Lanvin successfully modernized ancient Japanese costume and custom, eliminating all complicated technique necessary to dress a young woman in traditional kimono.

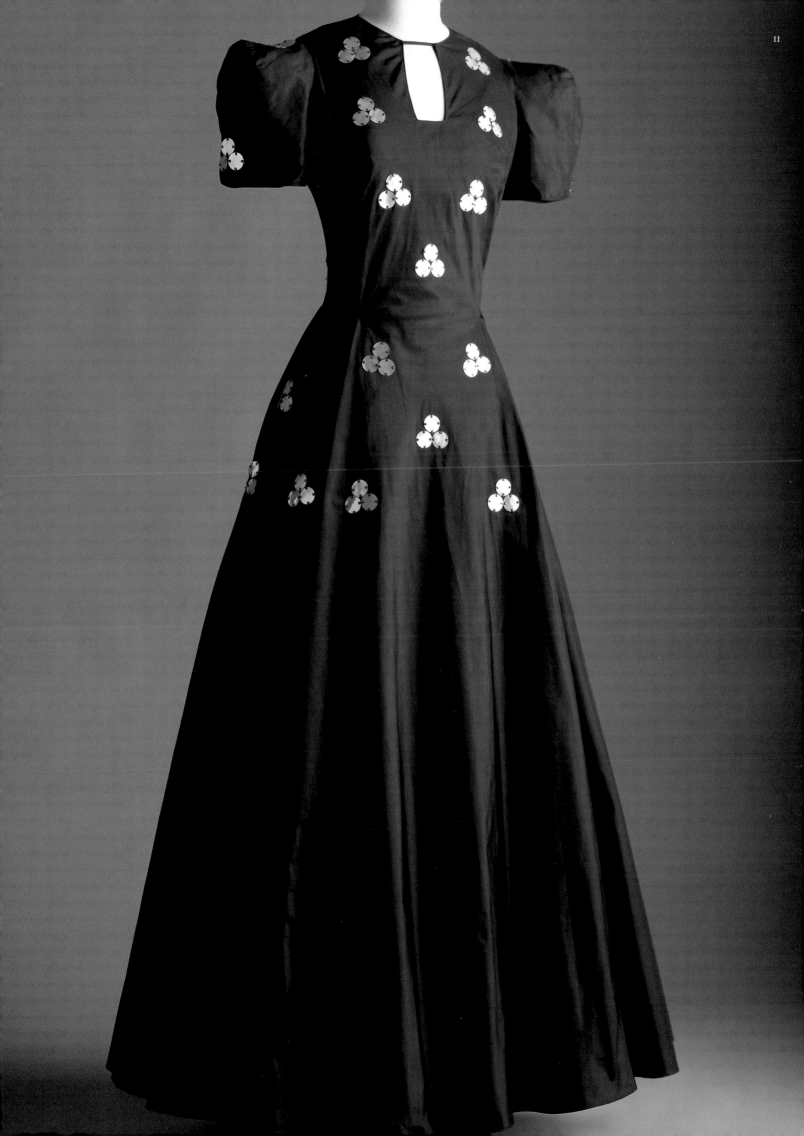

Preceding spread: Figure 10. Illustrations of form, movement, and direction, from the most subtle to the obvious, created within a traditional Japanese *mon* design. The circle, with no beginning or end, is a symbol of eternity, perfection, and completeness.

Figure 11. 1938 evening dress of navy blue silk taffeta embroidered with a *mitsuboshi* (three star) *mon* or family crest formed by a cluster of three mother-of-pearl discs, each topped with a single silver cup sequin and silver-lined seed bead.

Figure 12: Sporty red silk crepe drop-waist dress embroidered with a pair of fish positioned mouth to mouth. "Merveille de la mer" was designed for the Exposition of 1925.

Figure 13: Carp embroidery for "Aquarium" model of 1925. A strong geometric design was rendered in four colors of chainstitch embroidery for maximum visual effect.

Opposite page: Figure 14. Evening gown of cream-colored wool crepe, 1937-38, embroidered with silver sequins forming multiple carp shapes and air bubbles creating depth, dimension, and movement. In 1938, Madame Felipe Espil wore this dress to a social event at the White House.

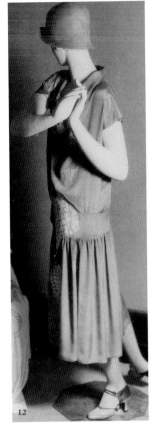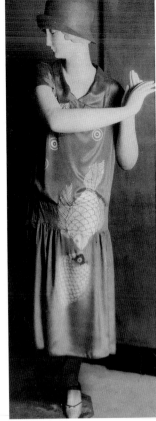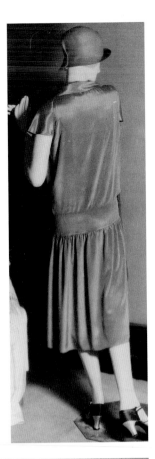

Chinoiserie also found its way into Lanvin's design rooms in the form of traditional iconography. Detailed hemlines of Manchu court robes, rendered in dense silk embroidery of intense primary colors, and with cloud, mountain, and water formations, are somewhat literally interpreted but executed in filmy, vaporous, monochromatic borders in direct opposition to the traditional method.

1 Quoted from Patricia Mears, curator of the exhibition *Japonism in Fashion: Japan Dresses the West* (Brooklyn Museum of Art, November 20, 1998-February 14, 1999).

2 Ibid.

3 Quoted from Akiko .Fukai, from the exhibition *Japonism in Fashion*, (Kyoto Costume Institute, 1996-97).

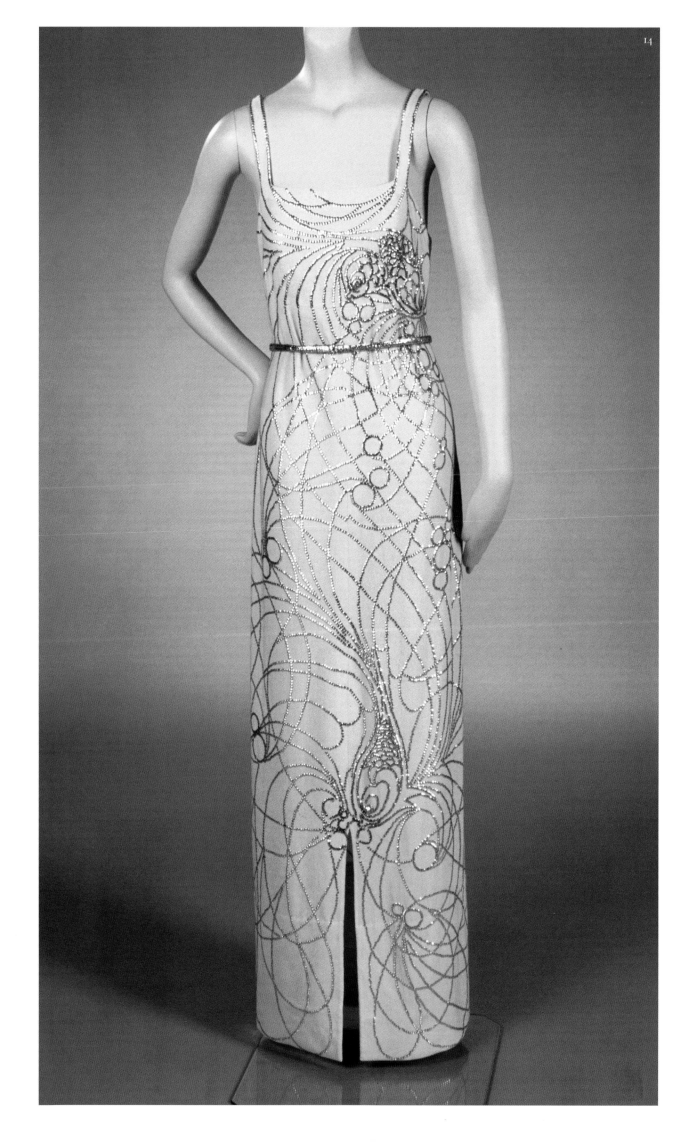

Figure 15: "Brimborion." Madame Lanvin slices the deep sleeves of the traditional Japanese kimono into ribbons, two shades of blue, revealing the rose-colored lining. By incorporating deconstructed sleeves, no wrapping front, and a truncated waist, she has updated an ancient form. 1923.

Figure 16: Appliqué detail of "Véronique," Velvet circular appliqués on tulle, 1925.

Opposite page: Figure 17. "Véronique." *Robe de style* of black and white silk taffeta accented with a light blue taffeta sash. The medallion *mon*-inspired motifs are velvet circles appliquéd onto white silk tulle and trimmed with black lace scallops.

Following spread: Figure 18. Ivory silk taffeta *robe de style* of winter, 1924-24. Appliquéd medallions of silver lamé are outlined in pearls re-enforcing the repetitive circular motif. The roundel appears on the skirt three times: twice on either side of the front skirt and once on the back.

Figure 19: Rendering of "Colombine," 1924. Bouffant *robe de style* of cream-white silk taffeta on which large circles of black silk velvet are appliquéd and edged with white pearls. A fitted taffeta bodice is complete with a silver re-embroidered *vestée* while a large rust-colored velvet bow appears at the center front dropped-waist.

15

16

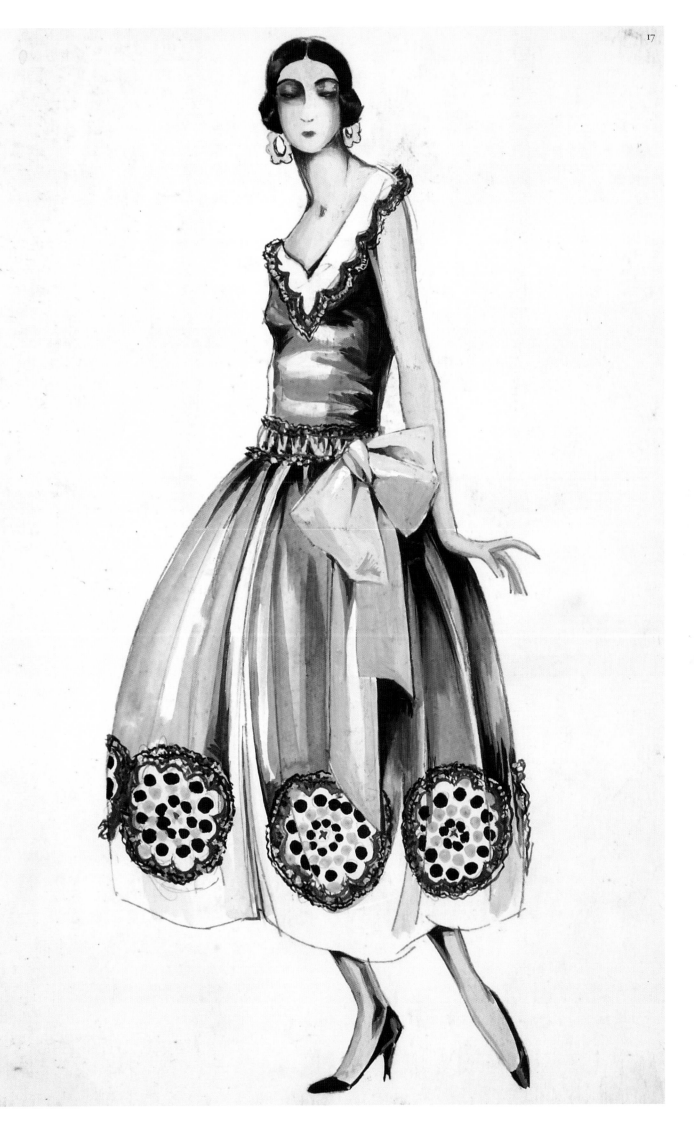

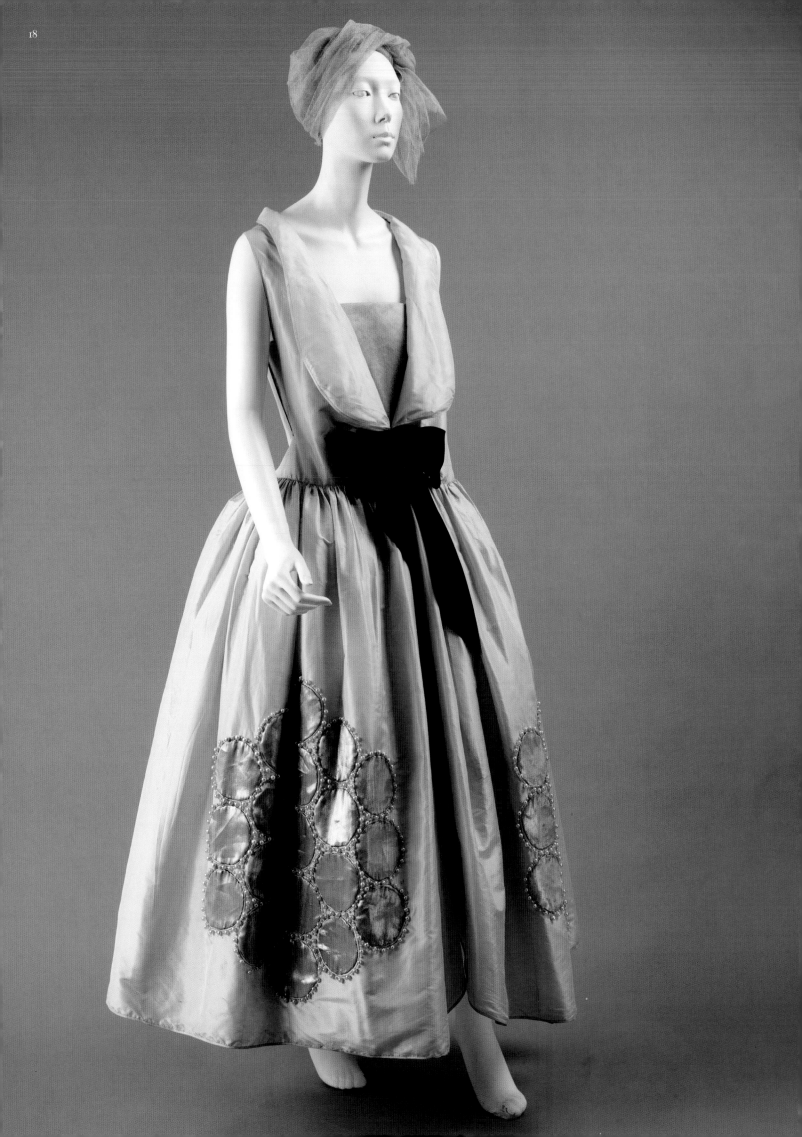

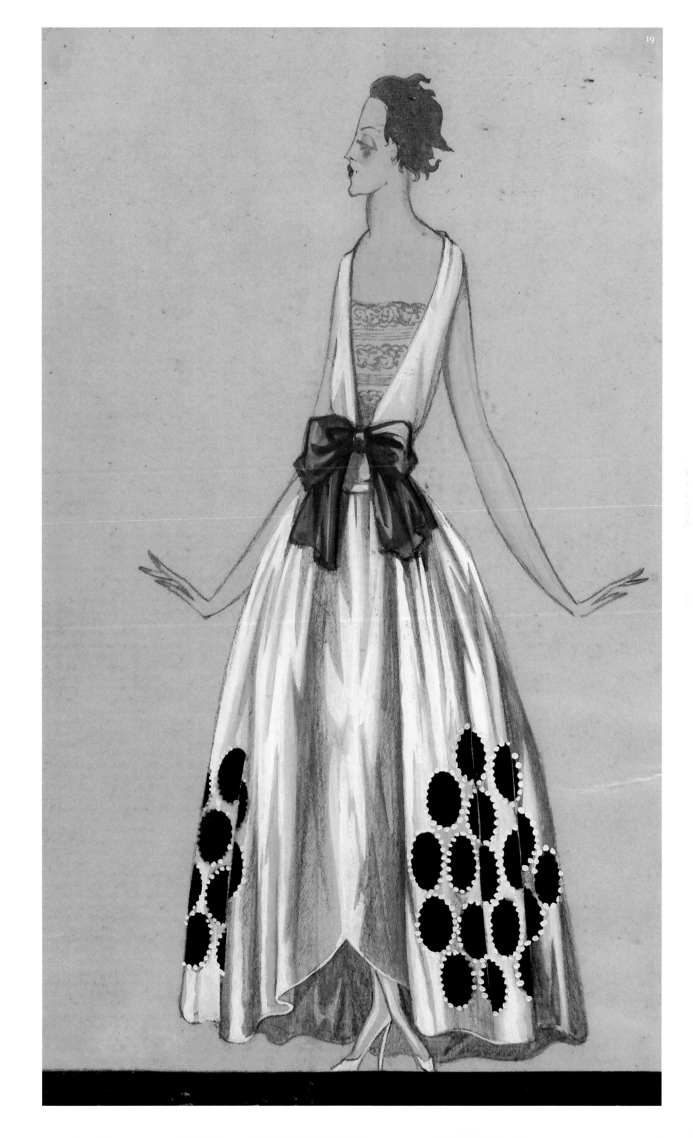

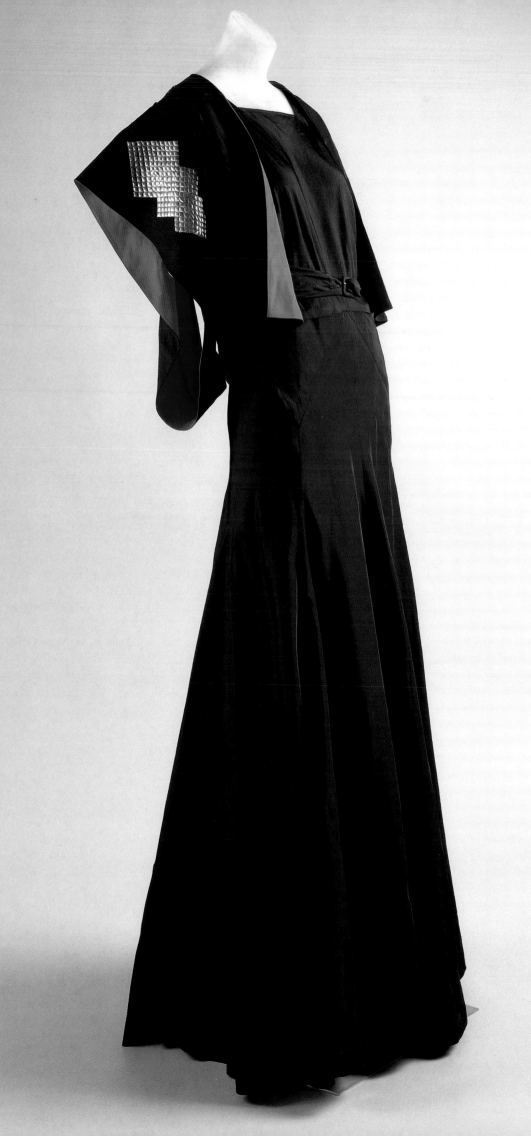

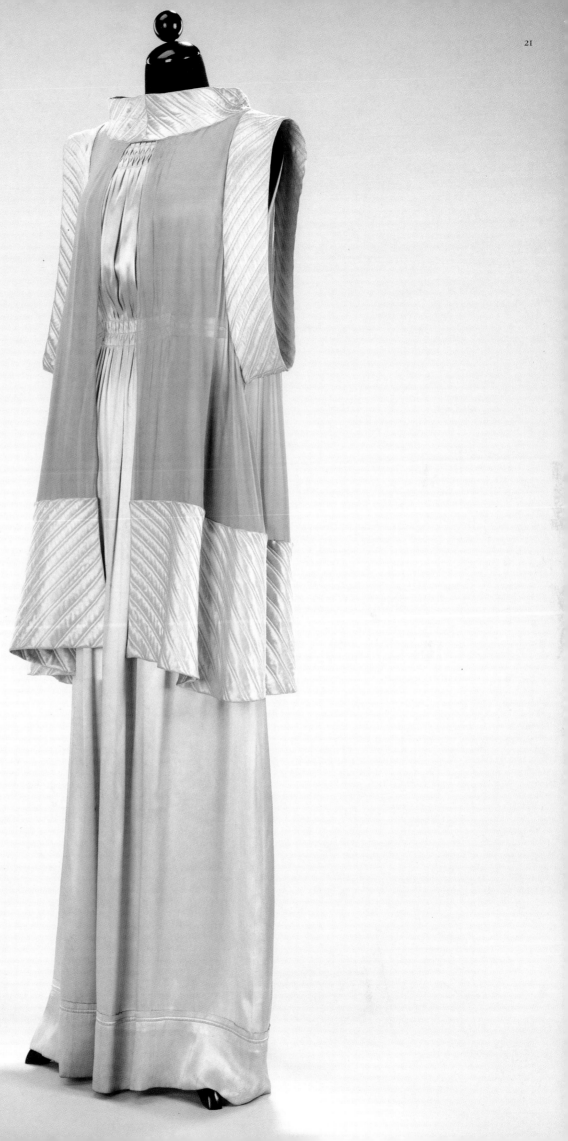

Preceding spread: **Figure 20.** Two-piece evening ensemble, 1934. Truncated kimono jacket of black and red silk taffeta embroidered with gold-toned metal diamond-shaped plaques. Black silk bias-cut dress with the same metal embroidery.

Figure 21: Monochromatic sleeveless floor-length silk satin dress with self-fabric drawstring waist and decorative open-welt seam detail at the hemline. The flared kimono-style jacket of silk georgette features a deep armhole similar to that of a kimono, minus the cumbersome long flowing sleeves. The armholes, neckline, and hemline of the jacket are bordered with diagonal trapunto-stitched satin, 1935.

Right: Figure 22. Traditional Japanese aesthetic interpreted into an evening bag of red lacquer, embellished with black Japanese characters. Red tassels and onyx beads anchor the bottom of the structure while a braided cord and ivory *netsuke* create the wrist strap, 1920-21.

Figure 23: Japanese-inspired parasol/pinwheel motif. Solid black concentric circles rendered in chainstitch embroidery are filled in with filigree-like red chainstitch embroidery. 1921.

Opposite page: Figure 24. Black silk taffeta belted dress with Japanese *obi*-inspired back detail. The *obi* belt of red and cream silk taffeta, appliqued onto black taffeta, is trapunto stitched with silver metallic thread, summer 1928.

Following spread: Figure 25. Navy blue silk velvet beaded in the style of Chinese Manchu court robes using the symbols of water, mountains, and sky. The pattern is executed with cut bugle beads in primary colors of red, blue, and yellow highlighted with silver. From the 1917-19 collections.

Figure 26: Having purchased many exotic textiles fragments and complete garments from various vendors—the Chinese in particular—Madame Lanvin consistently referred to these objects for color combination, pattern, motif, and embroidery technique. Traditional symbols of peonies, butterflies, and seashells have been cut away from the supporting textile or garment, while the metallic gold cording forms the arabesques that hold the motifs together.

Figure 27: Antique swatch of Chinese rondels.

Figure 28-29: *Robe de style*, "Vuilleur de Nuit," summer 1924.

Pages 166-167: Figure 30-31. Overall view and detail of black taffeta dress with Chinese-inspired embroidery of silver metallic sequins and chainstitch. 1926.

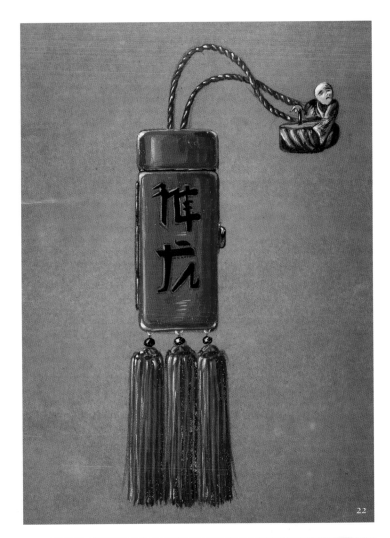

22

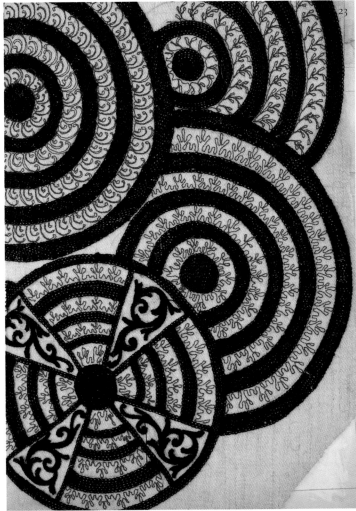

23

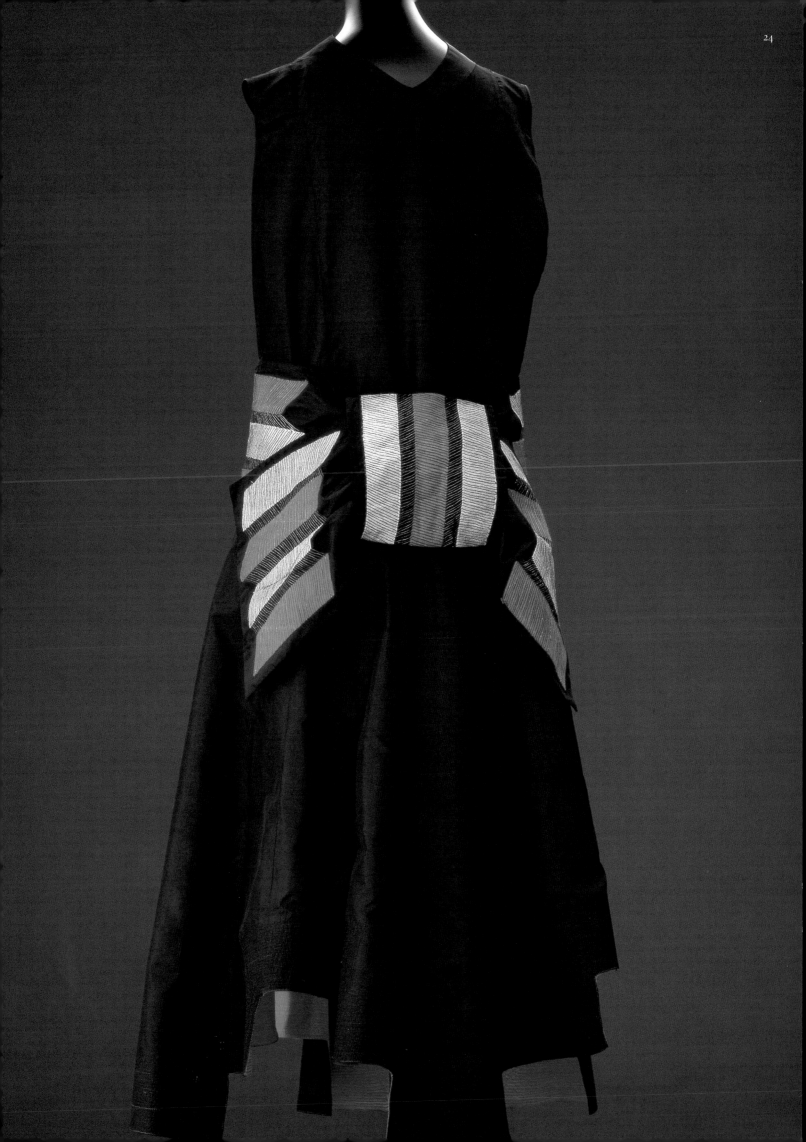

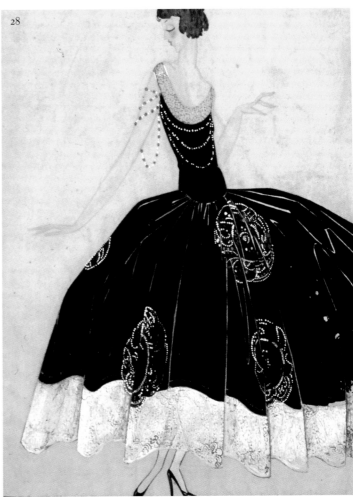

25

26

27

28

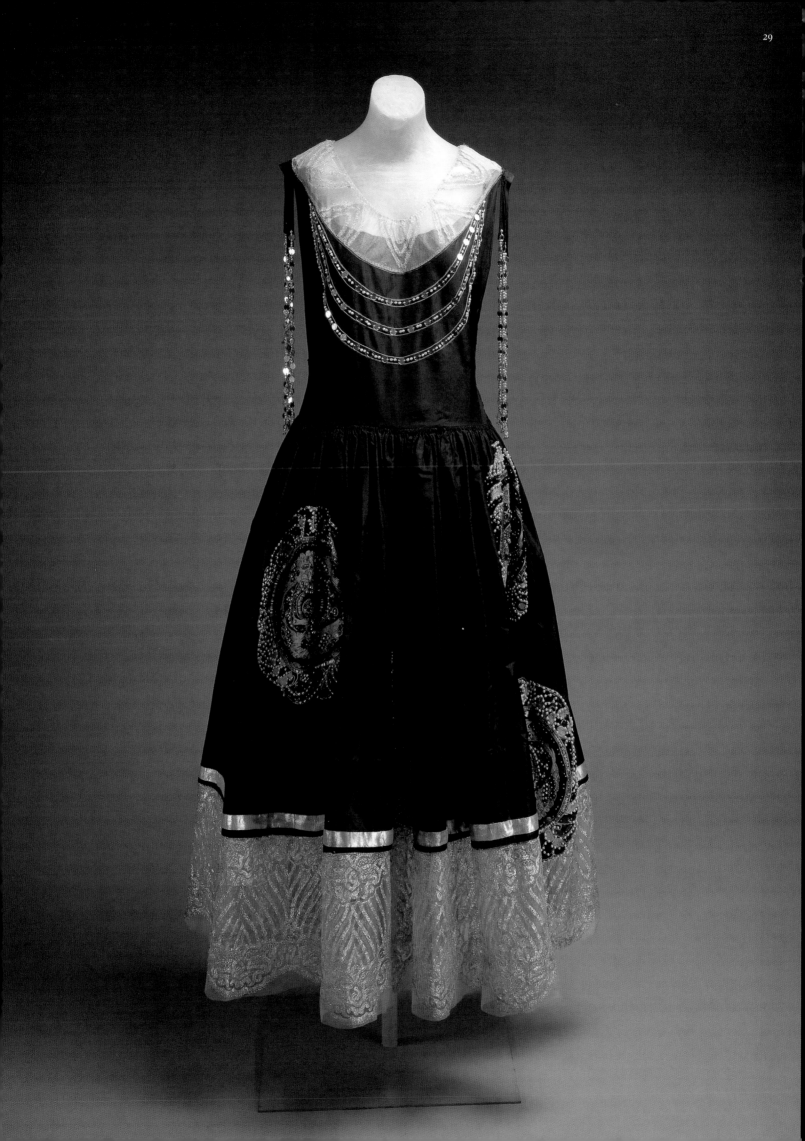

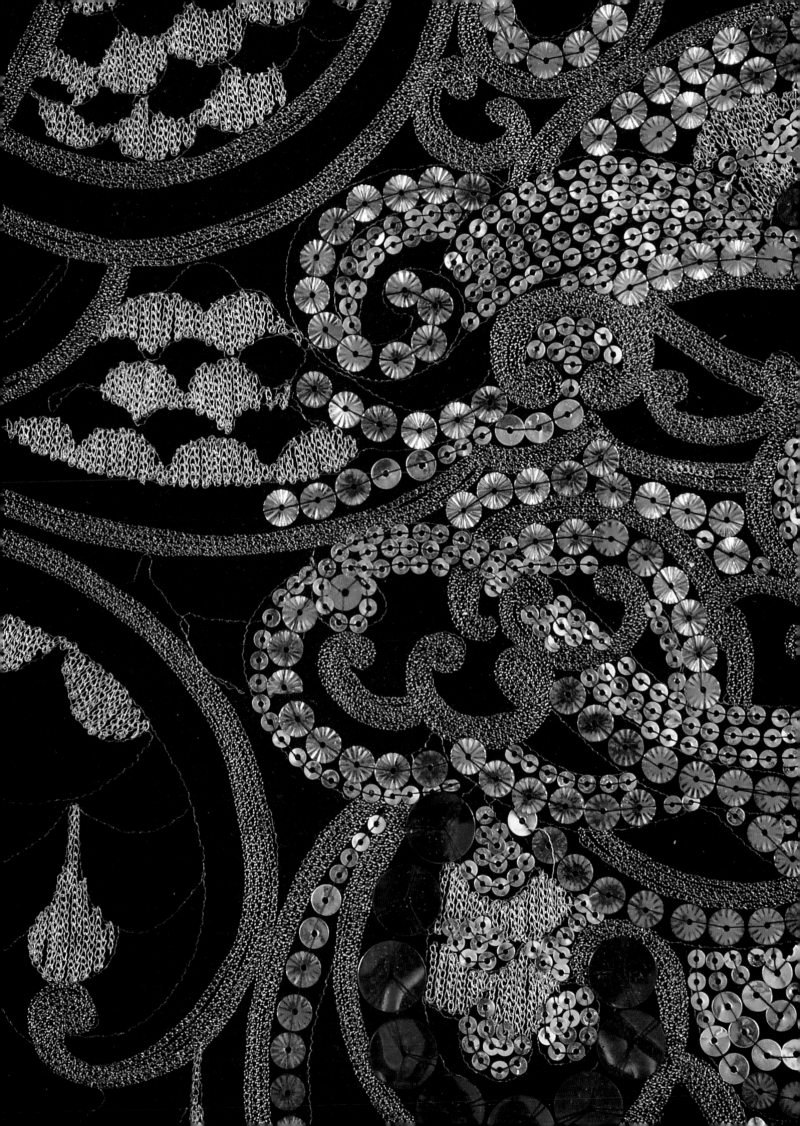

FAMILIAL SYMBOLISM

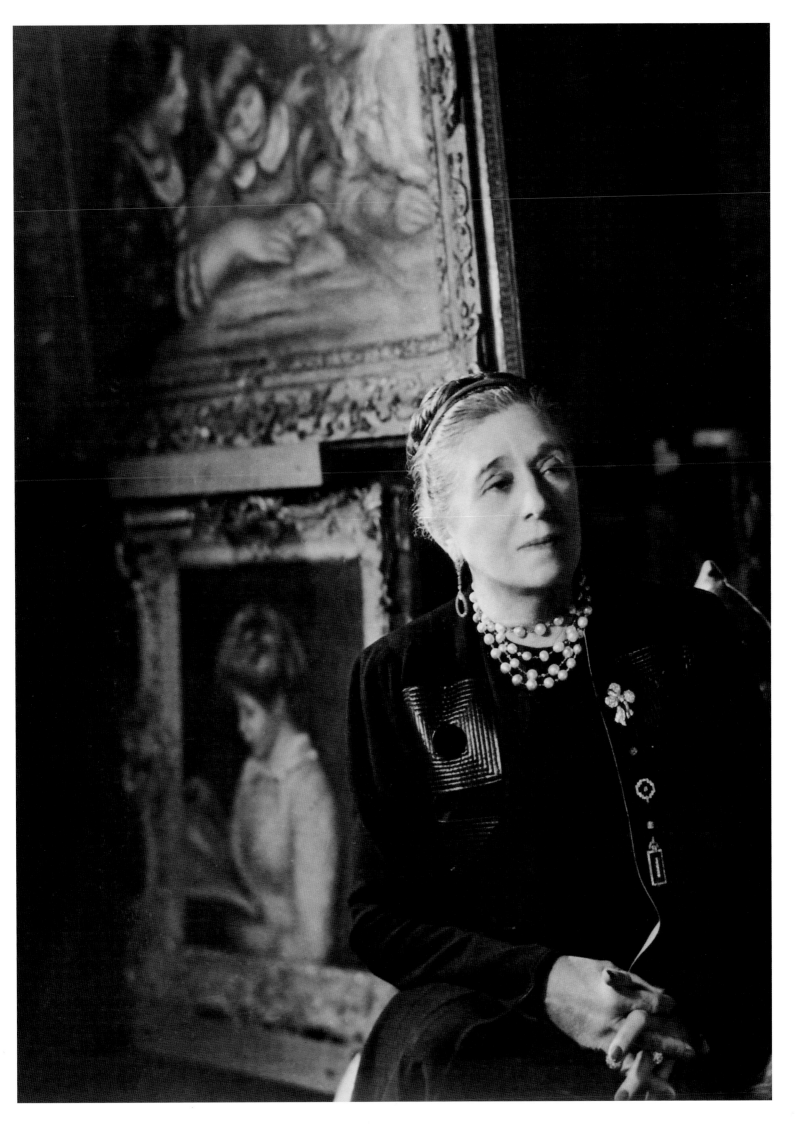

Previous page: Figure 1. Madame Jeanne Lanvin photographed in her home, 16 rue Barbet de Jouy, with Renoir paintings in the background, a small part of her vast collection of fine art. 1937.

Right: Figure 2. Jeanne Lanvin and Marguerite Marie-Blanche preparing to attend a costume ball, 1907.

Opposite page: Figure 3-4. Symbolic emblems rendered in embroidery including the four-leaf clover, interlocking knot, and a Japanese mon-inspired composition, summer 1921.

Figure 5: "Vermillon," 1913.

Figure 6: Symbolic flora embroidered in red on a field of silver lamé. 1925.

FAMILIAL SYMBOLS appear consistently in Lanvin designs, in particular the daisy or *marguerite* (her daughter's namesake), the three-leaf clover or *tréfle*, and a three-part Japanese *mon*—a symbol of kinship frequently represented by a cluster of three elements. Other symbols often found in her work include circles and related formations that create a never-ending cycle; and the bow, signifying an eternal tie or bond. Flora used within motifs, such as laurel leaves, bay leaves, ivy, and evergreens, all embody notions of perpetual life, love, and vitality. These familial symbols are found individually or in combination. (Fig. 3-4)

Over many decades, the bow motif appeared repeatedly in photographs and illustrations of Madame Lanvin and Marguerite Marie-Blanche. (Fig. 1 & 7) A bow brooch was a particular favorite and Madame Lanvin wore it often on hats or lapels. After her death in 1946, Marguerite Marie-Blanche wore the pin in memory of her mother. Created by Van Cleef & Arpels, it was described as "an art deco diamond bow brooch pavé set with old European-cut diamonds, circa 1920."[1] It was sold through the St. Moritz branch of Christie's auction house in February 1998.

Several styles in the many bound volumes of Lanvin fashion illustration bear the name Marguerite or Marie-Blanche. Photographs and illustrations prove that if a dress or an ensemble was designed for Marie-Blanche, the design bore her name. The direct relationship between the maturation of daughter and Lanvin design is intriguing: the founding of the childrenswear business coincided with the wardrobe needs of Marguerite; hence, the birth of a new segment of the Lanvin business. As Marguerite matured as the muse of her mother, so did the Lanvin style.

Reminders of the Lanvin mother-daughter relationship are present throughout every collection as a symbol, or beaded or embroidered motif. It was common practice for Madame Lanvin to name each new style, and many are named "Marie-Blanche." It was also not unusual that a presentation rendering of a model or ensemble bearing the daughter's name would have a strong facial resemblance to the real Marie-Blanche.

1 *Christie's Auction Catalog.* (St. Moritz, February 1998), np.

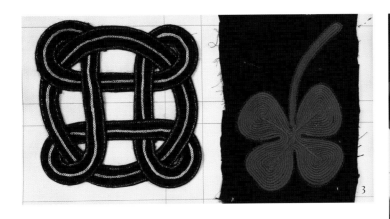

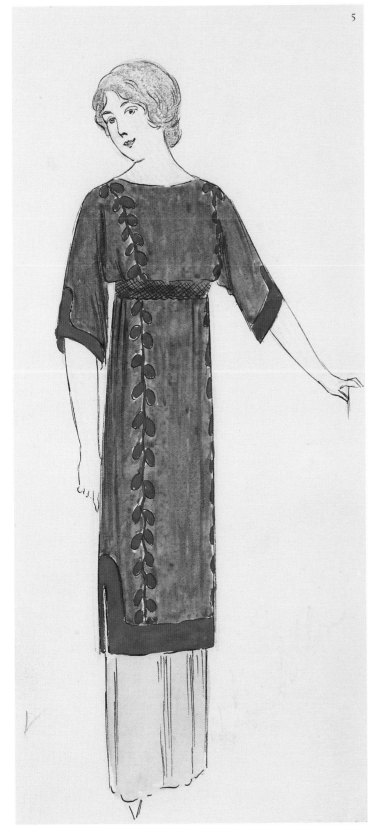

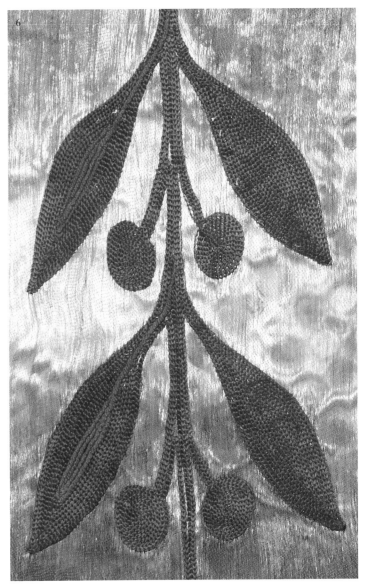

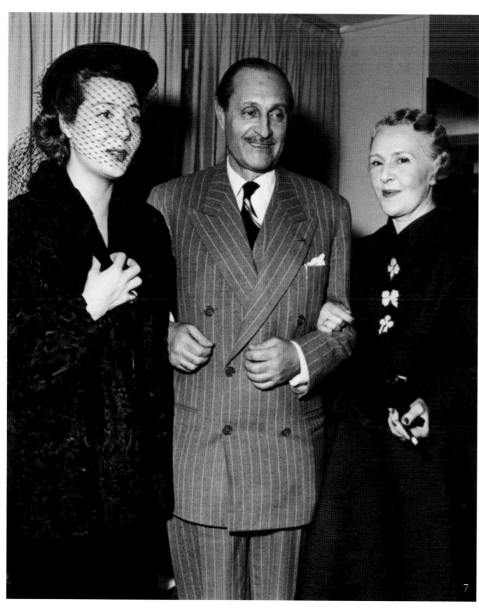

Figure 7: Marguerite Marie-Blanche (right), accessorized with three *diamanté* bow brooches, circa 1950.

Figure 8: Floral bouquet tied with a bow executed on a foundation of silk tulle, 1929. The abstracted motif is rendered with rich texture and tonality achieved through the use of ribbons. Ribbons are sewn "on-end" to the tulle, while folding the ribbons back and forth, filling in the desired shape. This technique creates a three-dimensional aspect to the tonal rendering achieved through color usage, but also by changing the folding direction of the individual ribbons.

Opposite page: Figure 9. Black silk chiffon evening dress with plunging back neckline. Seven *diamanté* bow brooches are the only embellishment on this otherwise simple design. Created for the collection of winter 1948-49. Marie-Blanche was at the design helm of Lanvin until 1950.

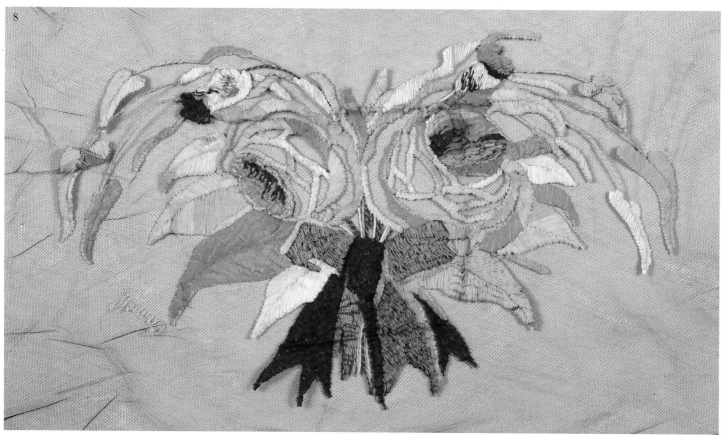

Opposite page: **Figure 10.** Back view of Figure 9.

Figure 11: Crystal bow embroidery, circa 1933.

Figure 12: Marguerite Marie-Blanche (far right) appears in an advertising campaign for Lanvin, continuing her role as muse. *Vogue* 1932. Photographed by George Hoyningen-Huene.

Figure 13: Silk chiffon appliqué secured by silver metallic chainstitch onto a silk chiffon foundation. The flower petals are outlined with silver-lined bugle beads, while the overall flower is outlined in pearls. Pearls are used again to enhance the leaf structure as well as the scrolling stems. Date unknown.

Figure 14: "Marguerite," or daisy embroidery, executed with wool yarn on silk chiffon, 1920s.

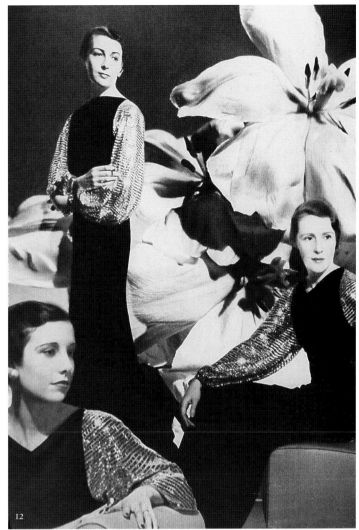

CATHOLIC SYMBOLISM

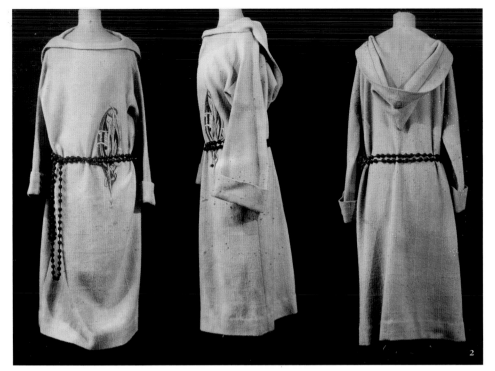

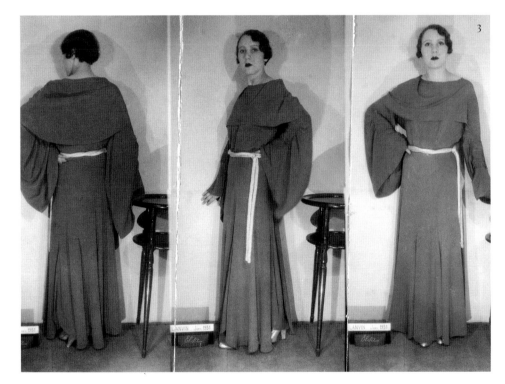

Previous page: **Figure 1.** The office of Madame Lanvin holds designs from the Childrenswear collection of 1911. Many of the volumes were custom-covered and embroidered to suit the taste of Madame. A a cream and gold-brocaded ecclesiastic textile was used for this particular example only to be embroidered with gold metallic sotuache.

Left: **Figure 2.** "Penitente." A stylized monastic robe with embroidered motif and beaded rosary-like belt.

Figure 3: "Elsa," 1930-31. Simple monk-like robe with bell sleeves, draped neckline, and twisted metallic rope-like belt. Franciscan monks wear rope belts with three knots, symbolizing the vows of chastity, poverty, and obedience.

Opposite page: **Figure 4.** Ivory silk chiffon dress—a non-panniered *robe de style*—with gold lamé ribbons applied across the bodice create a cruciform motif. Additional ribbon streamers, attached at the dropped-waist, are placed at both the side seams and center front. White glass seed beads, arranged in a geometric border motif, are used to attach the ribbon to the chiffon and serve as a foundation for additional beading, 1922.

FRANCE ASSUMES THE TITLE of "oldest daughter of the Roman Catholic church" and has contributed saints, popes, anti-popes, theologians, and missionaries to the Church. Marriage, family, the raising of children—and their ecclesiastical education—carried the weight of sacrament for much of France's long history, and religious icons and symbolism were an important part of Jeanne Lanvin's heritage and ideology.

The finery and regalia of the Church—vestments, accessories, and headdresses—are consistently drawn upon as inspiration for designs. In naming designs, saints and sinners are referred to by name including "Saint Catherine," the

patron saint of virgins and philosophers who was martyred because she was a Christian. Her feast day is known as *fête des vielles filles* (festival of old maids), celebrated by unmarried women over the age of twenty-five.

Variations of monk robes and implied rosary beads appear consistently as well as nuns' habits that are easily translated into bridal veils. Angels, cherubim, and seraphim are represented in abstract forms but typically referenced to the religious paintings of Fra Angelico.

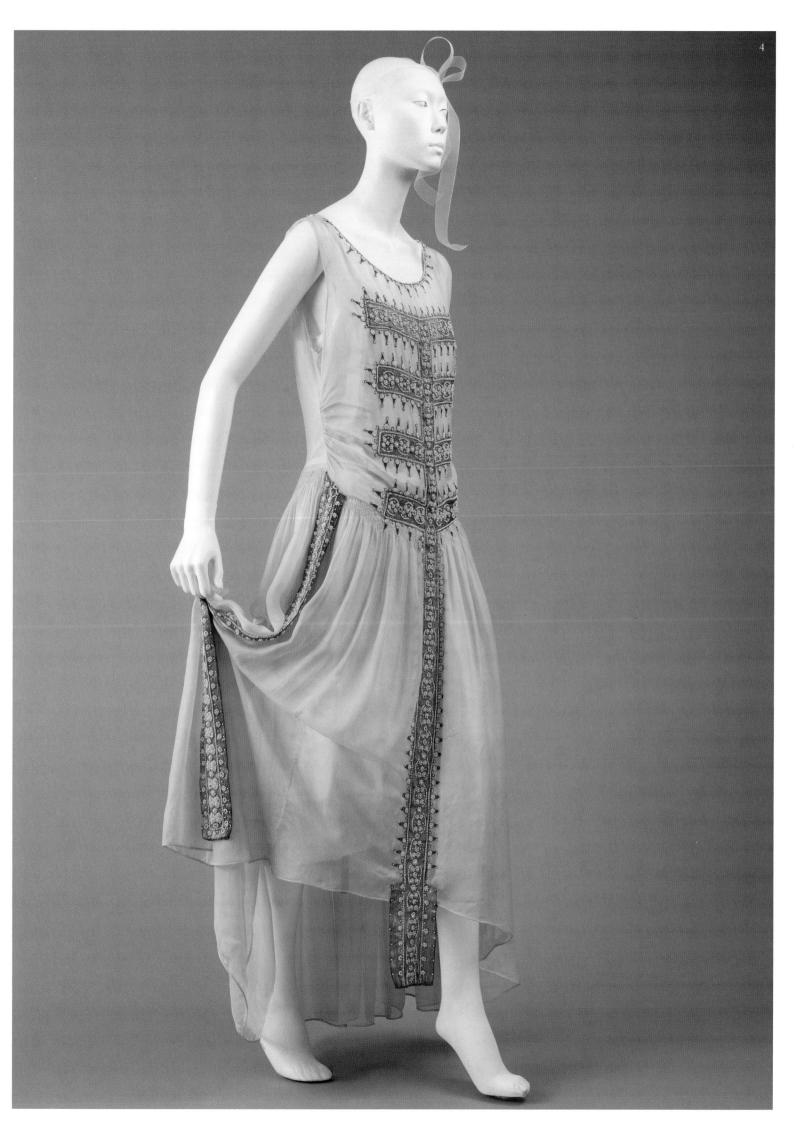

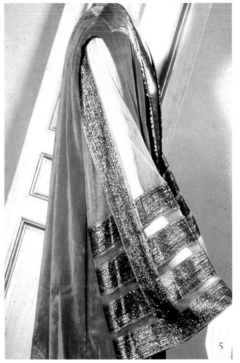

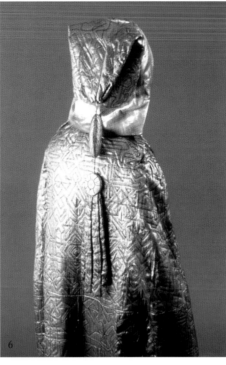

Figure 5: *Robe d'intérieur* in the style of monastic costume. Underdress of gold lamé with v-neckline and modest length. Overjacket of red-orange silk velvet with a gold lamé scalloped border. Sheer silk chiffon sleeves are appliquéd with gold lame bands. 1925.

Figure 6: Embroidered monastic cape of silver lamé. The non-functional, oversized hood is finished with a self-fabric oblong pendant and large tassel. "Claire de Lune," May 1925.

Figure 7: Black dinner dress. The singular ornament in this ensemble is an asymmetric draped sash of stainless steel beads arranged in a rosary-like formation. *Les Modes*, circa 1914.

Figure 8: Within the Lanvin millinery atelier, the tulle hood (in Figure 9) is fitted on a co-worker, from around 1930.

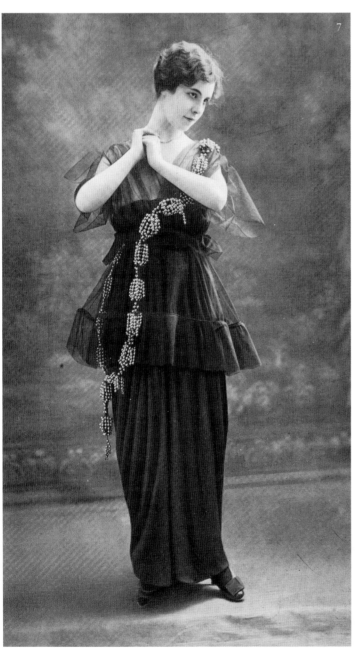

Opposite page: Figure 9. Shoulder cape of black silk tulle formed from concentric bands. Gathered at regular intervals and punctuated with a cluster of four gold sequins, elliptical voids were created. Although styled after the highly functional and utilitarian monastic wool capes and cloaks, this version is luxurious. A decorative evening accessory of lightweight silk tulle, it barely covers the shoulders. From the 1930s.

Following spread: Figure 10. Evening dress, 1936, loosely fitted and gently waisted; the angels wear a similar silhouette in the frescoes of Fra Angelico.

Figure 11: Detail of gilt kidskin strips appliquéd onto a white silk chiffon signifying purity, 1936. An identical linear pattern is present on some of the angel robes painted by Fra Angelico.

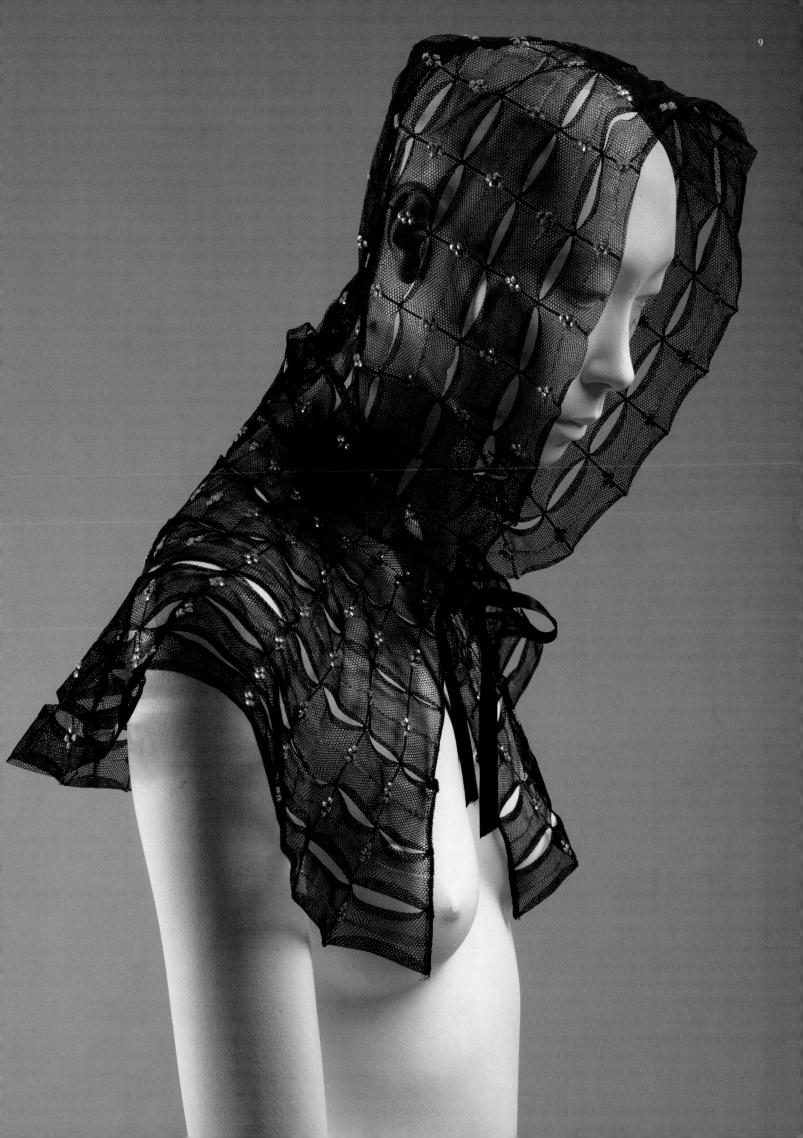

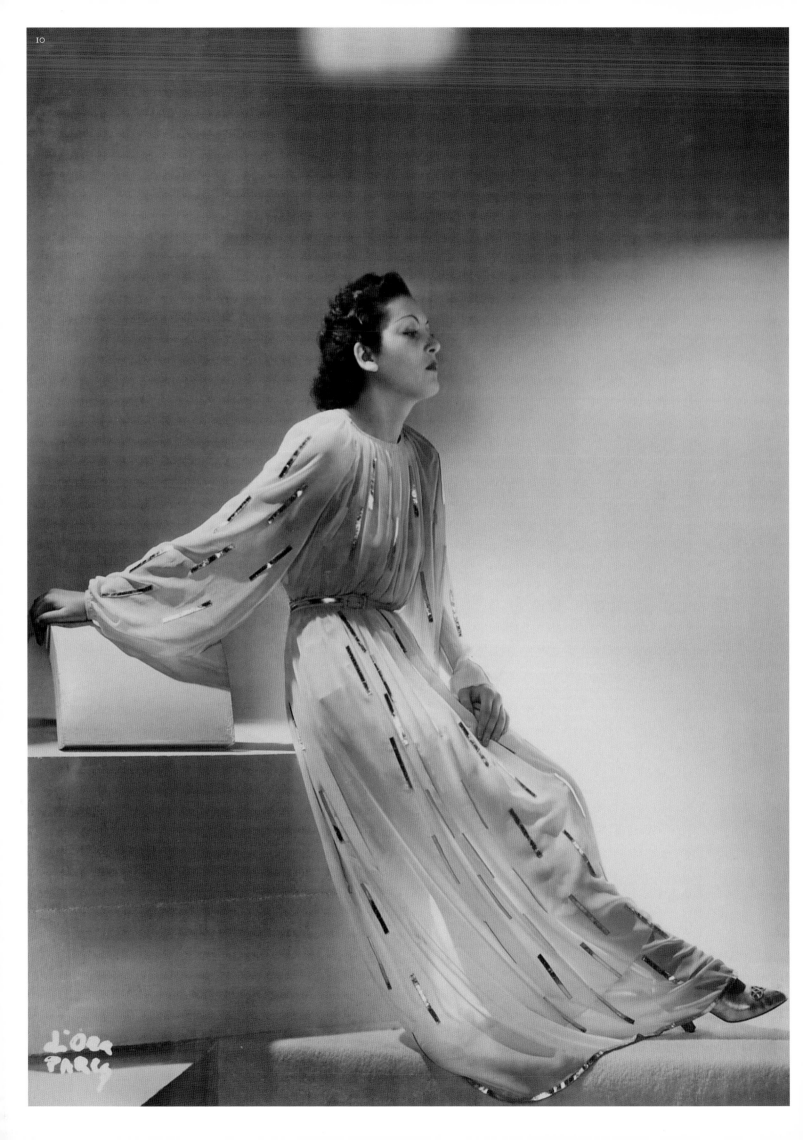

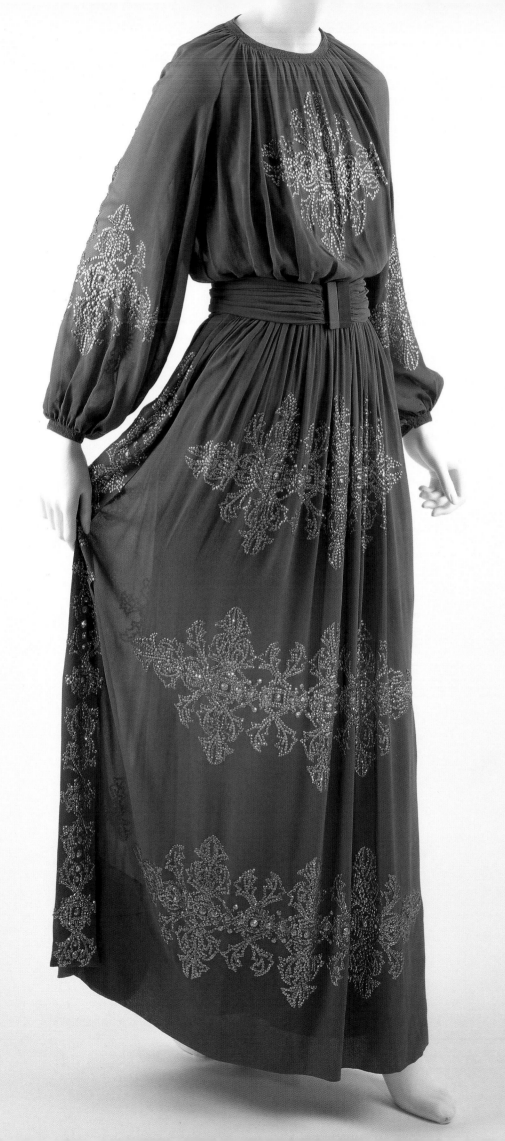

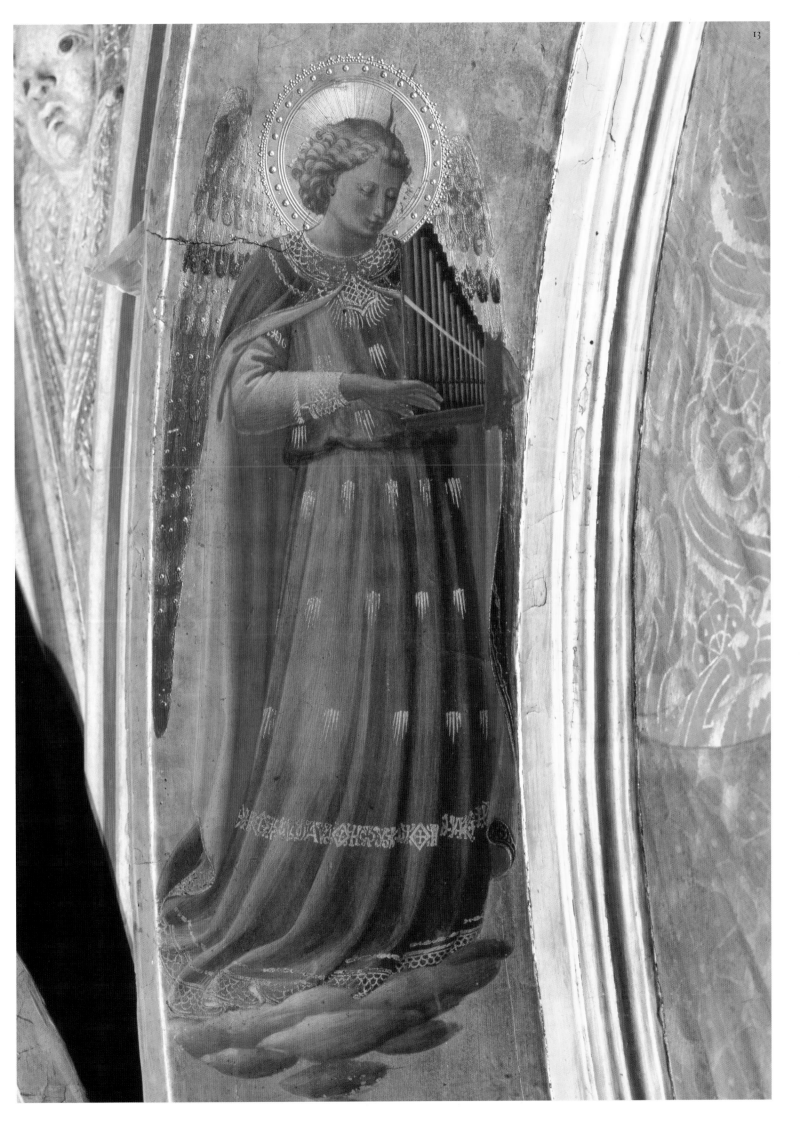

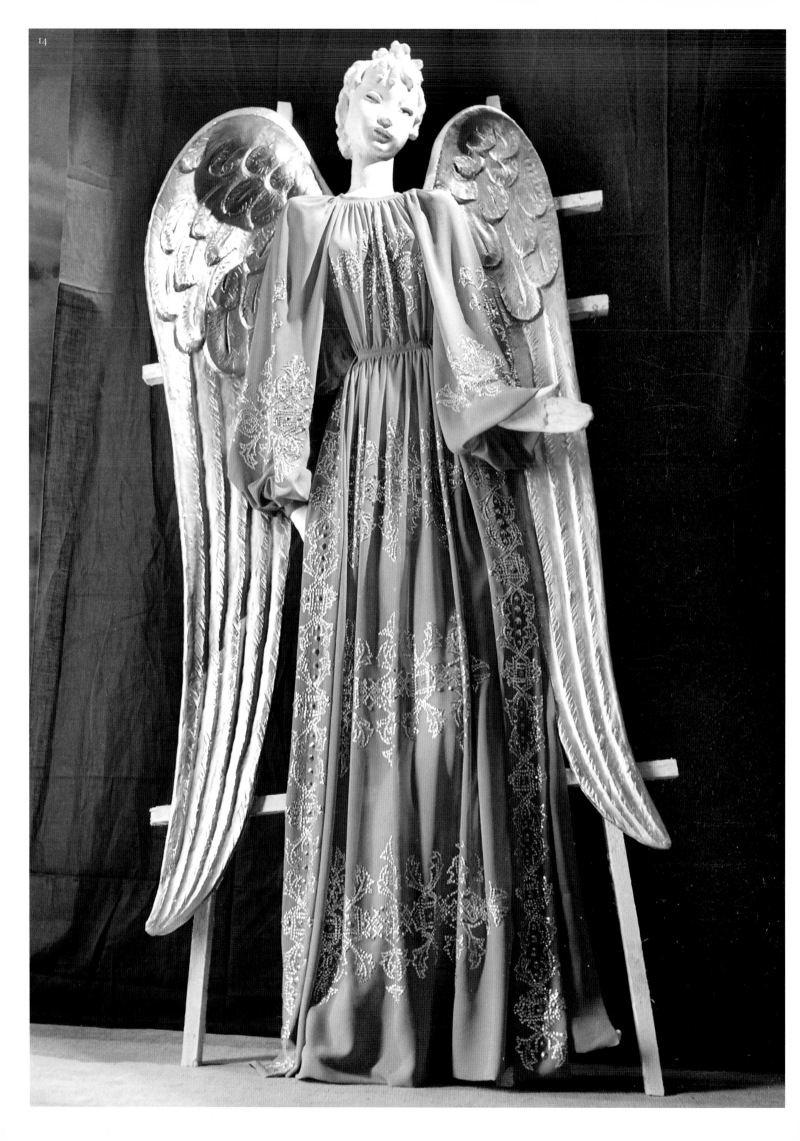

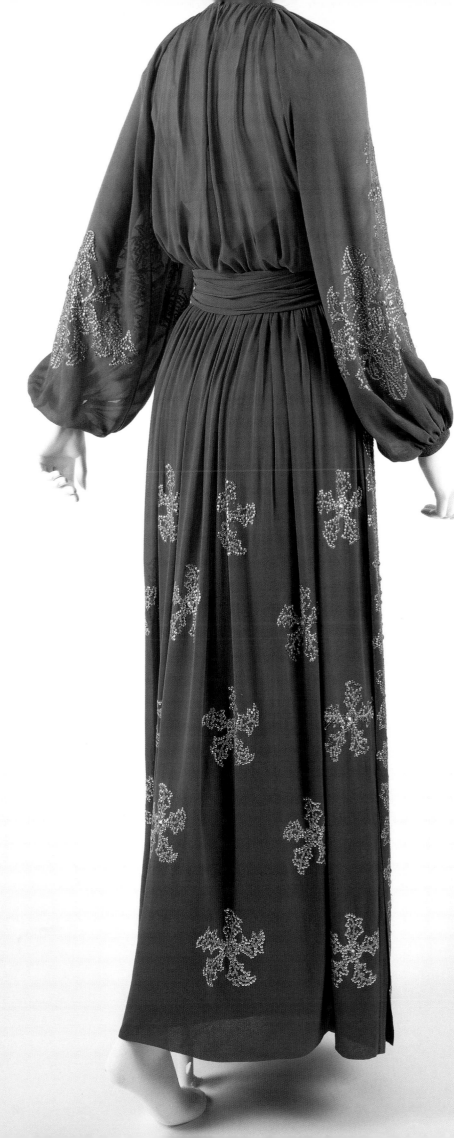

Figure 12 (Preceding spread) & 15: "Lanvin blue" silk crepe dinner dress in yet another silhouette similar to the angelic robes found in the frescos of Fra Angelico. Embroidered with silver and gold sequins, medallion-like motifs differ in style from the front to the back of the dress. The crepe streamers that flow at the side seam feature an additional embroidery pattern, 1939.

Figure 13: *Angel with Organ* by Fra Angelico (1433). Egg tempera on plaster. Detail from the Linaiuoli Altarpiece in Florence, Italy.

Opposite page: Figure 14: "The Parisian Elegance Comes to New York." Madame Lanvin presided over and organized l'Exposition de New York, July 1939. As the participating couturieres used plaster mannequins on which to show their latest creations, Jeanne Lanvin used an angelic form on which to feature her dinner dress.

Following spread: Figure 16-17: "Concerto", cream silk crepe robe with separate black celluloid collar. Full sleeves shaped with darts and seams allude to the billowing sleeves of angel robes and choir members. The separate collar, fitted over the shoulders, was created from three-dimensional black celluloid pyramidal shapes mounted on a foundation of black tulle. While giving the visual impression of volume and heaviness, the collar is amazingly lightweight. The slick shiny surface of the celluloid contrasts masterfully with the matte finish of the silk crepe dress. Collection of 1935.

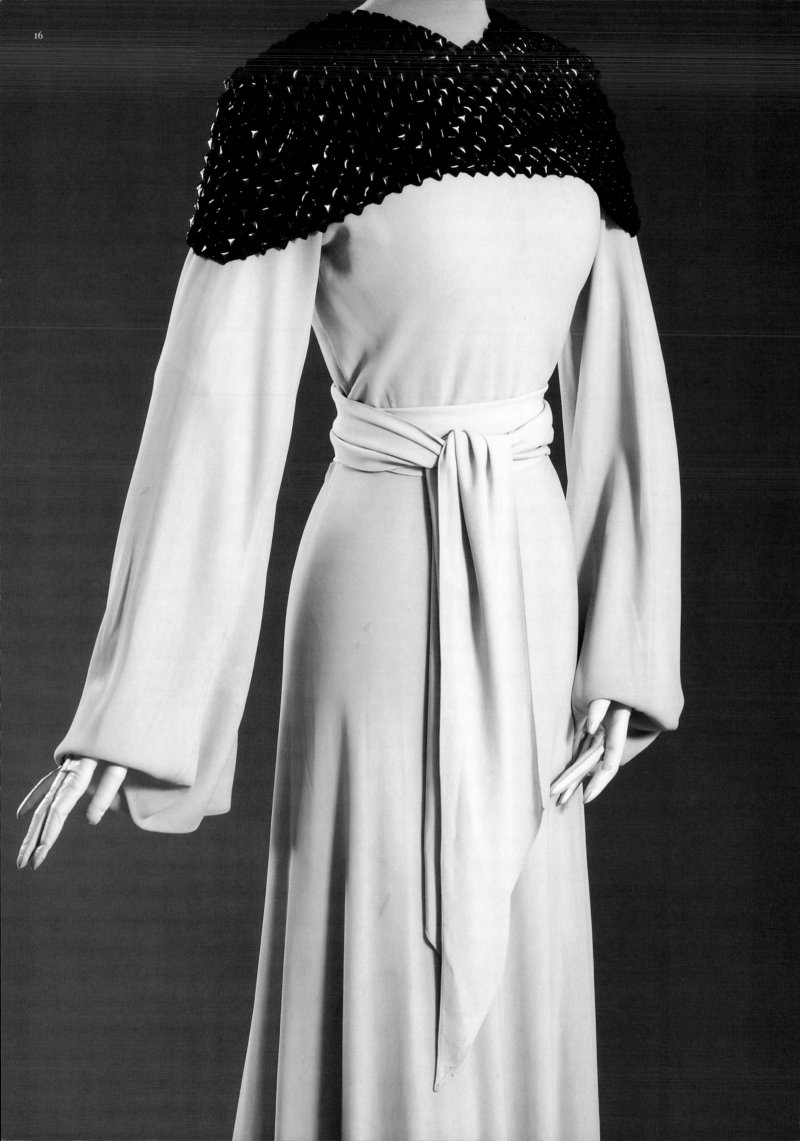

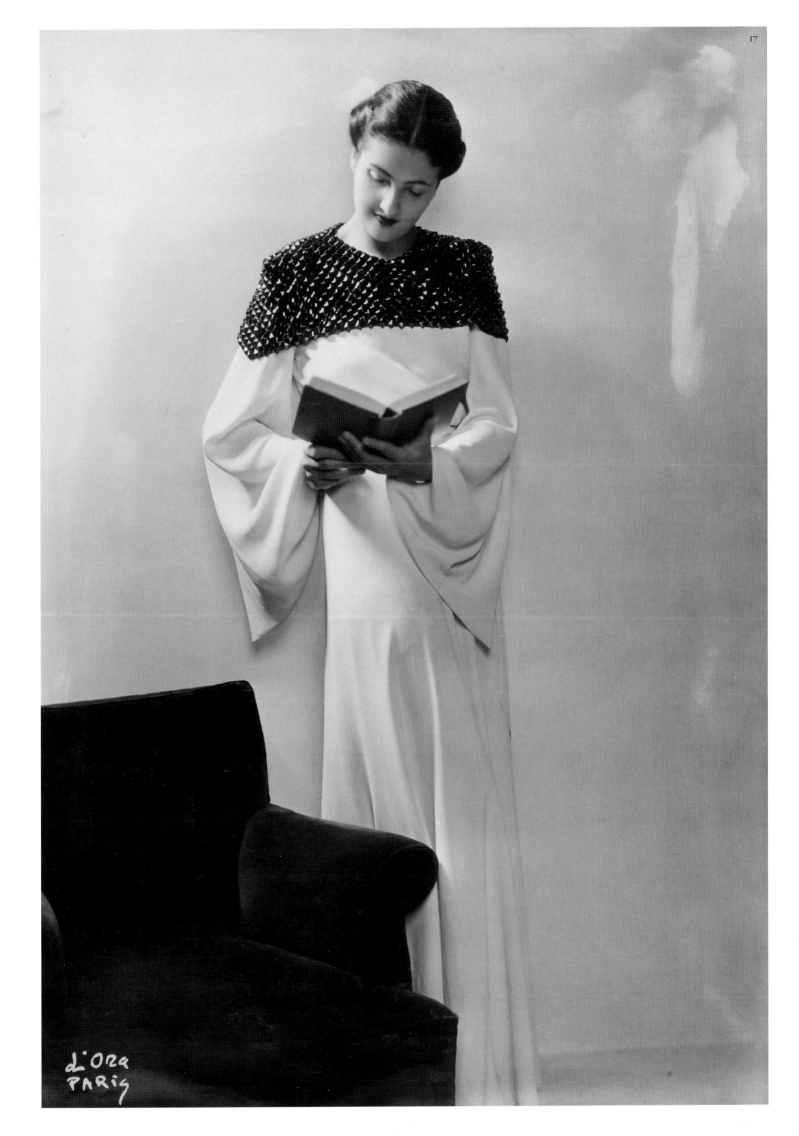

Figure 18: In a millinery form similar to the Bishop's miter, executed in black tulle, the exotic motif is rendered in highly opalescent mother-of-pearl discs. 1920.

Figure 19: "Le Cloître," The monastic inspiration for this ecclesiastic dress, shoulder cape, and millinery choice.

Figure 20: "Lanvin blue" velveteen coat with shaped sleeves and full swing-back. It is embroidered across the chest and upper-arms with alternating rows of gold cording and single rows of gold sequins. Although it is a single row of sequins, they are inverted cup sequins, in a stack of four and linked from stack to stack by the exposed thread, evoking the feeling of impenetrable armor worn by that of Joan of Arc. The color blue signifies divine love, truth, constancy, and fidelity, winter 1939-40.

Opposite page: Figure 21. "Bernadine." An oversized black dress cinched with a long white rosary, and a habit of a black veil draped over a white cap. It is no coincidence that this gouache recalls popular devotional pictures of Saint Bernadette of Lourdes. 1923.

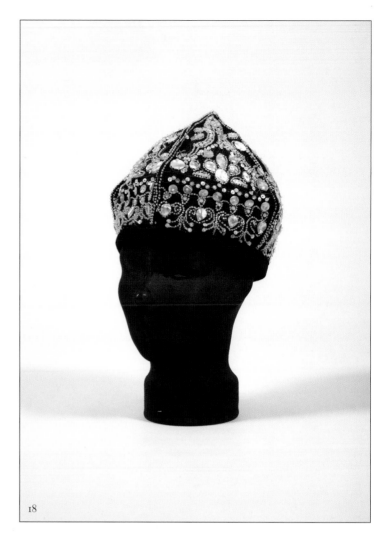

18

19

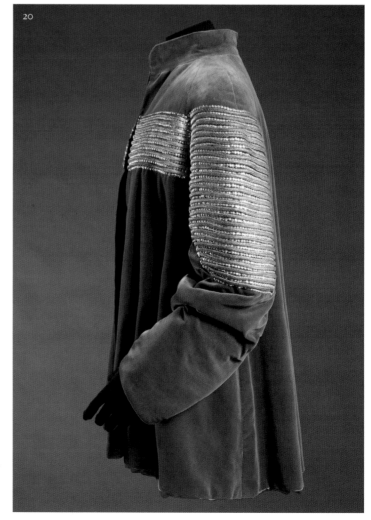

20

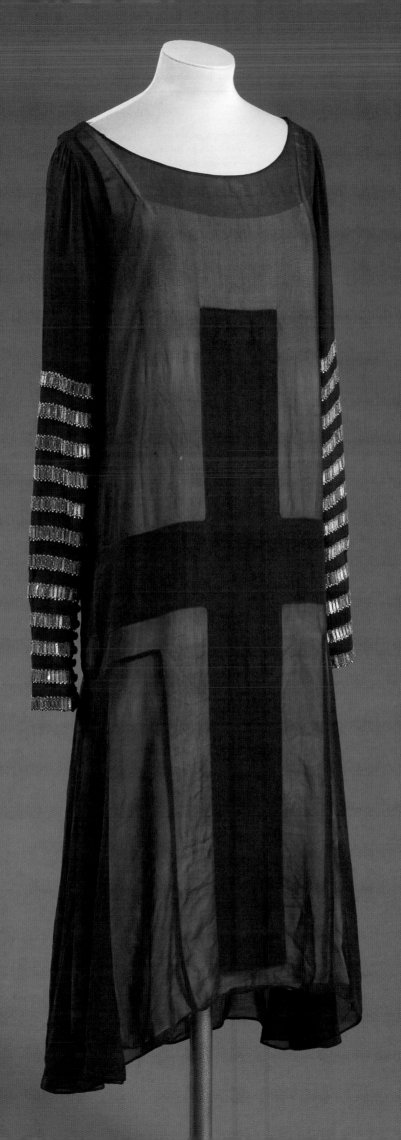

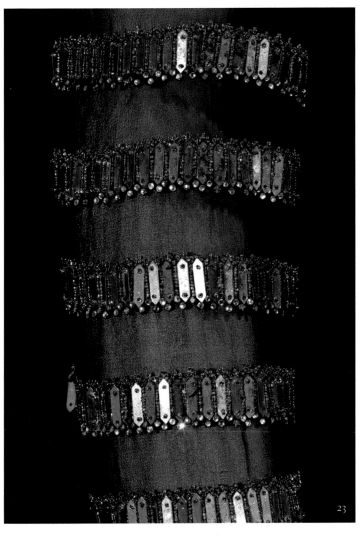

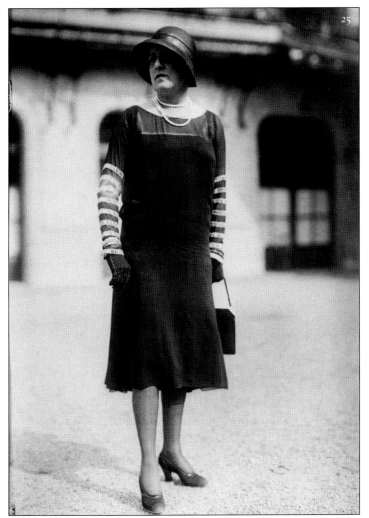

Opposite page and above left: Figure 22-23. "Fausta," winter 1928. Navy blue silk chiffon dress over a navy blue silk crepe underpinning. Appearing simple at first glance, the quality of workmanship is exceptional, as appliquéing chiffon to chiffon is a near-impossible task. The large self-fabric appliquéd cross, which reaches vertically from bustline to hemline, and horizontally from sideseam to sideseam, dominates the dress. For this particular image, a flesh-colored slip is employed in order for the seaming details to be visible.

Figure 24: Original gouache design of "Fausta," 1928.

Figure 25: Princess de Faucigny-Lucinge dressed in "Fausta" over the navy blue underpinning. Other details of this dress include a soft scoop neckline, long-fitted beaded and embroidered sleeves, and a flared skirt that flows freely with the wearer. Evoking the theme of armor and heraldry worn during the Crusades, the sleeve embroidery consists of gold lozenge-shaped *paillettes* and gold seed beads applied in rows of regular intervals.

5

DEVELOPMENT OF AN EMPIRE THROUGH DETAILS

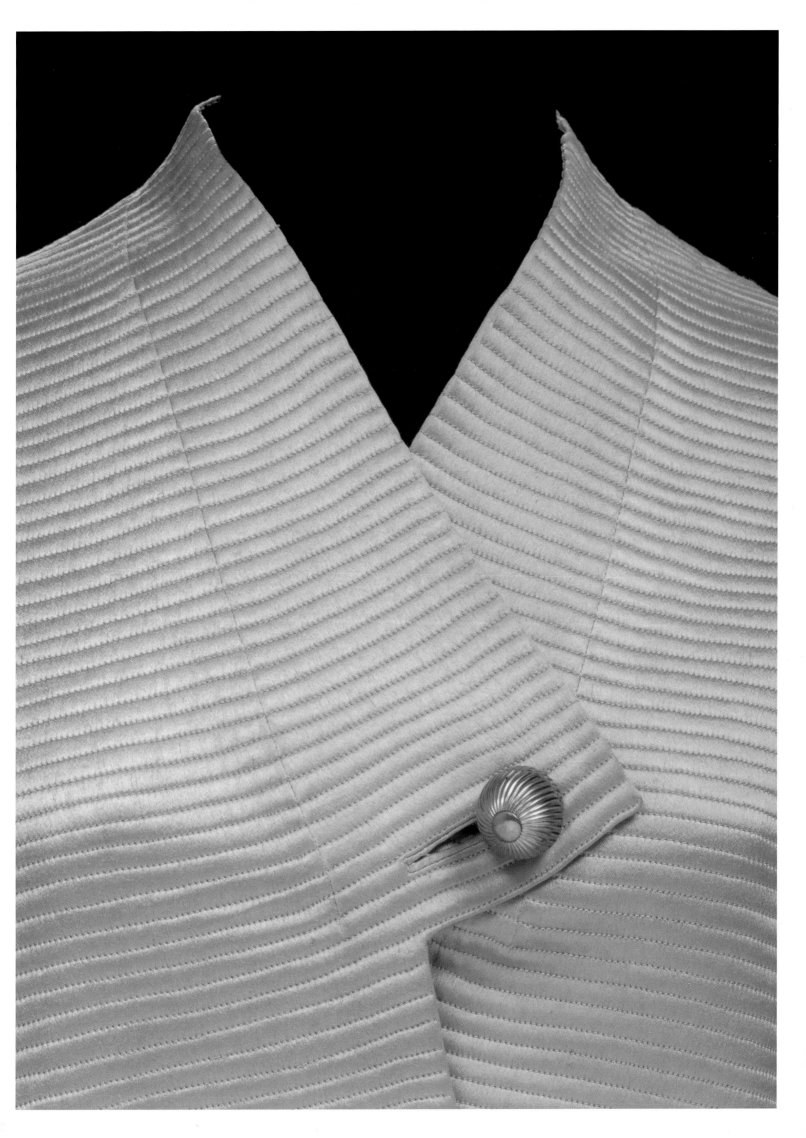

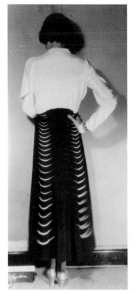
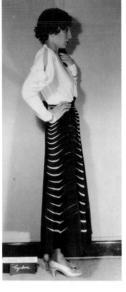
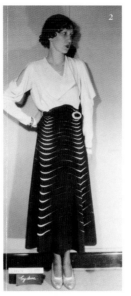
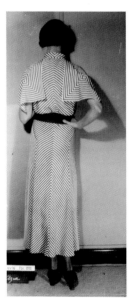
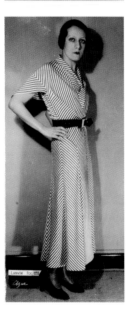
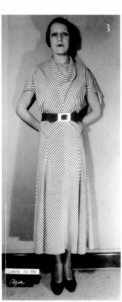

SEAMING TECHNIQUE serves many purposes: it creates a well-fitted garment, it is a source of subtle ornamentation, and it joins multiple components together. Madame Lanvin used seaming to create textiles with strong visual impact. Two ensembles featured in Vogue of 1933 demonstrate the clever, but very simple method with which a base cloth of blue and white horizontal stripes was manipulated to create figure-flattering and visually appealing apparel. "Azurée" (Fig. 3) was created from a horizontal-striped fabric. The fabric was cut into panels on the bias and seamed back together, mitering the stripes, creating a chevron pattern. The bodice of the dress is also on the bias, lending itself to the softly draped cowl neckline.

Artistic seaming and decoration are evident in a silk crepe evening dress with curvilinear bias seams that are sliced, and delicately rejoined, by a simple yet elegant self-fabric detail. Revealed is a minimal yet tantalizing amount of flesh-toned silk. The fabric treatment used to join the seam is a self-fabric loop turned back and reconnected to the point of origin, resulting in minimal triangular detail with maximum effect. (Fig. 6-7)

Piecing or seaming assorted fabrics together is another creative process through which original textiles are created. "Gulliver," from 1925, illustrates this. An original embroidery swatch was created using wool-twill suiting fabrics—one in light gray and another in thin stripes of black and gray. (Fig. 5) "Gulliver," a wool coat, is primarily gray embellished with an elaborate border for the hemline and center front opening. (Fig. 4) With a machine-made chainstitch in yellow, black, and white, outlined columns and an interlooping border motif add additional visual elements while disguising the seams of the pattern. Ingeniously seaming together two base cloths while manipulating grain lines, dense threadwork accents complete an entirely new textile.

The word appliqué comes from the French word appliquer, meaning "to put on or to lay on." As a method of decoration, appliqué has been a popular technique and has a long history

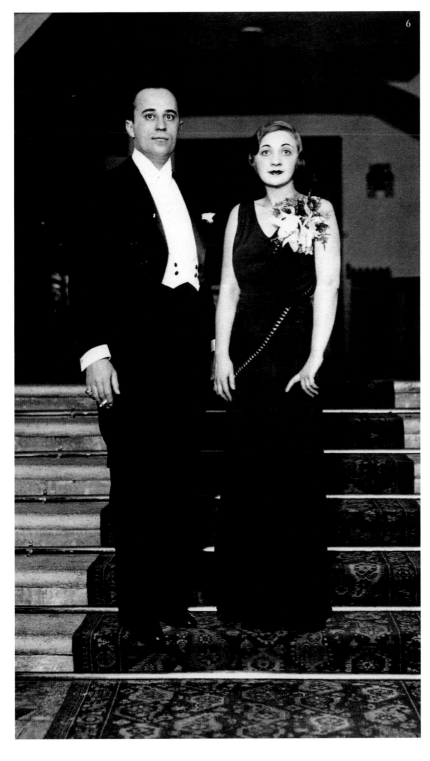

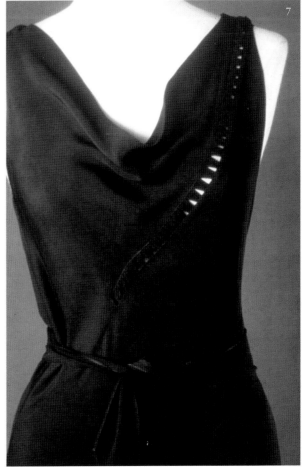

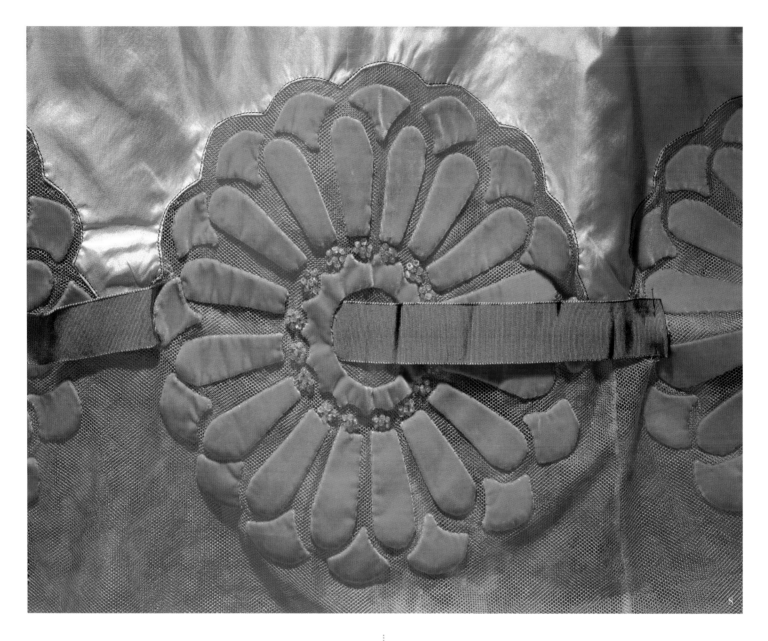

dating back to ancient Egypt. Needles are the main tools used in appliqué, whether to complete the process by hand or machine. The primary idea of appliqué is cutting a shape from one fabric and sewing that shape onto another fabric. Appliqué is a simple yet effective method of decorating fabric. It is not exclusive to fabric use; it can also be combined with other materials such as beads or sequins and is often combined with other types of needlework such as embroidery to create the desired effect. (Fig. 8)

Appliqué was often used in Lanvin collections. In its most basic form, a fabric is appliquéd upon itself, perhaps tone-on-tone, creating a subtle pattern with shape instead of contrasting color. (Fig. 32)

Cutwork is a needlework technique in which portions of a textile are cut away with the resulting "void" reinforced and sometimes filled with embroidery or needle lace. Cutwork is related to drawn threadwork, in which only the warp or weft threads are withdrawn (cut and removed), while some tech-

niques of cutwork draw both warp and weft threads. In the created open spaces, the threads are then "embroidered" in groups to form patterns; techniques used include binding, interlacing, or looping. Many times the patterns were inspired by the embroidery of European peasants, who used the technique to decorate their simple, unadorned clothes.

Madame Lanvin used cutwork to give visual prominence to basic textiles while adding interest to hems and edges. Because this technique left voids in the textile, it was typically used for spring and summer apparel, when linen or simple cotton weaves were employed. A traditional, homespun technique, it is an embroidery method that young girls would have learned at home from other women; cutwork lent charm to the otherwise sophisticated style of Lanvin. (Fig. 12-14)

Punchwork is a technique used for piercing skins, such as leather and suede, with patterns. (Fig. 20) This is achieved either with a die, with which one punch will create the com-

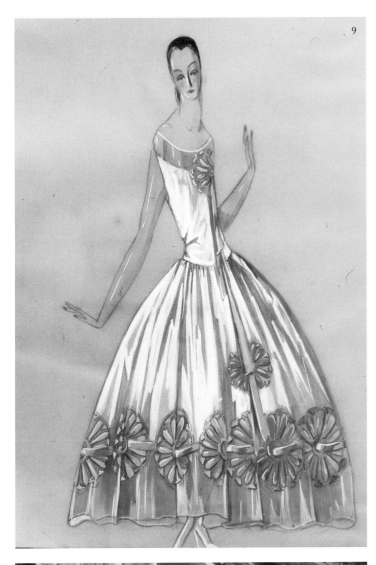

9

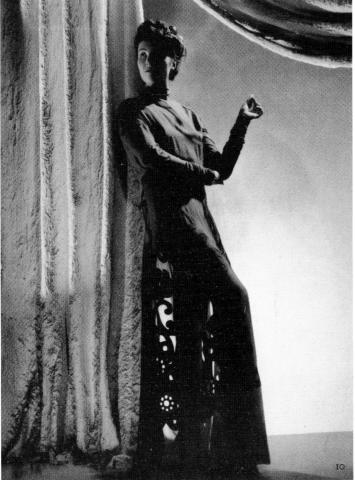

10

Opposite page: Figure 8. Detail of appliqué from Figure 9, "Fête Galante," 1924.

Right: Figure 9. "Fête Galante." Cream silk taffeta *robe de style* detailed with a pink silk tulle neckline and deep hemline border to which velvet daisy petals have been appliquéd. The centers of the flowers are laced together with "Lanvin blue" grosgrain ribbon and accented with small clusters of aurora borealis rocailles beads.

Figure 10: Dress of midnight blue chiffon with arabesque and floral appliqués. From the waist down it consists of another textile, lightweight and just as dark. The dress is completely transparent and worn over a jersey bodysuit and silk tights. *Le Figaro Illustré*, September 1939.

Figure 11: Illustration of figure 17-13 wrapped in a "mummy cape of cloqué wool; under it, a chiffon dress, under the dress-silk tights." *Harper's Bazaar*, from 1939.

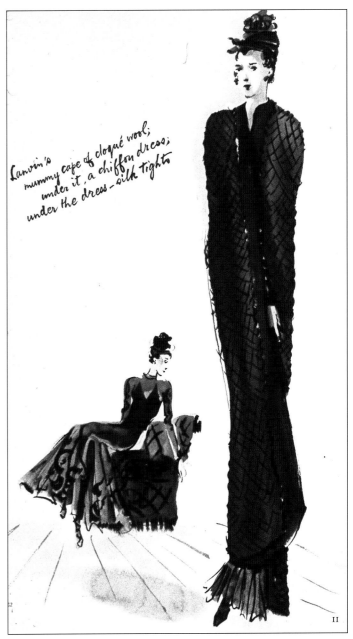

Lanvin's mummy cape of cloqué wool; under it, a chiffon dress; under the dress-silk tights

11

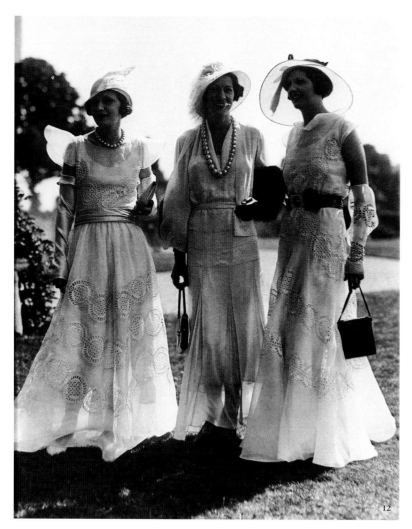

Figure 12: Even as late as 1931, Women continued to wear the full-length, full-skirted designs Lanvin offered. These three ensembles are all Lanvin—from millinery and over-sized pearls, to handbags and shoes. The dresses and gauntlets of the women on the left and right are embroidered using cutwork technique. **Figure 13**: Cutwork embroidery, 1917. Portions of textiles are cut away as the resulting void is reinforced and/or filled with embroidery or needle lace. In this case, the remaining supporting structures are reinforced with white gimp cord and re-embroidered with metallic gimp. **Opposite page: Figure 14.** "Madère," is a red slip dress with a white duster detailed with the cutwork embroidery as seen in Figure 13.

plete effect, or with a punch tool and a mallet that makes individual holes. Although the Lanvin swatch shown demonstrates the punch effect on suede, great success was achieved by using the high-quality kidskin. An image from Vogue of 1920 demonstrates the visual beauty of this technique (Fig. 18) and raves about Madame Lanvin's application: "Fashions seemed eminently satisfactory to us until suddenly Lanvin discovered kid cut-work, but now we wonder how anything else ever seemed quite so chic. No one could ever think of anything smarter, we are convinced, than to slip an overblouse of white kid, cut out in all manner of primitive peasant designs, over a black chiffon costume."[1]

Trapunto stitch, a technique similar to quilting, involves the sandwiching of cotton batting between two layers of fabric. Additional body was given to the fabric by stitching narrow rows, typically one-quarter inch or the width of a sewing machine presser foot, over the entire piece of fabric, or only to specific pattern pieces prior to garment construction.

Stitching is in some concentric formation, although not necessarily parallel lines. This technique was used in the mid-1920s, but enjoyed great success in the 1930s when lavish beading and embroidery lost favor. As fashions became sleek and slinky, shedding all superfluous decoration, the elegance of evening clothing was maintained through textured metallic lamés, shiny satins, and plush velvets. Madame Lanvin used the most beautiful silk charmeuse available to make the body of a garment and then trapunto-stitched the self-fabric using metallic thread as a highlight on stiffened pieces for collars, cuffs, jackets, and fishtail hemlines.

The typical bias silhouette, with its long, slender and graceful lines, was adorned with minimal and subtle detail. Heavy, elaborate beadwork and embroidery of the 1920s was absent during the 1930s. If beading was used on garments, it was most commonly found in tone-on-tone combinations or used sparingly. The use of lamé as the metallic highlight on a

Madère

Figure 15: Counted threadwork swatches. Counted threadwork patterns were submitted to give options while exploring ideas and techniques. Once the warps and/or weft threads are drawn, they may be bundled together in various patterns inspired by peasant embroidery. Figure 16: Cut-work embroidery executed on a large bold scale lends a sophisticated style to Lanvin designs. Ideally executed using a plain weave textile, this homespun technique is modest and charming. Around 1921.

Opposite page: Figure 17. Lanvin client wears an ensemble detailed with large-scale cutwork, 1921. Figure 18: Kid cutwork shown for the first time as modern fashion updated it from the common garb of the Middle Ages. Vogue, December 1, 1920. Figure 19. "Phèdre," August 1933. Figure 20: Swatches of fine gauge suede detailed with punchwork, fall 1925.

garment all but replaced the opulent, overworked effect of embroidery and beading.

Two evening dresses by Lanvin feature trapunto technique. "Phèdre" (Fig. 19), was shown by Madame Lanvin in August 1933. A halter-neck gown of black silk crepe, it is accented with trapunto-stitched silver lamé detail. The soft, round shoulders of a woman—the new erogenous zone—are revealed; the bosom, arms, and legs are completely concealed by luxurious, slinky silk crepe. The angular cap of the sleeve is peeled down to reveal a sliver of silver lamé textured with angular trapunto stitching. The rear fishtail hemline splays in two angular forms mirroring the sleeve detail. The surface effect is subtle as the black crepe is trapunto-stitched in black thread. As the fishtail moves with the wearer, the hidden silver lining reveals itself. Defined by smooth, clean lines, and accented with textured metallic angles, the inner structure or support of the dress is nonexistent.

The silk charmeuse dress in Figure 30 is a standard bias-cut gown typical of the decade with the exception of the mitered, trapunto-stitched bodice. The coordinating jacket, with a lantern-shaped sleeve, is also completely trapunto-stitched, lending body to the fabric and warmth to the wearer.

The chartreuse green silk swatch from Lanvin's 1925 summer collection (Fig. 29) demonstrates the use of cotton batting for texture, dimension, and body. Considered trapunto, but more generally in the family of quilting, curvilinear patterns are stitched in repetitive or concentric formation. The primary stitching was executed with a functional and decorative metallic-gold chain stitch. Additional areas of the pattern were filled in with contrasting stitching.

A 1939 Lanvin ensemble, worn by the Princess de Faucigny-Lucinge (Fig. 26), is a successful marriage of trapunto and quilting techniques. Black leather was stitched into large quilt-like squares only to be trapunto-stitched in concentric circles. Each square is quartered by two crisscross rows of

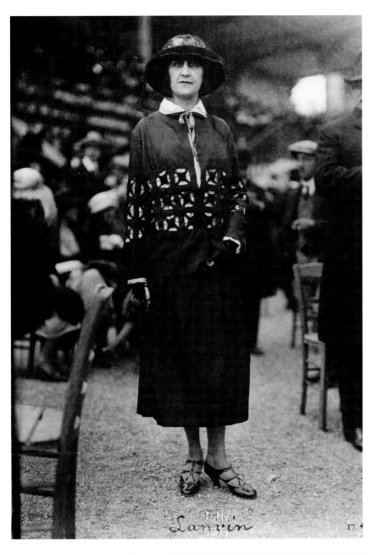

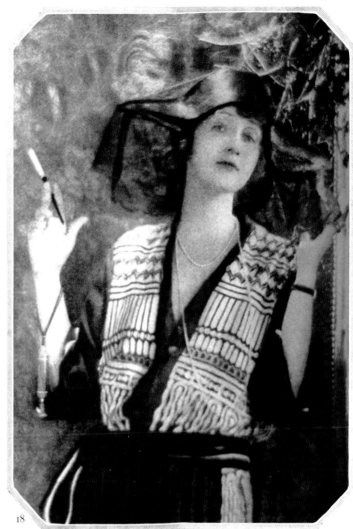

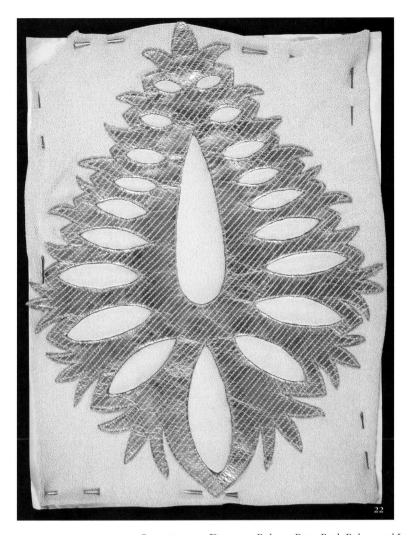

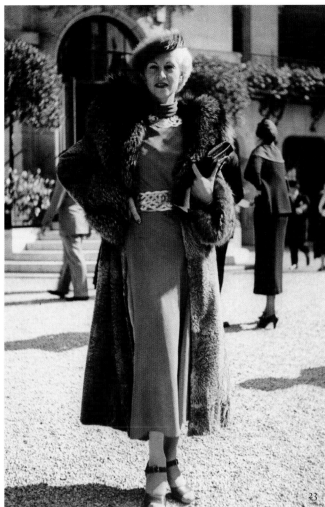

Opposite page: **Figure 21.** Rubens, Peter Paul. *Rubens and Isabella Brant in the Honeysuckle Bower* (1609-10). Oil on canvas. Munich Alte Pinakothek. Rubens' leather jacket, featuring intricate cutwork designs, illustrates that this form of textile ornamentation and embellishment was used at the height of 17th-century society. **Above: Figure 22.** Gilt kidskin cutout, appliquéd and trapunto-stitched down. The central teardrop void formed a pocket opening, 1936-37. **Figure 23:** Madame von Mohrenschildt in a 1935 Lanvin ensemble. Cutout and appliquéd gold-gilt kidskin motifs embellish the neckline and waistline.

Following spread: **Figure 24-25.** "Sandra,"1934. Bi-color, reversible collar and hemline detail was trapunto-stitched to add body to the garment pieces that need structure to hold their intended form.

stitching. The large daisy- (or marguerite-) shaped buttons are no accident as they are symbolic of her daughter, Marguerite Marie-Blanche.

As the metallic shine of lamé replaced heavy, ornate beading, surface treatment was added to enhance the visual interest of an otherwise large metallic surface: detail is bold and highly tactile. Toward the end of the 1930s, the narrow silhouette gave way to increased volume in shape and form—not structure. An evening suit of kimono jacket and long skirt are ready to march into battle as deep, wide chevron channel stitching creates the feel of armor and angular shapes are emphasized by the stitch pattern. (Fig. 27) In contrast, the same quilting technique was applied to a lamé cape worn by Madame Lanvin in May 1939 for the Réouverture des Ambassadeurs Fête du MYCCA. (Fig. 28) With a graduated,

concentric cascade pattern, smaller at the neck and shoulders and larger at the hemline, the stitched metallic fabric evokes flowing waterfalls under reflective light. Elegant and understated, the dynamic piece of outerwear was worn over a dark, solid-colored dress.

1 *Vogue,* (December 1, 1920), 82.

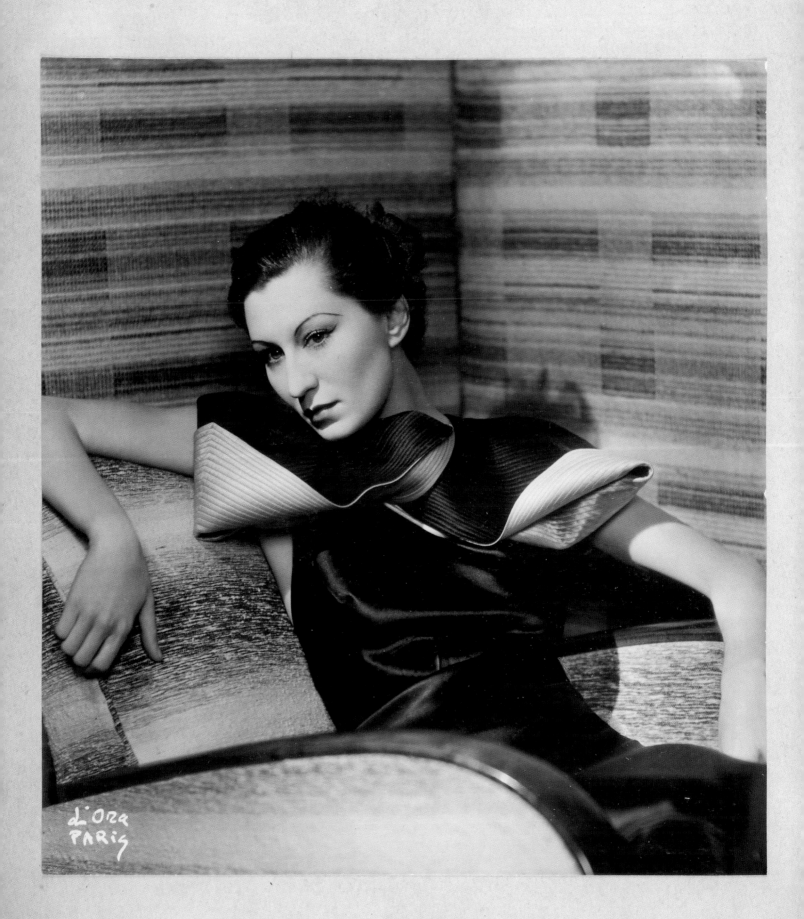

Sandra

d'Ora
PARIS

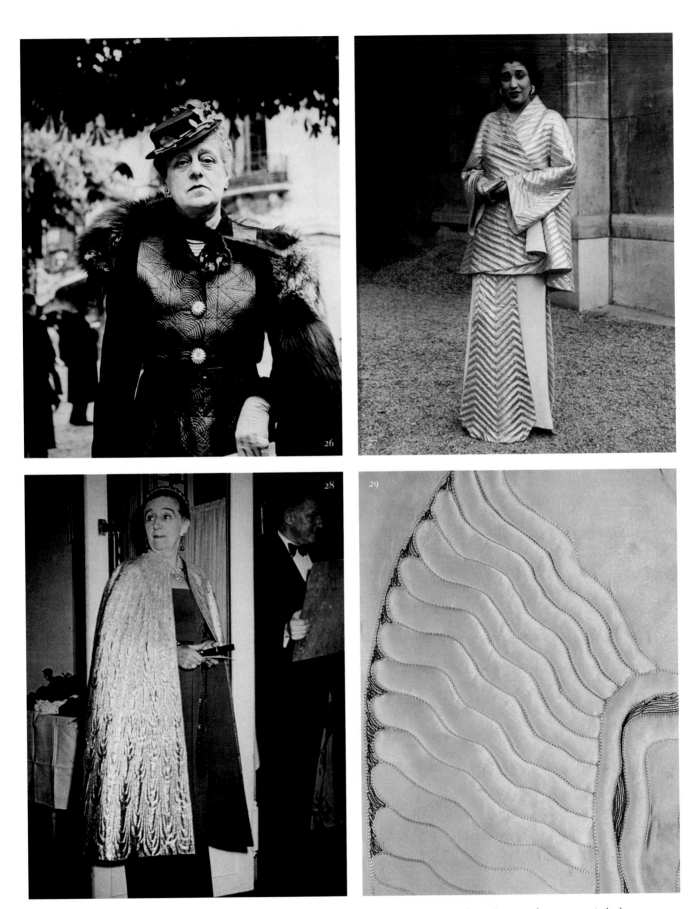

Figure 26: Princess de Faucigny-Lucinge in Lanvin, 1939. **Figure 27**: Madame Henri Pharaon, around 1937. Large-scale trapunto stitched into a chevron pattern. **Figure 28**: Madame Jeanne Lanvin, 1939. **Figure 29**: Two layers of chartreuse-green *crepe de chine* sandwiches cotton batting, as a gold metallic chainstitch creates the curvilinear tapunto pattern. Black chainstitch was used to fill in the flat, or voided, areas of the trapunto pattern for added visual dimension. Summer 1925. **Opposite page: Figure 30**. Lanvin matte-finish evening dress with metallic curvilinear trapunto neckline detail. The coordinating satin evening coat is planar, as two-dimensional sections of trapunto work have been seamed together in order to form three-dimensional forms like a shoulder or sleeve. Wrapping asymmetrically with double-buttons, the cotton batting creates the textural dimension of the trapunto-stitch, which also provides warmth for the wearer, September 1934. **Following spread: Figure 31**: Chartreuse satin and silver lamé are paired in a contrasting fabrication for an evening jacket from around 1938. Linear parallel and curvilinear scalloped trapunto-stitch patterns are mitered at a right angle, creating diagonal seams and marrying the rigid and curving patterns. **Figure 32**. Black silk chiffon coat detailed with black wool crepe appliquéd graduated design, 1929.

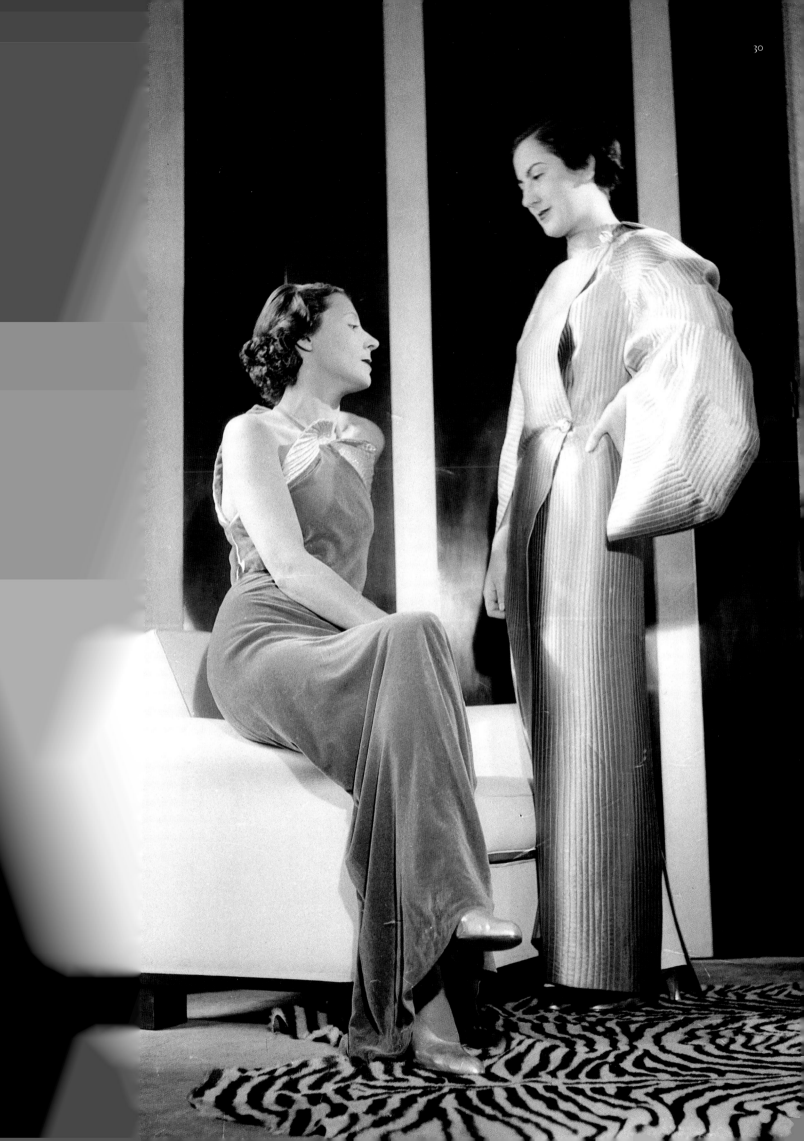

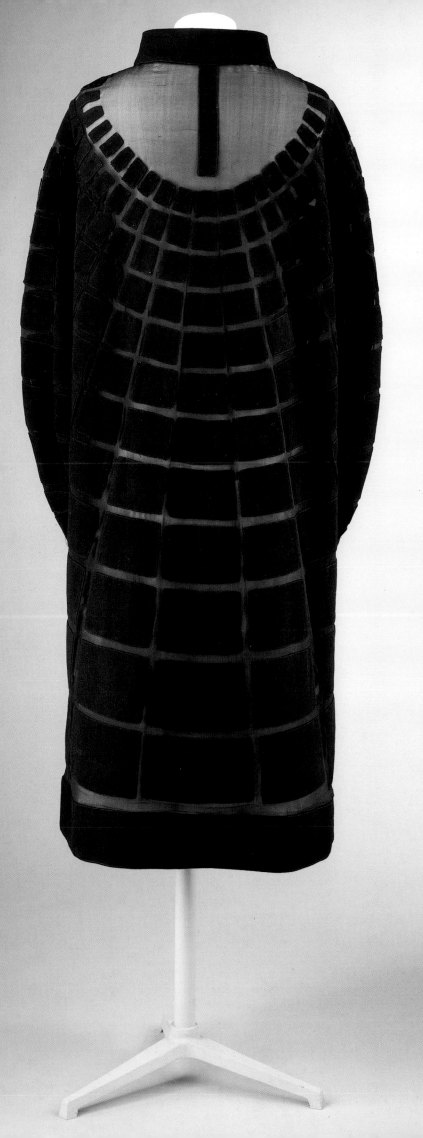

DESIGN
METHODOLOGIES

"IT IS IN THE MIDST OF countless bits of material, scraps of embroidery, laces, and old engravings, that these designers create upon a living manikin [sic], as a painter creates his picture on the canvas, all those harmonies of colour, those clever lines which make the marvel of a Paris frock."[2]

Designers communicate their ideas to staff in several ways; some means are more successful than others. A designer, the person responsible for the initial concept, may communicate with the *première* of the atelier by drawing, draping, verbal description, or images of inspiration. The *première* is the primary liaison between the creative director and various employees such as the patternmaker, draper, embroiderer, or seamstress. It is then the responsibility of the *première* to execute the first draft of the design according to the specifications and desires of the designer.

Apparel design and execution has many steps. A sketch artist, draper, patternmaker, seamstress, and sometimes a team of embroiderers are all involved to various degrees. Not all designers are proficient in all aspects of design. Some are unable to "drape" first patterns. Draping is the process of creating the first toile by using a dress form and muslin to create a three-dimensional silhouette. Not all designers can illustrate or sketch. Some designers choose to drape the chosen textile on a human form. Flat-pattern is an art form of its own, similar to the Japanese art of origami, in which patterns are created in two dimensions with paper, slopers, rulers, and scissors.

The whimsical, highly experimental and technically challenging nature of designs of the 1920s necessitated draping and creating silhouettes in the round on human forms. Many designs could not be conceived on paper in two-dimensional form and accurate patterns could not be made for such designs. Seamstresses would pin, tuck, and drape the fabric around the body of a model and the designer would issue instructions until the desired effect was achieved.

Photographs provide evidence that, over time, many designers have communicated their ideas in their own special way as their skills and abilities permitted. Jacques Doucet may be classified as a collector—a collector of art that would go on to inspire successful fashions for the family business and eventually raise its status to "fashion leader." "Most found Doucet the man almost totally removed from his couture business." He was not a tailor or a designer that sketched, but was was rather an inspiriational figure within his atelier.

Paul Poiret, a "hands-on" designer, was repeatedly seen in photographs draping on a model in the fabric of choice. Madeleine Vionnet, a pioneer in fashion design and fabric, draped her designs on a quarter-scale mannequin, perfecting the pattern before the execution of a full-scale design. A mathematician at heart, the influence of geometry and shape pervaded every aspect of her design. Due to the highly experimental nature of her creative process, these original patterns were executed by her alone. An original pattern, created in quarter scale, would be given to a pattern maker who would then grade it up to standard size.

Gabrielle "Coco" Chanel began her career as a milliner with some basic understanding of sewing and construction. She did not drape her own patterns, although she was able to achieve the desired look and fit of her designs by working closely with the *première* and a pair of scissors, which hung around her neck.[3] She did not sketch any of her own designs, instead having an assistant do that job.

With no knowledge of the fashion industry or apparel design and construction, Elsa Schiaparelli relied on pure instinct to navigate the technical aspects of design, and her intellect and knowledge of art history to guide her creativity and impressive use of color. Unencumbered by the technical contraints of fashion, she approached each design with spirit and the will to experiment until the final product met with her approval. She was initially encouraged by Paul Poiret,

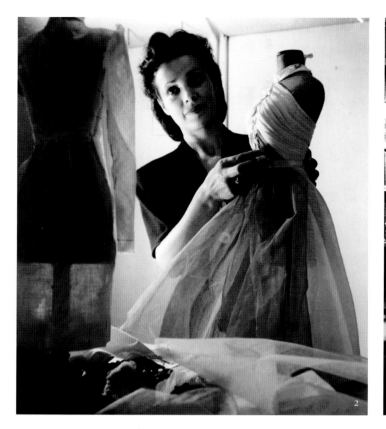

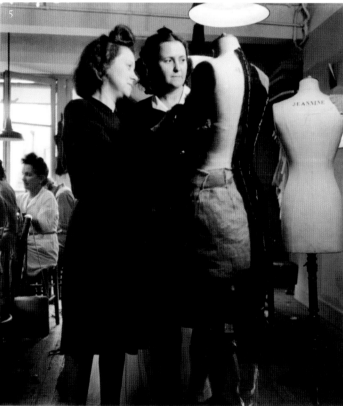

Figure 2: A patternmaker experiments on quarter-scale mannequins before making a full-size sample. This Lanvin employee is checking and fitting the smaller toile pattern she has constructed, circa 1937. Figure 3: Interior of Madame Lanvin's private office, with complete, full-size dresses and quarter-scale toiles ready for inspection, 1937. Figure 4: Young apprentices prepare garment pieces and press toiles for fittings. Figure 5: The *première* of the atelier works with a fellow patternmaker in order to achieve the best silhouette and proportions. Thread-basted grain lines are used to control and fit each pattern piece.

admired the technical achievement of Jeanne Lanvin, and appreciated the artistic quality of Madeleine Vionnet; however, she was much more ambivalent about the traditions that were inextricably linked to these skills.[4] It was more important for her to apply her innate ability and creativity in order to discover and pursue her own design direction.

While many designers possessed some way of communicating ideas either through sketching or draping, Elsa Schiaparelli could not. She relied on staffpeople–from artists to sketchers, patternmakers, seamstresses, and embroiderers–to properly execute her designs.

Madame Lanvin's many talents enabled her to translate fledgling and experimental ideas into successful designs–not because she was accomplished in all aspects of garment production, but because she possessed the ability to communicate ideas and inspirations to a staff that would then follow her directives. Madame Lanvin did not drape her own patterns. A photograph of her office with several miniature mannequins dressed in mock-ups of sample garments demonstrates a step in the design process. (Fig. 3) These mannequins would be executed by the staff and submitted for approval. It is likely that these miniature patterns were used to create the sample for the fashion dolls Madame Lanvin favored. (Fig. 4)

Changes may occur while working in quarter scale. Some major changes include alterations to the silhouette; others are as minor such as a change in flower, bow, or embroidery placement. Working in quarter scale allowed one to make as many changes necessary in the most cost-effective way, without wasted materials and loss of crucial time spent executing a full-scale garment. Once the design received final approval, it was graded to standard size from this, the original sample garment. Lanvin's eye for detail, balance, and harmony were then translated into a lavish gouache rendering.

Madame Lanvin did not sketch herself, but she employed stylists to translate her ideas into viable designs and renderings that could be read by the patternmaker. The Lanvin archive reveals that various artists executed the gouache fashion illustrations over the span of her career, and none were ever signed. Using the same *croquis* and stylistic choices of Lanvin, artists would proceed to render each garment in exquisite detail including the beading, embroidery, and lace. These sketches were used as a selling tool when clients placed an order, as they showed available options such as sleeve treatment, hemlines, collars, necklines, and embellishment. Some clients purchased a garment as designed and others preferred to customize. Of course, every change of detail from the original increased the cost of the final garment. Prices never appeared on presentation sketches–only multiple style options followed by a string of letters. Each letter was assigned a numerical value, and the arrangement of the letters spelled out the cost in a Lanvin-created code. (Fig. 6) The fashion renderings are sublime and serve as an aesthetic history, as the *croquis* styles changed with the artistic climes.

1 *Vogue*, (1919), np.

2 Quoted in Coleman, Elizabeth Ann. *The Opulent Era: Fashions of Worth, Doucet and Pingat* (London: Thames and Hudson, 1989),152.

3 De La Haye, Amy and Tobin, Shelley. *Chanel: The Couturiere At Work* (New York: The Overlook Press, 1996), np.

4 White, Palmer. *Elsa Schiaparelli: Empress of Paris Fashion* (London: Aurum Press, 1986), 86-7.

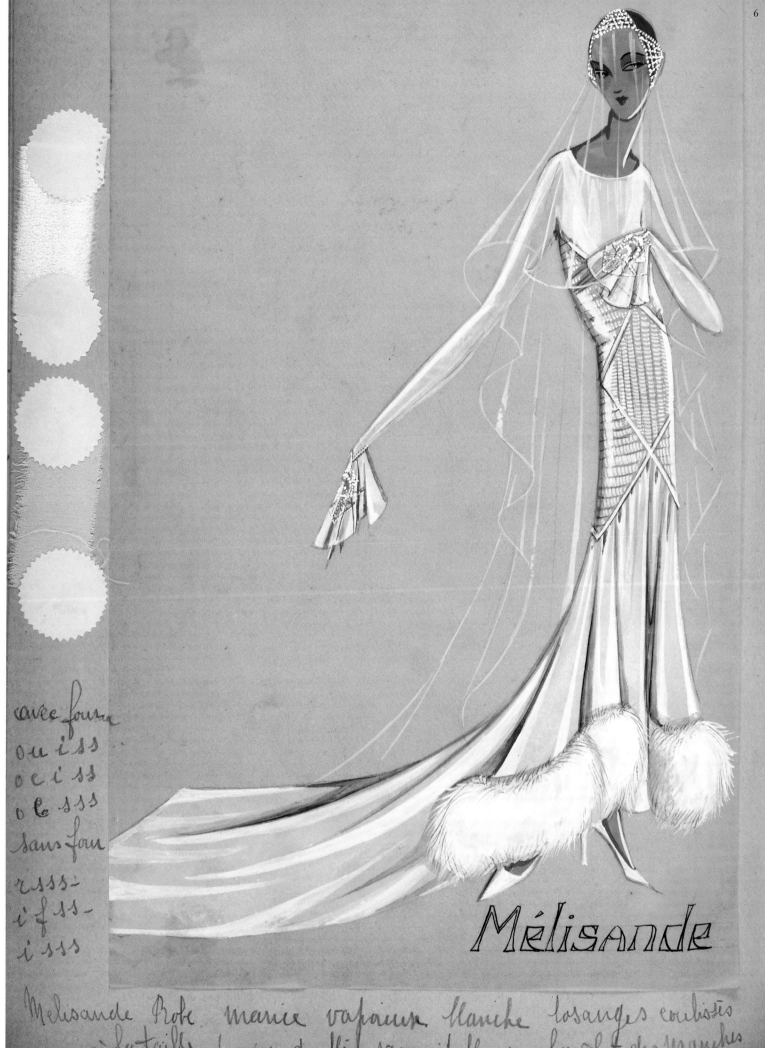

Mélisande

BEADING AND SEQUINS

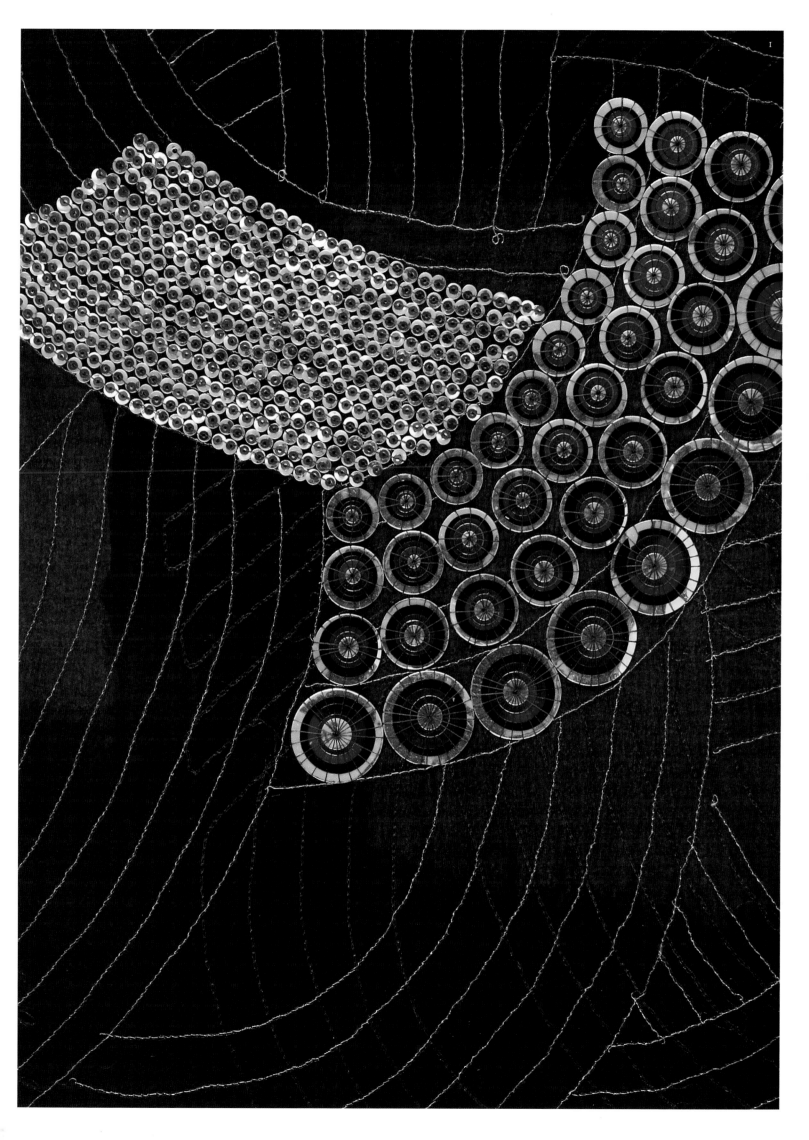

Previous page: Figure 1. Sequined embroidery swatch in disposition–black, silver, blue, and red on a black ground. Using the stacking technique, each layer of sequins is secured by multiple passes of the needle allowing the thread to form a starburst pattern on the sequin surface. **Above: Figure 2.** An advertisement from *Art, Gôut, et Beauté* for "Oiseau Bleu" mentioning the use of the Cornely embroidery machine. Summer 1928. **Figure 3:** "Oiseau Bleu" of light blue silk tulle embellished with circular pink tulle appliqués of various sizes. These pink appliqués were applied to the foundation fabric by a wide looping stitch of the Cornely embroidery machine as part of the design detail. **Opposite page: Figure 4.** "Junon," summer 1923. Light blue silk chiffon tunic in typical 1920s tubular silhouette. The Persian-influenced blue dress is heavily beaded and layered over a rose-colored slip with additional beaded borders.

NOT UNLIKE THE WORKS of artists she admired and collected, Jeanne Lanvin used base cloths as a canvas on which she painted; in her case, the mediums of preference were beading and embroidery. Madame Lanvin used various elements to execute beading patterns, including sequins, rocailles, bugle beads, pearls, crystals, mica pieces, seashells, celluloid shapes, mirror discs, metal studs and plaques, and mother-of-pearl shapes. Beaded elements were often enhanced with surface applications of ribbons, *soutache*, threadwork, chenille, tulle, and lace.

Some commonly used beading elements are seed beads (the smallest of the beads), rocailles, and bugle beads. Rocaille beads are round inside and out, and can be opaque, transparent, metallic, iridescent, lustered, pearlized, or silver-lined. Bugle beads–the longest of the three beads–are small glass tubes that vary in width and length from two to thirty-five millimeters. The outside of the bugle may be smooth or ridged and sometimes twisted. These beads are transparent, opaque, or may be lined with gold or silver.

Design piracy was rampant during the 1920s. Copyists threatened the profits of France's couture industry and risked its survival. In order to avoid contracting work to various outside embroidery houses that might plagiarize her ideas, Madame Lanvin created two embroidery ateliers of her own. By keeping all aspects of design and production under one roof, it was hoped the risk of piracy would be greatly reduced–especially if one had an infrastructure of loyal employees. Unfortunately, the vast majority of piracy was committed from within. The offer of even minimal sums of money to underpaid employees was enticement enough to sell out employers. Once a design, pattern, color, or material was in someone else's hands, such as a contractor, anything could happen and usually did, as there were many people thriving on the illicit trade . For the price of five or ten francs, the newest colors of a couturier's collection would be divulged.

To protect their craft and livelihood, a society for the prevention of piracy was formed in 1923 by Vionnet, Poiret,

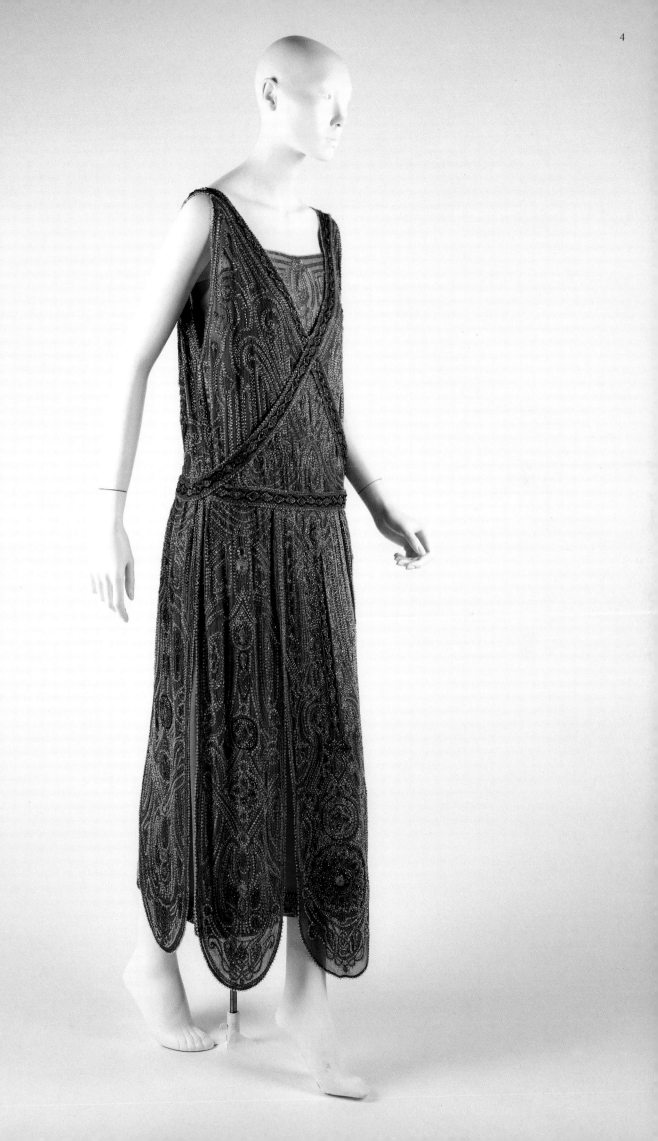

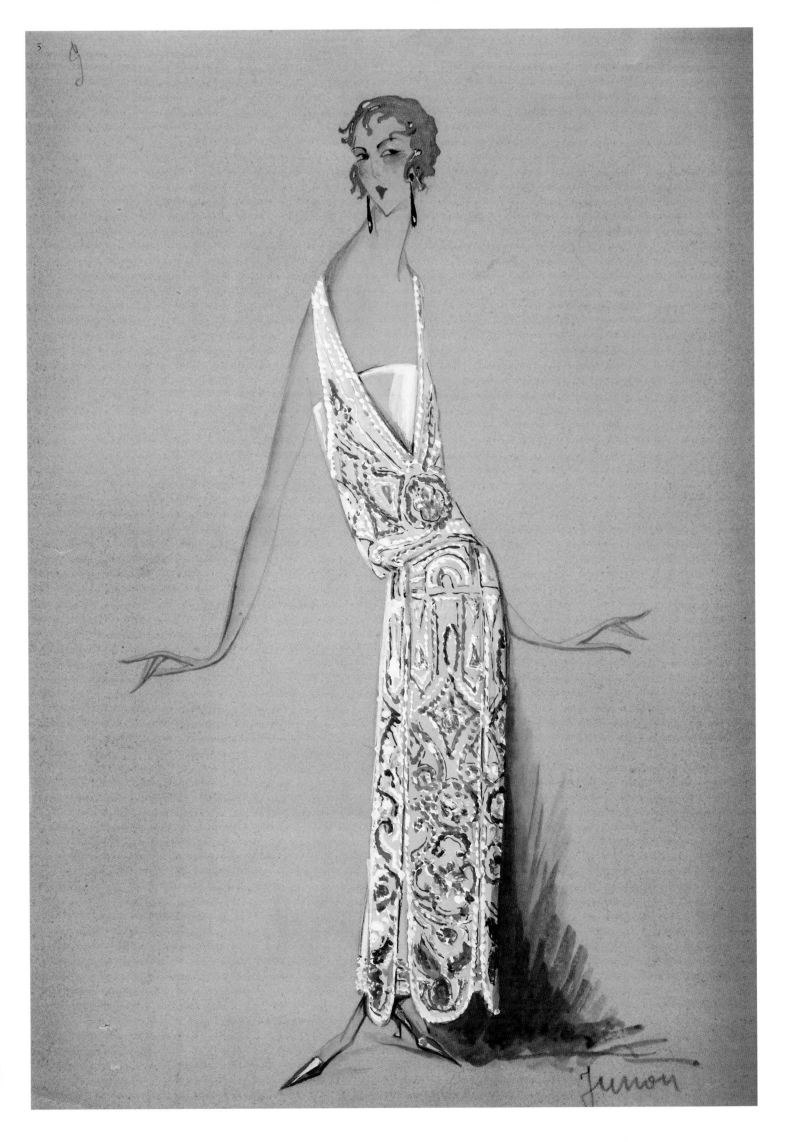

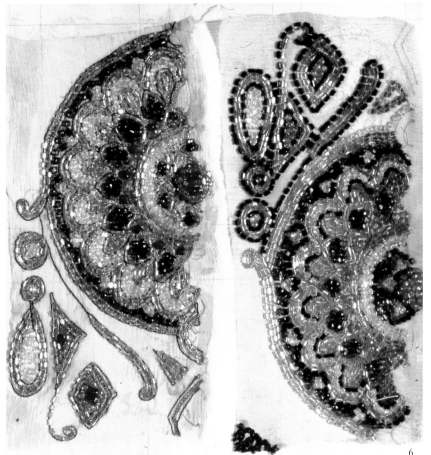

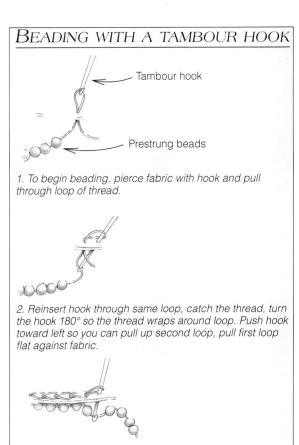

6

7

Opposite page: **Figure 5.** Gouache illustration of "Junon," 1923. **Above: Figure 6.** Beading swatches in development for various areas of "Junon." **Figure 7:** Beading diagrams demonstrate the multiple options of applying components, and combinations thereof, with a needle and thread. Beading with a crochet hook limits application options, but is the most productive method to fill-in large open spaces.

Madeleine Cheruit, Worth, Drécoll, and Madame Lanvin. This organization was called L'Association pour la Défense des arts Plastique et Appliqués. Although this may have curbed some illegal copying, the most determined were not deterred from their activities. In 1928, a second anti-piracy organization, the Société des Auteurs de la Mode, was formed. This group's objective was to organize reciprocal treaties with the hope of setting up international copyright laws.[1] A third organization, P.A.I.S., Protection Artistique des Industries Saisoniers, was also created.

By 1931 membership consisted of seventy-five members from couture, millinery, textiles and other related areas. They worked with the police and investigators to set up raids of the workrooms of well-known copyists. Often many elements associated with the copyists' trade were seized including toiles, garments, sketches, swatches, and designer labels. In order for the raid to be legally binding, the original couture creation along with the copy of the product had to be seized. Ruses to conceal illegal activity had been developed and perfected by copy houses, making it very difficult, if not impossible, for a successful prosecution of a case. These counter-tactics included producing their own shoddy line of apparel to be used as a cover for the illegal activity.

In order to register designs and protect herself from the copyists, Madeleine Vionnet resorted to photo-documenting her collection. In addition, she placed an ink thumbprint on the dress label so that loyal Vionnet clients could not be deceived by disreputable retailers or manufacturers. Madeleine Vionnet brought many of the larger perpetrators to court, not so much for the meager monetary rewards but to make them an example to all other copyists large and small. Madame Lanvin maintained a photographic record of each model in a front, back, and profile view. At the foot of each design is a plaque with the Lanvin name, the season and year, and the name of the model. This was considered proof positive of the exclusivity and originality of a design if a legal case should arise from a copy-house raid.

Two women, Camille and Madame Mary, were design directors of the two Lanvin embroidery ateliers; they were recognized by their chainstitched, embroidered signatures on each swatch. From the signature, Madame Lanvin would

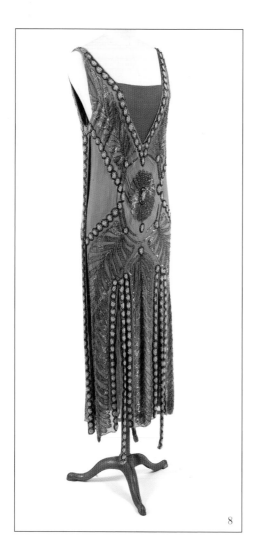

Figure 8 & 9: "Salambo," 1925. Cylindrical 1920's sleeveless silhouette with plunging v-neck, at front and back, reveals a lightly embellished slip. The beading was executed using the tambour method, as bugle beads and seed beads are applied easily and quickly in this manner. Additional models from the same year with similar silhouette and technique included "Maharanée" and "Mille et Une Nuit."

8

know from which atelier the swatch originated. The embroidery workrooms were responsible not only for the surface decoration of the apparel, but also for the experimentation and development of original beading and embroidery swatches using various components. In addition, as successful beading and embroidery patterns were re-used from season to season, reworking and re-coloring were necessary.

In 1865, a French engineer named Emile Bonnaz perfected the chain-stitch machine, which was manufactured by the Cornely Company. He invented and patented a machine that had a needle which was rotated by a handle under the machine table. Camille and Madame Mary used the Cornely machine to execute the chainstitch they used to sign their swatches and to create patterns filling in the ground space of embroidery. One of the embroidery ateliers used 12 machines in an attempt to meet the demand for Lanvin designs.

For the 1923 summer collection, "Junon" a long, slim, straight dress of light blue silk chiffon characteristic of flapper fashion, made an appearance completely covered in beads. Used were rocaille and bugle beads in various colors of opaque black, translucent blue, translucent pink, and opaque red, as well as silver-lined bugle beads. The sleeveless dress is cylin-

drical in form with a plunging V-neckline in the front and back and a drop-waist. The skirt is composed of six free-flowing panels with a rounded hemline. A geometrically beaded border outlines the V-neck, crisscrosses at the bust, wraps to the back, and returns to center front. The sheer dress was worn over a light pink crepe-de-chine slip, which fills in the deep V-neck of the dress; it is beaded in pink and silver with a similar effect for the back neckline. The beaded skirt panels move with the wearer revealing a hint of the pink slip underneath; a beaded border on blue chiffon is repeated on the hemline. (Fig. 4-5)

A beading pattern of Persian origin featuring roundels, scrolls, and geometric borders was executed using the tambour method of bead application. With tambour embroidery the textile is stretched taut over a frame and a tool resembling a crochet hook is used. It is a blind process in which the embroiderer is unable to view the work in progress because the wrong side of the fabric faces up. With a chainstitch or crochet technique, beads are applied to the right side of the fabric following the outline of the predetermined pattern. This method is best suited for bugle beads, seed beads, and rocaille as they are the easiest to use and quickest to apply.

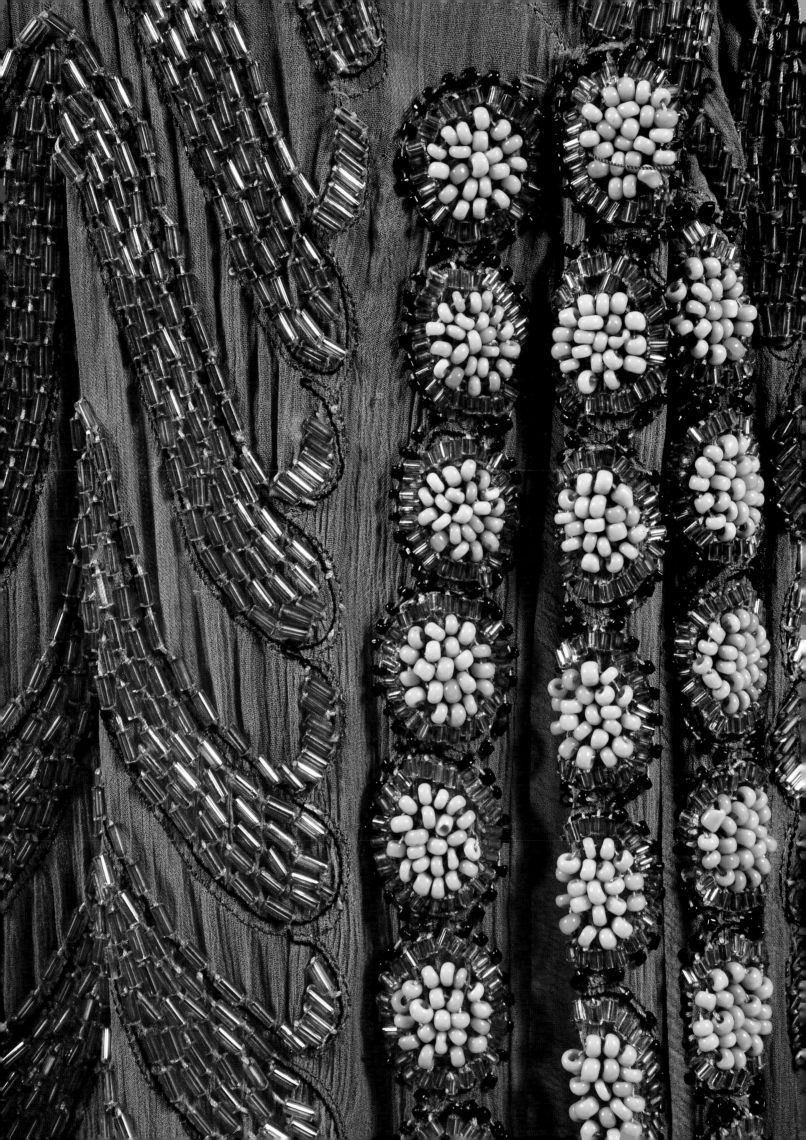

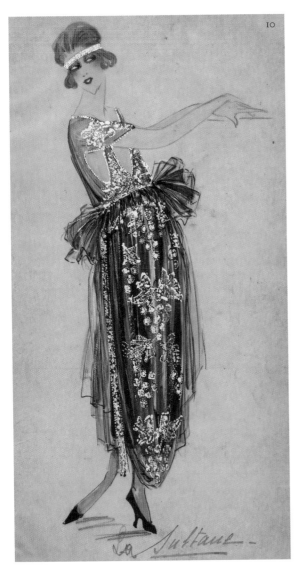
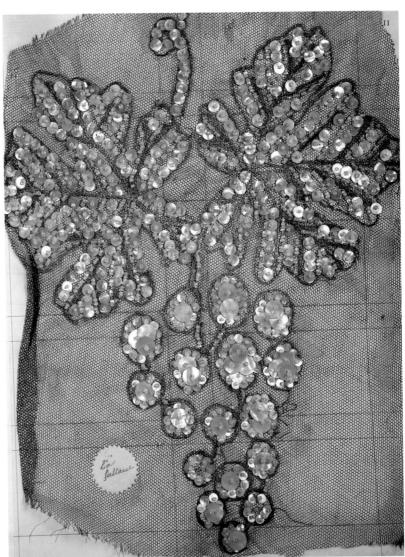

Figure 10 & 11: Gouache rendering and embroidery swatch detail of "Sultane," 1918-1919. Black silk tulle evening dress beaded with opalescent mother-of-pearl discs and seed beads, and embroidered with metallic threads.

Madame Lanvin often beaded and embroidered on silk tulle, a lightweight sheer netting that was strong enough to sustain beading. The trompe l'oeil effect was maximized as the usually flesh-toned tulle disappeared in the evening light, leaving admirers to view dazzling beaded and embroidered images that appeared to be applied directly on the human body.

Swatches of silk tulle were beaded with mother-of pearl discs in combination with clear seed beads and metallic chainstitch threadwork; this metallic threadwork tarnished over time. Although there is a noticeable absence of intentional color found in the embroidery, the fiery opalescent quality of mother-of pearl lends itself to the brilliance and femininity of the work. Clear seed beads are an obvious choice to anchor discs, since they do not detract from or interfere with the color and shape of the pieces. Glass seed beads are also used to highlight and outline the metallic threadwork, allowing the embroidery to maintain a visual feeling of lightness and a monochromatic color scheme.

Metal studs and plaques were used in embroidery to give a "machine age" feel to designs. Fashion and decorative arts mirrored each other's progress as both industries benefited from innovations in the other. "'Modernism,' a preoccupation with the machine and its forms, was expressed by the use of new materials, glass, metal, and bonded wood." "Not only was this term [Modernism] used at the time—but with occasional alternatives of Cubistic or Futuristic."[2] Steel components with an industrial look created an interesting pattern and visual interest without a brilliant sparkling effect. The faceted steel reflects light, but not to the extent of glass or crystal beads.

Because the steel components were applied onto dark colors such as black, maroon, and dark green, the textile absorbed the light, which the steel reflected. In addition, visual impact was heightened by applying faceted steel components to textural, lush fabrics like plush velvet and supple suede. The modernity of this application was no accident, as an exten-

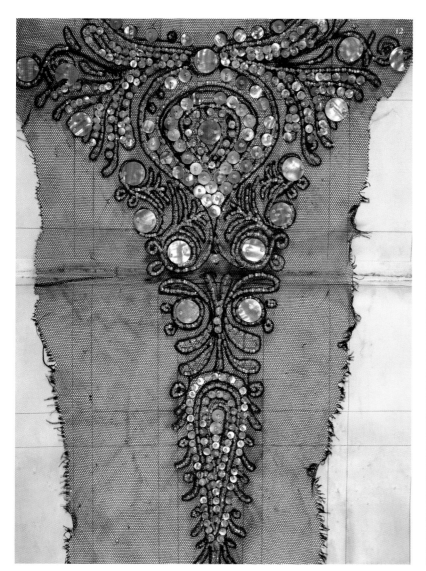
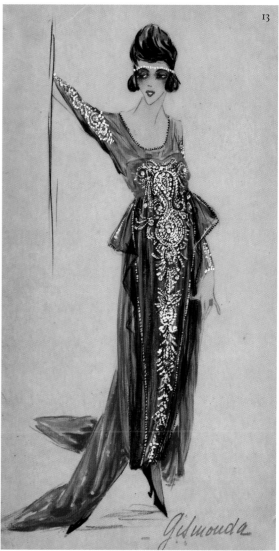

Figure 12 & 13: Embroidery swatch detail and gouache rendering of "Gismonda," 1919. Scarlet red evening dress embroidered with Persian-influenced motif rendered in mother-of-pearl discs, clear seed beads, and metallic thread chainstitch outline. The same embroidery pattern is applied to black silk tulle, which is used for the upper-bodice and sleeves.

sive knowledge of materials, color, and texture figured into the equation and resulted in the most sublime effect. Weight was a consideration when using steel components in embroidery; they were kept on a small scale in round and teardrop shapes, and were heavily faceted. (Fig. 26-27)

Aluminum, a lightweight white metal and highly corrosion-resistant, was used to form daisy motifs and linear patterns on beading swatches from 1945. (Fig. 28) In contrast to steel components, the lightweight aluminum was used in large hollow shapes; because of its malleable property, it was molded, textured, and brushed reducing the highly reflective quality of metal. Wanting to maintain a modern image for the house, Madame Lanvin experimented with a vast array of materials—the latest and greatest available. Typically used for building construction and aerospace design, aluminum was not considered a luxury metal, since it was cheap to manufacture; hence, its application to couture fabrics was a sign of an innovator willing to experiment and take risks.

The ingenious use of materials can communicate resourcefulness as well as innovation. In examples preserved in the Lanvin archives, small snail shells are painted red, and applied to silver lamé as an alternative to pearl. (Fig. 16)

A 1920s-era nautilus embroidery, using silver lamé as the foundation, features red, black, and white machine-stitched threadwork that forms the two-dimensional pattern of the embroidery. (Fig. 17) The three-dimensional aspect is created with the application of jet black, red translucent, and clear glass rocaille beads used in combination with jet black bugle beads and the smallest of white pearls. Red-dyed snail shells spotted with red seed beads form the two primary spirals of the nautilus pattern enhanced by the individually spiraling shells. The silver lamé base cloth serves as a neutral ground that augments the bold embroidery by gently reflecting light. Black and white beads and pearls, serving as complementary components, create a neutral environment in which to feature the brilliance of the red-hued shell.

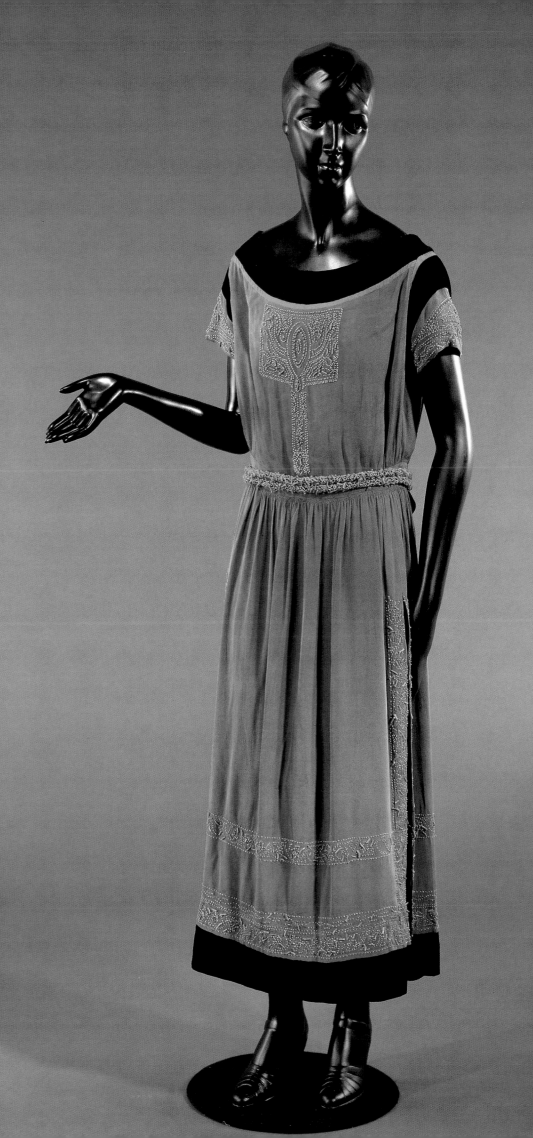

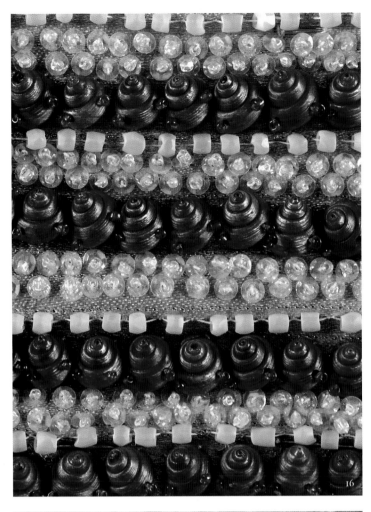

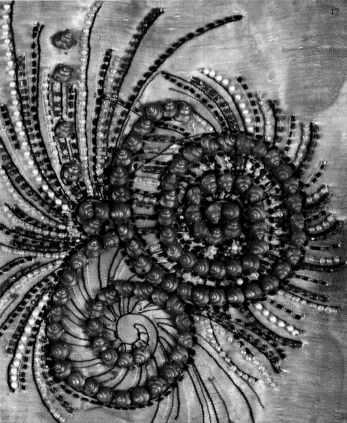

Preceding spread: **Figure 14.** Black silk taffeta dress with self-fabric ties at the neck and bottom of each sleeve. The coral-colored chainstitch patterns of Middle-Eastern influence are outlined and beaded in cut coral fragments, winter 1920-21.

Figure 15: "Lanvin blue" silk crepe day dress with black velvet border and belt. Coral-colored chainstitch embroidery is enhanced by the application of short coral branches applied in a random pattern, 1920-21.

Left: Figure 16. On a foundation of metallic silver lamé there is striking contrast between the red painted seashells and the other colorless components of milk-glass beads, clear iris cupped sequins, and clear seed beads—all of which are more subtle when placed against the silver surface.

Figure 17: Using a foundation of metallic silver lamé, dual nautilus forms are beaded and embroidered for maximum visual impact. Creating greater contrast to the light-colored foundation fabric, red, black, and white chainstitch embroidery are used to outline the spiral formation ending in assorted radiating lines. Jet bugles, red and clear rocailles, and seed pearls add to the radiating flat chainstitch, while red-tinted seashells help to reinforce the overall spiraling motif of the nautilus composition, 1921-22.

Opposite page: Figure 18. "Miranda," 1932. Mother-of-pearl hip girdle, in circular and scalloped pattern, becomes a grand accessory or peplum. Usable on many fitted models of the 1930s, it replaces the need for special pieces of jewelry. The fiery quality of mother-of-pearl creates a special ethereal effect, and the hip and stomach area become an erogenous point of focus.

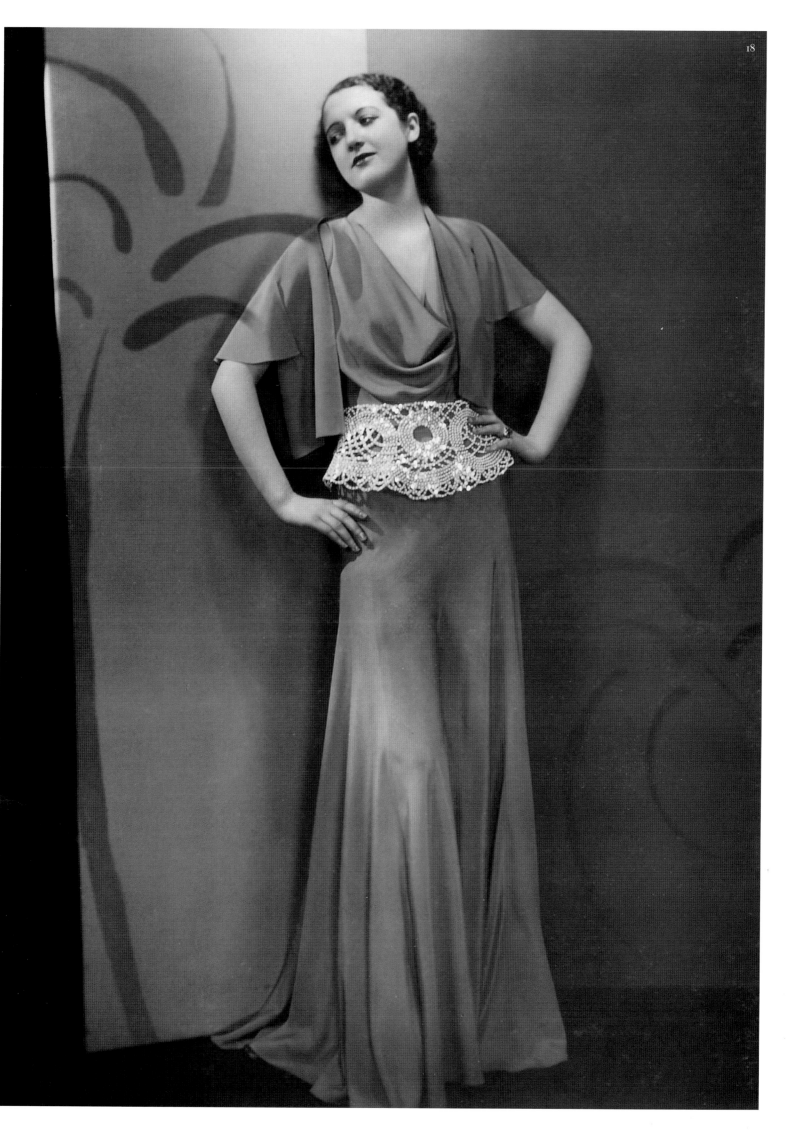

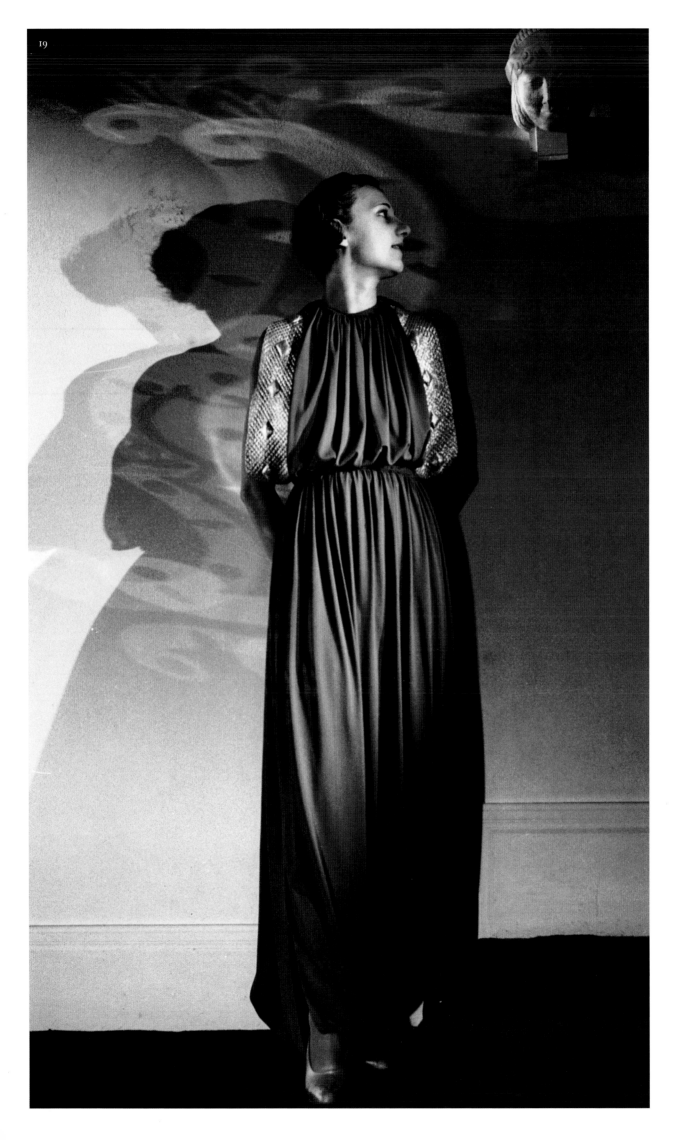

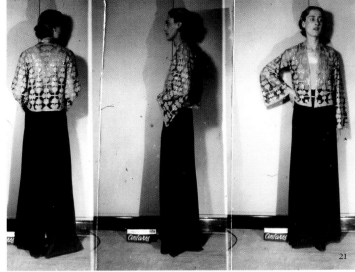

Opposite page: **Figure 19.** Metal plaques are applied in a scale technique implying an armored structure, symbolizing protection and resistance to evil. What appears to be a loosely fitted dinner dress is actually a cleverly constructed pair of harem-like pants, *Harper's Bazaar*, 1938. Above: **Figure 20-21.** "Antares," 1939. Madame Lanvin continued to play with the effect of a visually floating pattern by applying sapphire blue enamel metal tiles onto the surface of black tulle. Persian carpet patterns were the inspiration for this design.

Madame Lanvin employed coral fragments in embroideries dating from the 1920s, taking full advantage of their abstract shape and intense orange-red hue. Making the most of the exotic fragments, she produced several pieces that used coral as a surface embellishment. A dress from winter 1920–21 of black silk taffeta with self-fabric ties at the neck and wrists, is embroidered in coral-colored threadwork and coral fragments. Influenced by the Middle East, the geometric shapes, vertical rows, and horizontal borders of peasant-style embroidery cover the surface as the black ground lends itself to the intensity of the natural color of the coral. This particular embroidery pattern was used frequently in the 1920s, incorporating other components including chalk white beads, mother-of-pearl, and turquoise—all of which satisfied the preference for the exotic. (Fig. 14-15)

For summer 1924, "Veilleur de Nuit" (Night Watchman), a voluminous *robe de style*, was created using crisp, black silk taffeta and silver re-embroidered tulle. Naturally, the most important and impressive aspect of this dress is the beading and the embroidery inspired by the finery of the Imperial Chinese court, and the motifs of both the border and the roundels on the skirt draw from historical precedent. (Fig. 25)

The role and function of textiles in any society is both general and specific. While textiles serve the everyday needs of people, literally from birth to death, they may also serve to distinguish individuals, and groups of individuals, in terms of social class, gender, occupation and status within the group.[3]

The elaborate hierarchies of the Chinese court were expressed sartorially, and these hierarchies were distinguished by the type and quality of clothing and decoration. In Imperial China, the embroidery found on official robes served as a means of advertising the status and authority within the hierarchy of the court structure. The two cranes found circling the central spiral within each roundel, executed in green and silver chain-stitch threadwork, are a traditional Chinese symbol of longevity.

The surface decoration of this dress is a composite of threadwork, silver-lined bugle beads, silver seed beads, crystal with black plastic settings, celluloid discs and oblong shapes, mirror disks, and pearls. The central motif of the roundel, which appears five times on the skirt, is a spiral formation with a celluloid disc, amber in color, as the center and surrounding spirals created with rows of silver-lined bugle beads defined and outlined by a single row of both green and silver threadwork. The two cranes are placed at the top and bottom of the roundel as the wing-span extends to form an additional spiraling circular outline. The bodies of the cranes are highlighted by pearls, crystal and celluloid shapes. A circle of lozenge-shaped celluloid pieces anchored with silver-seed beads surrounds the central-motif. A formal circular outline is created by a silver-lined bugle bead border outlined in green threadwork. The outer perimeter of the roundel is decorated by a substantial border of the motif used to indicate water, and is executed primarily in pearls and enhanced with celluloid pieces, crystal, silver seed beads and silver bugle beads.

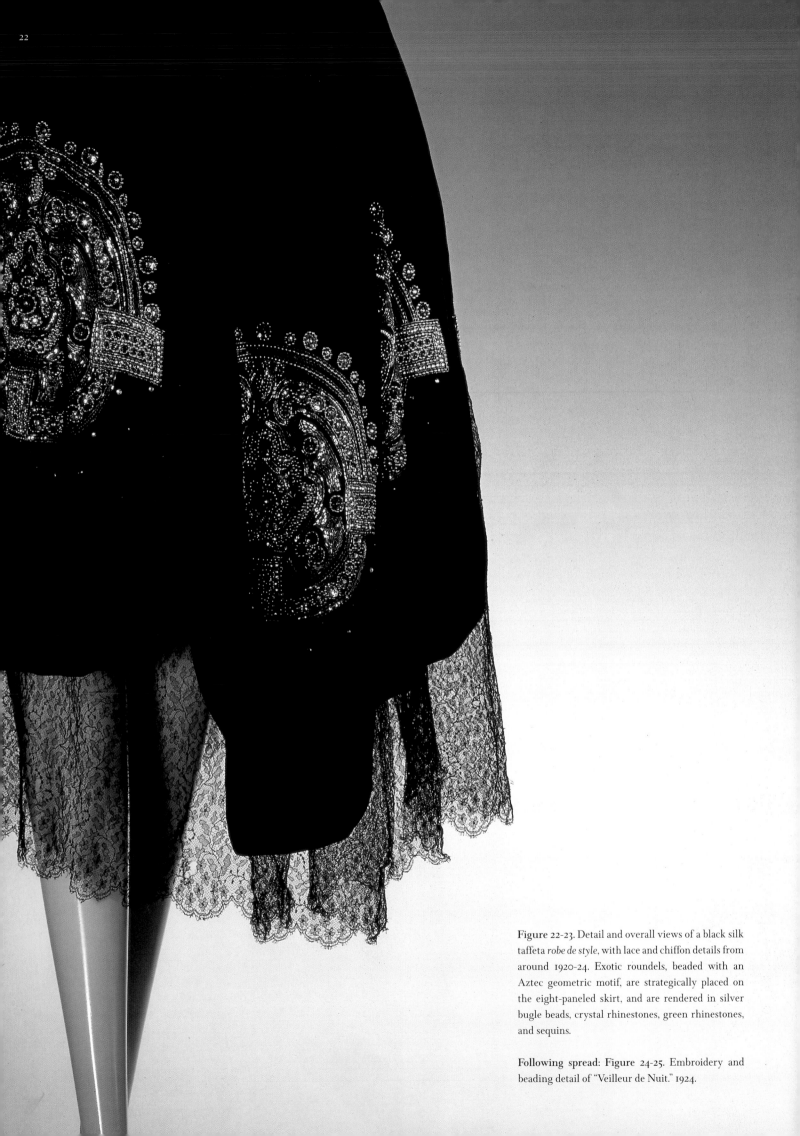

Figure 22-23. Detail and overall views of a black silk taffeta *robe de style*, with lace and chiffon details from around 1920-24. Exotic roundels, beaded with an Aztec geometric motif, are strategically placed on the eight-paneled skirt, and are rendered in silver bugle beads, crystal rhinestones, green rhinestones, and sequins.

Following spread: Figure 24-25. Embroidery and beading detail of "Veilleur de Nuit." 1924.

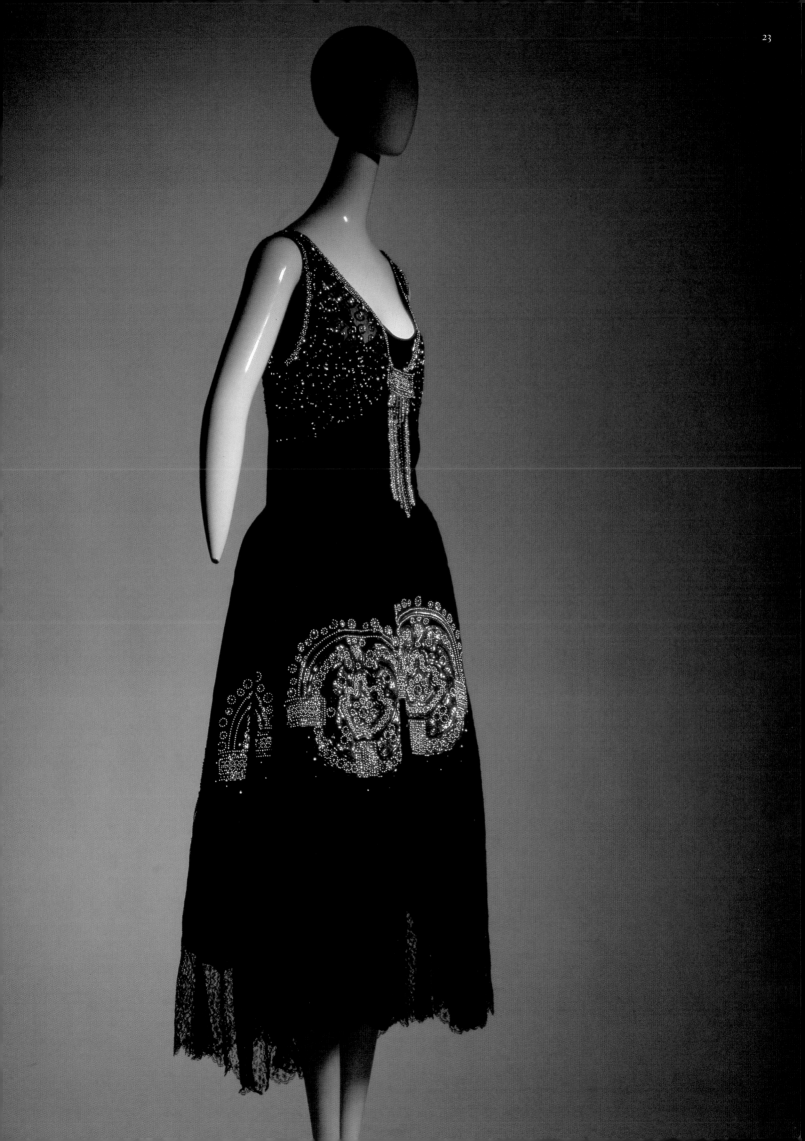

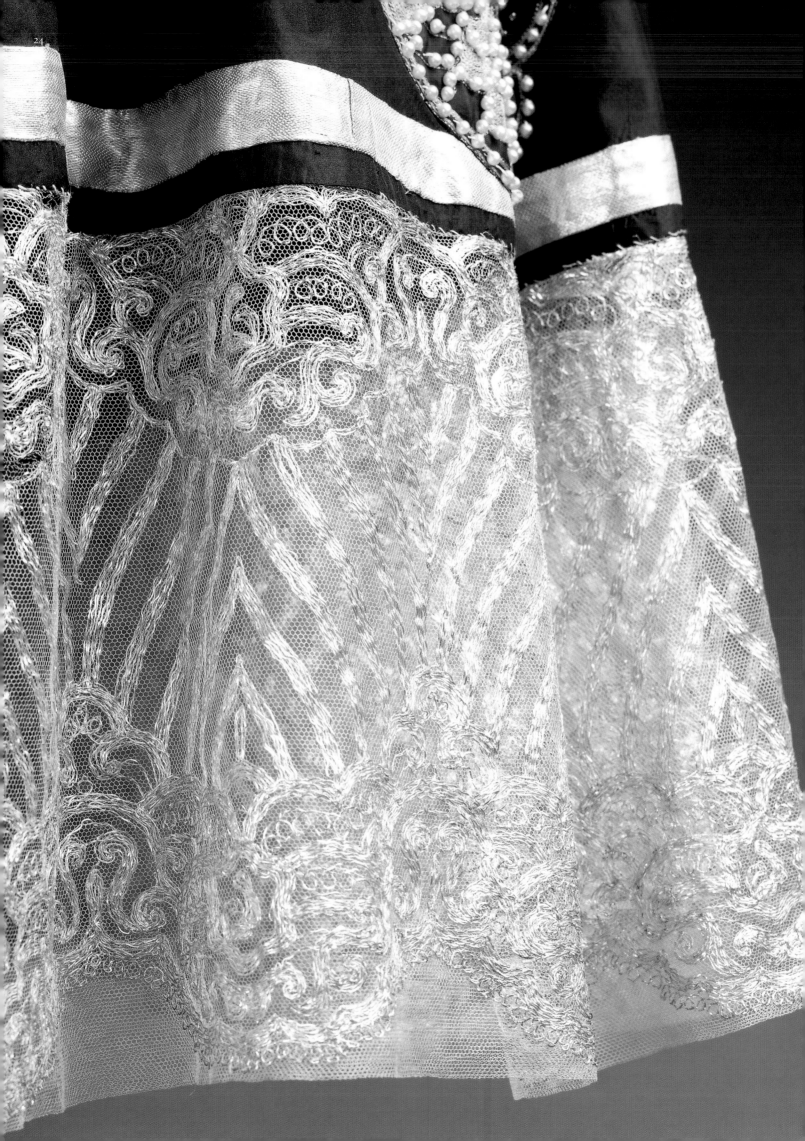

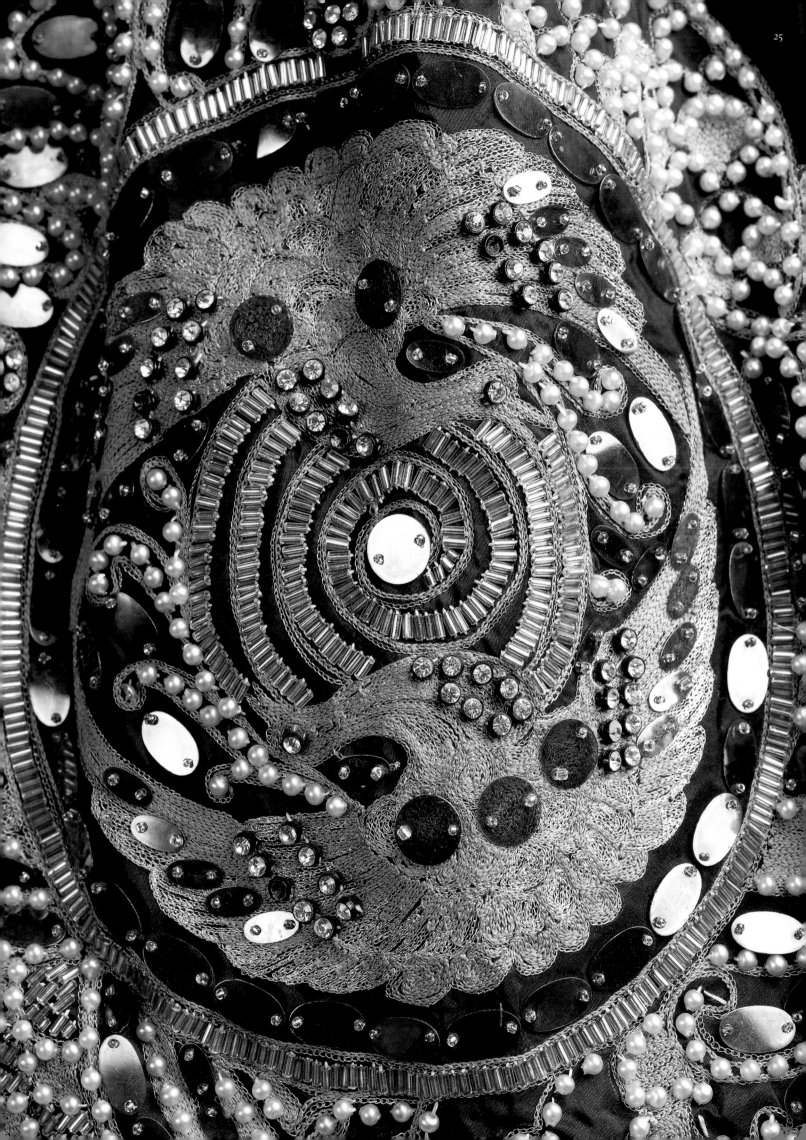

The silver tulle border of the skirt(Fig. 25) creates a light and airy effect in comparison to the dark heavy look of black taffeta. The border is executed in silver threadwork in a pattern suggesting the rainbow hem of a Manchu robe with its cloud formations and mountain range. The colors used while not explicitly referencing a Chinese palette, clearly reflect client preferences of the period, including the use of silver textiles in a variety of textures and effects, used in combination with, black, coral or jade green.

Sequins, which typically are plastic, are available in many sizes, shapes, colors, finishes, and printed patterns. Sequins are also available as transparent or opaque, flat or cupped, center punched or side punched. Thanks to technology and innovation sequins can be punched out of leather, suede, paper, linen, denim, and an assortment of other materials. Today, the sequin is used as a flat circle of distressed and patinated brass, which is similar to its original inception. In 13th-century Venice, the mint distributed 3.5-gram gold coins called *zecchins*, which the French later translated as sequin.

Inexpensive, lightweight, and reflective—in other words, perfect for experimentation—sequins often were used in Lanvin designs. There are many examples of brilliant and successful experimentation both on costumes and documented in the archive's sample books. Stacking was a commonly used technique, thanks to the sequins' light weight. Layering select colors in graduated sizes created dimension and visual illusion. Once the sequins were stacked, they were usually secured with threadwork. Having passed through the center punch with multiple passes all around the sequin, the threadwork became part of the overall design; it created a starburst effect over the stack of sequins. (Fig. 1)

A gold-embroidered evening dress and coordinating diadem was created for the summer 1923 collection. (Fig. 37) Flesh-toned silk tulle serves as the base of this dress, which is patterned with gold Cornely embroidery in overlapping circular motifs of assorted sizes. Lozenge-shaped *paillettes*, applied within the circles, add shine to the matte finish of the metallic threadwork, which reinforces the circular motif. The cylindrical, drop-waist silhouette is typical of the 1920s. It relies on a handkerchief-style hemline to create additional movement as the wearer danced to the syncopated rhythms of jazz in nightclubs and cabarets. A hip sash, created from layers of the same tulle, is secured with a *diamante* brooch.

Previous page: Figure 26. Faceted stainless steel and hematite beads applied in a circular motif on dark green suede, 1921.

Above: Figure 27. Faceted stainless steel and hematite beads are arranged in various floral and snowflake motifs on a dark ground.

Figure 28. Experimentation with aluminum components in teardrop and cabochon shapes—some are polished, some brushed, and others have a hammered texture, 1945.

Following spread: Figure 29. "Buckingham." Silk crepe evening dress with neck scarf and sequin encrusted overblouse, 1934.

Figure 30: "La Cible." Evening blouse of pave sequins in a spiraling Japanese *mon* motif, Winter 1931.

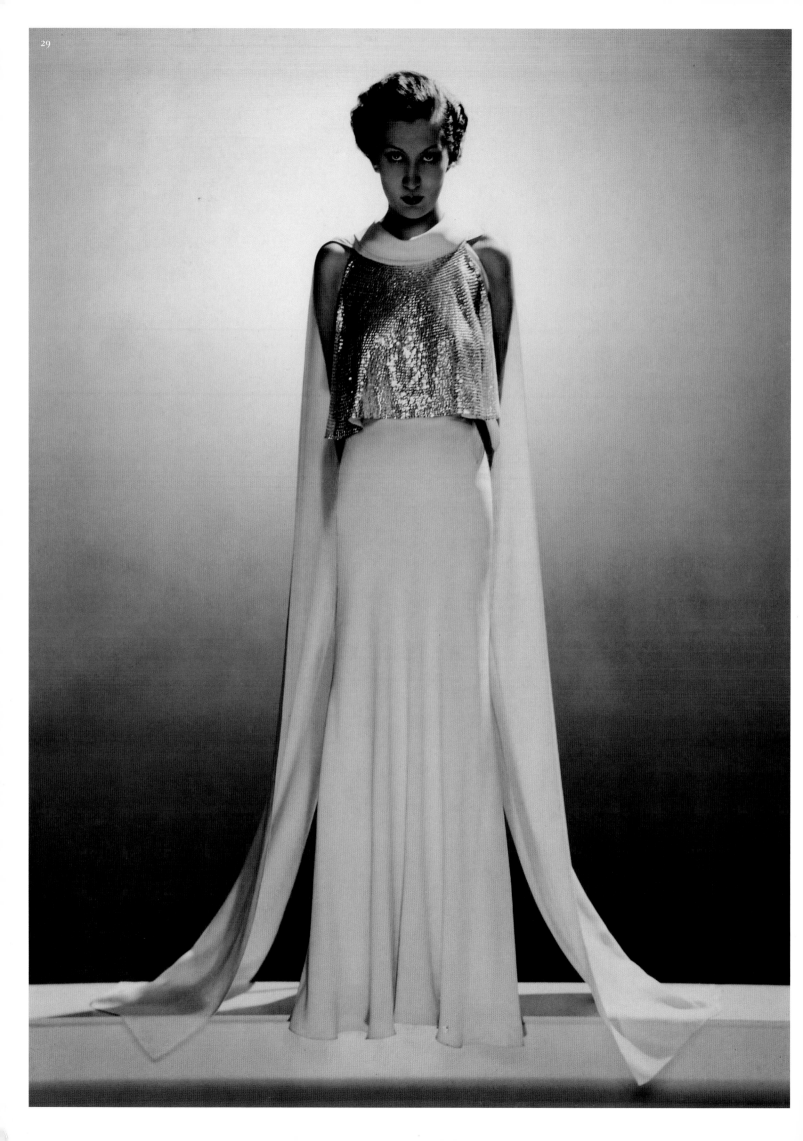

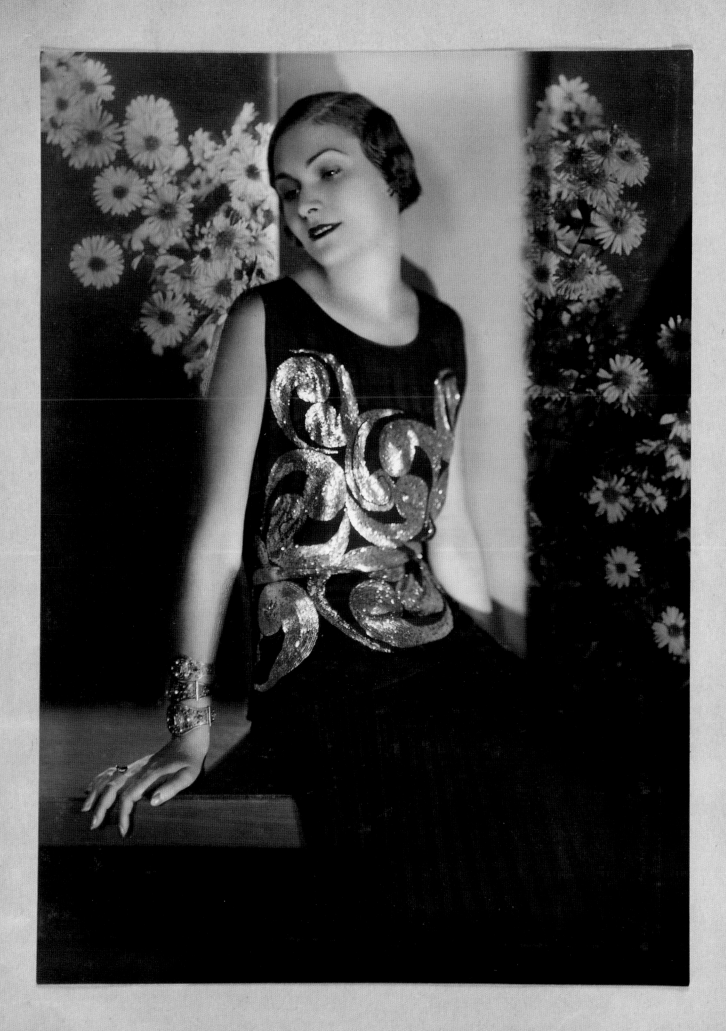

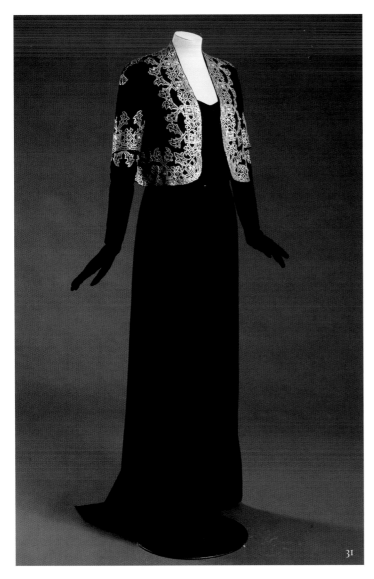

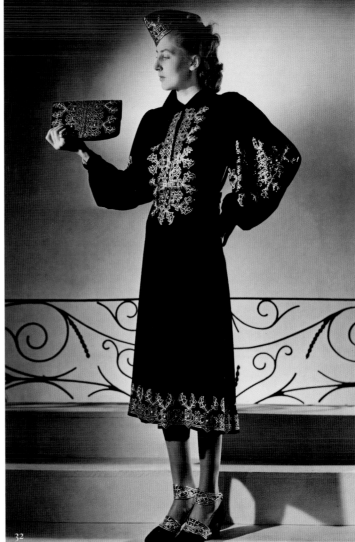

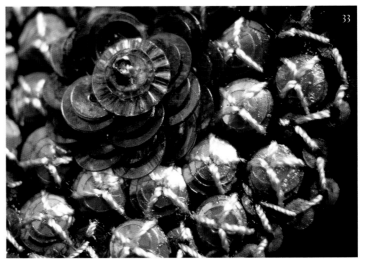

Figure 31: Black crepe evening dress with train, matching embroidered bolero jacket, and gloves. Sequin embroidery of North African inspiration is rendered in green, red, and gold. Both the short sleeves of the jacket and the tops of the gloves have an embroidered border, summer 1939.

Figure 32: Dress with hat, shoes, and bag–all embellished with the same embroidery pattern from Fig. 31, summer 1939.

Figure 33: Sequin detail with punched plastic pieces, stacked, arranged and threaded into motifs.

Opposite page: Figure 34. Black silk velvet evening jacket with sequined motifs, 1940. Creative spiral motifs were fashioned by stacking colored sequins of various sizes, while employing an assortment of application techniques.

Figure 35: *Art, Gôut, et Beauté* of 1927 shows an advertisement using a Lanvin design for the promotion of Cornely embroidery.

Following spread: Figure 36-37. Embroidery detail and overall views of a gold-embroidered evening dress and coordinating diadem, with a "flapper" silhouette. Summer 1923.

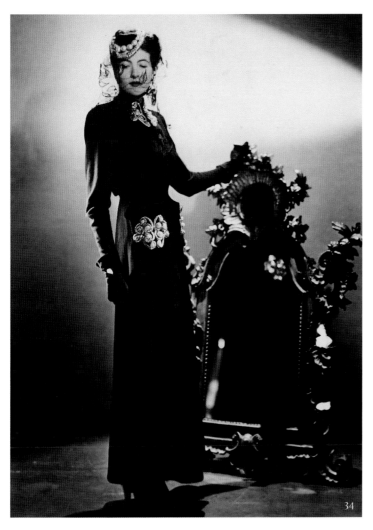

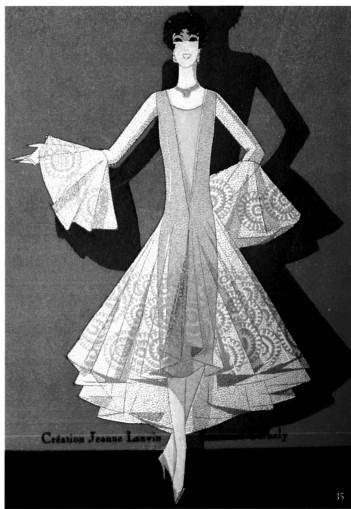

Although her design influences and inspirations were not always contemporary, Jeanne Lanvin was an advocate of modernity. She used the lightest of fabrics for comfort and applied the most interesting design detail for visual impact. This dress is constructed of the lightest and sheerest silk tulle, allowing a woman to move freely and creating an illusion of bare skin peeking through gold roundels. A flesh-toned *crepe de chine* slip was worn under the dress, further perpetuating the illusion of exposed flesh. The plunging neckline at the center front and back help maintain the feminine and youthful Lanvin image in a typical Roaring Twenties silhouette. Though the image of Madame Lanvin was closely associated with motherhood, romanticism, and modesty, she created extremely modern, daring, and wearable dresses for her clientele.

A 1927 (Fig. 35) dress was described as a "long tubular shaped gold lamé dress, the bodice of fine beige tulle embroidered with gold thread and lozenge-shaped gold sequins in a cartwheel design." Accompanying the dress is a three-quarter-length tulle jacket with trumpet sleeves elaborately embroidered in the same pattern more appropriate for the mature client. The embroidery pattern is typical of Madame Lanvin's modern design sensibility, as the circular pattern spirals around the body, graduating in size from smaller circles on the bodice to larger circles near the handkerchief hemline. Overlapping spirals give the impression of spinning gears in a machine as the metallic-gold finish is indicative of the taste for slick, sleek, and modern elements in all aspects of life in the "machine age." The applied design visually creates a visual sense of rhythm and movement even if the wearer remains still; the effect is heightened as the body moves to the rhythm.

The most impressive example of sequin work is highly technique-oriented. For Winter 1934–35, a royal blue silk-velvet dinner dress, of the simplest lines and silhouette, is definitive in historical reference. The silhouette is that of the angel robes from the frescoes of Fra Angelico and the gold-sequined embroidery pattern symbolizes armor. Although isolated to the elbow of the sleeve, the simple motif is labor intensive as sequins—domed, cupped, and flat—are stacked according to size in order to create a three-dimensional form. (Fig. 41–42)

Found in clusters of three, no less than ten sequins are used to complete the central formation. Having aligned the center holes of all sequins, the beading needle passed through the

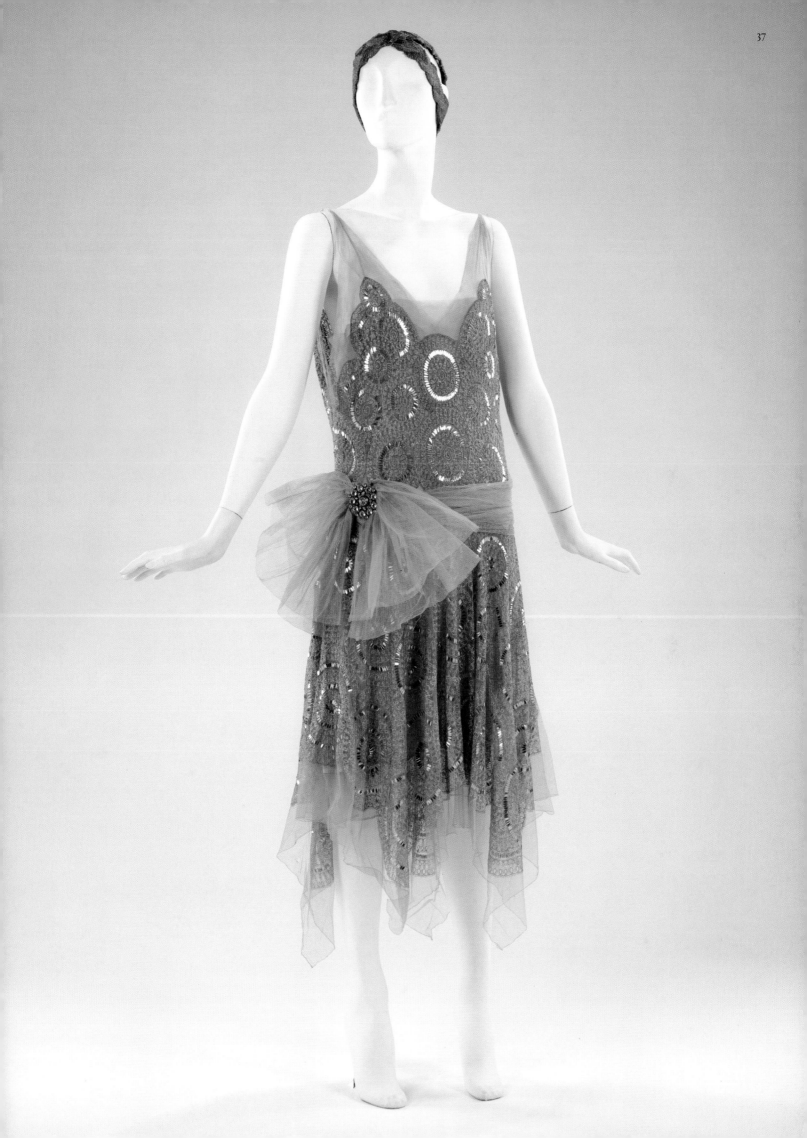

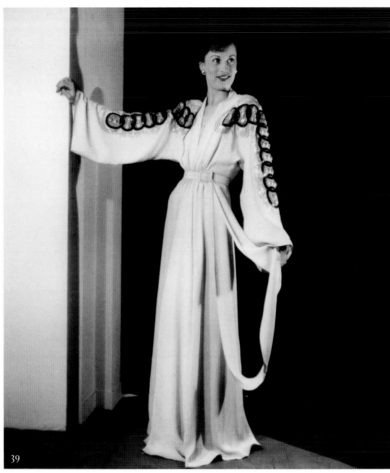

center punch six times in order to secure the stack through additional holes around the perimeter of the foundation. The smaller, flanking formations use eight sequins with a shorter but equally time-consuming result; they are secured in the same manner. The general area of the armor motif is filled in with a three-millimeter inverted-cup gold sequin layered onto a four-millimeter flat gold sequin. Each one of these simple combinations was then secured by four passes of the needle through the center punch. Although the individual component is a basic sequin, it has been manipulated and applied to maximum effect through dexterity and ingenuity. The plastic, lightweight sequins enable the use of the stacking technique as the weight is minimal compared to metal components or stones.

1 Kirke, Betty. Madeleine Vionnet, (San Francisco: Chronicle Books, 1998), 222.

2 Battersby, Martin. *The Decorative Twenties* (New York: Walker and Company, 1969), 29.

3 Harris, Jennifer, ed. *Textiles, 5,000 Years* (New York: Harry N. Abrams, Inc., 1993), 11.

Figure 38: Embroidery detail for "Le Soulier de Satin" [The Satin Shoe], 1944. The black circles rendered in sequins applied in fishscale technique create a solid form with a slick finish. Interlocking black circles, containing three silver discs like the three discs of the *mon*, are superimposed over stripes of blue and rose. A rigid geometric central motif is visually softened by overlapping swags of graduated silver sequins.

Above right and Opposite page: Figure 39-40. Overall view and gouache rendering of "Le Soulier de Satin" *robe d'intérieur* of white silk satin, 1937.

Following spread: Figure 41: Detail of stacked sequin-work from the sleeves of the royal blue velvet evening dress in Figure 42

Figure 42. Royal blue silk velvet evening dress, winter 1935-36. The simple lines and silhouette are similar to the robes of Fra Angelico angels.

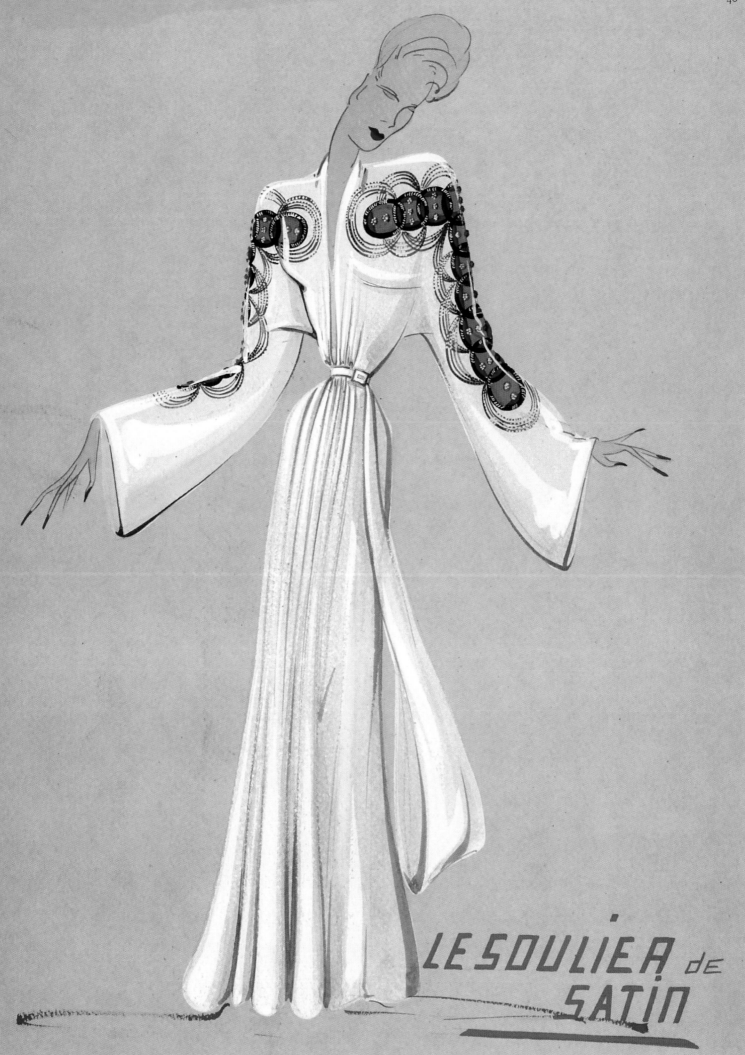

LE SOULIER DE SATIN

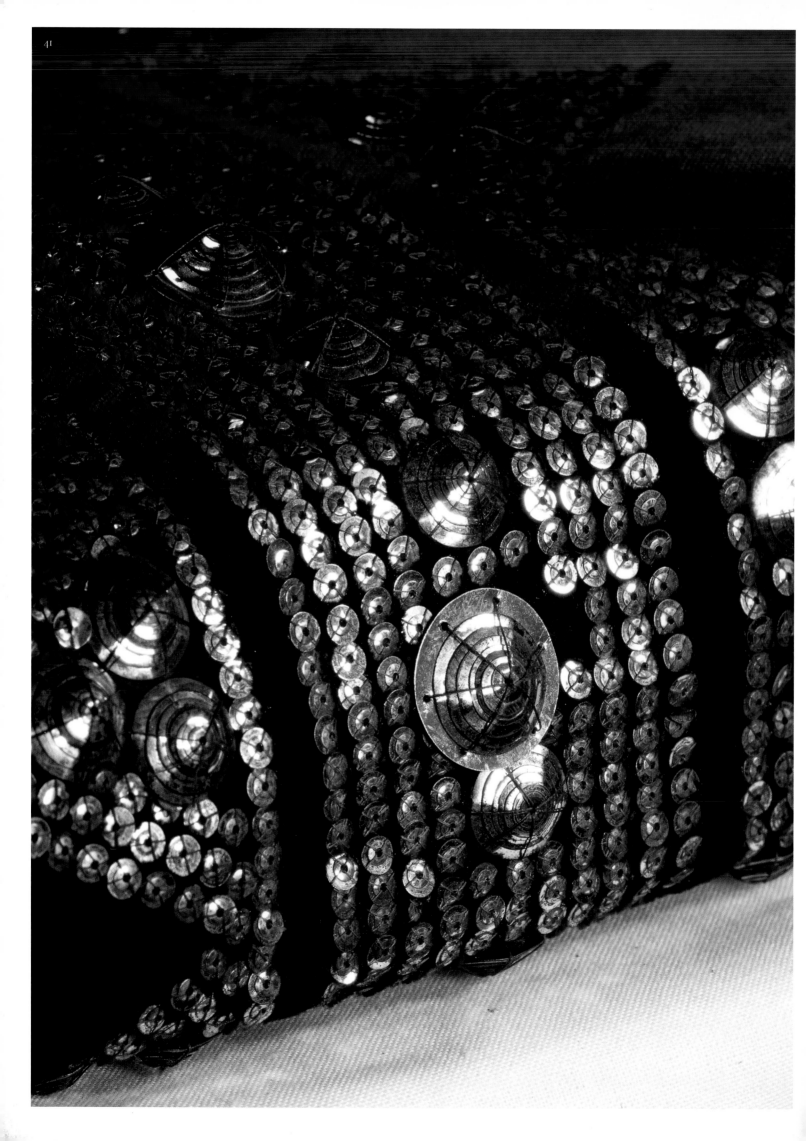

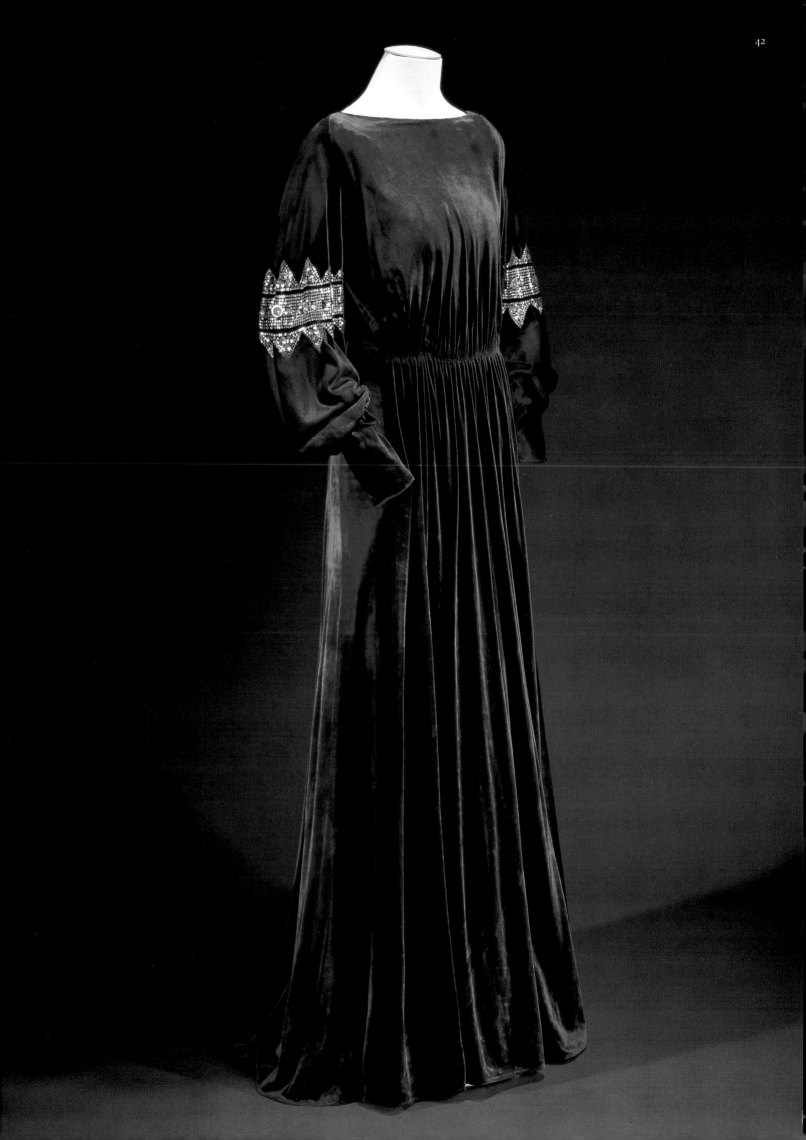

SUPPLEMENTAL ELEMENTS

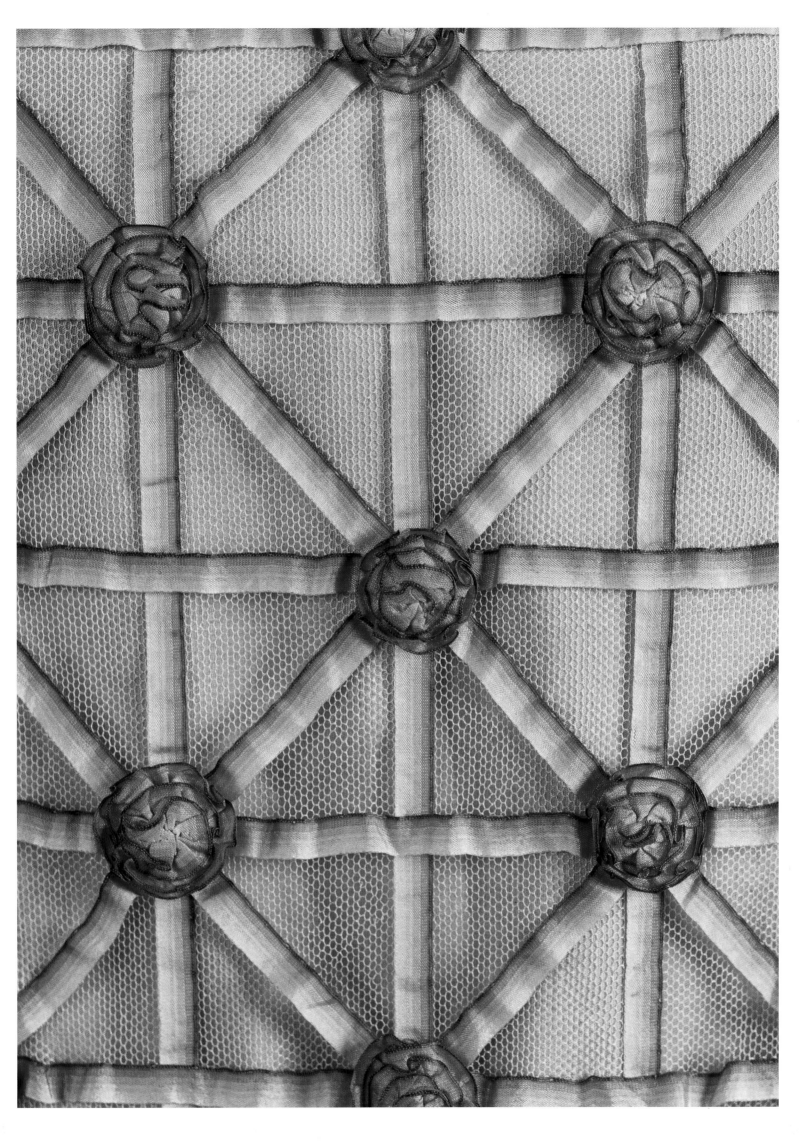

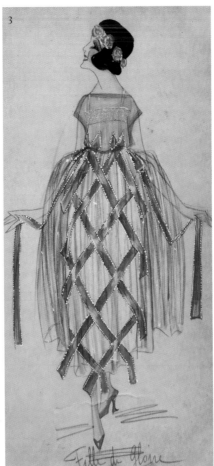

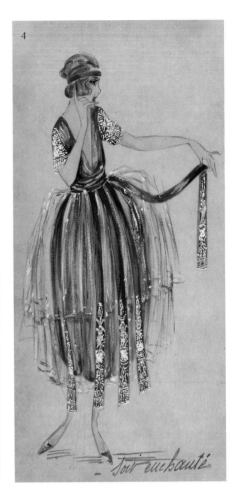

Previous page: Figure 1. "Roseraie," summer 1923. Detail of ribbon-work and flowerettes applied to silk tulle. **Above: Figure 2.** Gouache illustration for "Roseraie." **Figure 3.** "Fille de Gloire." Evening dress with appliqué of latticework ribbons, 1919. **Figure 4:** "Soir Enchanté." Evening dress with streamers of embroidered ribbons flowing over a voluminous skirt. 1919. **Opposite page: Figure 5:** Overall view of "Roseraie."

MANY LANVIN BEADING AND embroidery patterns involved supplemental elements such as ribbon, and yarns of wool and chenille, self-fabric details and *soutache*. Contributing to the overall texture and composition, the beauty and appeal of this embroidery is often due to the unexpected juxtaposition of materials and color. Ribbons of lamé, satin, grosgrain, and, most effectively, ombre—were frequently used, appliquéd to fabric or as bows and streamers.

In 1918–1919, Camille—a *première* of one the embroidery ateliers at Lanvin—created a small swatch of ribbon florets from one-quarter-inch-wide pink ombre, stitched in a circular motion and spiraling outward. This swatch was to be the surface decoration for the "Roseraie" dress, first sketched for the 1923 summer collection in Paris. (Fig. 5) In a 1928 illustration by Georges Lepape, a child is wearing the same dress, with minor stylistic alterations; it is referred to as "Lucrèce." The base fabric of the dress is ivory silk tulle embroidered with the narrow ribbon. Under the tulle dress is a pink silk *crepe de chine* slip. Although the slip is of the typical 1920s columnar silhouette, the skirt is full, creating a sweeping romantic effect. "Madame Lanvin has always been noted for

the youth and charm of her costumes. They are never over elaborate, never complicated, but always of a pleasing simplicity, and the cut and the trimmings reveal a mind essentially Parisian."[1]

Although there is no *pannier* structure in "Roseraie," the bateau neck, cap sleeve, drop waist, and full skirt are typical of the romantic, always flattering *robe de style* silhouette. Many of these dresses were accessorized with a suitable romantic picture hat adorned with flowers and flowing silk ribbons, created by the woman whose roots were based in the art of millinery.

In a decade where straight, tubular silhouettes were the aesthetic most subscribed to by designers and consumers alike, Jeanne Lanvin offered an uncommon, romantic alternative. This is not to say that full-skirted *robes de styles* were all that she offered to her customers, but she strongly believed in options as much as she did in modernity. "The Lanvin collection is a most complete expression of taste, imagination, and are in costumes which the Parisienne can actually wear."[2]

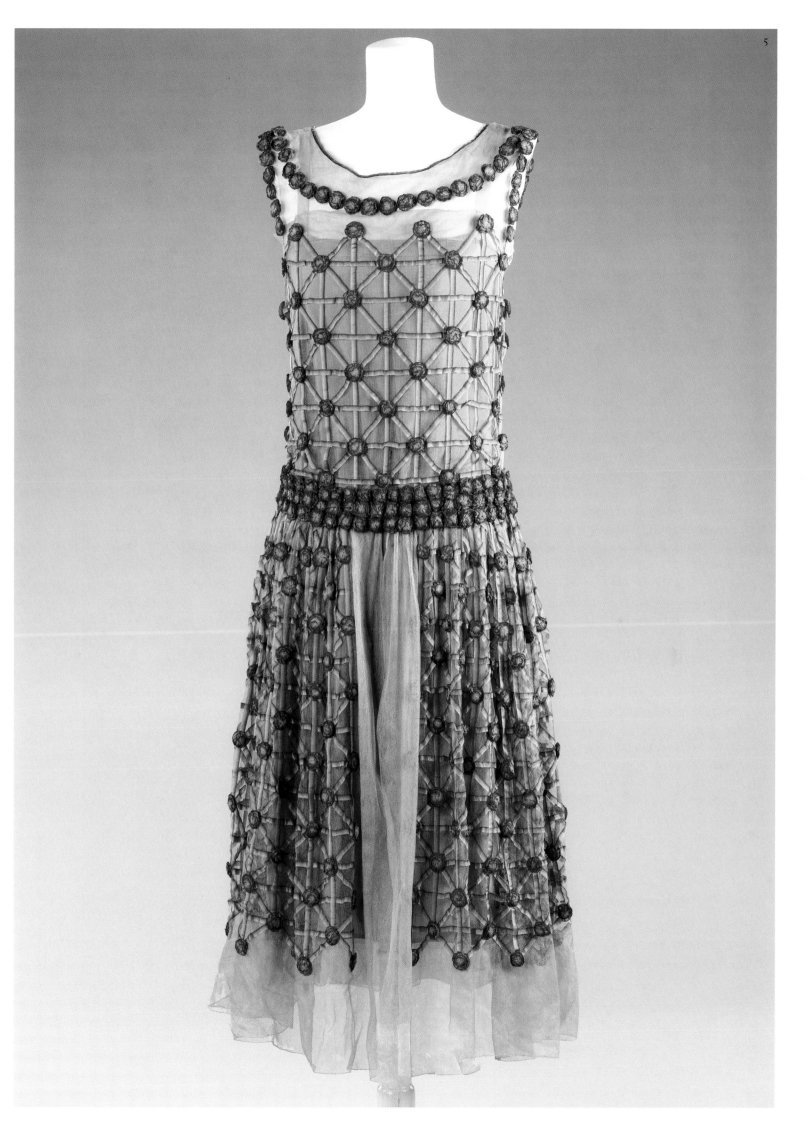

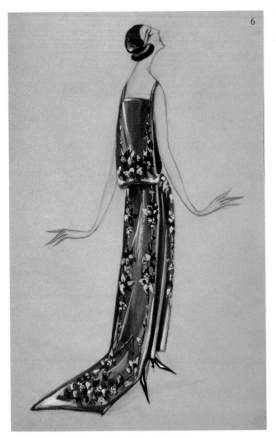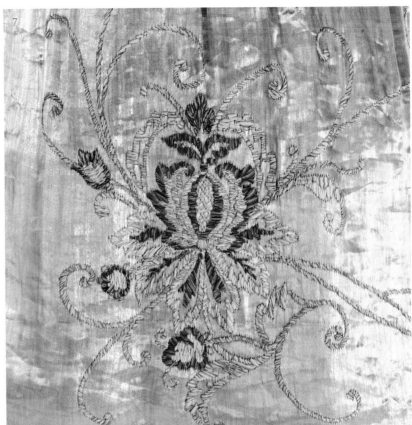

Figure 6: Gouache rendering of the dress of the same style seen in Figure 8. 1923. **Figure 7**: Embroidery detail of rose-colored pomegranate, signifying fertility, hope, and royalty. Rendered in polychrome ombréed ribbon, the vibrant green tendrils and leaves reinforce the image of vitality. Summer 1923. Opposite page: **Figure 8.** Backview of silver lamé robe de style with loosely bustled train lined in blue. **Following spread: Figure 9.** "Jolibois," deep blue silk taffeta *robe de style* in classic styling of open neckline, sleeveless, dropped-waist, and full skirt. Self-fabric loops accommodate a sash of contrasting color, winter 1922-23. **Figure 10**: Chenille embroidery detail from Figure 9.

A sophisticated and luxurious evening dress of silver lamé, an expensive metallic fabric often used sparingly, is lavishly embroidered with narrow ombre ribbons of green, yellow, blue, red, and pink. The coloration of ombre ribbons lends visual depth to the overall image of stylized pomegranate and scrolling vines and leaves. The motif is plentiful, found three times on the front skirt, twice on the back skirt, and at the top of the train. This creates visual balance. The train is lined in vibrant blue. The ensemble is complete with lamé headband, floret, and black egret feathers. Although not the full-skirted signature *robe de style*, and not the fashionable tubular silhouette of the 1920s, the gathered A-line skirt is a gentle compromise. (Fig. 7-8)

Chenille and wool yarns were used frequently, and separately, to create visual interest and surface texture, whether as a monochromatic color scheme or polychrome rendering. "Les Palmiers," (Fig 12) a *robe de style*, was first rendered as a blue dress with ivory palm fronds flanking each hip. A superb example of this dress exists in black silk taffeta embroidered in rich, cream-colored silk-chenille yarns. Chenille is known for its unique reflective and iridescent properties, due largely to the unique pile direction of the yarn, which is determined during the spinning process. It is the soft quality and sheen of chenille yarn that contrasts with the crisp, dull finish of black silk taffeta, which tends to absorb light.

In contrast to "Les Palmiers," a blue *robe de style* of the most intense hue serves as the canvas for a still-life rendering of a garden bouquet. Tonal pinks were used to render the *ranunculus* flowers, in various stages of bloom, with complementary green foliage and fronds. Golden orange and black chenille was used to visually ground the image on the blue silk taffeta. Once again, because of the light-reflective property of chenille yarns, the motif reads differently when viewed from various directions. (Fig. 9-10)

The earliest embroideries of Madame Lanvin's career, from 1909–1910, were usually bountiful feminine motifs of fruit and flowers. Basic wool yarns were dyed and used for shading and highlighting to create artistic three-dimensional renderings with subtle tonalities of color. Wool yarns were also used to create stripe patterns on otherwise plain woven goods, adding a special touch of luxury.

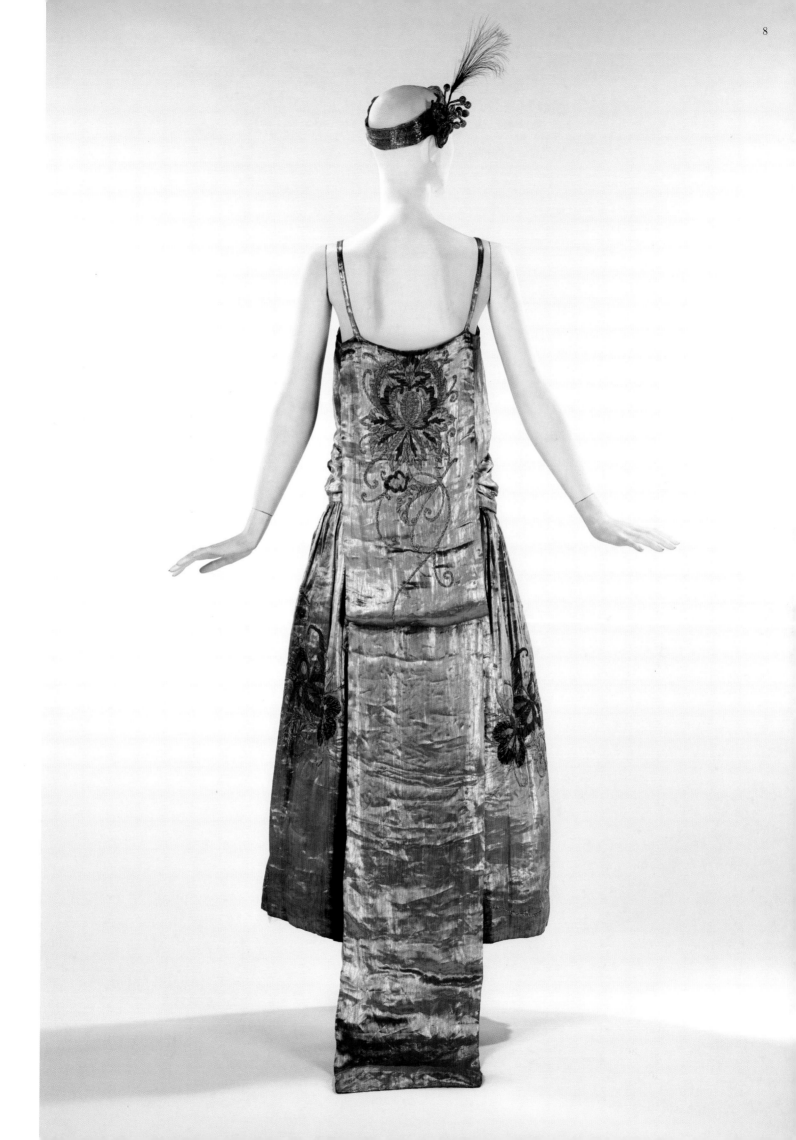

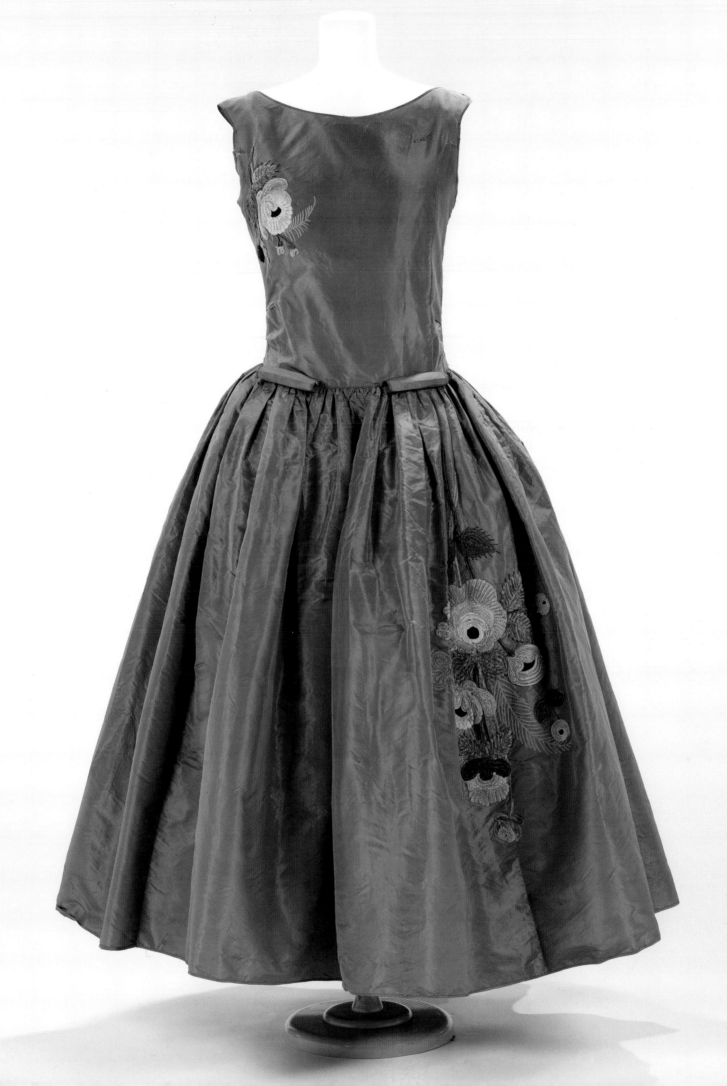

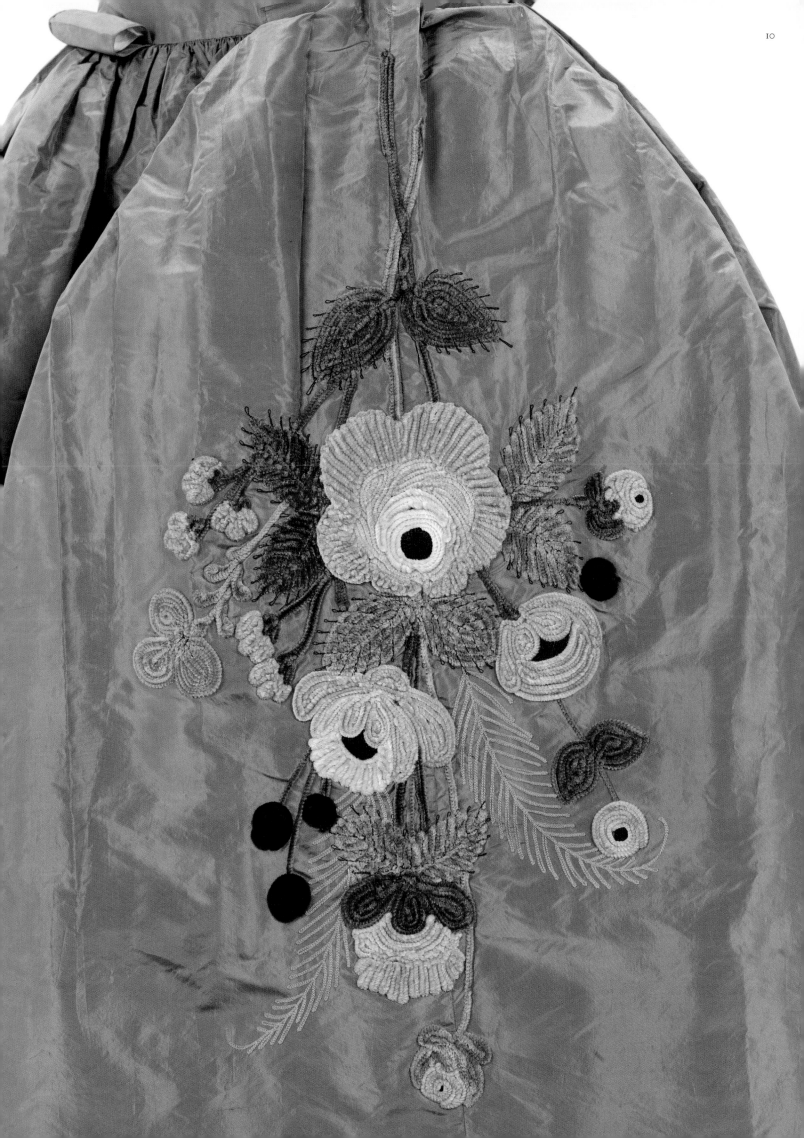

Figure 11: *Soutache* embroidered block-printed fabric handbag, circa 1910. Madame Lanvin abstracted the intricate print with *soutache* application in scalloped and vermiculli patterns. Metallic gold lamé was used to make the tunnel around the neck of the bag for the drawstring closure as well as the knotted double-corded shoulder strap. The long fringe gives additional visual interest and movement by stringing pom-poms of gold lamé and red. It is interesting to note that the face and back of the bag are completely different, as the back fabrication is solid Lanvin blue embellished with a central *soutache* motif.

Figure 12-13: Overall and detail views of "Les Palmiers." Black silk taffeta *robe de style* with embroidered palm fronds in cream-colored silk chenille yarn and cream silk taffeta streamers, winter 1922.

Figure 14-15: Detail and overall view of lampas coat (*robe d'interieur*) with embroidery of soutache, cording, and gimp, as well as a self-fabric closure and piping. 1913.

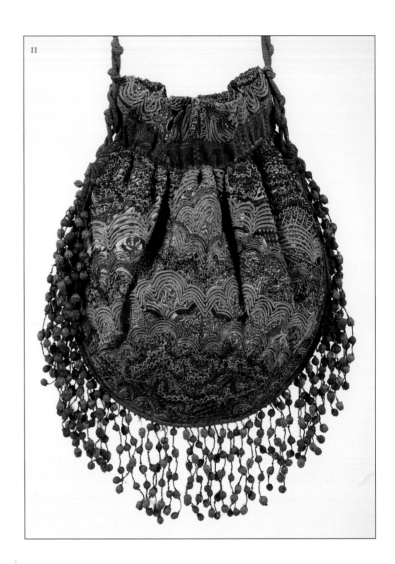

Lanvin used *soutache* as a surface embellishment from the beginning of her career—and quite frequently. *Soutache* is blended from various fibers including cotton, wool, and metallic composites. A 1910 evening dress of rose-colored silk and black chiffon uses metallic-gold *soutache* in the narrowest width to trace a delicate vermiculi pattern. (Fig 18-19) As always, the bodice, sleeves, and hem of the dress receive the most detail with gold *soutache* applied in an open, meandering pattern. This type of treatment added surface detail and interest to an otherwise plain garment or textile. Well beyond a basic application, whimsically placed points of rose-tinted gold *soutache* reflect the rose tone of the satin bodice, and are placed within the maze of gold vermiculi. It is an extremely subtle, yet incredibly sublime detail only detectable upon close inspection.

Originally, Lanvin *soutache* application was used to break up dominating printed patterns, many of them block-printed cotton or printed linen. Soutache was applied to create additional patterns as well as to outline existing patterns while abstracting others—as a way to superimpose patterns on prints. The alternative to this dense application, which created the effect of a solid color, was to open up the application and to allow colors and patterns of the printed base cloth to add to the overall interest and integrity of the design. (Fig. 11) The application of *soutache* was not reserved for apparel and accessories; it was also used as decoration for the bound volumes that contained the original designs of maison Lanvin. From the beginning, every Lanvin concept was archived and bound into volumes at the end of a season as a documentation and reference source. In typical Lanvin fashion, a textile "as is" was insufficient; in almost every case, textiles were embroidered, fulfilling the creative desire and aesthetic preferences of Madame Lanvin.

Some of the most beautiful effects were created in the form of self-fabric detail; whether decoration was created from and applied to the self-fabric or the fabric was manipulated, the results were formidable. Perhaps out of necessity, self-fabric details were prevalent in the early days of Lanvin's business. As early as 1912, a simple day dress was embellished—on the collar, around the sleeves, and as a deep scalloped border at the hemline of the dress—with cut, gathered, and applied blue-striped silk (Fig 16-17). As a day dress, self-fabric detail is less ostentatious and more appropriate for various occasions.

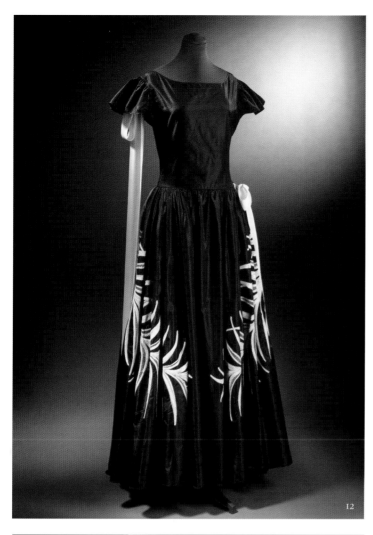

12

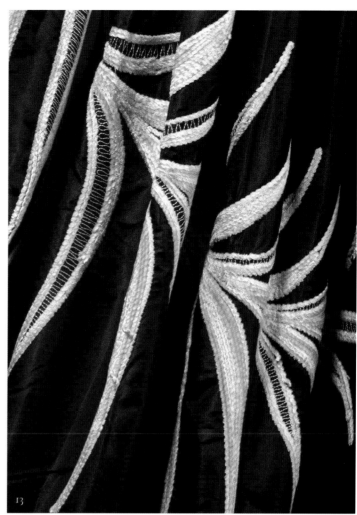

13

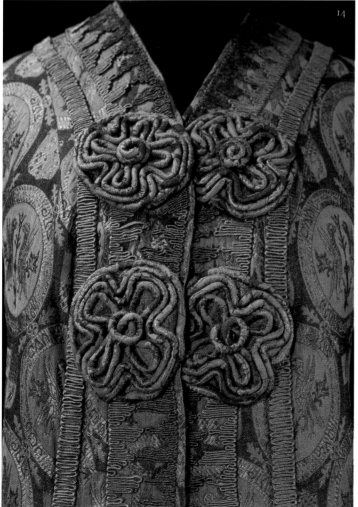

14

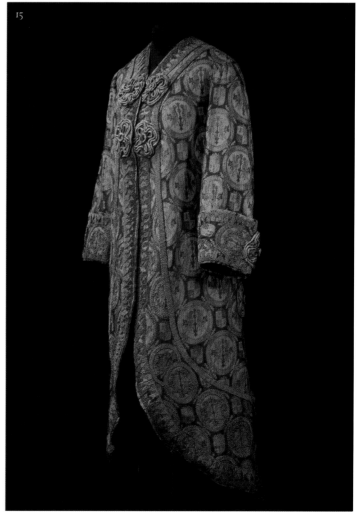

15

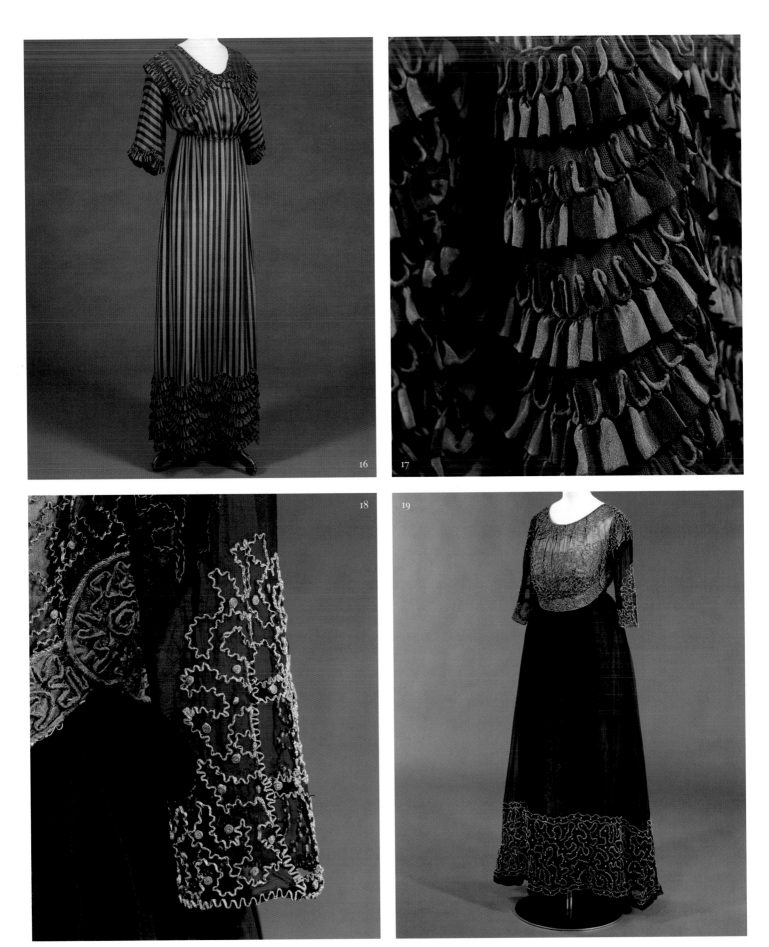

Figure 16-17: Overall and detail views, dress of royal blue silk *crepe de chine* with printed black stripes, 1912. Both the collar and hemline of the dress are detailed with multiple tiers of blue silk tulle edged with ruffles of striped silk, and embellished with self-fabric corded application. Figure 18: Detail of side bodice corsage and sleeve treatment of the 1910 evening dress in Figure 19. Figure 19: 1910 evening dress of black chiffon over a rose-colored silk bodice. Vermiculli *soutache* embellishment in gold and rose-gold is found on the bodice, sleeves, and hemline of the skirt. **Opposite page:** Figure 20: "Mousmé," 1933. Silk velvet kimono-style jacket textured by a smocking technique. Figure 21: Detail of original textile composition, 1933. Self-fabric covered geometric shapes connected by self-fabric cording.

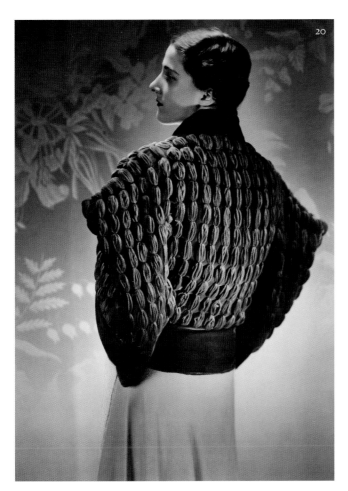

Madame Lanvin was a constant innovator maintaining a fresh image from season to season, and from one generation of clients to the next. Staying ahead of the creative curve, Madame Lanvin attempted to create an original fabric treatment by covering three-dimensional, faceted diamond shapes in a red textile only to connect them together, at irregular intervals, with thin self-fabric cording. The overall impression is that of an abstract sculpture that is malleable enough to wear. (Fig. 21)

Luxurious on its own, a kimono-style silk-velvet jacket with extended pagoda shoulders serves as evening wear, contrasted with an evening dress of matte silk crepe. Wanting to create additional contrast between the pile of the velvet and the dull-finished crepe, a large-scale smocking technique, in which ancillary threads are drawn together using one primary thread, is employed; this adds depth and dimension to the plush surface. (Fig. 20)

In a similar style painted in the portraits of Franz Xaver Winterhalter, the basic full-skirted silhouette is embellished with two opposing floral corsages and a sash of contrasting color. (Fig. 24) Modernizing the 19th-century inspiration, the structure of the dress is concealed as narrow bias bands are cut from one textile only to be layered one upon the next.

The most effective color combination when applying this technique is a black foundation and white bias bands. As the bands move with the wearer, the black foundation barely peeks through creating a small but effective defining line between the layers. (Fig. 25)

Madame Lanvin guaranteed the uniqueness of her own flowers—no one else could offer the same handmade flowers found on her dresses. A white organdy party dress for a young girl is embroidered with black branches and completed with a black waist ribbon. Clustered on black stems are ruched self-fabric organdy flowers, which have been hand-tinted in various shades of pale pink. No two flowers are exactly alike, and similar to the spontaneity of youth, diaphanous flowers spill across the front of the dress. (Fig. 29-30)

Although the morphology of a particular garment was sometimes not the most original, the surface embellishment, beading, embroidery, and minute details guaranteed the individuality and signature character of each Lanvin creation.

1 Harris, Jennifer, ed. *Textiles, 5,000 Years* (New York: Harry N. Abrams, Inc., 1993), 11.
2 *Vogue*, (1919), np.

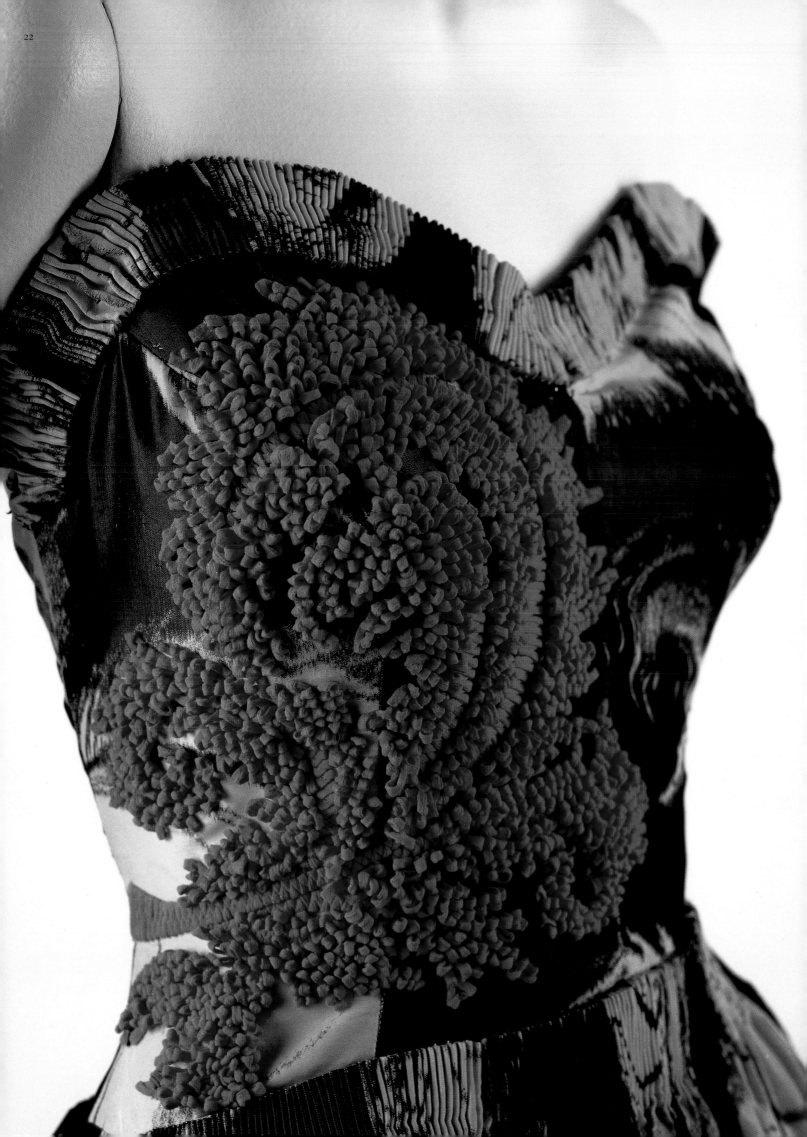

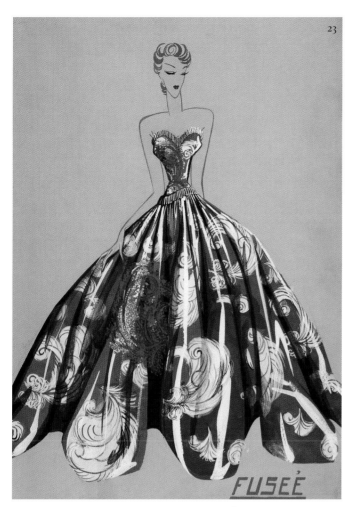

23

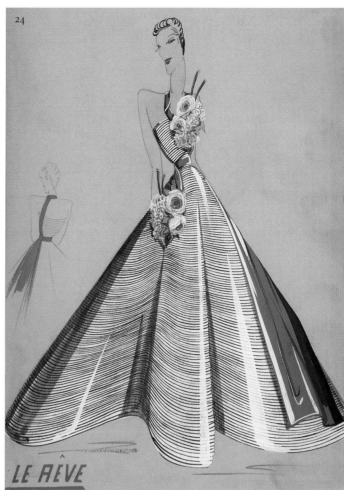

24

FUSEÉ

LE RÊVE

Opposite page: **Figure 22.** "Fuseé," 1939. Detail of coral-colored silk chiffon cording. Looped upon itself, the cording forms a feather-like texture simulating the plumes found in the cream warp-printed charcoal silk taffeta. Cartridge pleating of the printed self-fabric finishes the edge of the sweetheart neckline and waistline.

Figure 23. Gouache rendering of "Fuseé," 1939. Strapless evening dress with full cartridge pleated skirt. Chiffon cording looped upon itself was used to embellish one plume on the bodice and one on the skirt, both on the right side.

Figure 24: Rendering of "Le Rêve," from around 1939. Narrow bias bands of white organdy are sewn to a black silk tulle foundation. The created effect mimics the horizontal pleats seen on Japanese rice paper lanterns, while actually the weightless bias bands barely touch each other, revealing a slice of the black tulle foundation. Opposing corsages of silk flowers, one on the left shoulder and one on the right hip (which also functions as an evening bag) are tinted in colorful romantic pastel shades. Sash and streamers of Lanvin blue complete the youthful feminine image.

Figure 25: "Le Rêve," on a young Lanvin client Mademoiselle Denay, 1939; visible also is the *robe de style* "Cyclone" from the same year, worn by her mother, Madame Yvonne Denay.

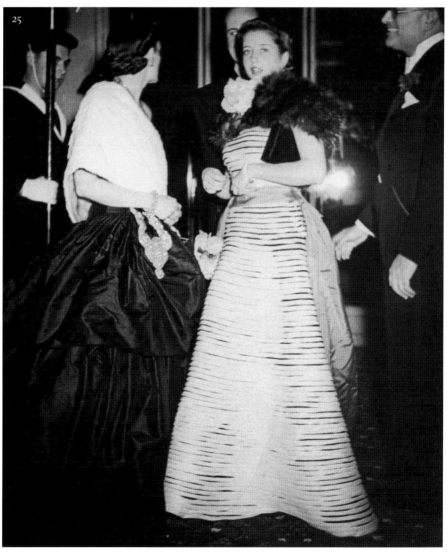

25

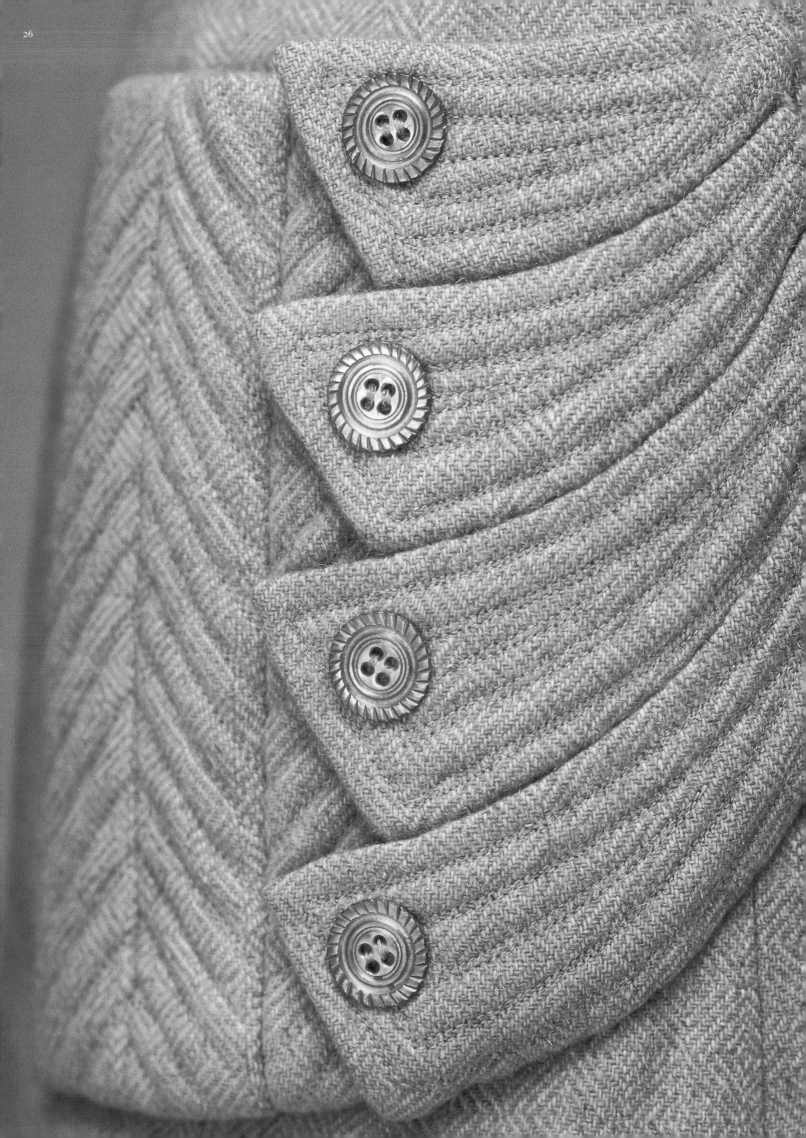

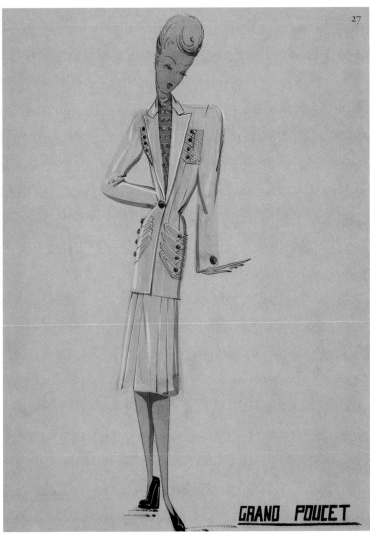

GRAND POUCET

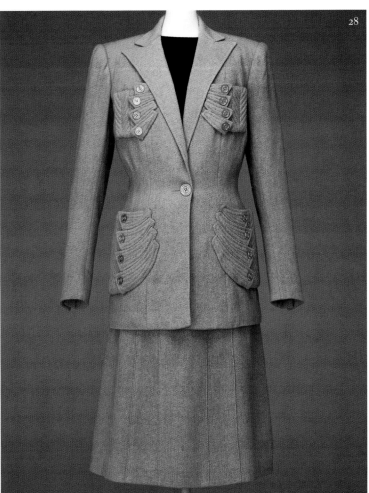

Figure 26-28: Detail, gouache rendering and overall view of Grand Poucet, February 1944. Although the original rendering shows the use of bright green under a neutral wool suit, it no longer exists with the ensemble. Working within the fabric restrictions imposed by World War II, this minimal use of fabric and components demonstrates the ingenuity of Lanvin. Self-fabric details are cut and applied into curvilinear shapes, punctuated with buttons, and a herringbone texture is sewn into the fabric and mitered together adding more subtle, visual interest.

Following spread: Figure 29. Detail of Figure 30. White organdy flowers hand-tinted in shades of light pink.

Figure 30: Young girl's full-length party dress of white organdy with self-fabric flowers hand-tinted in various shades of light pink. Black organdy stems are appliquéd across the front and side of the dress, onto which the flowers were sewn. The graphically detailed dress is belted by a simple black ribbon, Spring/Summer 1937.

Page 268-269: Figure 31: "Bagatelle" (dress) and "Mazurka" (cape). The sublime silhouette of the 1930s was typically cut on the bias and constructed with delicacy and skill, as seen in this Lanvin ensemble, winter 1935. By using a saturated hue of royal purple in contrasting textures and a piled smooth velvet satin, a modern, proportional silhouette was created. A bias-cut silk satin evening dress is simple in its clinging form and features an intricately seamed trapunto-stitched bib-like collar. The simple form of the short cape perfectly accommodates the intricate and dense hand-ruched silk velvet detail. The height of the velvet pile determines the amount of light that is reflected or absorbed. The various areas of light and dark created by this vibrant and richly textured surface serve as the principal embellishment for this ensemble. The evening cape fastens with two large, domed and silvered glass buttons.

Figure 32: Detail of hand-ruched silk velvet from "Mazurka."

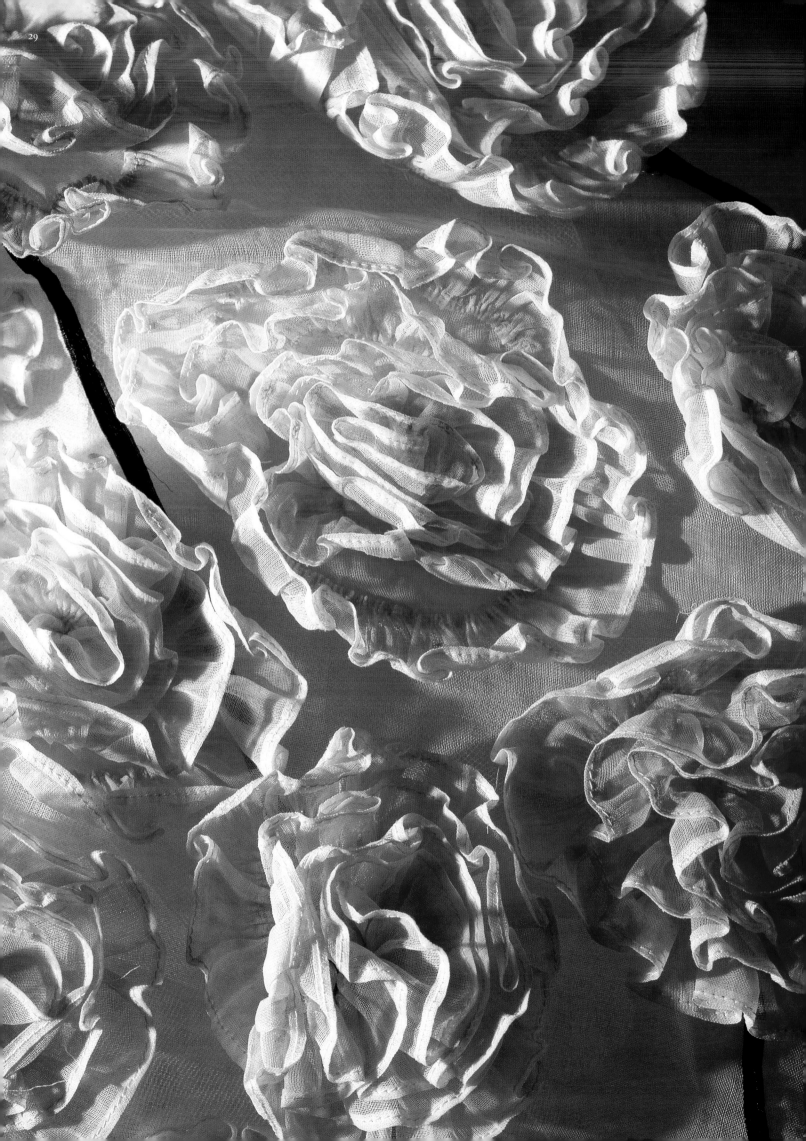

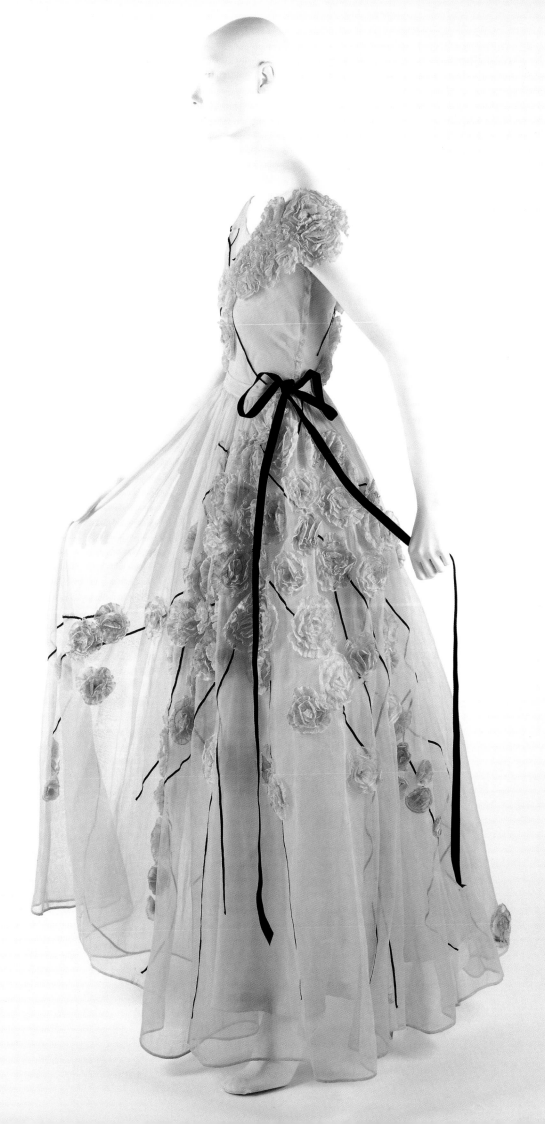

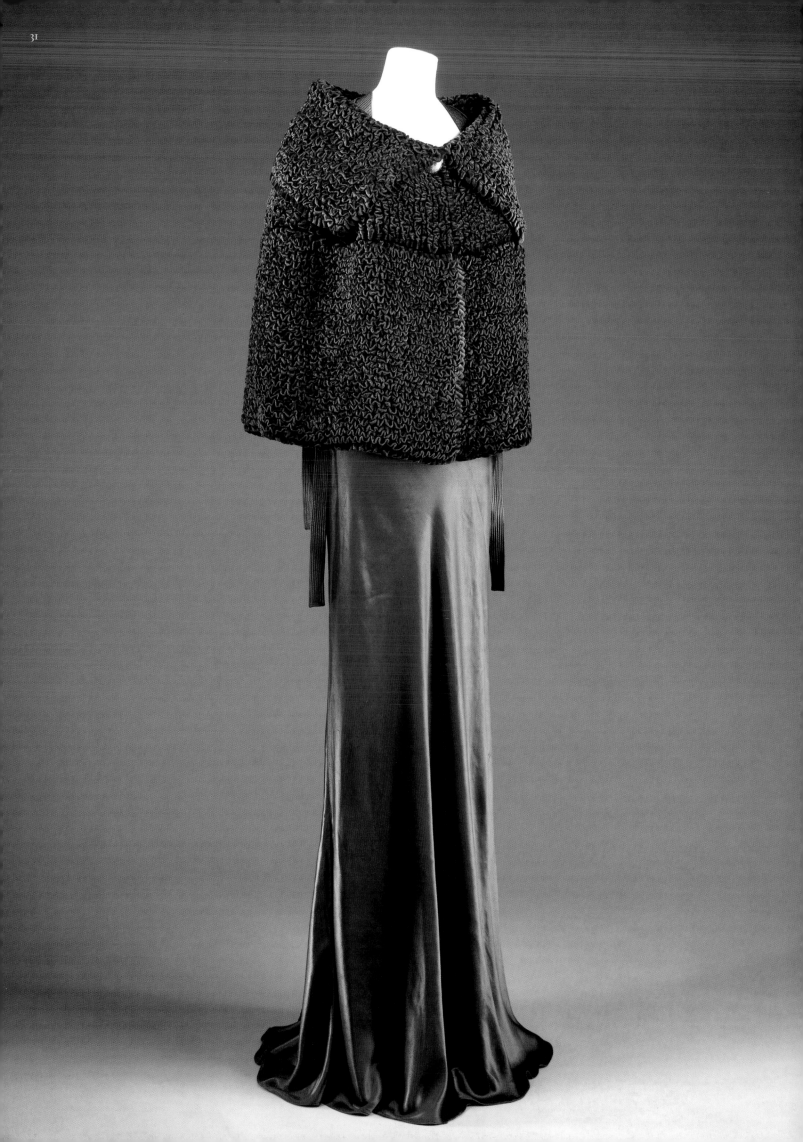

6

ARTISTIC INFLUENCES
AND COLLABORATIONS:
ART DECO

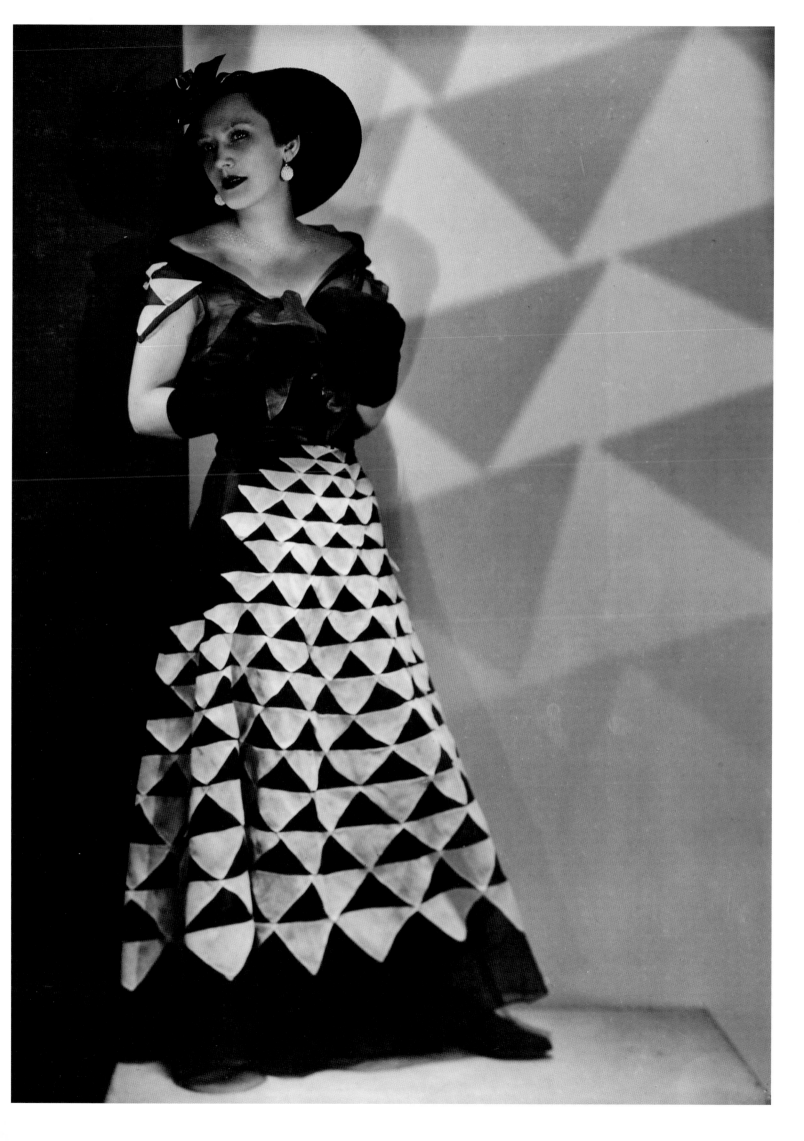

BY THE 1920s, the external influence of cubism lent its geometric and angular forms to the Art Deco style, and design objects were created with a modern, less feminine edge. Art Deco maintained a significant influence in the architecture and visual arts in the interwar years.

Consistent with the vocabulary of Art Deco, binary color combinations played a significant role in Lanvin designs. In some of the millinery work and in the first collection of women's couture in 1909, the ultra-chic combination of black and white was highlighted with the use of favorable "Fauvist" (or acidic) colors, which attributed to the influence of the Fauves–the wild beasts–and their unconventional color preferences. Later, the black and white combination was accented with the signature, sophisticated "Lanvin blue" details.

From 1909 on, the combination of black and white regularly appeared in many Lanvin collections, in addition to her interior décor, decorative arts, and personal style. Often, Madame Lanvin would appear in an impeccable black suit or a black-and-white-patterned blouse under a black suit adorned with some form of bow or tréfle. Perhaps the habitual wearing of black and white helped Madame Lanvin maintain balance and order in her work and personal life. Because her daily life and activities focused on color, texture, pattern, and design, wearing black and white may well have exerted a therapeutic effect, and enabled her to avoid saturating her design sensibilities.

This color combination, black and white, worked best with bold graphics, emphasizing design lines or creating illusions of movement and space. On May 1, 1924, Vogue featured two Lanvin designs under the heading, "Lanvin Stars Black Organdie With White Beads."[1] It may have seemed like major news at the time, but eventually extremely chic black and white wardrobes would become the norm. The dress is black organdy over a silver lamé lining. (Fig. 10) White organdy borders the bateau neckline and the hem of the skirt. A large pinwheel motif, executed in white and silver, is repeated over the skirt. The only color accents are the "flame coloured crêpe streamers" suspended from the front neckline. In the same issue, a black crepe dress is bordered in white organdy at the neck, wrists, and hemline. (Page 52, Fig. 27) White threadwork and beads are used in the circular embroidery motif, which graduates in size from the smallest on the bodice to the largest circles at the hemline.

Vogue of 1926, extolled: "For a woman with greater financial leeway and a taste for the striking, nothing could be better than the black and white wardrobe. Black has returned to the mode. It is the smartest evening note of the moment, and, by the autumn, many women will be wearing it by day. With the ever-lovely white as its contrast, it spells spring in terms of Paris."[2]

Jeanne Lanvin, and the design community in general, promoted the color combination of black, white, and silver as the epitome of chic. At the height of the Art Deco period, there

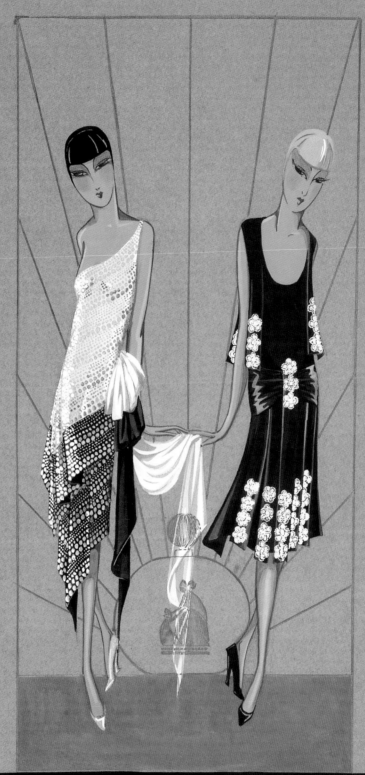

Jeanne Lanvin
∎ PRAGUE ‒ 1927 ∎

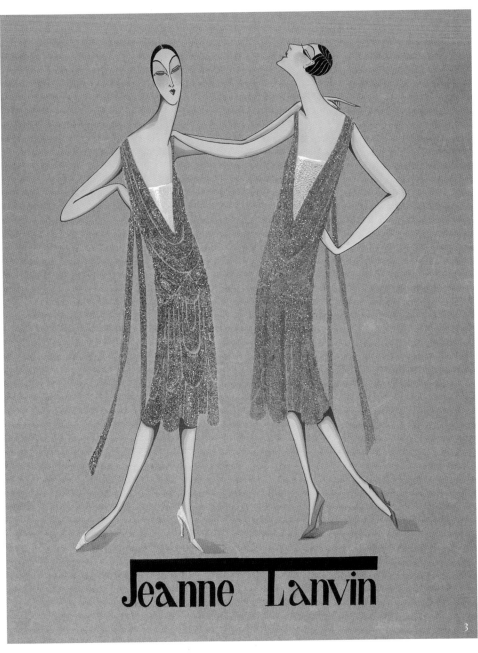

Figure 3: Promotional gouache rendering for Lanvin designs, 1925. Several sleek models were manufactured for the Exposition of 1925. The names were exotic as were the colors, motifs, and beading treatments. The two models featured in the illustration seem to be "Mille et Une Nuit", on the right, and "Imperatrice" on the left.

Figure 4: Documentational photograph for one of the ensembles featured in the Exposition of 1925. The cape is called "Claire de Lune" and the dress is called "Lesbos." May 18th, 1925.

Opposite page: Figure 5. Three-quarter back view of "Lesbos" in acidic chartreuse silk charmeuse with beaded ribbons.

Following spread: Figure 6. Promotional gouache rendering, 1927. An elaborate ensemble of evening dress, velvet cape, and crystal skullcap inspired by the Italian Renaissance.

Figure 7. Promotional gouache rendering for 1927. Elaborate evening ensemble with attached shoulder train, blue enamel accessories, and Italian renaissance-inspired millinery.

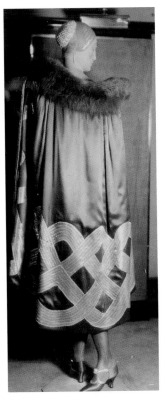
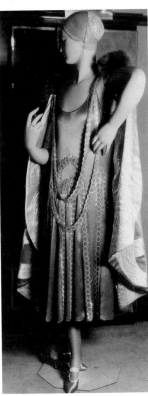
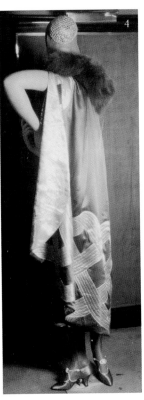

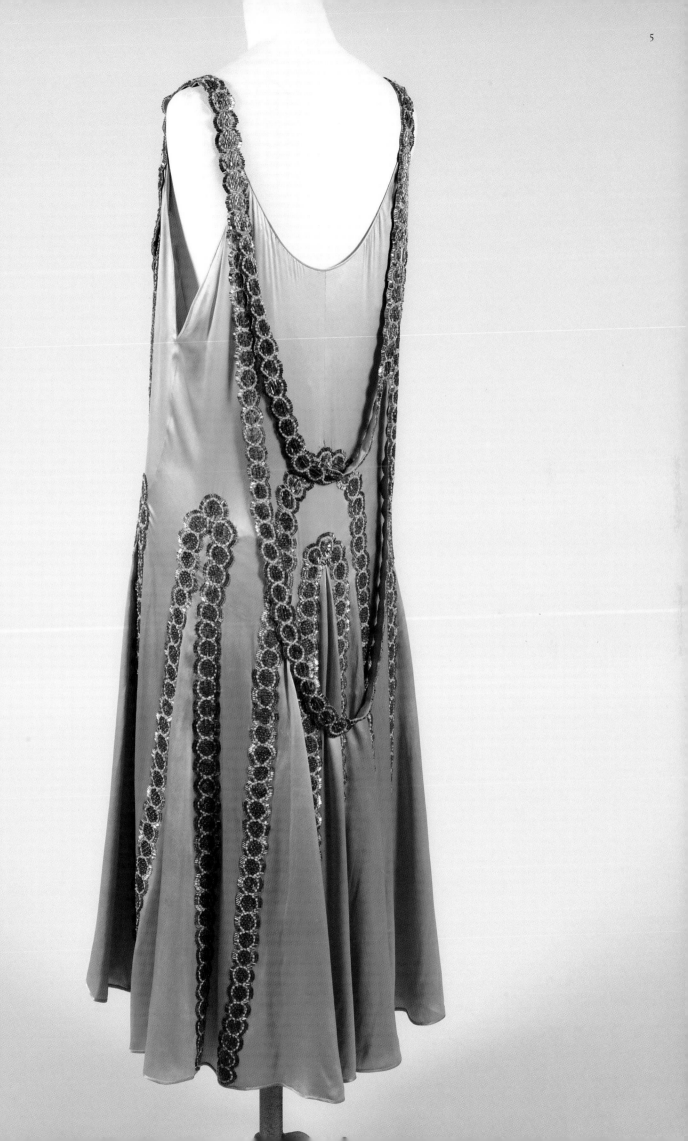

1927

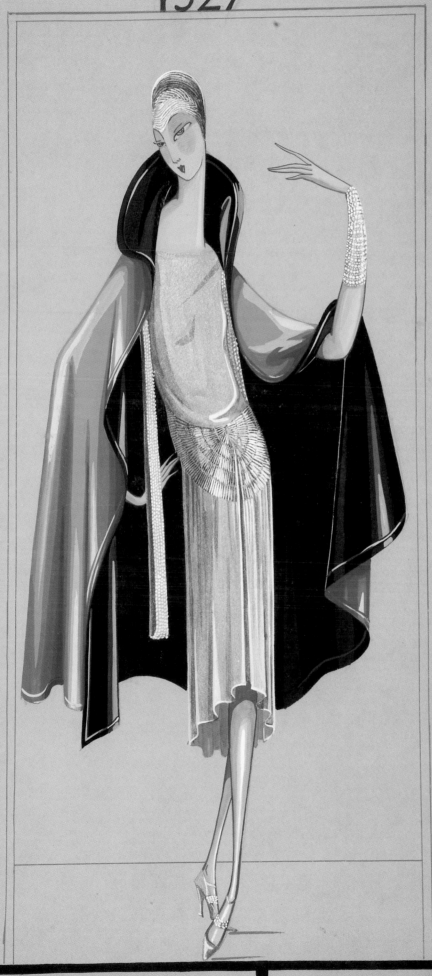

Jeanne Lanvin

1927

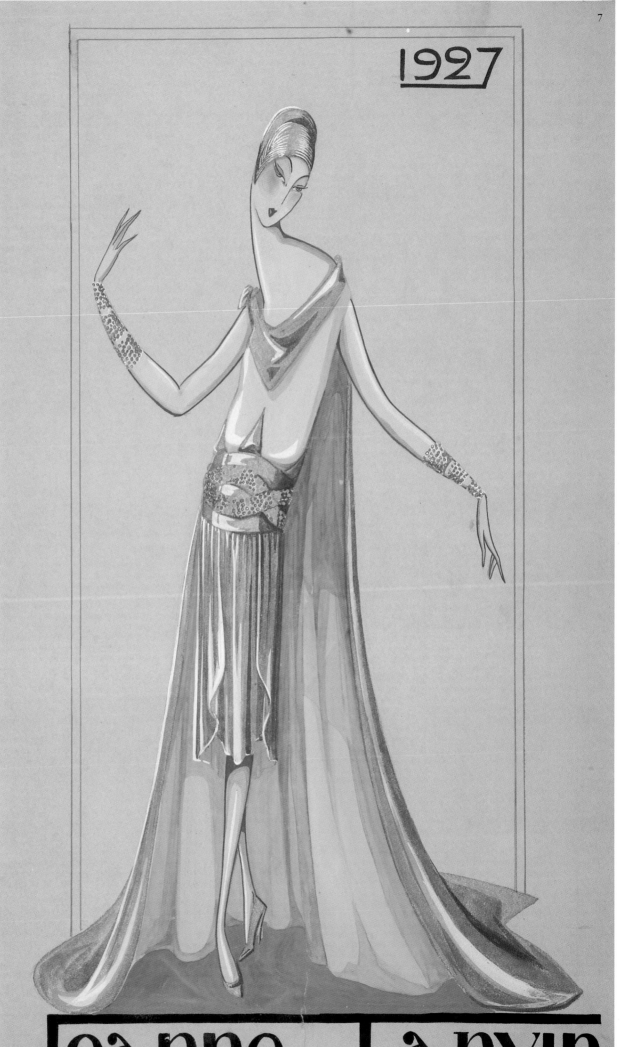

Jeanne Lanvin

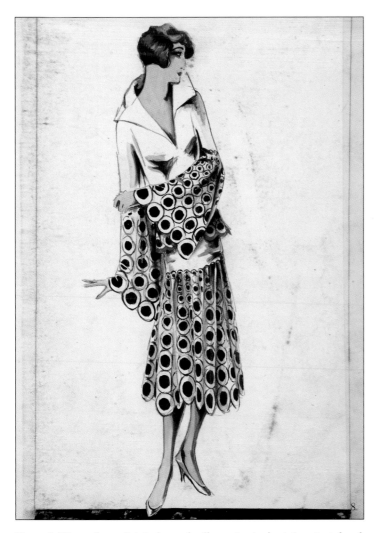
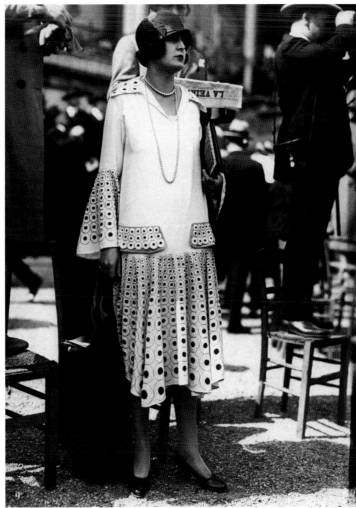

Figure 8: "Pierrot," 1925. Original gouache illustration in classic Lanvin style, where bold graphic patterns emphasize the use of minimal color. Barely accented in red, which appears at the v-neckline and the scalloped hemline. **Figure 9:** "Pierrot," as worn by a Lanvin client at the horseraces. The preference of this client is a dress with collar and pocket details.

was no other acceptable color combination in high fashion. Black was representative of the black lacquer that was so prevalent in the decorative arts and home furnishings.

The craze for silver, which swept the different aspects of interior decoration, also applied to dress and accessories. It had its beginning in 1922, and was to last for several years. Inexplicable as most crazes are, this enthusiasm for silver in preference to gold was shown in the widespread use of silver patterned brocades, silver tissue, silver embroideries, silver lamé, silver fringes, usually combined with backgrounds of black, coral or jade green.

Another of the robes de style *for which Lanvin is famous is a bouffant model of black taffeta, beautifully embroidered with strass and onyx. The plain black, as well as the black accented by beading, are important evening notes.*

A black taffeta picture frock from Lanvin shows a pronounced high waistline and is trimmed down the front and around the deep décolletage with beautiful crystal embroidery.[3]

One of Lanvin's most profound black and white designs is a silk chiffon evening dress from 1929 (Fig. 12-13). The torso is completely covered in white satin-finish and jet-black bugle beads. White is the dominant color of this diaphanous creation with scooped-neck and flared sleeves. The asymmetric design of the dress allows the garment to be sliced into black and white sections. Solid triangular areas are filled in with black and white bugle beads, except at the point where the triangles interlock asymmetrically. All of the triangles in this beading remain individual as no shape touches another. A narrow slice of white chiffon remains in between each triangle in the same way that a narrow area of grout divides tiles used in a mosaic. Although the dress is asymmetric in design and color, with more white chiffon than black, Madame Lanvin takes the opportunity to visually balance the positive and negative areas of the dress with the clever beading pattern. The area of black beading is larger and dominant, balancing the minimal use of black chiffon in the dress.

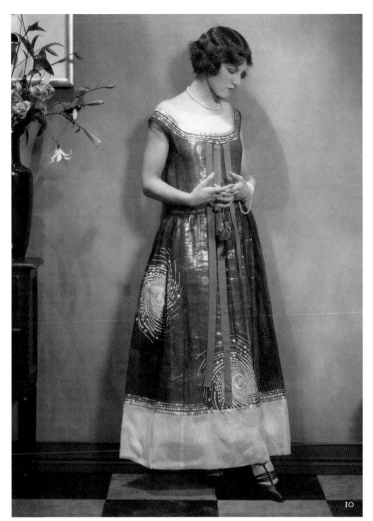
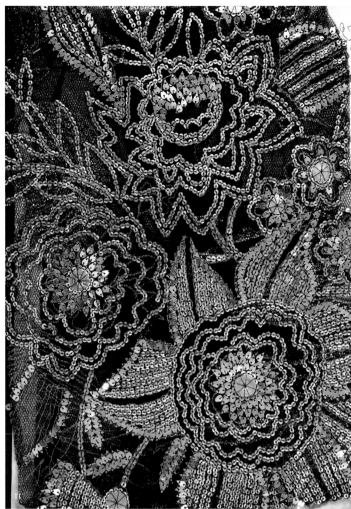

Figure 10: *Vogue*, May 1, 1924. Black organdy with milk-glass beads applied in a spiraling pinwheel motif layered over a silver lamé slip, anchored with a white organdy border and punctuated by the red ribbon streamers suspended at the center front neckline. **Figure 11:** Floral embroidery rendered in Art Deco style, using various types and sizes of silver metallic sequins on black tulle. 1934-35.

The geometric beading pattern is identical in format to the bathroom floor of Madame Lanvin's home at 16 rue Barbet-de-Jouy in the 7th arrondissement of Paris, which was designed and executed by the French architect Armand Albert Rateau from 1920–1922. (Fig. 32) The geometric and triangular design of the bathroom floor was created in white, black, and ochre marble, once again focusing on positive and negative space and the use of black. An onyx and ivory Japanese fan, now in the Lanvin archive, may have been the source of inspiration for this pattern. It featured a black and white triangular motif and the balance of positive and negative space, and was used for both interior and fashion design.

The collaboration between Lanvin and Rateau was the beginning of a productive relationship. The two artists continued to collaborate on many personal and business-related design projects. Some of these projects included the design and décor of Lanvin boutiques, Lanvin homes in Paris and Vésinet, the Théâtre Daunou for Jane Renouardt and Sacha Guitry, (Fig. 28-30) and the creation of "Lanvin Decoration" a

home décor business. As mentioned previously, the maison Lanvin mother-daughter motif was erroneously attributed to Paul Iribe; it was Rateau himself who created it in 1927. Iribe can only be given credit for the design of the perfume bottle, which is known as "le boule noir." The black vessel was also offered in gilt glass with a black insignia as well as porcelain colors of burgundy and "Lanvin blue" produced by the porcelain factories of Sevres.

1 *Vogue*, (May 1, 1924), np.
2 *Vogue*, (1926), np.
3 Ibid.

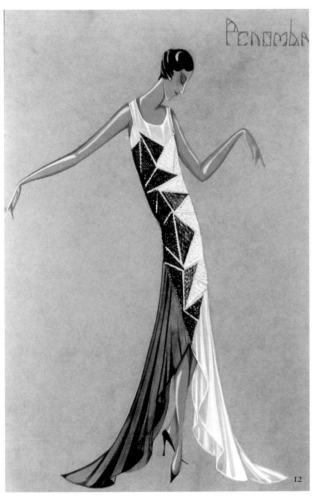

Figure 12: "Pénombre," [Half-light] original gouache rendering, February 1929.

Figure 13: Documental photograph of "Pénombre." Black and white silk chiffon cut and beaded in an asymmetric design. Geometric motif rendered in jet and white satin-finish bugle beads, which juxtapose the black slick finish of the jet against the matte shimmer surface of the satin-finish bugle beads.

Figure 14: "Le Sorcier," April 1929. Working with the absence of color, black and silver were used to render the geometric pattern of the overdress with sheer sleeves and flared cuffs over a tubular solid black silhouette. An upward-pointing arrowhead pattern is the central motif running down the center back of the overdress.

Opposite page: Figure 15. "Oxford," 1924.

Figure 16: Evening dress in an asymmetric black and white beaded geometric pattern, in the style of Art Deco, 1929. Name unknown.

Figure 17: Chevron alternating beaded bands of jet and white satin finish bugle beads create a slim silhouette for a sheer black silk tulle train attached at the rear hip level. February, 1929. Name unknown.

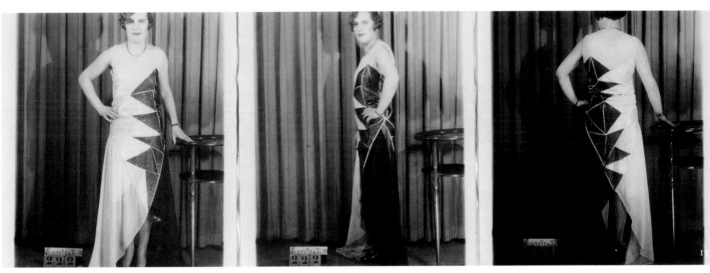

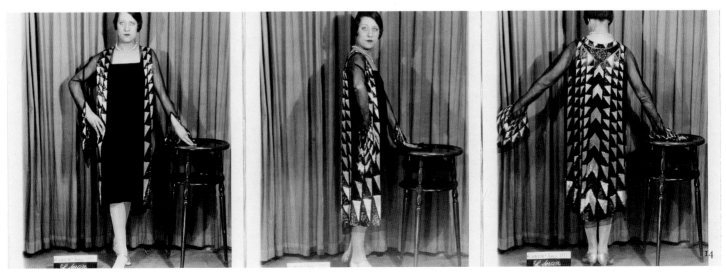

Following spread: **Figure 18.** "Iris Noir." Black and white silk taffeta kimono sleeve wrap coat. Using traditional Japanese construction techniques, a simplistic functional form is seamed from a single square of material resulting in minimal waste. Pure in form and function, the use of classic black and white is textured by the use of trapunto-stitch detail, which binds the black exterior with the white interior while adding additional body to the structure and warmth for the wearer. 1935. **Figure 19:** Detail of trapunto-stitch texture from Figure. 18.

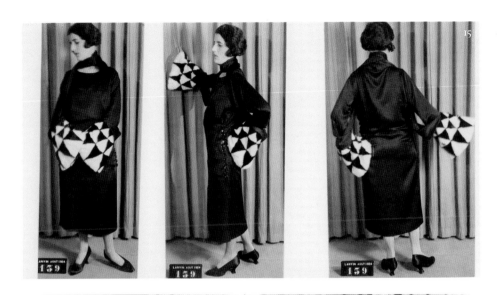

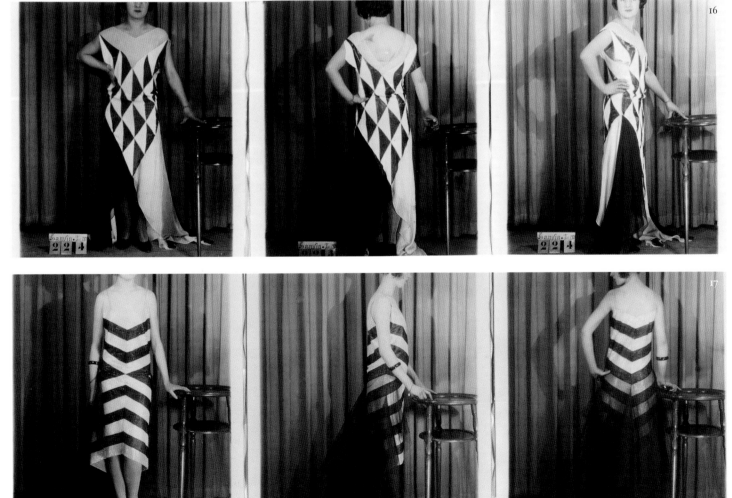

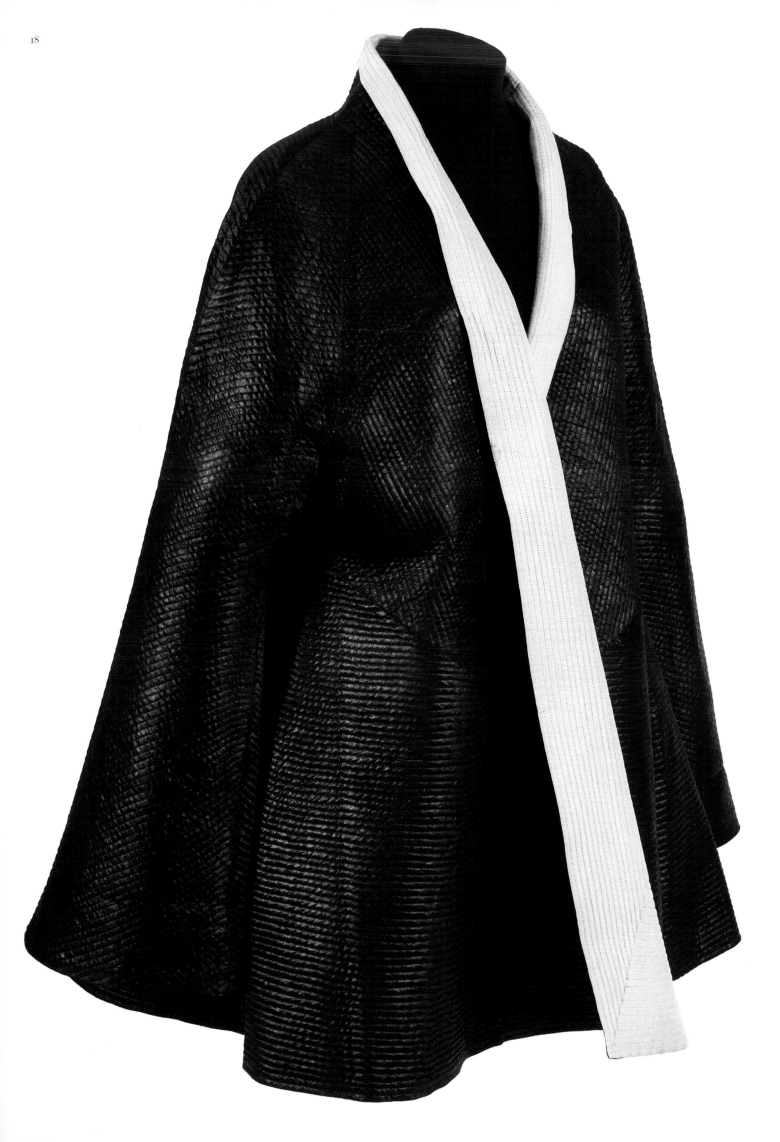

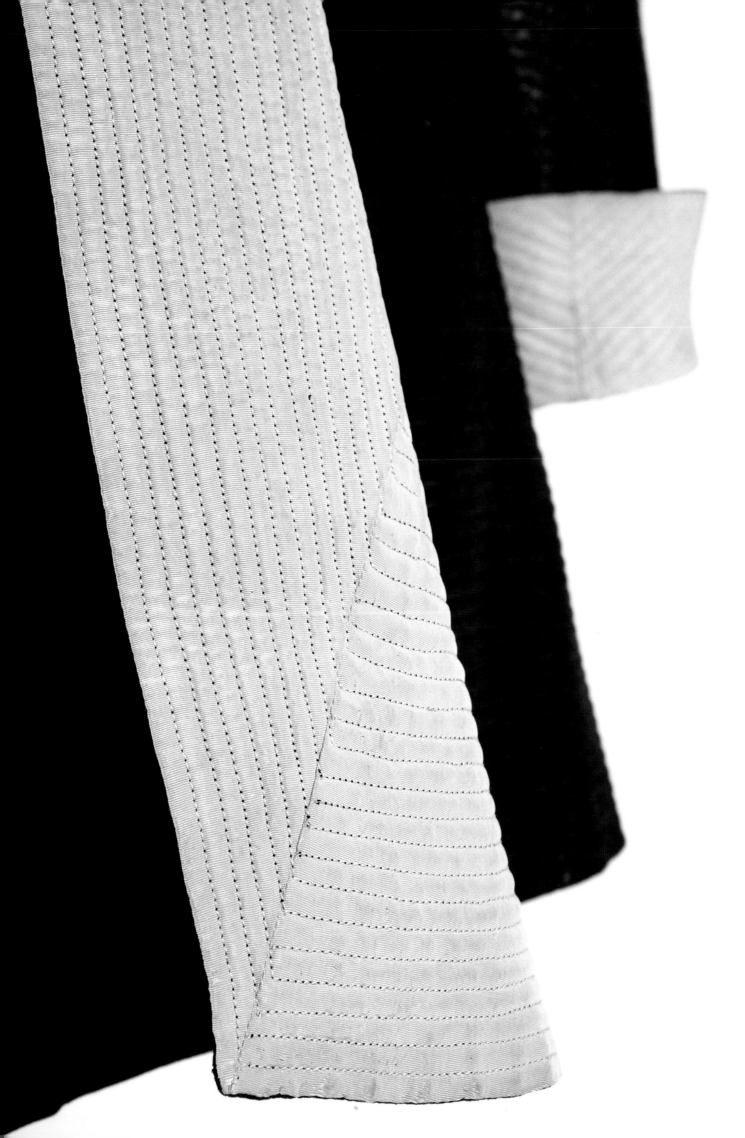

Figure 20: Preparation of mannequins for the Exposition Universelle de Paris, 1925. Pictured is the mannequin being prepared for fellow exhibitor, Madeleine Vionnet. On the right is an enlarged drawing of the Lanvin *griffe* enlarged on a grid in preparation for placement within the Lanvin exhibition.

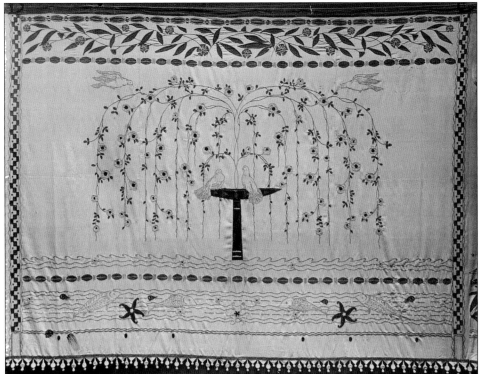

Figure 21: "Cannes," 1921. The work ensemble dyehouse and embroidery atelier of maison Lanvin created this mural and its details. On a ground of ecru tussor silk, the leaves and branches were rendered in blue and gray. In the center, the birdbath was rendered in navy blue wool with additional flowers and leaves rendered in blue and gray. The bottom border of the mural represents the sea, with embroidered motifs of fish and starfish rendered in navy blue and gray wool. The ball fringe on the hemline was created from wooden balls covered in ecru tussor silk.

Figure 22: "Berthier," 1921. Dyed and embroidered mural of ecru tussor silk. On the left side is a column of roses embroidered using white curly wool with leaves embroidered in brown wool. The top and bottom motif of bell-flowers embroidered in curly white wool are on a of panel of brown. All other motifs and borders near the bottom are also executed in a combination of white wool and brown. "Berthier" corresponds to the street address of the Rateau family home.

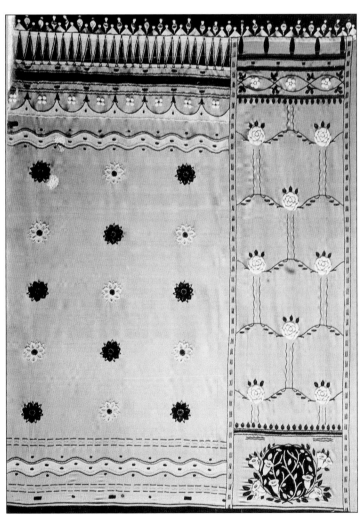

Figure 23: Madame Lanvin in the comfort of her home at 16 rue Barbet-de-Jouy, examines a sample from Lanvin Décoration.

Following spread: Figure 24. Gilt wooden mirror frame detail carved in a *mille fiore* pattern clearly featuring the "Marguerite" motif, 1920-1922. **Figure 25:** Sculpted bronze lamp base detail of four exotic birds, one of which is a pair of *lampadaires* with alabaster shades, 1920-1922.

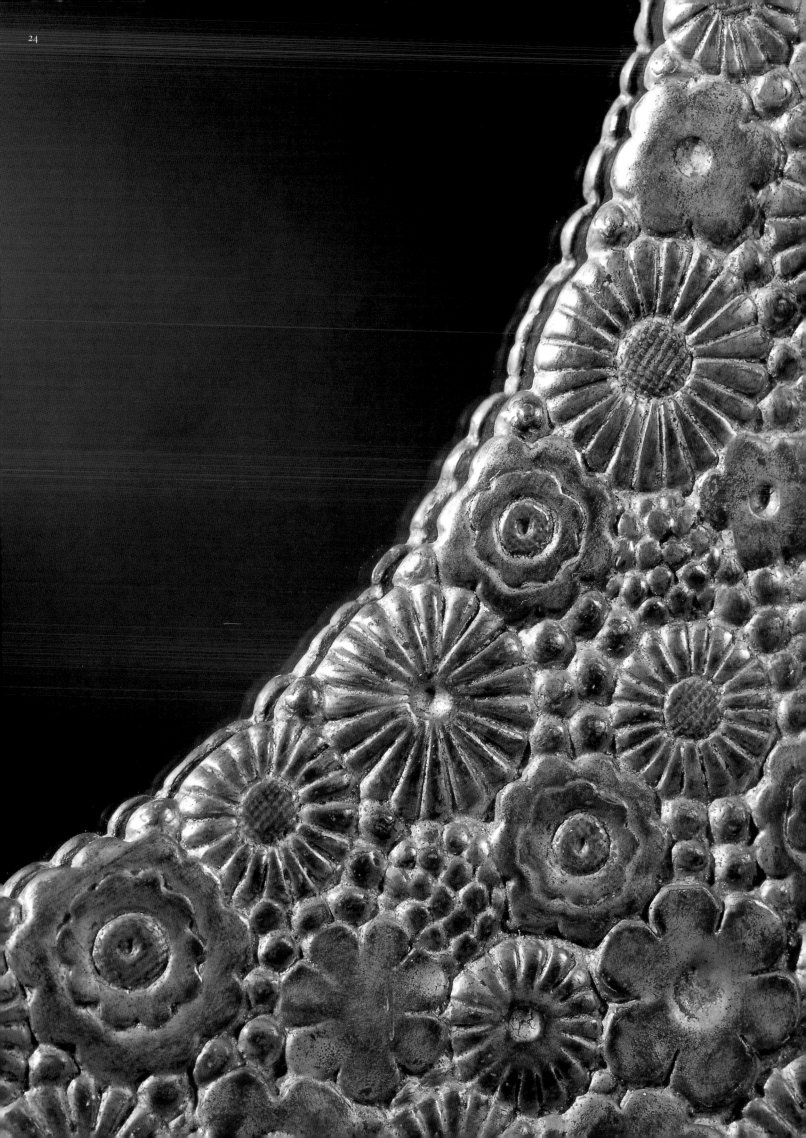

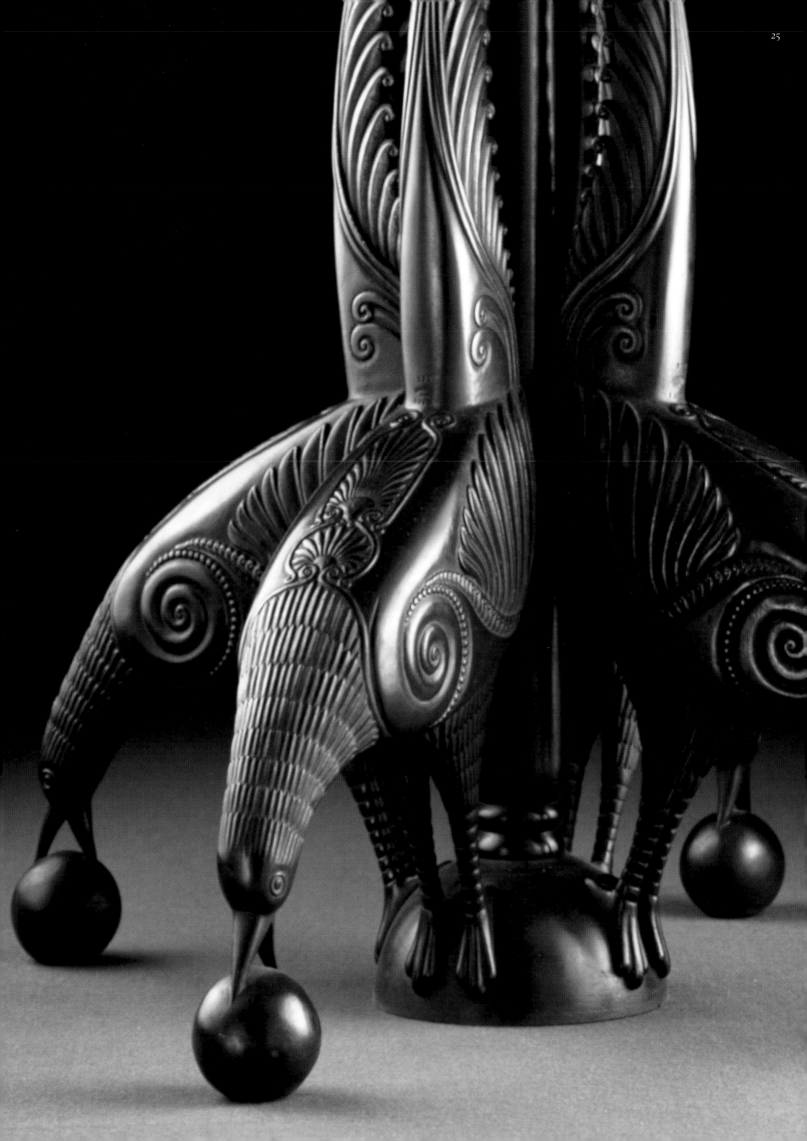

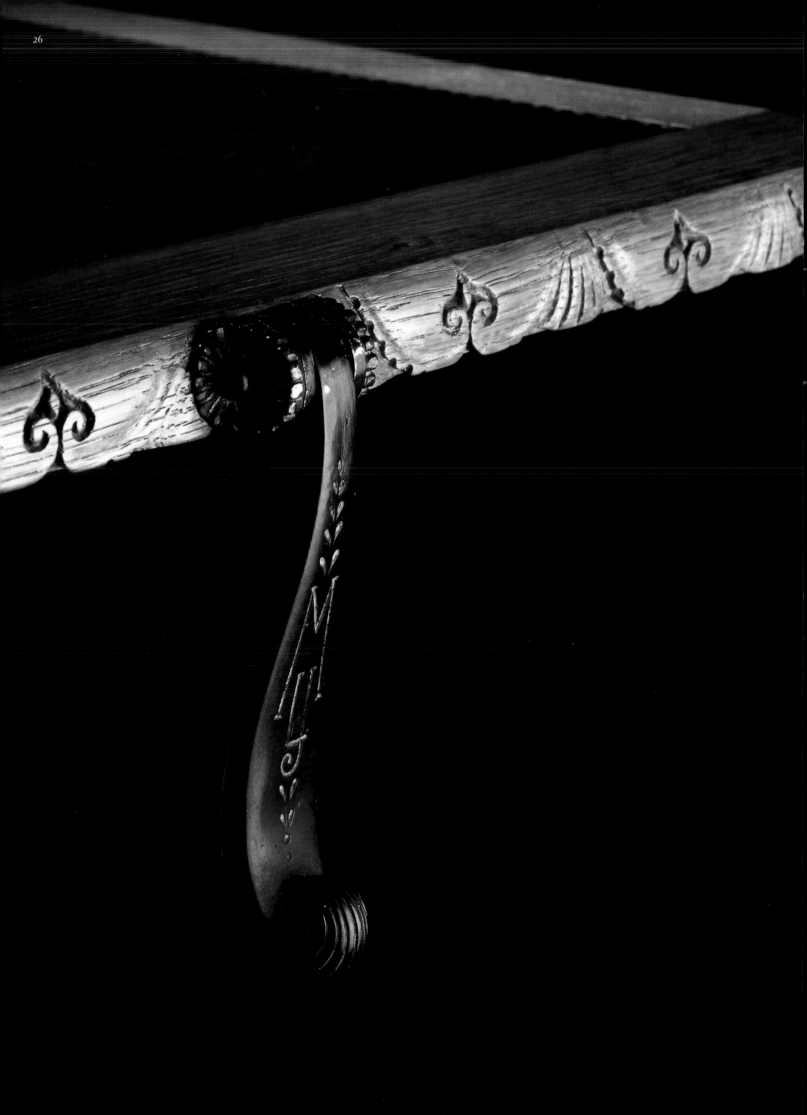

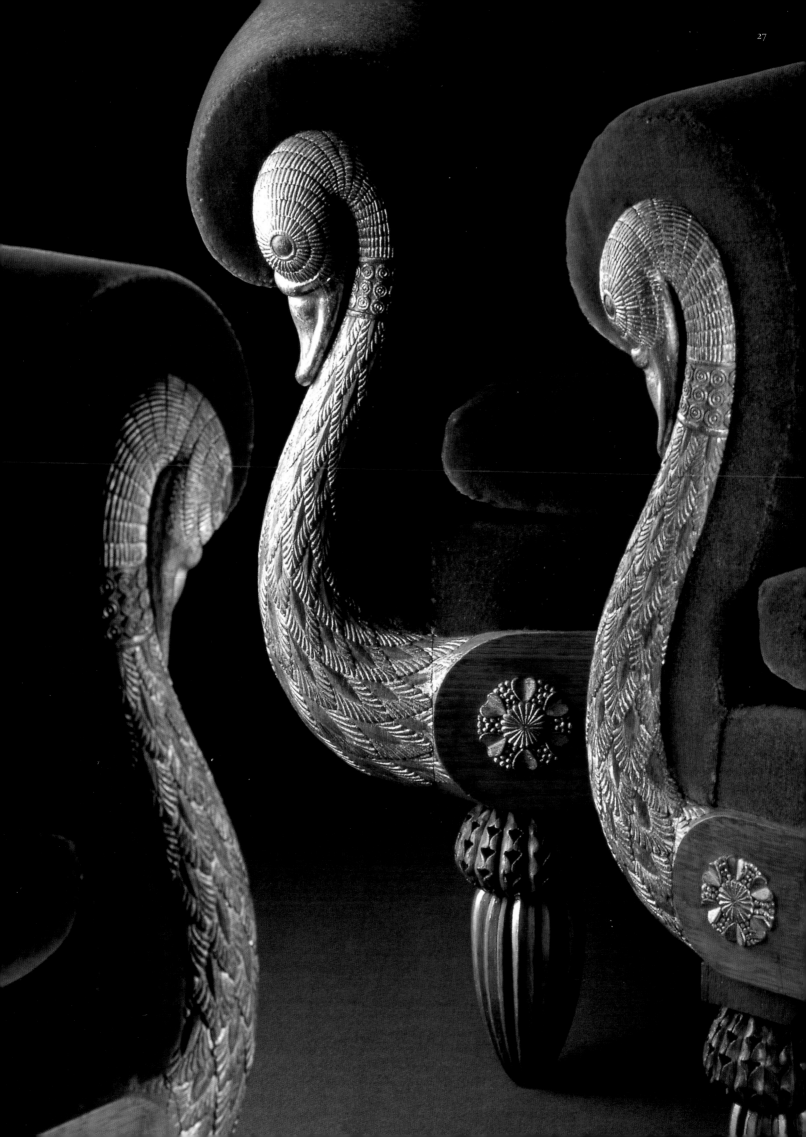

Preceding spread: **Figure 26.** Design by A. A. Rateau for Jeanne Lanvin. Detail Solid oak desk with carved ebonized marquetry topped with a thin layer of leather. Bronze handles with a black patina are finessed with a "Marguerite" motif and chiseled with the initials of "MJL" (Jeanne Mélet-Lanvin) in gold detail, 1920-1922. **Figure 27:** Gilt swan-neck detail. Ensemble of salon furniture—one sofa and two chairs—in oak, with gilt carving. Various gilt carved appliqués appear around "Marguerite" motifs surrounded by heart-shapes and three-leaf clovers. All of these design elements appear within the work of Jeanne Lanvin throughout her career, either singularly or in a combination of beading, embroidery, appliqué, architecture, and jewelry, 1920-1922.

Below: **Figure 28.** Théâtre Daunou, front elevation of the stage design and proscenium arch. Inaugurated December 29, 1921; designed and executed by Jeanne Lanvin and A. A. Rateau of Lanvin Décoration. Lapis-hued columns flank either side of the stage, with gilt sculpted appliqués of flora and fauna on an ivory background. The draperies and seats were covered in Lanvin blue velvet and the floors were covered in gold-colored rugs. Crystal wall-mounted sconces illuminated the theater.

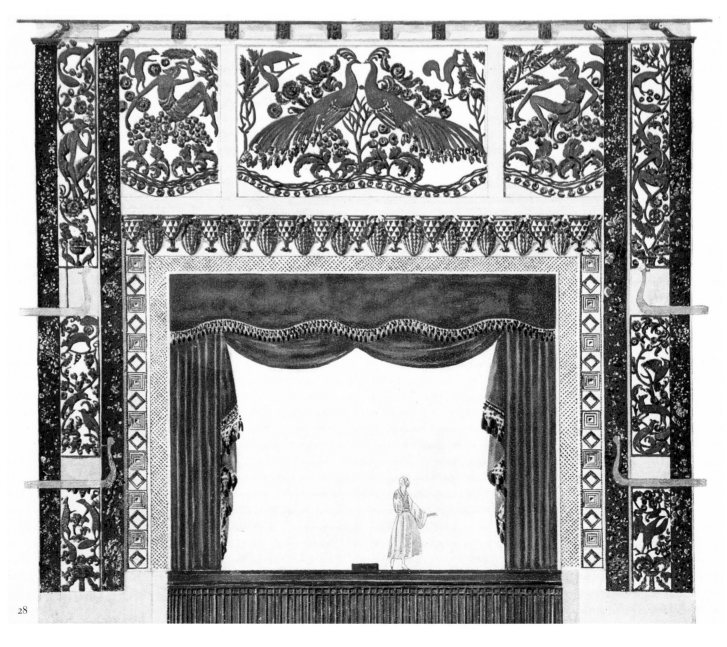

28

Figure 29: Théâtre Daunou, three-quarter front view of proscenium arch and draperies, 1921. The central motif above the proscenium arch is a pair of conjoined odalisque-like figures surrounded by gilt animals. This motif replaced an earlier peacock motif of similar composition.

Figure 30: Drawing of longitudinal section through Théâtre Daunou.

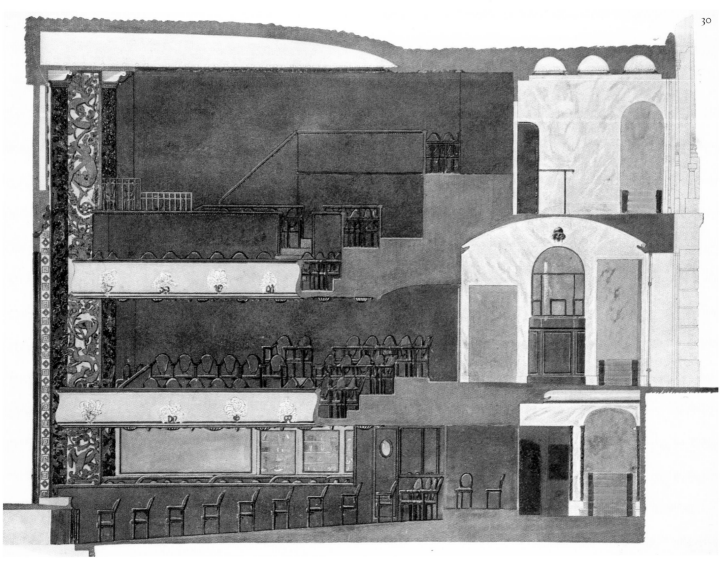

31

32

Figure 31: An ebony and ivory Japanese fan with triangular motif served as a design inspiration and appeared in various forms and materials throughout the career of Madame Lanvin, date unknown. Figure 32: Lanvin bathroom. Geometrically patterned floors of white, black, and yellow marble give way to creamy ochre walls surrounding the bathtub with carved exotic scenes of flora and fauna, recalling the garden of Eden. Sculpted bronze fixtures with ebonized patination add depth and drama, evoking the glories of ancient Rome, Greece, and Egypt, 1925. Opposite page: Figure 33. Boudoir of Madame Lanvin at 16 rue Barbet-de-Jouy, Paris..

Preceding spread: **Figure 34.** Bedroom of Madame Lanvin at 16 rue Barbet-de-Jouy.

Opposite page & above: Figure 35-36. "Collier Vert," March 1929. Black silk crepe and georgette with glass bugle beads. Using a repeating graphic motif in black and white, the added twist is the double draped collar treatment of black silk beaded with green glass bugle beads. The detail image of the label shows the season and date stamped in red ink, Summer 1929.

Following spread: Figure 37. Black velveteen wrap front coat with white wool chainstitch embroidery in radiating lines.

Figure 38. "Roland" model 36, February 19, 1925. This model was described in *Vogue*, May 15, 1925: "The newest development in dress designing is the cubist pattern painted by hand on the fabric itself-in this case, in shaded greys on beige kasha. The design suggests a gilet in front and trims the circular skirt fullness."

Figure 39-40. Airbrushed lacquer geometric patterns applied by Jean Dunand. Gradating in color, darkest to lightest, one swatch employs beige and black lacquer applied to ivory silk velvet. The violet swatch employs black and violet lacquer applied to lavender silk velvet, summer 1925. Always seeking the latest surface decoration techniques, Madame Lanvin used some of the textiles rendered by Dunand and his experimental workroom. Other designers such as Madame Agnés used these fabrics and airbrush techniques widely, and lack of exclusivity was reason enough for Madame Lanvin to discontinue use of these textiles. No additional airbrush lacquer swatches were found in the archive after its initial use in 1925.

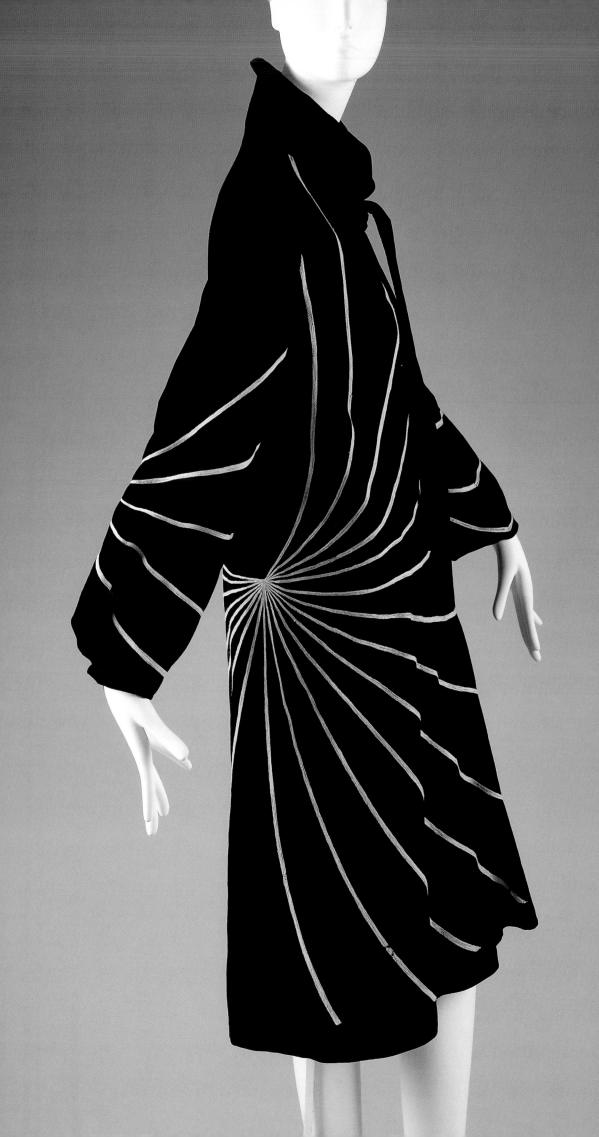

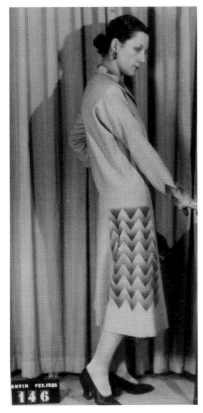
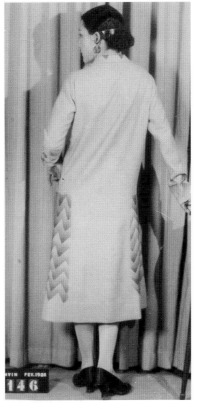
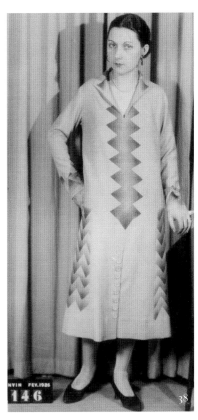

7

CONCLUSION

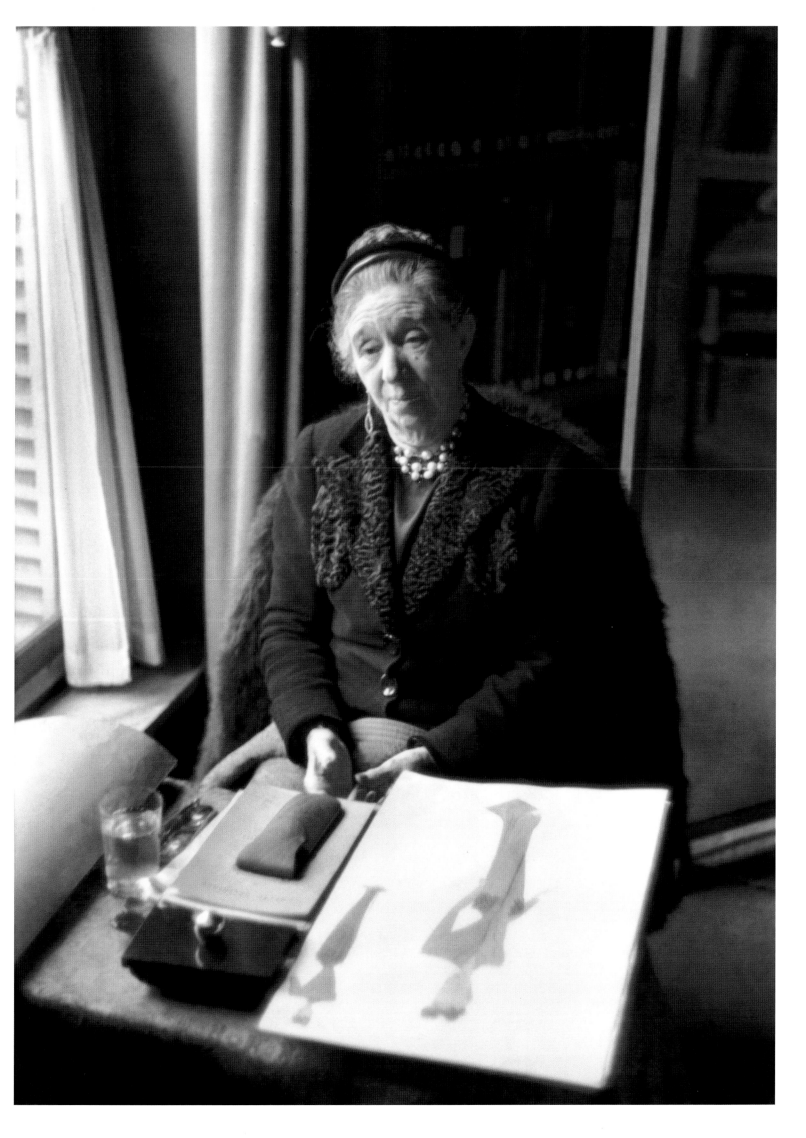

A PRODUCT OF THE PRIM AND PROPER

Victorian era, Jeanne Lanvin rose to achieve greatness both as a designer and as a leader within the French fashion industry. Jeanne Lanvin was awarded the Chevalier de l'Order de la Légion d'Honneur on January 7, 1926, and Officier de l'Order de la Légion d'Honneur on October 4, 1938; both awards were for her work organizing the fashion pavilions at many world expositions. (Fig. 2-3)

Jeanne Lanvin was a creative spirit with humble beginnings as an apprentice and a "simple" seamstress in Paris. A diminutive person with a powerful talent and drive to succeed, she worked long and hard, saving her minimal wages with the hope that she would one day be the mistress of her own establishment. Her perseverance and dedication were rewarded. She opened her first workshop in 1885; four years later she opened her own millinery shop.

It was only after the birth of her daughter that her full potential was realized. Lanvin created a small wardrobe for her child, which was envied by many other mothers. From this point, the millinery clientele placed clothing orders for their children. Soon the mothers wanted their own Lanvin creations, and she began creating clothing for them.

Fueled by the love and passion she felt for her daughter, she worked tirelessly to produce the most creative, original, beautiful, and youthful clothing and millinery that she could. Her young daughter was instrumental in helping her gauge the success of her designs. Using Marguerite Marie-Blanche as a model for her children's clothing, she could sample the public reaction to her latest creations. As her daughter grew and matured, so too did the collections of maison Lanvin; she was her mother's muse. Jeanne Lanvin's designs were well-received from the beginning, rising from the shadows of the likes of Pingat, Doucet, Worth, and Boué Soeurs; she created a name and place for herself within the Syndicat de la Couture and the fashion and artistic community.

Her friends and acquaintances were from a creative circle of artists, writers, filmmakers, musicians, interior designers, and architects such as Armand Albert Rateau, who became an important collaborator.

The world literally served as her inspiration as she searched various countries and regions and consistently drew upon the past. The Middle Ages and the Italian Renaissance were fertile sources of ideas for Jeanne Lanvin, as well as cultures on the other side of the globe. Japan, China, and India, as well as many others, served as inspiration for embroidery patterns, garment shapes, and color usage. Religion, in particular Catholicism, was a source of inspiration as well—especially the shapes and motifs from ecclesiastic garments. Many of her designs were named after mythological gods and goddesses; and symbols, such as the three-leaf clover, the bow, and the daisy, or marguerite, were present in almost everything she did. Stained glass, paintings, antique clothing, and many artifacts of the past inspired colors, which were created in her own dye factory in Nanterre, France.

Madame Lanvin was not a slave to fashion, and she heeded only those directions in fashion that she deemed appropriate for her clientele. The creating and designing were done within the confines of her office, which served as a library and an incubator of ideas. The custom, meticulously decorated fabric and braid-bound books continue to be housed in her office, placed perfectly on the immaculate shelves next to fabrics and artifacts collected over the years. These books are not merely a clear indication of the methodical way she ran her establishment, but are also a testament to Madame Lanvin's appreciation of all things beautiful. She was able to find something interesting or inspiring about objects that many would quickly dismiss as imperfect. Her ideas were truly original, and moreover, she was not as concerned with the paths taken by her peers. Frequently she was the one to be followed, especially during the zenith of her career in the 1920s. Many tried to copy, duplicate, and undersell her, but

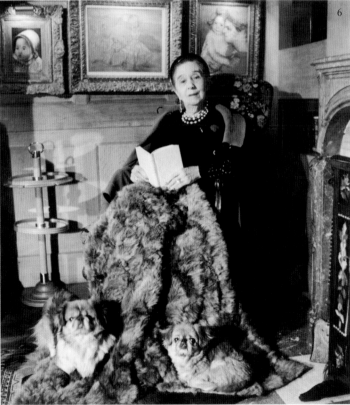

Figure 4: The personal observation recorded in *Vogue*, 1932, described the electric yet proper fashion presentation, with a personal welcome by Madame Lanvin accompanied by her muse, Marguerite Marie-Blanche. **Figure 5:** Madame Lanvin, enjoying the fruits of her many decades of labor, inspects the latest work from the ateliers while receiving messages from her butler, 1937. **Figure 6:** Madame Lanvin, avoiding a chill with a fur throw, enjoys the comforts of her vast home. Some of her fine art collection is in the background, and her faithful companions, two Chinese Pekingese pugs, are at her feet.

no one could replicate the delicate, ethereal quality of her gowns. They were made with the finest materials and executed by the most talented hands within the highly skilled ateliers of maison Lanvin.

What an astonishing person Madame Lanvin is! Imagine, in this commercial day and generation, being able to conduct a business with undiminished chic and elegance. It is a great tribute to the extraordinary personality of a woman who is one of the romantic figures in the world of Paris Couture. On the night of her opening, the salons, crowded with super-professionals, waiting to give the Collection the "once-over," changed as if by magic at her entrance.

This distinguished elderly woman, wearing a black dress, a red-and-silver paillette jacket, her wealth of hair coiled on her head in exactly the same chignon that she wore twenty years ago, and some lovely jewels around her neck, came in and made a tour of the room, like royalty, smiling and greeting everyone. She stopped to say a word to Monsieur Rodier, an old friend, and made a charming little gesture to show him that the dress she wore, under the paillette jacket, was made of his material. (They made a striking picture talking together—two people of the old school and the grand manner.) Madame Lanvin then seated herself at her desk, like the head-mistress at the commencement exercises of a girls' school (on the desk was a tight bouquet of deep-red roses tied with pale green ribbon). At a signal, the mannequins [sic], "her girls," began the parade, and all those business people sitting along the walls became, in my imagination, the mothers, aunts, uncles, and cousins who had come to see the young girls graduate from a "finishing school." Can you imagine that atmosphere at a Paris opening?[1] (Fig. 4)

On July 6, 1946, Madame Lanvin died peacefully at the age of seventy-nine. Louis Hontaa, the head of Lanvin personnel, Lucien Lelong, a longtime friend and contemporary, and her nephew, Jean Gaumont-Lanvin, all spoke at her grave.

Louis Hontaa, speaking to the maison Lanvin employees, recalled:

Never will you all know how much she loved and appreciated you. She was having trouble remembering names but remembered all of your faces, she was aware of your talent, she was proud of you.

I still picture her near her window, during the last winter she spent with us. She was sitting by her small black table, covered by a frayed textile, damaged by the books that she was constantly consulting. From time to time, she was raising her eyes to glance at Faubourg Saint-Honoré, the street life, the passersby, the store and the windows across. Then, she would hold tight a blanket that was not protecting her adequately against the cold that filled the room where she would stay all day. Her worried and alert eyes were eager to watch everything and to remember everything. And she would see everything, remember everything. As soon as she would come in, she would call her primary collaborators, pull out of her purse the small Hermès notebook where she would write her thoughts and ideas. These notes were clear, precise, logical, reasonable.

How much she loved this house, which she extended floor by floor, atelier by atelier! She could feel it vibrate within her body and these vibrations would resonate in her this sense of authority, this love for responsibility and this keen sense of kindness that made her character.

Indeed, she was embodying the dream of every worker, every employee. It was common knowledge that her debuts were difficult and that only her work and talent got her through to the highest level. Nobody could forget that as she was very young, she was always working at the atelier table, that she had first made her own hats, delivered by herself that same evening.

Lucien Lelong, Head of the Chambre Syndicate stated:

You, young employees, you have only known the "Grande dame," wearing her jewels and furs, surrounded by rare works of art, but do you know what labor, determination and intensity this culture and sense of beauty represented? Did you know that she studied by herself for innumerable days and nights to learn this artistic knowledge?

Hers was a fierce and tough era. Work hours were not counted, they were added without being measured without end, without rest.

She lived in the suburbs and took the last train before starting again the next day. No free Saturday, no Sundays, few vacations. She could be humane and understanding because she had lived through it. She hated wasted time of half-done work but she knew life was difficult and understood and approved of social evolution.

And Jean Gaumont-Lanvin, nephew of Madame Lanvin, offered:

You, the elders, the collaborators of the first hour, you must remember her as I met her when I was still a child, vibrant,

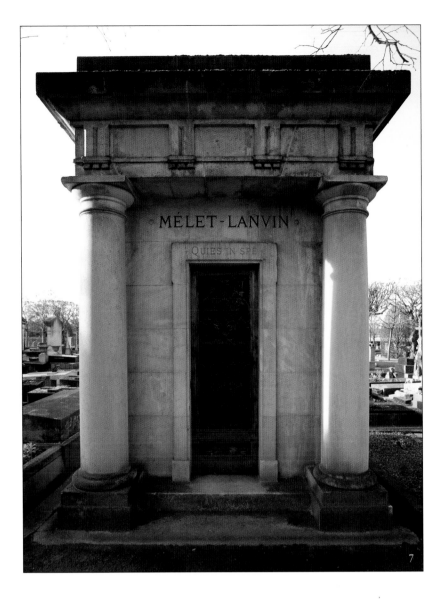

anxious, wearing a huge hat and going to the races with her younger sister, my mother. Not to bet, it was too expensive, but to watch the elegant women of the period and rush back to work in the evening full of new ideas.

She was feared, but also loved because she was fair.

She was not concealing her thoughts, was not looking for pretty phrases, did not pretend to know something she did not know. She had a natural instinct for what was noble and beautiful, refused to see ugliness. She loved the theatre, traveling, museums, small embroidery works, and books. She was the most pleasant company in travels, the most modest and cheerful host.

She detested witted phrases that would include a nasty comment. She simply loved life.

Then, one morning she left us. For days we thought this could not be...

Figure 7: Madame Lanvin died on Saturday, July 6, 1946 in her bedroom at 16 rue Barbet-de-Jouy. She was interred into her family tomb in the town of Vésinet, the location of her country home. The forged iron door of the tomb reflects the Lanvin-blue color from the stained glass in the open ironwork. The blue stained glass was also used in the windows on either side of the tomb. As the monogram inscribed on the Rateau desk in page 288, Fig. 26– "MJL" for Jeanne Mélet-Lanvin–it is clear that the matriarch never forsook the Lanvin family name, maintaining her independence and dominant position within the family and industry, and took Mélet as her middle name.

Opposite page: Figure 8. A portrait of Madame Lanvin by François Kollar. Visible in the portrait is her wedding ring, and the Cartier earrings, which she wore throughout the years. True to Lanvin style, her abundant gray hair is braided and swept up into a neat, minimal coiffure. This photograph was taken when Madame Lanvin was 70 years of age. Yvonne Printemps, a longtime loyal client and actress states, "She has extraordinary hands, the most beautiful I have ever seen; the tips of her fingers turn up towards the sky."

1 Vogue. (October 1, 1932), 31.

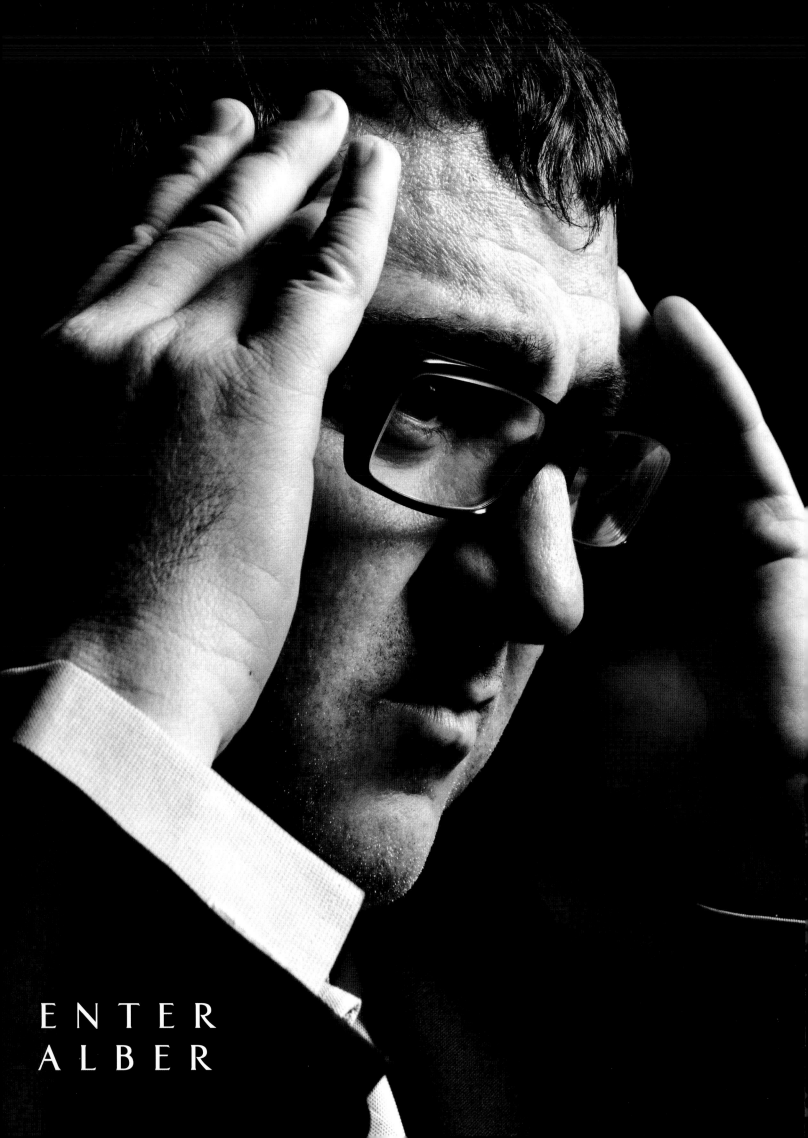

ENTER
ALBER

THE PRESENT SUCCESS of the long-awaited Lanvin renaissance—after several decades of cruel anonymity—is no surprise. Finally a designer, or creator if you will, has given appropriate homage to Jeanne Lanvin, and the winning business formula that she created, developed, and perfected throughout her long, groundbreaking career.

Madame Lanvin knew her clientele—their needs, wants, and desires—better than they knew themselves. They looked forward to direction from the designer they most trusted and respected. Faithful Lanvin clientele spanned the generations within a single family. The first purchase for a child may have been that of a baptismal gown and the last purchase may have been a simplistic black dress and hat for a widow.

Alber Elbaz has created the same environment for the Lanvin women of the twenty-first century. Mothers are shopping with daughters, daughters are shopping with their daughters, and grandmothers are shopping with their granddaughters. All of these women with their range of needs and desires are having them fulfilled by the same designer.

Elbaz creates sublime silhouettes in the form of sophisticated suits, fluid dresses, and voluminous coats. He is not reinventing the House of Lanvin but wisely following the unwritten, yet prescribed, design formula laid out by Madame Lanvin herself: blur the lines that define the generations, design garments that are suitable and flattering for various body types, create a complete head-to-foot wardrobe for a woman. Options are crucial but never fully subscribe to the current trends; instead, a permanent style of youth, femininity, and beauty is promoted.

For the first time since the death of Jeanne Lanvin, a designer has skillfully extracted the essence of Madame Lanvin from her empire, her archives, and her office; the essence has manifested itself as "imperfect perfection." Elbaz has himself stated that "after perfection there is nothing." Through the veils of distressed silk tulle, shreds of silk charmeuse, raw exposed seams, and decorative functional fastenings, there is the foundation of this (im)perfection—one can only explore and push its boundaries after mastering the challenging craft and techniques of perfect garment construction.

On the "imperfect" exterior of Elbaz creations is what appears to be carelessly cut charmeuse in narrow strips, which move with the wearer while carelessly revealing the foundation. In reality, the silk charmeuse is carefully sliced on the bias, utilizing the knowledge that fabric cut on the bias creates edges that do not fray—and therefore, require no edge finishing.

Only after an intimate relationship is developed with textiles is one able to derive esoteric pleasure from experimenting with and creating new weaves and fabrications. Some of the fibers, and combinations thereof, subjected to the experiments of Elbaz include wool woven with paper fibers and linen woven with metal filaments. Only after one fully understands and appreciates the potential and limitations of a medium is one able to achieve certain supple silhouettes, strong shapes, and subtle character. All of this may be achieved by manipulating the use of the warp and weft, as well as bias direction, of the textiles in the three-dimensional draping or two-dimensional flat-patterning process.

With the knowledge and ability to manipulate textiles in the pattern and construction process, one may avoid the need for seams and seam finishes—the need for interfacings, zippers, closures, and hems—altogether. With free-form organic shapes, it is entirely possible and desirable to avoid the traditional and typical two side seams. When choosing to adorn

the human form in the round, seams fall where they may and ideally, typically, they fall into a position allowing for the most flattering forms. What appears to be a casually and carelessly cinched waist, whether on a cashmere coat or chiffon dress, is ingeniously engineered to create a quasi-spontaneous result.

Asymmetry in hemlines, sleeves, necklines, and closures enhances the effect of an impulsive, uncontrolled image. Slips of chiffon are timidly twisted and turned in contrast with leather-lashed waists. At the same time, tiers of pleated chiffon are suspended from barely-there silk tulle and grosgrain encrusted with the illusion of heirloom estate jewelry. Supple shoulders, bare backs, and daring décolletage are the best features of all. Erogenous zones are clearly mapped out, and Elbaz reveals all.

Two-piece suits are soft sculptures gently revealing the purest feminine form. Without hard structure, there is no disguising of shapes under a rigid, tailored façade. The achieved goal is to flatter the form, not to distort it. Ladylike suits, sans right angles and rigid tailoring, maintain a body-caressing shape. Textured wools allow for fluid folds in A-line skirts and desired drape and movement in cardigan-style jackets. Exposed seams, self-fabric fringe, and structural stitching achieve the looks of haute couture hand-me-downs. Distressed and prematurely aged brass paillettes and assorted components add the welcome patina of lived-in and worn-out familial comfort.

Elbaz has nested himself comfortably in the fashion incubator created by Jeanne Lanvin. He maintains a private and intimate office space within the larger design atelier, where whimsical elements of personal inspiration fill the small space. Framed and unframed photo clips from old movies are mounted to the wall. The desk, one of Jeanne Lanvin's black lacquer art deco desks, is paired with one of his own utilitarian chairs. The desktop is the setting for elements of youth, fantasy, and humor including a circus big top in miniature as well as various antique dolls and toys. Vintage films—their themes, ambiance, and actresses—play an important inspirational role in the creative process; stacks of VCR tapes and DVDs confirm this as do the range of titles and subject matter.

Pieces of Rateau furniture are found throughout the design atelier. Multiple chairs—some used, some unused—in various styles of modern baroque Rateau are within the space; they are both functional and inspirational. Elbaz utilizes the remaining Rateau furniture inventory as ambient décor for inspired and whimsical *mise-en-scène* window displays and as functional forms within the boutique, such as a vitrine displaying the current collection of accessories. The new interior design of the boutique reflects the modern direction of the collection as well as a temporary "work in progress" feel created by propped up mirrors for fittings, rolling racks of pieces from the current collection, and the absence of any permanent fixtures. The boutique is like the Lanvin collection itself, ever-changing, ever-evolving. With every season brings change in silhouette, mood, color, direction, inspiration, and emotion.

The modern interior and direction of Lanvin is grounded with vintage, large-scale black and white photographs of polished Lanvin models in head-to-toe ensembles. These strong representative images grace the walls of the curving stairway and are found on the floor propped up against the baseboard moldings. A conscious effort is made to marry the past and present as the house looks to the future: at this productive juncture, the two eras meld seamlessly.

RUNNING ORDER

Above: Polaroids of the running order for the Fall/Winter 2007-08 show.

Above: A picture from the Fall/Winter 2007 show at the Trocadéro in March 2007.

Following spread: Alber Elbaz' sketch for Barney's window in New York City, July, 2004; Installation by Sui Jianguo in the womens boutique on Faubourg Saint-Honoré, July 2003.

Above: limited edition porcelain "Miss Lanvin" dolls by the Chinese artist Franz, reproducing Spring/Summer 2007 looks.

Above: Alber Elbaz' sketch for the window of the womens boutique on Faubourg Saint-Honoré, 2007.

Pages 324-327: Fall/Winter 2006-07 campaign.
Pages 328-329: Alber Elbaz' sketch for Fall/Winter 2006-07 collection.
Pages 330-331: "Rumeur" perfume ad campaign, Winter 2006.

This spread and following: pictures from the Fall/Winter 2007 show at the Trocadéro in March 2007.

Spring/Summer 2005 campaign.

Following spread: Fall/Winter 2002-03 campaign. **Pages 340-343:** Fall/Winter 2007-08 Womens Accessories collection.

This spread: Fall/Winter 2007-08 Womens
Accessories collection.

Pages 346-349: Fall/Winter 2003-04 campaign.

Pages 350-351: Spring 2006 Womens Accessories
collection.

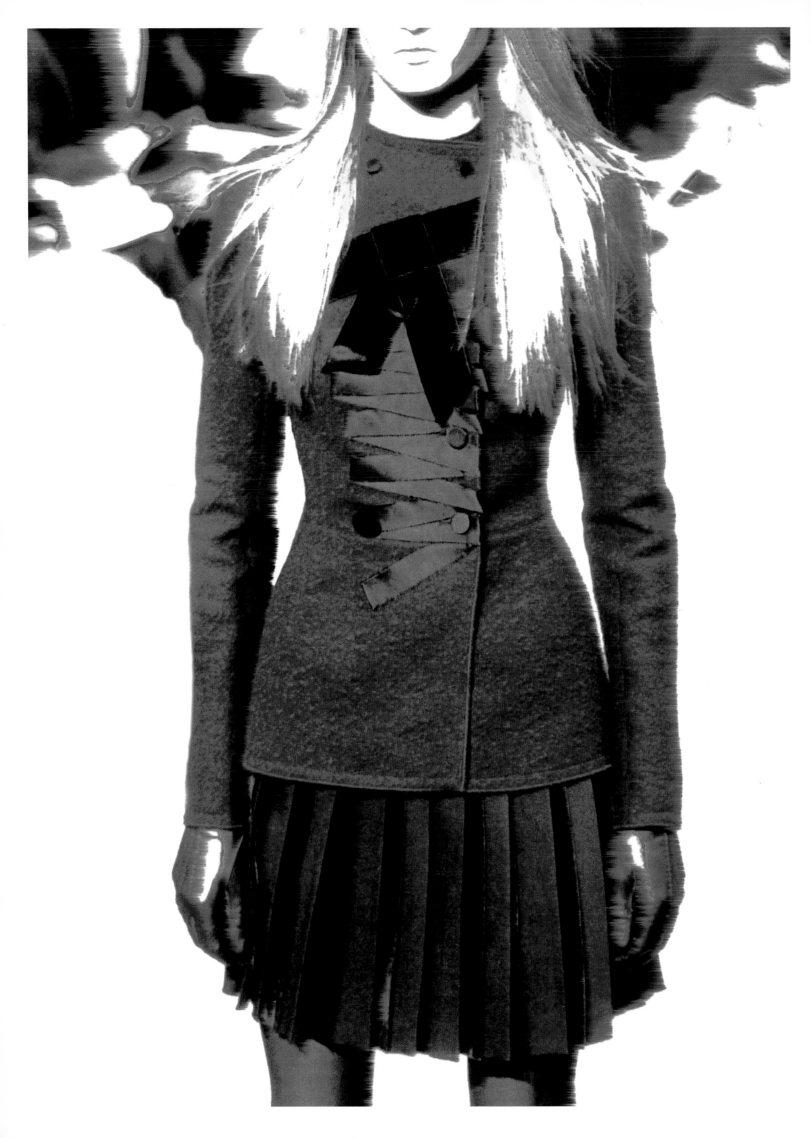

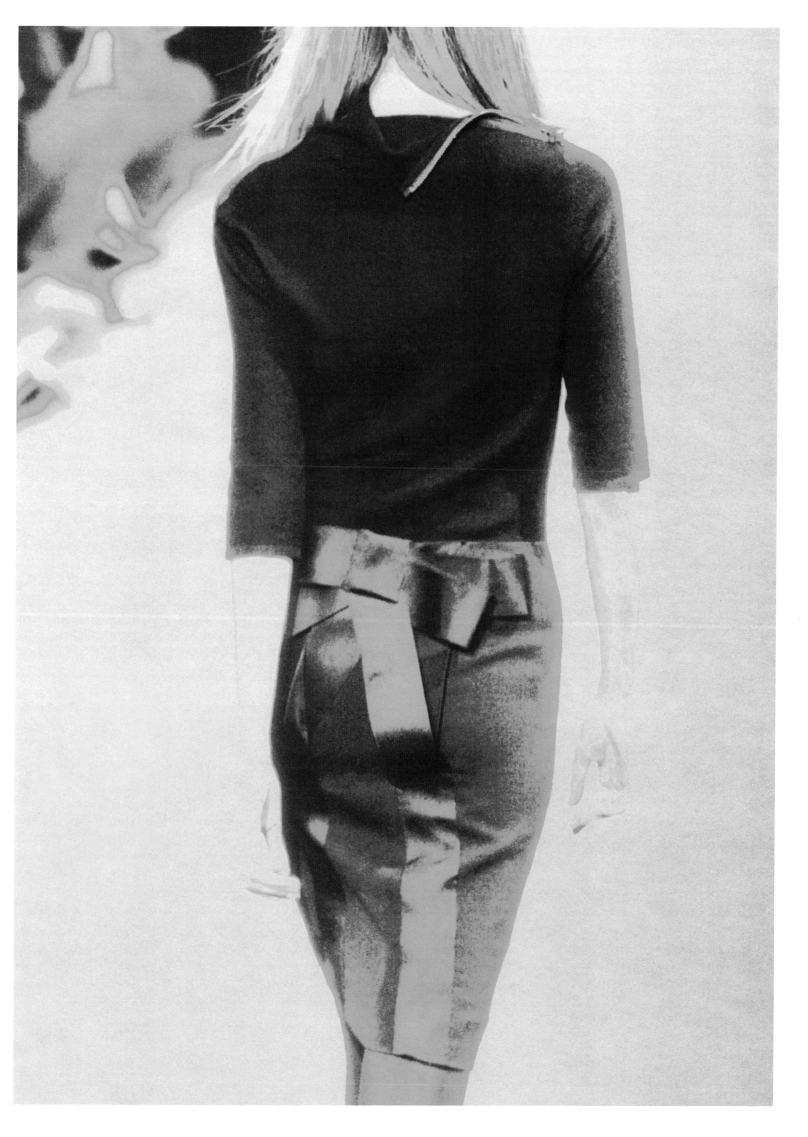

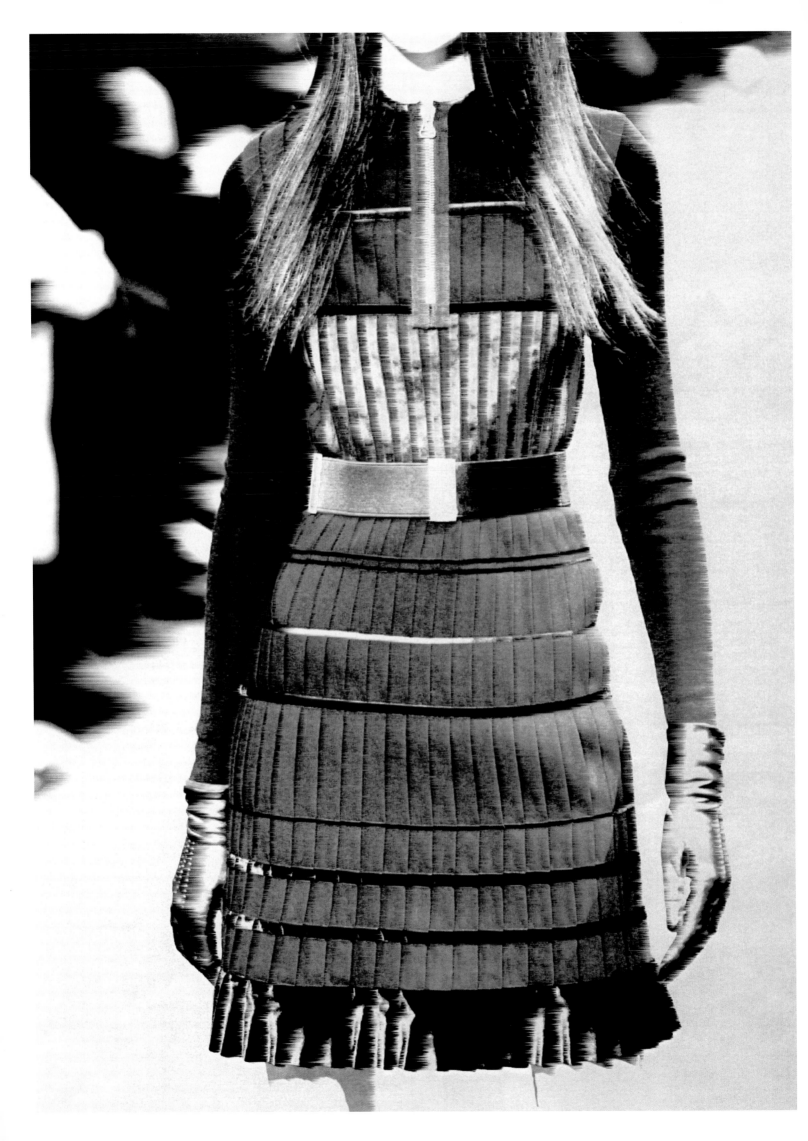

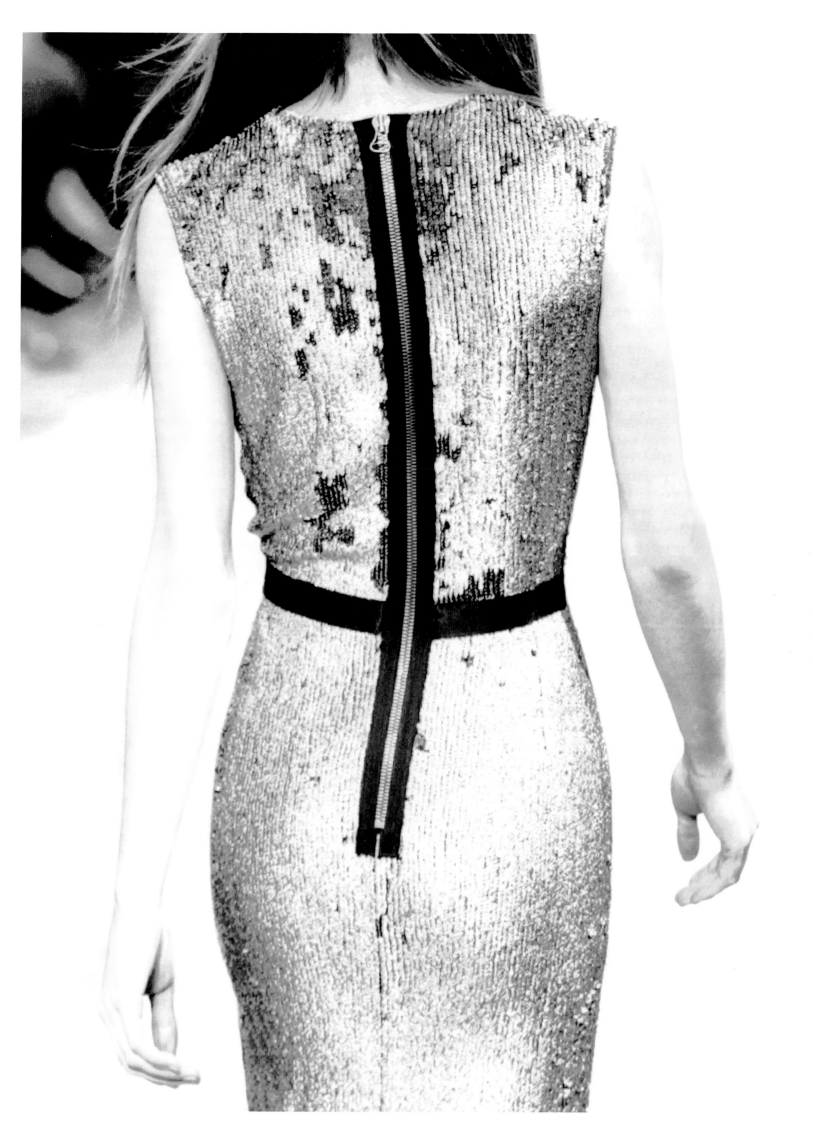

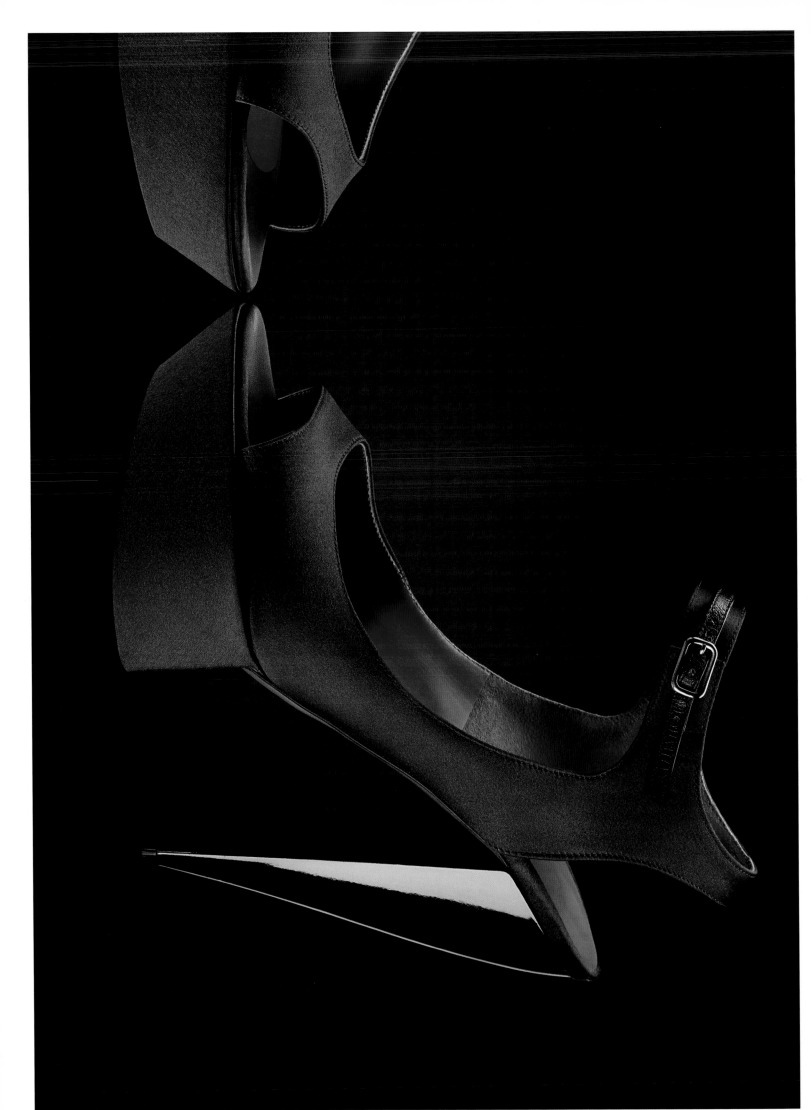

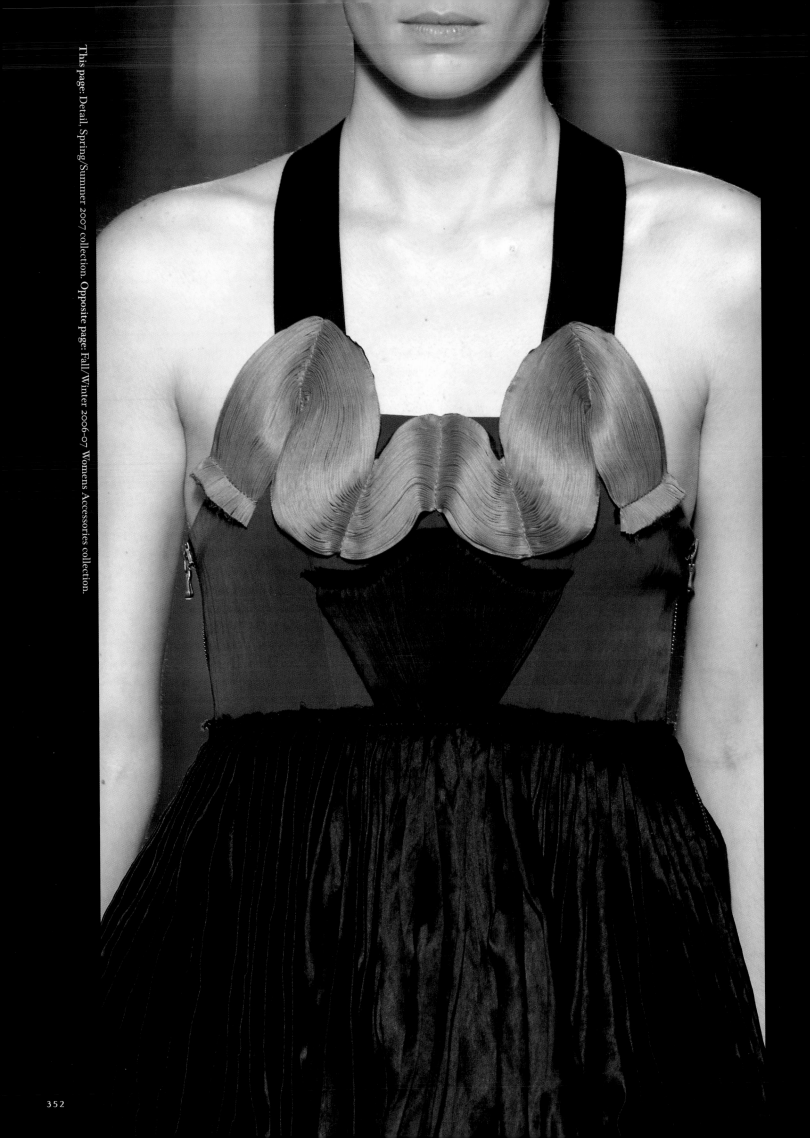

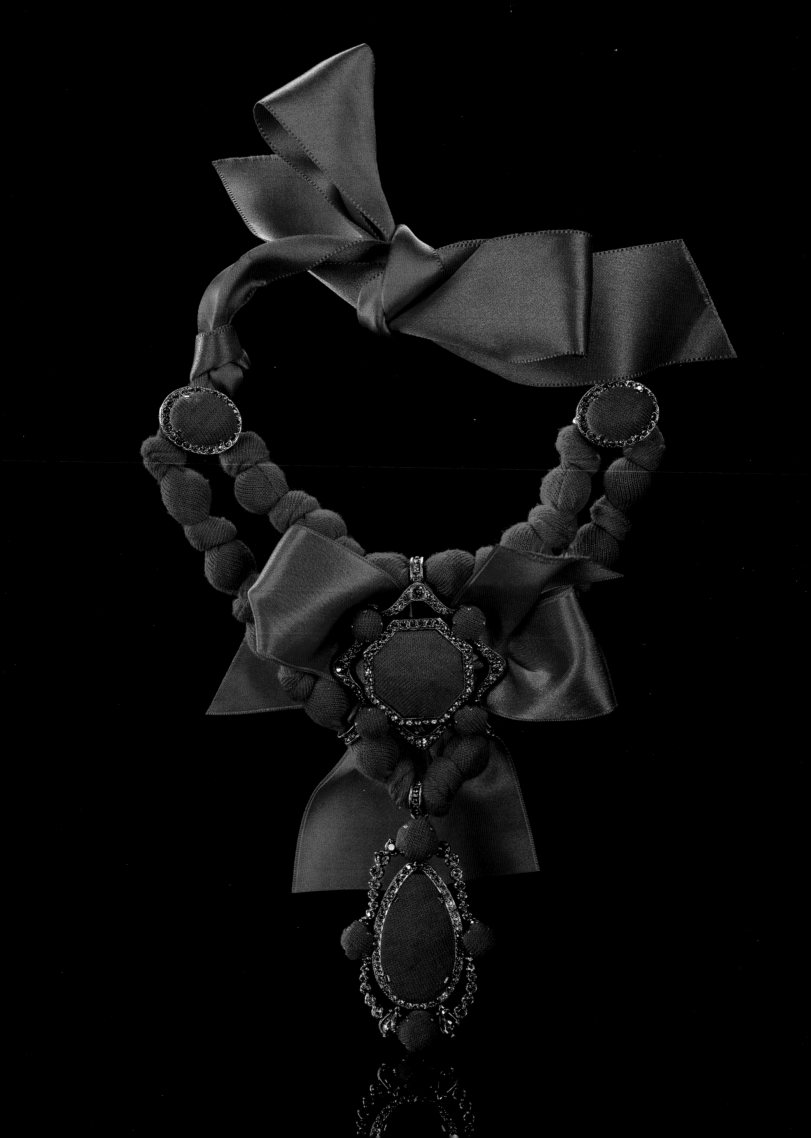

Pages 354-355: Installation of Fall/Winter 2006-07 Womens accessories collection at the Hôtel Crillon Paris, April 2006.

Pages 356-357: Spring/Summer 2006 campaign.

Opposite page: Installation by Yue Minjun in the womens boutique on Faubourg Saint-Honoré, January 2005.

This page: Portraits of Alber Elbaz in the January 2005 window for *Les Echos*, April 2005.

Following spread and pages 360-363: Fall/Winter 2004-05 campaign.

Pages 364-365: Alber Elbaz' sketches for the 2007 edition of *Bottin Mondain*.

CHRONOLOGY OF KEY EVENTS

1867 Birth of Jeanne Lanvin on January 1.

1883 Begins working as an apprentice rimming hats in the workshop of Maison Félix at 15 rue du Faubourg Saint-Honoré.

1885 Sets up her own workshop in rue du Marché Saint-Honoré with the support of her first client.

1889 Starts her own millinery business at 16 rue Boissy-d'Anglais.

1895 Marries Emilio di Pietro. They divorce in 1903.

1897 Birth of Marguerite Marie-Blanche di Pietro. Madame Lanvin is compelled to make an entire wardrobe for her daughter.

1901 Maison Lanvin grows to now include 16–20 rue Boissy-d'Anglais.

1907 Marries the journalist Xavier Mélet, who later becomes the French consul in Manchester, England.

1908 Opens a department of childrenswear under the Lanvin label.

1909 As a full-fledged couturier, with a womens and girls department, she joins the Syndicat de la Couture.

1915 Participates in the San Francisco World's Fair.

1920 A partnership, personal and professional, was formed between Madame Lanvin and Armand-Albert Rateau. They create a new department known as Lanvin Décoration.

1923 A dye factory in Nanterre is developed to create original colors desired for the designs of Madame Lanvin. Later, perfume laboratories are established there in conjunction with André Fraysse.

1925 Jeanne Lanvin serves as Vice-President of the Pavillon de l'Elegance at the Esposition Internationale des Arts Décoratifs, Paris. At this point, Lanvin is made up of 23 ateliers employing up to 800 people. Lanvin boutiques are opened in Cannes and Le Touquet. Her first perfume, "My Sin" is launched to great success, especially in the United States. Marguerite Marie-Blanche marries Count Jean de Polignac and officially changes her name to Marie-Blanche.

1926 Madame Lanvin is made Chevalier de la Légion d'Honneur. Her nephew, Maurice Lanvin, becomes the director of a new men's department at 15 rue du Faubourg Saint-Honoré. At the same time, she opens new departments for furs and lingerie.

1927 Launch of "Arpège" perfume contained in the round black bottle with gold raspberry stopper, designed in collaboration with A. A. Rateau. New boutiques are opened in Deauville, Biarritz, Barcelona, and Buenos Aires.

1933 Two additional perfumes are launched, "Scandal" and "Eau de Lanvin."

1934 Launch of the new *eau-de-cologne*, "Rumeur."

1935 A Lanvin collection is shown during a fashion show gala held aboard the *SS Normandie* during its maiden voyage from France to New York. She participates in the International Exhibition in Brussels.

1937 Participates in the Exposition Universelle, Paris.

1938 Jeanne Lanvin is created Officier de la Légion d'Honneur.

1939 Participates in the Golden Gate International Exposition, San Francisco, and the World's Fair in New York.

1945 Contributes to the exhibition "Théâtre de la Mode" as an effort to relaunch the industry of French couture after World War II.

1946 Jeanne Lanvin dies on July 6 at the age of 79. Marie-Blanche becomes the chairman and managing director of Jeanne Lanvin SA and Lanvin Parfums SA.

1950 Marie-Blanche selects the Spanish designer Antonio Canovas del Castillo to head the haute couture division of Lanvin.

1963 Jules-François Crahay, a Belgian designer, takes over after Castillo.

1985 Maryll Lanvin, wife of Bernard Lanvin, takes over as head designer of the haute couture division of Lanvin.

1990 To great acclaim, Claude Montana is appointed and presents five haute couture collections.

1993 Maison Lanvin officially withdraws from haute couture and focuses on ready-to-wear and luxury goods for men and women.

CHRONOLOGY OF DESIGNERS

Jeanne Lanvin 1885–1946

Marie-Blanche de Polignac 1946–1950
Director General of Jeanne Lanvin SA and Lanvin Parfumes SA

Antonio Canovas del Castillo 1950–1963
Designs all womens collections beginning with Spring/Summer 1951–1962

Bernard Devaux 1960–1980
Hats, scarves, haute couture; womens "Diffusions" line 1963–1980

Jules François Crahay 1964–1984
Haute couture collection: Spring/Summer 1964–Fall/Winter 1984
Boutique de Luxe: Spring/Summer 1964–1984

Maryll Lanvin 1981–1989
"Boutique" collection: Fall/Winter 1982–Fall/Winter 1989

Robert Nelissen 1990
Womens ready-to-wear: Spring/Summer 1990

Claude Montana 1990–1992
Haute couture: Spring/Summer 1990–Spring/Summer 1992

Lanvin withdraws from haute couture in 1993

Eric Bergère 1990–1992
Womens ready-to-wear: Fall/Winter 1990–Spring/Summer 1992

Dominique Morlotti 1992–2001
Womens ready-to-wear: Fall/Winter 1992–Spring/Summer 1996

Ocimar Versolato 1996–1997
Womens ready-to-wear: Fall/Winter 1996–Spring/Summer 1998

Cristina Ortiz 1998–2001
Womens ready-to-wear: Fall/Winter 1998–Spring/Summer 2002

Alber Elbaz 2002–present
Womens ready-to-wear: Fall/Winter 2002–present

MENSWEAR DESIGNERS

Christian Benais 1972
Mens ready-to-wear collection

Patrick Lavoix 1976–1991
Mens ready-to-wear collections

Martin Krutzki 2003-2005
Mens ready-to-wear collections

Lucas Ossendrijver 2005-present
Mens ready-to-wear collections

ACKNOWLEDGEMENTS

I am deeply indebted to the many people and institutions around the world that have contributed to this book. Many generous people have offered their knowledge, time, information, passion, and resources making this book project an educational and memorable experience.

Rizzoli International Publications, Inc. was brave enough to take on a project regarding the work of a woman who few know by name and fewer by face. Their trust in one editor was acknowledged as he pushed for the green light on this project: Without Ian Luna and his foresight, I would continue to sit on a mountain of research and documentation. I am most grateful for the fortuitous introduction that brought us together for this experience of a lifetime.

Many people at Rizzoli have stood behind this project assisting and facilitating the many aspects and endless details of publishing: Charles Miers, Ellen Nidy, Julie DiFilippo, and Pam Sommers have made this a valuable learning experience.

LANVIN/ PATRIMOINE LANVIN

Patrimoine Lanvin: Odile Fraigneau; Lanvin, S. A.: Hania Destelle, Stephanie Albinet, Reuben Teik Hansen, Marine Pacault, Isabelle Tasset, and Mathilde Castello Branco.

MUSEUMS

The Brooklyn Museum of Art: Kevin Stayton and Jan Glier Reider; The Costume Institute at the Metropolitan Museum of Art: Richard Martin, Harold Koda, Andrew Bolton, Shannon Price, Lisa Faibish, Jessa Krick, Jessica Regan, Emily Martin Dunn, Denita Sewell, Chris Paulocik, and Tatyana Pakhladzhyan; The Victoria and Albert Museum, London: Annie Heron; Musée Galliéra: Sophie Grossiord, Fabienne Falluel, and Sylvie Lécallier; Musée de la Mode et du Textiles/Union Centrale des Arts Dècoratifs: Marie-Hélène Poix, Rachel Brishoual, and Chloé Demey; Museum of the City of New York: Phyllis Madgeson; Chicago Historical Society/Chicago History Museum: Timothy Long; Cincinnati Museum of Art: Cynthia Amneus; Museum of Fine Arts Boston: Hillary Kidd and Erin Schleigh; Philadelphia Museum of Art: Dilys Blum and Monica Brown; New York Historical Society, Fenimore Art Museum; Kyoto Costume Institute: Akiko Fukai, Jun Kanai, and Rei Nii; Fashion Institute of Design and Merchandising, Los Angeles: Kevin Jones; The Museum at the Fashion Institute of Technology: Valerie Steele, Patricia Mears, Irving Solero, Claire Sauro, Tamsen Schwartzman, Fred Dennis, and Ellen Shanley; Musée de la Poupée, Paris, France: Sammy Odin; Maryhill Museum: Betty Long-Schlief; Staatliche Museen zu Berlin: A. Schoenberg and C. Waidenschlager; National Gallery Victoria: Megan Patty and Jennie Moloney.

OTHER INSTITUTIONS

Bibliothéque Nationale de France: Georges Gottlieb; Bibliothéque Forney; Centre des Monuments Nationaux; Windsor Castle; The Royal Collection; Royal Enterprises; Historic Royal Palaces, Kensington; Bibliothéque de Musée des Arts Décoratifs; Roger-Viollet/Getty Images: Monique Comminges and Shane Phillips; Art Resource, New York F. I. T. Library: Joshua Waller, Steve Rosenberg, and Elizabeth McMahon; Reunion des Musées Nationaux; Musee de la Mode de la Ville de Paris: Dominique Revellino; Bibliothécaire.

PUBLICATIONS

Condé Nast Publications, Inc.; Fairchild Publications, Inc.; *Harper's Bazaar*, a publication of Hearst Communications.

INDIVIDUALS

Tom Irizarry, Barbara Castle, Barbara Spadaccini, Kevin Jones, and François Lesage. Francois Rateau and the Rateau family for their generous permission to use private images from the portfolio of A. A. Rateau. J-F Schall, generously allowed me the use of images taken by his father, photographer Roger Schall, in an attempt to document events and moments in the private life and career of Madame Lanvin. Martin Kamer, realizing the importance of this project, selflessly gave of his time, images, knowledge, and contacts in order to facilitate the research process only five minutes after our initial meeting. Odile Fraigneau, who shared her limited office space with me and trusted me to carefully leaf through the many bound volumes of gouache designs and beading/embroidery swatches as I entered the highly guarded inner-sanctum of the Lanvin empire. It is such a rare privilege to work side by side with someone who is as passionate about a topic.

Mandy Sahay DeLucia has been a dear friend for almost a decade now. Literally, without her support, dedication, and passion for this project, it would have been impossible to complete this massive undertaking on my own. I remain eternally grateful to her, her husband Paul, and her son Julian.

IN MEMORIAM

Two very special people have affected my life and career during and after my time at the Fashion Institute of Technology. Richard Martin gently pried my eyes open to the world of fashion beyond that of the design room. For the first time, I viewed fashion in the context of a museum environment, and his kind gift has changed my life. His generous assistance and understated enthusiasm confirmed my belief in this massive undertaking from the beginning.

Rose E. Simon was a mentor and professor while studying at F. I. T. After graduation, continuous serendipitous contact fueled a relationship that would continue to grow for eighteen years. She became a dear friend, a fountain of wisdom, and my voice of reason. She granted me the rare privilege of recording her oral history as she witnessed and participated in the birth of the American fashion industry as we know it. A formidable woman, delicate lady, and rare talent, she too followed the varied directions of her artistic interests. I miss her dearly and constantly reflect upon her wisdom.

ILLUSTRATION CREDITS

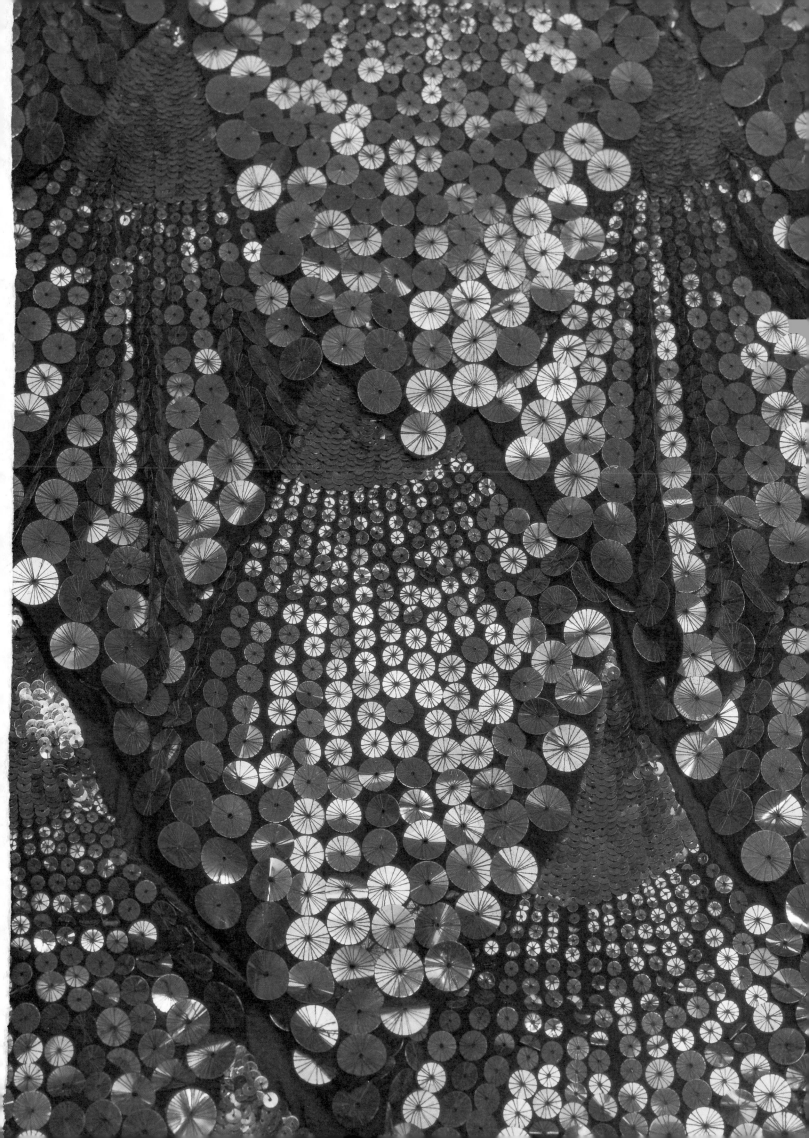